The
Death of
Authentic
Primitive
Art and
Other
Tales of
Progress

The
Death of
Authentic
Primitive
Art and
Other
Tales of
Progress

SHELLY
ERRINGTON

UNIVERSITY OF CALIFORNIA PRESS
Berkeley · Los Angeles · London

University of California Press
Berkeley and Los Angeles, California

University of California Press, Ltd.
London, England

© 1998 by
The Regents of the University of California

The epigraph by M. M. Bakhtin is reprinted from *The Dialogic Imagination: Four Essays* by M. M. Bakhtin, edited by Michael Holquist, translated by Caryl Emerson and Michael Holquist, Copyright © 1981. By permission of the University of Texas Press.

In addition, the author wishes to thank the respective editors and publishers for permission to reuse, in revised form, her previous articles: "Progressivist Stories and the Pre-Columbian Past: Notes on Mexico and the United States," in *Collecting the Pre-Columbian Past*, edited by Elizabeth Boone (Washington, D.C.: Dumbarton Oaks, 1993); "Making Progress on Borobudur: A New Perspective," *Visual Antropology* 9, no. 2 (1993); and "What Became Primitive Art?" *Cultural Anthropology* 9, no. 2 (1994).

Library of Congress Cataloging-in-Publication Data

Errington, Shelly, 1944–
 The death of authentic primitive art and other tales of progress/ Shelly Errington.
 p. cm.
 Includes bibliographical references and index.
 ISBN 0-520-21095-6 (alk. paper). — ISBN 0-520-21211-8 (pbk.: alk. paper)
 1. Art and anthropology. 2. Art, Primitive. 3. Art and society. 4. Ethnological museums and collections. I. Title.
N72.S6E77 1998
709'.01'1—dc21 98-17204
 CIP

Printed in the United States of America

08 07 06 05 04 03 02 01 00

9 8 7 6 5 4 3 2

for
Clifford Geertz
and Benedict Anderson

After the decline of the ancient world, Europe did not know a single cult, a single ritual, a single state or civil ceremony, a single official genre or style serving either the church or the state (hymn, prayer, sacral formulas, declarations, manifestos, etc.) where laughter was sanctioned (in tone, style or language)— even in its most watered-down forms of humor and irony. . . . Laughter remained outside official falsifications, which were coated with a layer of pathetic seriousness. Therefore all high and serious genres, all high forms of language and style, all mere set phrases and all linguistic norms were drenched in conventionality, hypocrisy and falsification. Laughter alone remained uninfected by lies.

M. M. Bakhtin

Contents

Illustrations

Preface

I did not quite know it at the time, but the idea for this book originated when I visited the Michael C. Rockefeller Wing of Primitive Art at the Metropolitan Museum in New York soon after it opened in 1982. Like many other anthropologists, I felt highly ambivalent about the Met's celebration of "authentic primitive art," although the reasons for the ambivalence were not fully clear to me then. In any case, I immediately started doing fieldwork on primitive art exhibits by taking notes on installations, talking to curators, looking into archives, and going on docent-led tours. Two years later the Museum of Modern Art's famous and notorious exhibit "'Primitivism' in 20th Century Art" prompted a spate of seminars, articles, and books about primitivism and authenticity that opened up those topics to rethinking. During the next ten years I read the barrage of new books and articles that came out on museology, collecting, the history of primitivism, the art market, primitive art, and the representation of colonized people in world's fairs.

Although I read those works avidly, my own thoughts had taken a ninety-degree turn away from European and U.S. primitivism and museology only a couple of years after the MoMA "Primitivism" show, and toward the ways that artifacts of cultural minorities and indigenous peoples were being represented in the museum systems of third-world nation-states. My attention was diverted to this subject matter as a result of a brief trip taken in the summer of 1986 to the Philippines and then to Indonesia.

I visited the Philippines to attend a committee meeting for the Social Science Research Council Joint Committee on South and Southeast Asia just a few months after the revolution that ousted Ferdinand Marcos and installed Corey Aquino as president. The surge of hope that expressed itself throughout the country, the amnesty proposed for the New People's Army, the successful efforts by the people of the Cordilleras to stop creation of a dam that would have in-

undated their homes and ancestral graves for the sake of providing Manila with more electricity—all seemed to suggest that the meaning of the nation-state and the place of cultural minorities in the process of modernization were being rethought, or at least renegotiated. Curious about how ethnic minorities were represented under the Marcos regime, I visited a miniature village outside Manila that Imelda Marcos had ordered put up. Supposedly inspired by Indonesia's Taman Mini Indonesia Indah (Beautiful Indonesia-in-Miniature Park), it had examples of houses from all over the Philippines. Yet the park was small and did not seem to represent a major investment, financial or conceptual, in the Philippines' representation of minorities.

From Manila I flew to Indonesia for a few weeks in order to visit the people I had stayed with during my anthropological fieldwork in South Sulawesi in the mid-1970s. Passing first through Jakarta, I marveled at the new international airport at Chengkareng, architecturally themed and decorated to evoke a Central Javanese palace; and I visited the amazing Taman Mini Indonesia Indah, opened in 1973, the project of the wife of Indonesia's then-president Suharto (known as Ibu Tien), who claimed it was inspired by Disneyland. In contrast to the Philippines under Marcos, Indonesia under President Suharto, through his development program called the "New Order," was creating a distinctive iconography of national identity, one that incorporated and celebrated Indonesia's various ethnicities—although just what forms that incorporation took remained to be seen.

From Jakarta I arrived in South Sulawesi, where a social visit turned into a small research trip when I told my best friend and informant there, Andi Anthon Pangerang, about my newfound interest in museums and cultural theme parks. Together we visited the former residence of a ruler of a former kingdom, which had been converted into a museum of the lowest local level in the expanding push of the government to create a national museum system.

It was a museum like none I had been to before, its contents consisting largely of whatever the curator—himself a high noble pining for the years of yore—had been able to assemble. The entire museum functioned as a shrine to the *ancien régime*: one side room had become a convenient storage place for clothing and artifacts used by the local nobility for their ceremonies, while another side room was set up as a shrine, used nearly daily by people of the former king-

dom, who sometimes traveled from distant islands to reunite there with their families and make offerings to the spirits (as happened on the day we visited). The beleaguered curator was being pressured on two fronts. He was a practicing and devout Muslim, but other local Muslims of more fundamentalist persuasions objected to the museum's very existence, believing that it promoted animism and *feodalismo* (feudalism or hierarchy); consequently offerings were made only within the confines of the museum and somewhat covertly. But on the other side, the supposed centerpiece of the museum and certainly of the shrine, the kingdom's collection of sacred regalia (which in the old days was an important aspect of royal authority) had been carried off bodily by the henchmen of the local Jakarta-appointed Bupati (regional governor) for storage at his own residence, apparently to keep its power for himself. Walking around the museum, I noticed that, like all residences in South Sulawesi, this former royal residence had a "navel post," where the Ampo Banua or house-spirit resides—evident from the fact that offerings had been placed at the post's base. This post was also festooned with a fire extinguisher, presumably in accordance with a regulation from the national government.

The paradoxes and ironies of this museum's existence and functions struck me as a complex metaphor for things happening in the world at the time. I had no narrative then that would link them all, but a book began to form in my mind that would have something to do with museums, nationalism, military dictatorships, and old regimes and minorities "left behind" in programs of economic development. In other words, it was not the invention of primitive art nor its triumph in the Metropolitan that gripped my attention by the end of that trip, but what was currently happening, literally and symbolically, to the artifacts and lives of people who occupied the space of the "unmodern," the space of the "primitive," the "backward," the economically and symbolically peripheral, in the nation-state imaginaries that replaced the colonial ones.

As a result of another trip to Indonesia, in the summer of 1989, the art market entered my developing story. While visiting Toraja-land in the mountains of South Sulawesi, I saw and heard about the efforts that Toraja people must now make to prevent their ancestor figures from being stolen to be sold as "art." In the mid-1970s, when I had first visited the area, the effigies and the societies that created

them were somewhat difficult to get to; but with the development of Bali as a major tourist site, the spillover of tourists seeking authentic exotic rituals and authentic artifacts, as well as the infrastructure and connection to world art markets that results from state-sponsored tourism, had spread to Toraja-land. Hence Toraja effigies began to appear in European and U.S. primitive art galleries. On that trip, funded by the Asian Cultural Council of New York, I visited monuments, museums, and palaces in Sulawesi, Java, and Bali, research that enabled me to write chapters 7 and 8 of this book. I was fortunate to tour South Sulawesi in the company of Toby Volkman, Charles Zerner, Leo Goodman, and Andi Anthon Pangerang, while doing the interviews, making the observations, and taking some of the pictures used in chapters 4 and 7. I am grateful to them all for their insights and friendship, not to mention their patience at my insistence on stopping to photograph every transmutation of a Toraja-style house I saw. (I did miss the topiary, though, and still regret it.)

From these fieldwork sites and in the context of developments in the world and in my own discipline, my story was shaping up to be about discourses of progress and the kinds of primitive art and artifacts it produced in different eras and different nations. It was curious. In my discipline and in Euro-American thought generally, the notion of progress and with it the idea of objectivity were collapsing, and of course the notion of the "authentic primitive" artifact or person had been thrown into doubt if not completely discredited. The ideas of Michel Foucault about the knowledge-power system had been thoroughly assimilated in my intellectual circles, as had some of the implications of Edward Said's ideas on Orientalism; and we were denizens of a world experiencing the "postmodern condition" of no grand metanarratives (to echo Jean-François Lyotard). Yet at the very same time, the idea of progress in the guise of economic development theory had been taken up by third-world governments and transnational corporations with a vengeance, and the definitive symbolic end of the Cold War—which occurred with the fall of the Berlin Wall only a few months after I returned from my 1989 summer research trip—meant there was only one game in town. The game was neo-liberalism (Reaganism and Thatcherism were clearly on the ascent at the time) and the town was the world.

The place of "authentic primitive art" is in some ways a small part of the broad sweep of ideas and events I just mentioned, but, because

humans attribute meaning to objects and invest themselves and their ideas in objects, it is not an insignificant one. The notion of art—transcendental and ahistorically valid as a category—has been a powerful one in the West since the Renaissance; and the phenomena that accompany it, support it, help constitute it—art collecting, the art market, its display in museums and other public sites—have had tremendous effects, at least since the eighteenth century, on how objects are accumulated, looted, preserved, circulated, displayed, and their meanings imagined. The ways the objects are imagined in material displays and history books reflect as well as produce the ways the people who made them are imagined in dominant discourses. Hence the easy "knowledge" and opinions that bureaucrats and policymakers have of the marginalized people under their authority may well be a function of their grade-school history courses or the museum displays and theme parks that formed their views long before they were aware of it.

An invitation to give a talk in the fall of 1989 on the National Museum of Anthropology of Mexico by the Instituto de Investigaciones Estéticas at its annual conference added Mexico to my story-in-progress. Expanded and cast into English, the talk was later presented at Dumbarton Oaks. It appears as chapter 6 in this book. The Instituto's kind invitation put me in touch with new colleagues and friends, who continue to educate me in the most agreeable ways; and it put me back in touch with Mexico, where I had grown up but which I had not visited for many years. I am especially indebted to Dr. Clara Bargellini and her husband, Gabriel Cámara, and to José Luis Reza, for their friendship and generously shared knowledge of Mexico.

I was fortunate to spend the academic year 1989–90 at the Center for Advanced Study in the Behavioral and Social Sciences at Stanford. Besides being a pleasant sojourn that allowed me to finish up another book and to begin this one in moderate earnest, the weekly talks by Fellows inspired humorous drawings illustrating concepts, some of which appear in the introduction to this book. I drew pictures of facts and data upon hearing Lorraine Daston's scholarly disquisition on the history of objectivity; and by trying to summarize the talks of economists in visual form I discovered the graph as a form of cartoon. And at the end of 1989 the Berlin Wall fell, producing many interesting discussions at lunch about the fate of the world,

now that there was no "second-world" political bloc, but only a first and a third. Reginald Zelnik and Donald Donham, both interested in and thoughtful about the implications of this event for global politics, were exemplary conversation mates and colleagues. That year I began also to go to primitive art galleries and emporiums in San Francisco, grilling conservators and collectors and dealers about the state of primitive art and their interests in it.

My "fieldwork" method for this book, in short, was nothing if not opportunistic. Anytime I went anywhere for a conference or vacation, I stopped at local museums, talked to curators, took pictures, sought out signifiers of the primitive. On a trip to Scandinavia I visited Skansen and the National Museum, which was having a giant metanarrative exhibit on the whole of Swedish history; in Hawaii I visited Polynesian Cultural Center; in Florida, went to EPCOT Center at Walt Disney World; in Tijuana, visited Mexitlán, a privately owned cultural theme park; in Santa Fe, strolled through the Indian Art Market; in Sedona, inventoried a "trading post" filled with kitsch; in Las Vegas, explored the Luxor hotel, including its "museum shop" with genuine Egyptian items for sale, and took a tour of "King Tut's burial chamber" replicated there. At home I turned to my advantage the avalanche of glossy colored catalogs that daily inundates my mailbox by (successfully) poring over them for evidences of primitivism. Everywhere I acquired T-shirts and refrigerator magnets.

In the mid-1990s I settled down in real earnest to pull it all together to make this book. In the course of so many years, so many events, so many conversations, and so many fieldwork sites, and with an argument that connects some of the silliest kitsch to some of the saddest events in economic globalization, to some of the most heroic resistance, to some of the blackest humor, I have acquired many debts of gratitude.

First the institutions and institutional contexts. Aside from those already mentioned (Social Science Research Council, Asian Cultural Council, and the Center for Advanced Study in the Behavioral and Social Sciences), I am grateful to have been spending some time at the Institute for Advanced Study in Princeton when I first visited the Rockefeller Wing. I am indebted to the MacArthur Foundation for support in the early years of the project and for the continuing privilege of associating with other Fellows in a variety of contexts, which

always broadens one's knowledge and influences one's views. The University of California at Santa Cruz provided help in a variety of ways. At the invitation of the Council of Provosts I presented a public lecture on this book in 1996, a festive occasion, which James Clifford kindly consented to introduce; in it I struck the tone and prepared many of the cartoons and pictures that now appear in this book's introduction. The faculty Committee on Research has generously provided grants throughout the years. The Document Processing Center, especially Cheryl Van der Veer, gave invaluable help in sorting out references and proofreading; my undergraduate office assistants, Bonnie Goldstein De Varco and Sholeh Shahrokhi, almost kept me organized (not quite). My colleagues in anthropology, in art history/visual culture, and in the history of consciousness, and the lively students in all those fields, both undergraduate and graduate, consistently welcome and encourage exploratory courses and written work—no disciplinary boundary-policing inhibits the free pursuit of a topic wherever it might take one. Acknowledgments for pictures appear under "Illustration Credits," but I want to express my gratitude to Dr. Ellen Raven of the KITLV of Leiden University, whose heroic efforts, far beyond mere duty, to facilitate my obtaining photographs and permissions from the Kern Library and the KITLV eventually were successful. At the University of California Press, Sheila Levine "acquired" the book when there was not that much to go on; Laura Driussi read and made very useful comments on the manuscript; Barbara Jellow designed the book with special attention to effective use of my numerous pictures; and Sue Heinemann, project editor, kept track of progress and made only very sensible and helpful copyediting comments.

In the project's early and middle stages, I fortunately belonged to an exceptionally supportive and critical writing group drawn from my department, consisting of Diane Gifford-Gonzalez, Olga Najéra-Ramirez, Carolyn Martin Shaw, and Anna Tsing; it is a pleasure to acknowledge them. In the ante-penultimate, penultimate, and ultimate drafts of the last several years, three people have given of their intellectual energy more than generously. Hildred Geertz, twice as an "anonymous" reader for the Press, understood what I was up to and let me know in both detail and in broad strokes what she liked and what she did not. She paid more "quality attention," as they say in parenting self-help books, than almost anyone else. Lucien Taylor

similarly encouraged my paper on Borobudur when he was editor of *Visual Anthropology Review* and then read and commented on a complete draft of the book's manuscript and several versions of the introduction. And Kathryn Chetkovich, a writer and freelance editor, worked with me over a period of several years; she has an exceptional talent for understanding and delighting in an author's style and thoughts while providing an intelligent foil to test them against. Readers of the introduction and preface, in various permutations, to whom I am grateful, include Margaret Fitzsimmons, Leo Goodman, Orvar Löfgren, Carolyn Martin Shaw, and Amin Sweeney. For hospitality and good conversation that aided and abetted this project, I am grateful to a very large number of friends and colleagues, but for fieldwork help in or at the site, I want especially to thank Allison Leitch and Steven Feld in Santa Fe and Orvar Löfgren and Anne-Marie Palm in Lund, Sweden.

Those are the people and institutions who have helped during the short and medium durée of the writing of this particular book. The *longue durée* of the intellectual context that allowed it to be produced was formed with the influences of Clifford Geertz and Benedict Anderson. All scholars of Southeast Asia writing in English are indebted to them both. They have had such enormous influence because they asked questions worth asking and answered them compellingly, provoking the work that followed theirs also to address questions worth answering, even when later authors found different answers. Not every ethnographic region in the world is so fortunate in its scholarship.

For some of the same reasons, they both have influenced writing and thinking far beyond an area specialty and far beyond their disciplines. Clifford Geertz, in tacking between the tiniest deep detail and some of the largest issues pertinent to the human condition, showed that humans are animals who will use whatever is at hand, however unlikely, to make meaning—worth remembering not only in the face of the ersatz scientism he so criticized but also in the conditions of globalization. And by writing prose that people enjoy reading while opting for complex analysis over bad-faith simplicity, he created breathing space for all commentators on social life, especially those who go under the rubric "social scientists." A generation later, Benedict Anderson's work on nationalism recast the topic; but its importance is just as great, in my opinion, as a model of how deep cultural

analysis can be made relevant to the broadest political analysis; and his sweeping but highly informed prose with occasional wry asides is a pleasure to read. As an area specialist and as a "social scientist," I am indebted to each of them, but I have dedicated this book to both—an odd combo in many people's minds, including, I daresay, in theirs—for personal reasons of gratitude.

A Note on Punctuation
and the Primitive

Once upon a time, an author could write a historical work confident that the object of knowledge that was the book's essential topic unfolded over time in a slow and orderly manner, and confident that "it" was the same thing, albeit changed with time, at the beginning and end of the story. That sort of conventional history produced titles like (I am making these up) "The Rise of the Family" or "Hysteria—from the Ancient Greeks to the Present Day." Their authors did not feel obliged to ask deeply, for instance, whether Greek "hysteria" shares anything whatsoever with present-day "hysteria" other than the Greek root of the English word, and therefore whether to write such a history makes any sense.

In years of late, Michel Foucault's work more than anyone else's destroyed the legitimacy of that mode of writing. The Foucault-friendly premise on which this book is founded is that "primitive art" is not a timeless category existing in the abstract world of ideas and essences but a constructed category that appeared at a certain moment. Nor did the category remain stable once it was invented: both the semantic field in which the term exists and the objects gathered under its rubric changed over time and varied across contexts—those contexts being (for my purposes) institutional displays, markets, and collections.

To take that stance, however, forces the author of a history—even a loosely historical account like this book—to confront the issue of how to name something that is *not* the same thing in the story's beginning and end. One alternative to conventional history prompted by this dilemma and adopted by some historians is to make the methodology fully as important, sometimes more so, than the subject matter of their books, in order to emphasize and explicate the dilemma itself. In this book I have tried to take a more moderate course than either extreme (the two extremes being conventional history, which imagines the categories as transparent and constant, and

a self-questioning history, heavy on abstract language and focused on method). But an author's moderation requires a tolerant reader. I know this because I have dealt with copy editors.

The necessity of writing an *apologia pro verbis meis* first occurred to me when a copy editor suggested changing my sentence that began "Freud's construction of the primitive . . . " to "Freud's construction of indigenous people. . . . " I have it on good authority that Freud wrote nothing whatsoever about "indigenous people," and although, like the copy editor, I do not want to offend, I also do not want to be anachronistic. The book is premised on the fact that the object of knowledge changes in different contexts and is constituted partly by the way it is named, the unmarked use of which in my own account, in what is obviously a historical context of a word's use, is supposed to evoke in my readers an idea that is specific to that era or context. To try to find a neutral language that names a constant object is precisely not what I am trying to do.

The reason for finding a "neutral language," I am well aware, is not because copy editors want to promote anachronism but because they rightly strive to avoid language that is disrespectful; that is obviously my wish, as well—although in this regard I can do no better than quote the art historian Frances Connelly, who wrote, "The derogatory connotations of the term 'primitive' have provoked efforts to find less value-laden substitutes. The real need is not for neutralized substitutes but for recognition that the term does not describe a Yoruba figure or an Egyptian relief, but a set of ideas belonging to Europeans." That said, it still remains true that the author of a work about the primitive and primitivism needs some devices to show ironic distance from terms that could be misinterpreted as being uttered in the author's own voice.

Occasionally I do want to show ironic distance from a term, in which case I sometimes capitalize the first letter of the word; for instance, in the introduction I make a point of capitalizing Reason, Objectivity, and some other terms. Several years ago, when one of this book's chapters was being published as an article, the copy editor changed my deliberately written Primitive Man (it may even have been a direct quote from a museum label) to primitive humans, in accordance with the journal's policy of not capitalizing ordinary words and eliminating sexist language. The new low-impact change (which fortunately was caught before cast in ink) did nothing to alert the

reader that it was the museum's voice, not mine, that was speaking. I had written the words with initial caps to signal to the reader that the term is not my own and also to evoke recognition of a certain voice and mind-set that believes in the importance of its own pronouncements.

Other than the occasional initial capital, another punctuational tactic I use to show ironic distance is to put quotes around a term like "authentic primitive art" or "tourist art" the first time it is used or when I want to remind the reader that it names an ephemeral category or a changing one. The danger of not using the quotes at all is that a reader will not "hear" the premise of my argument (that authentic primitive art, or tourist art, or whatever, is a constructed category); yet if I always marked changeable categories with quotation marks, it would belabor what ought eventually to be obvious and would become irritating. Therefore, for the most part I have assumed that readers will understand the larger argument and will provide their own quotes around terms, tolerantly understanding that I am trying to spare them annoyance rather than that I am reifying a category.

When speaking in my own voice about actual people and their condition, I have used terms that are historically appropriate in the context of my text (such as "colonized people," or "people of Africa, Oceania, and the Americas," or "fourth-world people," or "people on the periphery of the global economic system") and sometimes specifically the ways that some groups currently are referring to themselves (Native Americans, Aboriginals of Australia, Canada's First People, the indigenes of Latin America—a translation of *los indigenas* rather than the now-derogatory *indios*), even though some of these names will persist only a few years, and there is debate among the communities themselves about appropriate terms (for instance, "American Indian" is favored over "Native American" by some). I trust that my readers, including those of the groups mentioned, will understand the short life of names and the changeability of what they denote.

INTRODUCTION

• • •

TWO CENTURIES OF PROGRESS

Primitive art, the story goes, was "discovered" at the turn of the twentieth century by artists haunting flea markets and the Trocadero. From those origins it has progressed (so to speak) to wide acceptance within the mainstream of art. In 1982, with the opening of the Michael C. Rockefeller Wing of Primitive Art at the Metropolitan Museum in New York, primitive art reached the peak of its rise to fame (figure 1).

The opening of this new wing represented a triumph for the Rockefeller family's collection of primitive art. Even more significantly, it was a triumph for the category of objects we call "primitive art." If artifacts were social climbers, making it into the Met would be like having a debutante ball and being listed in the Social Register—a sign you'd really made it. Being in the Met signified visibility and institutional endorsement at last. Primitive art had made it to the top.

The market and institutional consequences were immediate. Major art museums featured temporary exhibits of exotic arts, and galleries of primitive art cropped up everywhere. When the home furnishings department of Macy's in San Francisco had a show of primitive art from the Amazon that winter, I rushed to see it, camera in hand. In a darkened space on the seventh floor, surrounded by jungle noises piped in through the sound system, I read an illustrated brochure predicting how valuable the art would become and explaining the perils that Macy's buyers had faced to obtain this primitive art—though the natives had received the buyers with warmth and enthusiasm, we were assured. I reflected that, whereas we all know that good art doesn't match the sofa, Macy's set out to convince us precisely that, tastefully arranged, it does (figure 2).

Two years later, New York was awash with primitive art: five major exhibits were on view, prompting James Clifford to dub 1984 "the

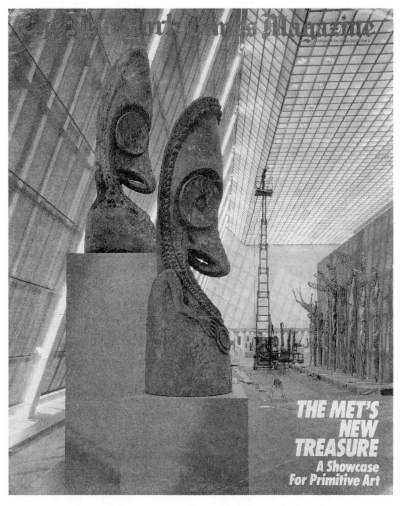

Figure 1. Institutional acceptance of primitive art peaked in the United States with the opening of the Michael C. Rockefeller Wing of Primitive Art at the Metropolitan Museum in New York in 1982.

Winter of Primitive Art." The most important was the Museum of Modern Art's major show "'Primitivism' in 20th Century Art," a retrospective of the influence of primitive art on major modern artists— the Cubists, Surrealists, and so forth. It showed, in effect, that primitive art had reached the status of a dead modern master.

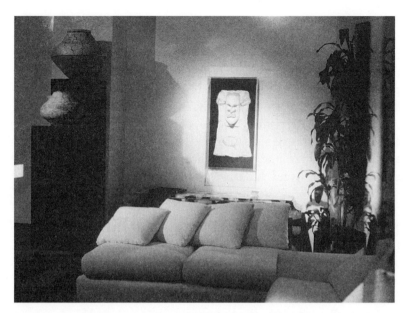

Figure 2. Good art matches the sofa at Macy's San Francisco, at its home furnishings department exhibit of Amazonian art for sale in 1982.

The year 1984 was the apogee of primitive art's career in this century. But its apogee was also its nadir: 1984 marked the fact that authentic primitive art had died, or at least had become moribund.

For one thing, the exhibits during the winter of 1984 prompted a swirl of commentary that revealed just how contested the *concept* of "authentic primitive art" had become, more or less while no one was looking. Developments in the disciplines of history and anthropology during the previous fifteen years or so had eroded the notions of "authenticity" and "the untouched primitive," especially when the two were linked; and in the aftermath of 1984's exhibits, the concept of "authentic primitive art" was attacked head-on by a pack of cultural critics, leaving it bloody and for dead. (Well, at least deconstructed.) Art criticism and museology would never be the same again.

By 1984 authentic primitive art had begun to "die" for another and quite different reason: new sources to supply the artifacts that could be counted as "authentic" and "primitive" were disappearing at an alarming rate. Dealers would unhesitatingly explain to cus-

tomers who were resisting the high price of a tribal artifact, "But they're not making it anymore." This second type of "death" of primitive art—the limiting of its supply—does not kill the concept of primitive art, of course. Quite the contrary. The concept of authentic primitive art is alive and well among collectors, primitive art galleries, and the art market generally. But the supply is more limited than ever, just at the point when the art has achieved mass appeal. As a consequence, a new generation of artifacts claiming to be "art" or art-like, "authentic" and "ethnic" if not "primitive," in various permutations of the terms, has rushed in to expand its market share.

The double "death" of primitive art sketched above gives me the first part of this book's title, *The Death of Authentic Primitive Art*. The argument behind the title's second part, *And Other Tales of Progress*, requires considerably more explanation—the book, as a matter of fact. Here I provide a brief synopsis of the assumptions behind the book as well as an explication of its plot.

My position is that artifacts themselves are mute and meaningless. Their meanings are created by the categories they fall into and the social practices that produce and reproduce those categories.

To put it more dramatically: Discourses create objects. A "discourse" is not just a way of talking about things. Discourses materialize and narrativize categories by creating institutions and using media that illustrate, support, confirm, and naturalize their dominant ideas. Objects may physically preexist those discourses and their institutions, and they may persist beyond them; but, appropriated by new institutions, their meanings are remade and they are transformed into new kinds of objects.[1] The notion of "discourse" also includes the notion of power. The "power" may include the power and positioning of individual speakers, but more commonly it is the power of the categorizations of knowledge and the material practices that perpetuate them and re-create them. The material forms of discourses that I focus on in this book consist of sites for the public display of narratives and artifacts signifying the primitive and the past—state museums, exhibits, private galleries, historical reconstructions, and cultural theme parks.

"Authentic primitive art" is a set of objects constructed by the conjunction of three distinguishable discourses: of the "authentic,"

the "primitive," and "art." Like the discipline of art history itself, the discourses of "authenticity" and "the primitive" were made possible by the metanarrative of progress. The idea of progress, in turn, rests on the notion of linear time, which took its modern form during the course of the nineteenth century. Linear time became the microstructure of the idea of progress—an infinite, gradual gradation of cause and effect that leads upward and onward, ever better.

The idea of progress was materialized and made public in the nineteenth century and well into the twentieth by exhibition practices whose major sites were the world's fair and the museum (of science and technology, of natural history, and of fine arts); the display of the idea of progress was at its height at the turn of the twentieth century, when primitive art came into being as an object.

What does the idea of progress have to do with the primitive? Just this: Progressivist meta-stories of the nineteenth-century sort invent, indeed depend upon, the notion of the "primitive," because the universal line of time needs a starting point from which to measure change and progress. To paraphrase Voltaire's famous dictum about God, if the "primitive" did not exist, it would have to be invented. And it was.

The nineteenth-century narrative of European technological progress was displayed in world's fairs and natural history museums by exhibiting objects of primitive technology and material culture; these objects signified the rude beginnings of humankind, before history and letters began, when humans lived in nature, without civilization. In the twentieth-century narrative of European modernity and modernism, invented and displayed objects of primitive art signified the "traditional" as opposed to Europeans' modernity.

By the late twentieth century, nearly a hundred years after primitive art's invention, the idea of progress had undergone many transformations. In some postmodern circles, the idea has been discredited. And even some strands of popular culture in Euro-America express doubts about the unceasing striving for technological advances and economic success, as measured by the gross national product, at the expense of quality of life, danger to the world's environment, and social justice. By contrast, governments of third-world (or "developing") countries have tended to embrace the idea of progress with enthusiasm. Originally called "modernization," more recently "development," the idea of ceaseless forward economic and tech-

nological movement has been given new life by an alliance composed of authoritarian third-world regimes, transnational corporations, international monetary and development agencies, and consultants from the industrialized state economies. Like early discourses of progress, these late-twentieth-century avatars invent objects that appropriate and refer to the primitive and the past, although these are more likely to take the form of glorifications of national heritage rather than primitive art, or the form of massive reconstructions of historic buildings and archaeological sites as tourist attractions, or cultural theme parks celebrating ethnicity or national history, or decorated and themed airports and hotels.

So much for my assumptions. As for the book's plot, Part One examines the double "death" of primitive art; in it I claim that the golden era of authentic primitive art came and went with the twentieth century.

To periodize the story briefly, between the two world wars, the category of "primitive art" was in the process of being formed, its boundaries defined, its canonical criteria established ("authentic," "primitive"). A taste for it in both collectors and artists was rather avant-garde, and its history in this phase is deeply intertwined with that of modernism in mainstream art; it was being validated institutionally, partly through important temporary exhibits at the Museum of Modern Art. The second phase spanned the thirty years or so after World War II; institutionally, it was validated by the opening of the Museum of Primitive Art in New York in 1957, and the period culminated and ended in 1984. I count that period the golden age of authentic primitive art, when collectors, curators, scholars, and the public alike accepted the category as established and valid and explored "its" meanings in a multitude of celebratory exhibitions, catalogs, and scholarly writings.

We are now in the third phase of the transformation of meanings of objects made by the indigenous peoples of Africa, Oceania, and the Americas. This phase cannot be understood without understanding world events and the status of the "primitive" in those "third-world" nation-states whose peoples and territories were European colonies during the first half of the twentieth century. Those regions were the source of the artifacts that became "primitive art" in the

West in the first place. By the last fifteen years of the twentieth century, any unitary "story of primitive art" one might have been able to construct dissolved or fragmented. It became necessary to rename the object of study and discuss the various narratives it enters and is constructed by. I must therefore tell several stories taking place in several locations that are nonetheless intertwined.

In Euro-America during this present phase, ideas about primitive art are both hotly contested and highly marketed. The contestation became visible in museum and art market circles in the mid-1980s with the very public attacks on the concepts of authenticity and primitivism. The concept of "authentic primitive art," in the circles inhabited by cultural critics, many art historians, many anthropologists, and quite a few museum curators, is questioned and questionable. More to the point for the art market, the supply of objects that can be promoted as "authentic primitive art" is very much on the decline. If, as dealers say, "they're not making it anymore," that is because the societies that formerly produced it have increasingly become part of the global economic system. The process of market globalization has consequences that result in a dwindling supply of "authentic primitive art." In the first four chapters of Part One, I explicate the story I've outlined thus far.

In the United States, therefore, the late twentieth century marked the end of the golden era of authentic primitive art. Ideas about authenticity, about primitivism, and about art are very much alive, however, in the mass market if not among cultural critics. These ideas are materialized in new artifacts, where they coexist in new permutations. (Note the difference in seriousness in the claim made by the two labels "primitive art" versus "ethnic arts.") Market forces, cultural categories, and cultural politics combine to create a variety of configurations and claims about the descendants of "authentic primitive art," ranging from what I call "high ethnic art" to "collectibles," "crafts," "kitsch," and others. I provide readings of a few of them in chapter 5 by way of exhibitions, catalogs, and market sites.

The book title's second part, *And Other Tales of Progress*, also names Part Two. Those "other tales" are narratives of nationalism, modernization, and development. In much of the world, the idea of progress and its particular construction of the "backward primitive" has *not* dissolved and fragmented into a postmodern plethora of overlapping and contested tales. In much of the world, the descen-

dants of the people who made the kinds of things that became "primitive art" in Paris at the turn of the twentieth century are now either the elites of nation-states or their sometimes unwilling citizens. Since the mid-twentieth century, when the European colonies had revolutions of independence and became nation-states, their elites have been engaged in constructing national identities and have come to occupy different places within the global economy from those of the colonies that formerly occupied the same territories and peoples. The elites of these nation-states create narratives of nationhood, lately coupled with narratives of economic "modernization" and "development." These narratives, like Europe's analogous narratives of colonization and technological development of the nineteenth century, cast "primitive" peoples as "backward," "Stone Age," and generally unmodern, likely to be left behind on the great superhighway of history. The constructions of the primitive, of the past, of ethnicity, of nature, and of time itself have different and often unfamiliar—or sometimes all too familiar—configurations there.

These nationalist and development discourses are the topic of Part Two, consisting of case studies drawn from Mexico and Indonesia. I write about these places merely because I happen to speak their official languages and know something about them, but the kinds of processes and the configurations they reveal can be seen in many other nation-states at the end of the twentieth century. These two countries' state museum displays, monument-restoring, cultural-theme-park-designing, and airport-constructing in the interests of "nationalism" and "development" draw upon and echo themes of progress that were evident in Europe and the United States in the heyday of world's fairs and the establishment of state museums.

In the remainder of this introduction, I offer less a "history" of progress than an orienting vision, painted in broad strokes (plus cartoon graphs of my own devising), of two centuries of the idea of progress and some of its consequences for the classification and display of objects from the non-West, particularly those artifacts that were known in the United States as "authentic primitive art." (Artifacts from Africa, Oceania, and the Americas became "authentic primitive art" by the mid-twentieth century; but my story is more encompassing in earlier eras.) I begin with a prehistory of primitive art, because the things that eventually were to become authentic primitive art had not always been that. They passed through earlier

eras—curiosities first (from the sixteenth to the eighteenth centuries, with some ambiguity in the eighteenth century), then material culture (mainly the nineteenth century)—before entering the third era (the twentieth century), the era of primitive art.

THE PREHISTORY OF PRIMITIVE ART

Europeans began collecting exotic artifacts almost immediately upon discovering the world beyond Europe. Certainly many of these artifacts were valued only for their metal and were melted down for gold and silver; but between the mid-1500s and the early 1700s, Europeans were enchanted with unfamiliar items from newly discovered lands. Countless exotic objects found their way to Europe during these centuries and were avidly collected and displayed by the wealthy, the powerful, and the scholarly either in special rooms or in "curiosity cabinets" (or Wunderkammer, "wonder-inspiring cabinets").[2]

Seen through nineteenth- and twentieth-century eyes, the juxtaposition of the things in these curiosity cabinets is strange indeed. A 1599 account describes "an African charm made of teeth, a felt cloak from Arabia, the shoes of many lands, an Indian stone ax, a stringed instrument with only one string, a Madonna made of feathers, a seahalcyon's nest, a charm made of monkey teeth" (quoted in Mullaney 1983: 40). Mixed with such curiosities were works of European art, Chinese porcelain, and European armor, weapons, and shields.

Steven Mullaney has argued that "What the [Renaissance] period could not contain within the traditional order of things, it licensed to remain on the margins of culture" (1983: 44). The Wunderkammer can be seen as a mode of knowledge, one that sought to come to terms with the newly discovered worlds not by assimilating and colonizing them figuratively through absorbing them as aspects of knowledge—those moves were to come later—but by assigning them to the margins.

As a mode of knowledge about the exotic, the curiosity cabinet reflected a state of knowledge about the newfound Other that lasted less than a couple of centuries. Objects that had inspired wonder in the sixteenth century were relatively ordinary by the end of the seventeenth, and consequently lost part of their charm in European eyes. By then Europe was in its protoscientific and protoindustrial

phase of capitalism, and collections became far more specialized. At the turn of the eighteenth century, groupings of objects in collections prefigured the taxonomy still used in museums today: fine arts (paintings gathered by the English on their newly instituted grand tours to Italy and installed in their new stately homes, built on land made available through the enclosure movement that ousted peasants from bogs and fens, their fortunes made and titles bought with the profits from slave and rum trade, etc.); natural history (exotic flora and fauna, including the living collections that would eventually be converted into botanical and zoological gardens); and scientific instruments. The world itself and its diverse peoples were becoming more familiar, and Europe was beginning, although it had far from succeeded in, its quest not just for trade but for domination.

The eighteenth century was notable for two events in the prehistory of primitive art: the founding of the auction houses of Sotheby's and Christie's, and the effort by Linnaeus to produce a catalog of all knowledge.

Art cannot come into existence without a market for it, both buyers and sellers. Sotheby's was founded in the 1740s, Christie's in 1762; the traffic in objects of all sorts had reached a point that such institutions could come into being. In his book on art collecting, Joseph Alsop (1982) calls the art market a "by-product" of art. I would reverse the causality implied in that statement, arguing that "art" is produced and reproduced by the art market rather than causing it. In either view, the two are interdependent, and the founding of Sotheby's and Christie's must therefore be counted as a significant event in the invention of the discourse of art in Europe.

The other eighteenth-century event of relevance to the prehistory of primitive art is Linnaeus's attempt in his *System of Nature* (1735) to construct a comprehensive taxonomy of everything in God's world. Flora and fauna from all over the world were sent to Linnaeus. The principles of his vast taxonomy were based on the Great Chain of Being, which itself was based on Aristotle's hierarchical classification of the world into mineral, vegetable, animal, and human realms, and subsequently elaborated by medieval and Renaissance thinkers. In the Great Chain of Being, each category of creature had a "king" or highest form, and a lowest one.[3] The lion was the king of beasts, for instance; hence a fitting symbol for a king of men is the lion. Linnaeus's taxonomic categories were hierarchical, not merely stratified: that is, higher categories encompassed lesser ones, and so on

down the line. Thus was born the system of classes, orders, genera, and species, which is still used in scientific biological classification.

Linnaeus had laid out the structure of the natural world; it remained for Charles Darwin to enunciate a principle by which beings in one category could turn into another, could transform themselves from simple to complex, could, as we say, "evolve" from "low" to "high." In her book *Early Anthropology in the Sixteenth and Seventeenth Centuries,* Margaret Hodgen claims that without the extensive and meticulous taxonomy perfected by Linnaeus the century before, Darwin could not have invented the theory of evolution. Seen in this light, Darwin's accomplishment was to temporalize the Great Chain of Being, Hodgen writes.

Why should simple be "low" and earlier, and complex be "high" and later? Why should a spatial metaphor be used for a temporal unfolding? One clear and simple answer is that the metaphor is based on the Great Chain of Being, itself a spatial arrangement in which Man is at the top, poised between the angels and the animals, while mollusks are at the bottom. Temporalized, a spatial "high" becomes "advanced," and the whole thing can be turned to the use of the concept of progress. Second, of course, is that Man is doing the classifying, not mollusks. If mollusks were to invent an evolutionary scheme, we can be fairly certain that bivalvity rather than bipedalism would feature large as an evolutionary accomplishment.

How did the cataloging and categorizing impulse of Linnaeus and other Enlightenment thinkers affect the collection and display of objects from the then-not-so-newly-discovered worlds outside Europe? My impression is that, if the Renaissance "licensed" such exotic items to remain comfortably at the margins, the eighteenth century felt some unease with them, in part, perhaps, because of the ambitions of the new encyclopedic efforts at systematizing all knowledge. There is no place for anomalies in a totalizing system. By the beginning of the eighteenth century, the "artificial curiosities" (things made by humans in distant places, like shoes and weapons) had ceased to be "wonders" in the Renaissance sense, but they were not yet the objects of scientific knowledge that they were to become in the nineteenth century. They were anomalous, interstitial.

We have some hints of this in the fact that voyages of exploration in the eighteenth and early nineteenth centuries concentrated on collecting flora and fauna, whereas articles of human manufacture had no Joseph Bankses to record and track them. Thus, while the longitude,

latitude, climate, and circumstances of collection of every leaf and in-sect gathered on Captain Cook's third voyage were recorded, human artifacts were recorded, if at all, as "Otaheite," a general term for the South Seas (Kaeppler 1979: 169). Adrienne Kaeppler has tried to trace what happened to all the artifacts collected as oddities by the seamen and officers on Captain Cook's voyages; after conducting painstaking research, she concludes that the task is simply impossible. Even when objects were given to the British Museum by Cook and the naturalist Banks, the items went unrecorded: as she puts it, the donors were more important than the gift. The mirror image of collecting in the field is collections back home. There, too, these objects seem not to have had a firm place. Ethnographic material in the collection of Sir Hans Sloane, which formed the basis of the British Museum, was classed merely as "Miscellanies" (surely a step below "wonders") and documented haphazardly; the contemptuous nickname for the British Museum's ethnography collection in its early years was the "rag-and-bone Department" (Kaeppler 1979; King 1985).

In the centuries before the eighteenth, artifacts from distant lands were licensed to the margins, as wonder-inspiring, exotic, and un-classifiable; in the nineteenth century, they were to be put at the bot-tom of the evolutionary scale. But in the eighteenth century, they were simply between categories: collections were specialized by then, and distant humans' artifacts belonged nowhere, for they were neither fine art, nor natural curiosities, nor scientific instruments.

It remained for the nineteenth century to find a secure place for these artifacts. That place came to be prior to time. But to put the primitive prior to time, Europe had first to invent it.

THE NINETEENTH-CENTURY IDEA OF PROGRESS

By temporalizing the Great Chain of Being, nineteenth-century Eu-ropeans came to understand that "low" means prior and simple, and eventually inferior, gaining a significance at once temporal and moral. We can depict the basic structure of the story of progress with a graph whose axes (better/worse and earlier/later) were laid down in the late eighteenth century (figure 3).

As a literary genre and a way of organizing consciousness, linear or historical time was invented during the late eighteenth and first part of the nineteenth centuries; that period also invented deep geo-logical time and, concomitantly, the notion of the human past as a

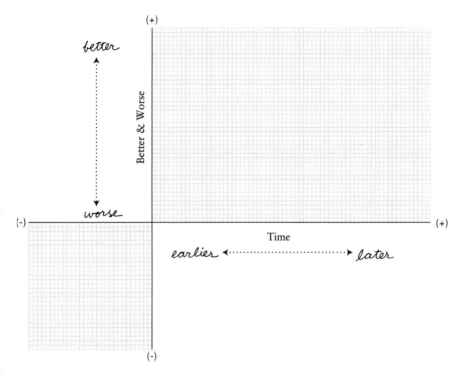

Figure 3. Better & Worse and Earlier & Later.

continuous multistep progression leading "up" to the present.[4] By the mid-nineteenth century, the notion that historical "time" is structured as a continuous, progressive unfolding of events had produced some of the grandest metanarratives ever told: about Man's spirit, whose highest expression lay in art, religion, philosophy, and the state; about the changes brought about by natural selection, which eventually resulted in *Homo sapiens sapiens*; and about the phases, from precapitalist to feudal to capitalist and thence to the revolution, through which human history had passed or would soon reach.

In the late eighteenth and early nineteenth centuries, European stories of historical progress showed their Enlightenment roots, rephrasing the episodic stages of "ancient, medieval, and modern," a story Europeans had been developing since the Renaissance to tell themselves about their own past. In stories of that sort, European history could be told as a self-sufficient unfolding, moving from the glory that was Greece and the reason that was Rome, to the darkness of the Middle

Ages, and to the final culmination of superior civilization in the Renaissance. The nineteenth century added ancient Egypt, Babylon, and Sumeria as precursors to Greece, and hence to Western civilization. In that later story, "archaic civilizations" had agriculture and writing but were under the sway of religion, and they therefore had not attained the true scientific rationality that placed Europeans at the very peak of creation.

In the context of a solidifying colonial expansion (late eighteenth century to World War I), the Europeans' story about themselves became a story about Man's climb from a low and tribal existence to his culmination in European civilization. The idea of progress was a brilliant solution to the problem of the Other: this narrative located artifacts, and the people who produced them, at the bottom of the scheme.

Putting the primitive at the low beginning would not have been quite as brilliant a solution if there had not been compelling social reasons to conceptualize these people as inferior. Those compelling reasons were produced by the advent of full-blown colonialism during the period that has usefully been called "the long nineteenth century" (from 1789 to 1914). During the first half of that extended century, the nation-state in its modern form was invented, and the new state structures took over the administration of the territories that private companies, with increasing state military support, had been trading with and controlling. (The Dutch East India Company was disbanded in 1798, and the British East India Company in 1851.) By the second half of the long century, European nation-states were in the final phase of the conquest, colonization, and parceling out of Asia and Africa that would reach full stability after World War I. The colonies provided the raw materials and often the markets, as well, while the processing of materials took place largely in Europe, with its newly developed industrial and factory infrastructure.[5]

By the second half of the long nineteenth century, progressivist "historical" narratives became the accepted, mainstream, scientific way to account for present differences among observed entities (species, races, civilizations . . . whatever). Thus nineteenth-century social theories tended to cast time, like an Aristotelian drama, as having a beginning, middle, and apex-end (Europe in the present). The nineteenth century was indeed the era of tripartite phases: magic, re-

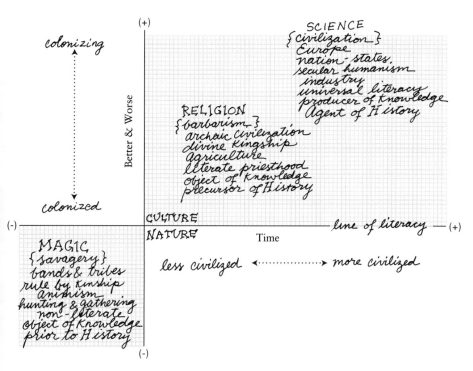

Figure 4. Progress: The Metanarrative!

ligion, and science; savagery, barbarism, and civilization; feudalism, capitalism, and socialism; archaic, medieval, and modern.

Literacy came to draw a clear line between the primitive and the archaic. Without literacy, a people could not enter history, in either sense of the word: they did not have the documents that would allow their histories to be examined by historians, and consequently they could not enter history (the genre of writing); and their lack of documents also made it appear to Europeans that Primitives did not themselves live in historical time, but lived rather in repetitive and circular Myth—hence they did not live in history (the worldview). (The scholarship to elaborate, and then to dispute that idea, came later.) Archaic civilizations, by contrast—the East Indies and the Chinese occupied this slot among the colonized—had literacy, but their religious priesthoods controlled writing, hence they were classed as not-yet-democratic and not-yet-scientific (figure 4).

A great deal of scholarship during the past twenty-five years has shown that the nineteenth-century story of progress, on the face of it a simple one based on technology, is actually composed of a tremendous number of implicit as well as explicit dichotomies, which allowed an almost infinite gradation of categories between them and which informed both scholarship and social practices in ways that are very much still with us. The point is: social, conceptual, and institutional categories generate their opposites. As Europeans increasingly came to think of themselves during the nineteenth century as essentially and characteristically secular, rational, civilized, and technologically advanced, they almost necessarily generated an imagined Other that was savage, ignorant, and uncivilized. We can diagram the metanarrative of social evolution as shown in figure 5. The conviction that society had "evolved" in Social Darwinist form dominated both scientific and popular thought alike at the turn of the twentieth century. This particular view of progress cast dark and colonized peoples at the low beginnings of humankind's journey to its high peak, European civilization. "Nature" itself was not held in low esteem, but its human inhabitants were seen as fit subjects to be civilized by European manners and colonial administration.[6]

Near the end of the twentieth century, a great change took place in the relative value placed on "nature" and, especially, on its denizens. Nature came to be no longer inhabited by uncouth and superstitious savages living in dark and dangerous jungles but by innocent human hunters and gatherers living in friendly rainforests that helped the earth's air and provided humans with the basics for miracle drug cures.

This reversal in popular culture of the value of people presumed to live "close to nature" has multiple implications for how their artifacts and images are conceptualized, commodified, and displayed. But for the nonce, I want to take a break from telling a story about progress and its vagaries and permutations in order to point out and analyze some of the ways the idea of progress, and the relations between nature and culture that are implied by it, were displayed at the turn of the twentieth century, when primitive art was discovered and Pablo Picasso found African artifacts not just in

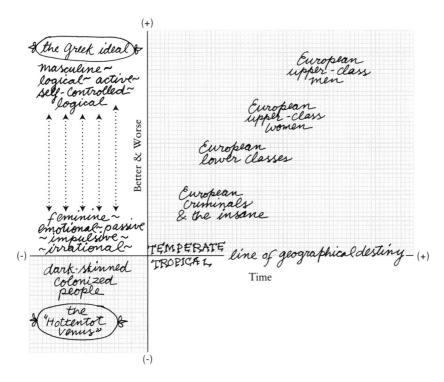

Figure 5. Social Evolution: The Metanarrative!

the flea market but in the Trocadero, Paris's museum of natural history.

DISPLAYING THE IDEA
OF PROGRESS

The era of great state and public museums coincided with the invention and rise of the idea of progress: the nineteenth century was "the museum age," as Germain Bazin (1967) calls it. In the new "democratic" age after 1789, as nation-states began to take their modern form, all sorts of formerly private "arts" became public arts, both ac-

cessible to the public and in the ideological service of the nation-state. As Philip Fisher summarizes this transformation: "The game preserve becomes the public zoo; the collection of books, the library; the pleasure grounds of large estates, the public parks, forests, reserves; private collections are transformed into museums and the music once heard only in private settings becomes social and democratized in the public concert halls" (1975: 590).

Many public museums were founded on private collections in the narrow sense that the objects from the latter were transferred to the former; but there was a profound conceptual rupture, not a gradual evolution, between these two types of display. As Mullaney puts it, "The museum as an institution rises from the ruins of such collections, like country houses built from the dismantled stonework of dissolved monasteries" (1983: 41). Private collectors, then as now, acquired their objects with varying whims, tastes, wealth, interests, motives, and connections. Public institutions of the nineteenth century systematized the principles of collection and display and eliminated, rearranged, and regrouped the components, dividing them into categories and often arranging them chronologically.

Throughout the nineteenth century, hundreds of museums were founded all over Europe and the United States: museums of fine art, of natural history, of industry and technology, and (rather late in the century) of history. Regardless of the subject matter, the contents of most museums were arranged and exhibited as an unfolding development through time—especially as the century wore on and knowledge of all sorts was increasingly cast in the form of progressivist, evolutionist stories, which became the common sense of the day.

The emerging disciplines of folklore and archaeology were used for nationalist purposes. Indeed a very strong argument could be made that these disciplines' creations were part and parcel of the invention of the nation-state and its need to justify itself at home as well as abroad. The idea of "folk" served the notion of "nation" and for nineteenth-century Europe meant, roughly, a people with a common language and, as the century went on, one "race" or "blood" and one cultural "heritage." The effort to justify and discover the unity of race, culture, and language forms a good part of the interest

in folklore and craft in that century.[7] Archaeology, for its part, served nationalist purposes partly because it was a way of nationalizing the very ground, the territory lying within national boundaries in which the nation-state was located, by claiming the depositors of remains as ancestors to present-day citizens. Artifacts and arts discovered and collected in the practice of these disciplines were put into the burgeoning number of new museums.

World's fairs were the other great nationalist invention of the nineteenth century. Beginning with the Crystal Palace Exhibition of 1851, world's fairs were about trade, manufacture, and the national glory of the newly industrial powers of Europe. The theme of every world's fair, therefore, was (European) progress in some form. Because colonized peoples were not centers of manufacture and civilization, they were not initially represented at the fairs or were represented only as sources of raw materials.

Four types of display institutions with nineteenth-century origins interest me here because they became public sites for mass education in the idea of progress: the world's fair, the museum of science and technology, the fine arts museum, and the natural history museum.

The World's Fair

The concepts of the nation-state, of the extraction from the non-European world of the raw material that made industrialization possible, and of the colonization of the people from whose territories the raw materials were extracted—all came together in material and symbolic form in a series of events that displayed and glorified them: the world's fair.[8]

The idea of progress has a dark underside: up from what? The answer became increasingly visible during the second half of the long nineteenth century because it was increasingly exhibited at world's fairs: up from the brutish and savage state of Early Man, whose living exemplars are contemporary humans living in a rude state. Stone Age Man, as "he" eventually came to be called, was usually colonized as well. By the turn of the twentieth century, it was common practice for the displays of European nations to include a colonial exhibit showing typical architecture and artifacts. Often, the natives themselves were on display, as in the 1904 Exposition in St. Louis,

where a timely colonial display was possible because the United States had just annexed the Philippines.

THE MUSEUM OF SCIENCE AND TECHNOLOGY

Museums of science and technology most clearly exhibit the notion of technological progress, which is the core story on which nineteenth-century Europeans' conviction of their superiority rested. If Australian Aboriginals had invented the idea of progress, complexity in kinship might have been at the top of the evolutionary ladder, while the impoverished and pathetically simple bilateral kinship systems of Euro-America would have been at the bottom. If Javanese nobles had invented the idea of progress, a developed sense of shame and status would have been at the peak of creation, whereas the arrogant, demanding demeanor of Europeans would put them with madmen and infants at its undeveloped beginning. But Europeans invented the idea of progress, hence technological power and the ability to extract resources were put at the top, while Australian Aboriginals became nineteenth-century writers' favorite example of the primitive, and the Javanese (had they come to museum curators' attention) would have exemplified a medial stage (as did the East Indians and the Chinese).

This nineteenth-century story organizes items not in true historical sequences but in imagined "stages," which lead up to the present. This mode of organizing displays of "primitive technology" and other human artifacts was very popular in the late nineteenth century, particularly in world's fairs, and it persists in museums of science and technology to this day.

A notable example is Chicago's Museum of Science and Industry, which I visited in 1986. An exhibit called "What Became Money?" (sponsored by a bank) began with the shell money of New Guinea and progressed to the peak of technological achievement at that point, the automated teller machine. Another installation, on "computing" (and sponsored by IBM), had its origin point as the abacus and its apex was the IBM PC. These temporary installations nicely expressed the spirit of the museum's origins in the 1893 Columbia Exposition.[9]

Aside from technology museums, this type of story lives yet in "educational" entertainments at Disney theme parks—for instance, in AT&T's Story of Communications in the Spaceship Earth building at EPCOT Center at Walt Disney World, which I visited in 1993. Familiar

with the general structure of these tales, I anticipated that its subtitle ought to be something like "From Smoke Signals to E-mail." I was almost right: the story actually moves from cave paintings to telephones. Visitors absorb the unfolding tale by riding little carts that spiral up inside the globe, passing Animatronic scenes depicting significant stages in the advance of communications technology. In older versions of the progress narrative, telephones might have been the peak of human communication history and might have been reached at the top of the dome, at the story's end. But Disney World is continually updated, and so, at the top of the dome the little vehicles turn around, and the riders descend, backward, into the future, gazing upward into a starry sky full of spaceships communicating over vast distances.

THE ART HISTORY MUSEUM

Both the idea of art and the idea of the nation-state in their modern forms were invented in the late eighteenth and early nineteenth centuries. Very soon, each was mapped onto the new idea of continuous progressivist time that emerged during the nineteenth century. The one became the history of art: one work of art influences another one, one school or style influences the next, and all unfold within the line of time. The other one became the story of the nation, in which the autochthonous roots, character, and greatness of a people, a "nation," were discovered to lie in the folklore of peasants and the ruins produced by peoples living centuries earlier inside current national territorial boundaries.

These two stories—the story of art and the story of the nation— merged and gained visible form with the invention of the state museum of fine art, where new nation-states displayed objects ransacked from their own churches and archaeological ruins, joined to the objects plundered from conquered foreign nations, all brought together and exhibited in such a way as to tell a story of national glory.

The notion that art has a history is an idea that entered the popular imagination during the nineteenth century. For one thing, the discipline of art history was invented and elaborated from the end of the eighteenth century (see Minor 1994); the idea that art's history unfolds over time and in national "schools," however, was embodied and popularized by the founding and internal arrangement (which was chronological and eventually national) of state museums

of fine art. Philip Fisher argues that European museums of fine art became in the nineteenth century spatial vehicles for public instruction, and one of the principal things the public was instructed in was history, especially art history. Thus the subject of the fine arts museum "is not the individual work of art," Fisher points out,

> but relations between works of art, both what they have in common (styles, schools, periods) and what in the sharpest way clashes in their juxtaposition. . . . That we walk through a museum, walk past the art, recapitulates in our act the motion of art history itself, its restlessness, its forward motion, its power to link. Far from being a fact that shows the public's ignorance of what art is about, the rapid stroll through the museum is an act in deep harmony with the nature of Art, that is, art history, and the museum itself (not with the individual object, which the museum itself has profoundly hidden in history). (1975: 591)

André Malraux, in his *Museum Without Walls,* explicitly contrasted "the practice of pitting works of art against each other, an intellectual activity," as "the opposite pole from the mood of mental relaxation which alone makes contemplation possible" (1949: 16). This comparative movement of the mind makes the discipline of art history possible.

A stroll through the art museum is therefore a stroll through linear time: it is no accident that the Guggenheim Museum in New York, that most linear of museum spaces, is forever having retrospectives: its radically linear space and the gentle slope of the floor propel the viewer inexorably through the unfolding of time.[10] The museum's physical structure makes it difficult to organize, display, and therefore for the viewer to conceptualize the history of art as anything other than an illustration of conventional art history's enabling assumption, which is more or less "one piece of art influences another." (Its corollary: "And some are better than others.")

THE NATURAL HISTORY MUSEUM

Alone of the four major exhibition sites, the natural history museum did not educate the public in the story of progress. The realm of the natural history museum was the realm of nature, not of (human) history. The natural history museum's internal organization is geographical and taxonomic, with the result that a stroll through any particular museum of natural history is a safari in geographical space rather than a stroll through time (figure 6). Actually, because it is arranged taxonomically as well as geographically, it is less like a safari through

Figure 6. A stroll through the natural history museum is like a safari through objective knowledge.

Figure 7. Objective knowledge reveals itself in taxonomic displays and dioramas.

nature itself, which is messy and incomprehensible, than through the taxonomic model of thought characteristic of "objective knowledge." Objective knowledge about nature, true to its Enlightenment sensibilities, has two major modes of display in this type of museum: taxonomy (a large number of items of one class, showing their range of variation) and realism, prototypically the diorama (figure 7).

In an enlightening article about the invention of modern taxidermy, the historian of science Donna Haraway (1989) gives us a persuasive argument about what "nature" meant in the first decades of this century, when the realistic dioramas we now associate with the great natural history museums of this country were created. She argues that the impulse informing both the invention of taxidermy and the resulting dioramas that aim for a startling realism was to freeze in time an image of nature as an undisturbed Eden, the realm where civilized and technological Man does not intrude. Haraway shows us that the American Museum of Natural History, ostensibly about evolution and change, was actually formed within an overwhelmingly taxonomic and static mode of knowledge, whose impulse was to preserve and stave off change—to prevent the world's decadence, to halt the erosion of the Garden.

The natives represented in classic natural history museums are the objects of knowledge rather than the producers of knowledge, for their representations and artifacts lie in the realm of nature, which is studied, rather than of history, the realm of people who acquire knowledge and penetrate nature's secrets. As William Pietz (n.d.) points out, the neoclassical architecture—cool, solid, stable, and orderly—in which many natural history museums are housed, sometimes left over from or inspired by world's fairs, reinforces and evokes a concept of knowledge and objectivity existing outside time (figure 8).

The realm of Nature is the realm of laws, not events; of objects and processes that can be understood by Reason; of an Edenic constancy, untouched by money, pollution, and technology. The introduction of money and technology would break the timeless harmony and inaugurate the incessant succession of new events that we give the name "history."

MUSEUM TYPES
AS CATEGORIES OF KNOWLEDGE

The contrast between two modes of organizing artifacts—as aspects of nature in natural history museums or as aspects of civilization or culture in fine arts museums—struck me acutely in 1982 right after I had visited the newly opened Rockefeller Wing of Primitive Art at the Metropolitan and continued as I interviewed curators and ob-

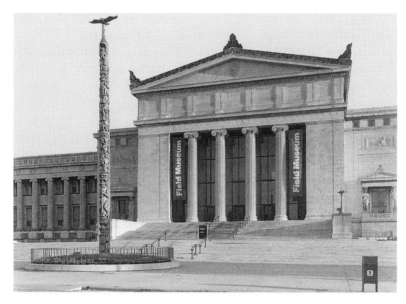

Figure 8. With many natural history museums, such as the Field Museum in Chicago, the orderly neoclassical architecture suggests a timeless knowledge and objectivity.

served exhibits in both types of museums over the course of the next several years.

One is the matter of time. The natural history museum (as a type of museum) displays nature, which is represented as existing in a state of stasis or, at best, dynamic equilibrium. The fine arts museum (as a type) shows time, nationhood, civilization—in short, culture. Unlike other kinds of art, however, a hallmark of "authentic primitive art" is that it cannot be placed on a line of art-historical time, because the people who produced it are said to have lived in the timeless realm of myth, and, like them, their artifacts did not enter history. They present, therefore, an anomaly in a fine arts museum.

One sees this difference displayed explicitly within one fine arts museum, the Metropolitan Museum of Art in New York. Its Rockefeller Wing of Primitive Art lies on the far left of the central hall and entrance (facing it), parallel to the Egyptian Wing (of Archaic art, though it is not called that), which lies on the far right. Both wings were new in the early 1980s, and their architecture is similar: starkly

modern grids. I thought of them, therefore, as each other's alter-egos: parallel but opposite. The visitor's first encounter with Egyptian art is the Line of Time, depicting 3,000 years of Egyptian art (also available as a foldout brochure at the museum store). In perfect counterpoint, a map at the entrance to the Rockefeller Wing locates Africa, Oceania, and Mesoamerica, in effect telling us that we should understand this collection geographically, spatially rather than temporally. These objects, like the people who produced them, stand symbolically as people without history—though they do have different "styles."

Another contrast is the presence of money. I inquired of one prominent anthropologist who saw the new Rockefeller Wing before I did what he thought of it. He paused thoughtfully and then answered, smiling, "Well, it's the best that money can buy." The bemused hostility of his answer points to a prominent characteristic of this installation and, indeed, of many installations in fine arts museums: in the art world, aesthetic value is inseparable from the idea of monetary value. Curators I interviewed at natural history museums, by contrast, seemed to enjoy pointing out that many of the objects on display in their museums as well as in their basement storage areas were irreplaceable and worth thousands and thousands of dollars; but these, like their companions the baskets, the rattles, and the harpoons, tend to be shown in ways that downplay the monetary value they might bring if they were to be put on the market.

And finally there is the matter of Absolute Spirit. The art in art history museums must move forward in a restless Hegelian unfolding of the spirit. Its mode of arrangement is by temporal periodicities of styles and schools, Absolute Spirit revealing itself in beautiful objects through European temporal sequences. (In chapter 2 I point out that ritual/ceremonial objects from Africa, Oceania, and the Americas are far more likely to become "authentic" or high primitive art than are pedestrian utilitarian ones, I believe because these objects better express the transcendent qualities that are said to be the hallmark of art over craft.) After taking the tour of the Rockefeller Wing in 1982 and making extensive notes on the labels (for example, Fijian clubs "intended to shatter enemies' skulls and insult the sacred part of the body"), I noted that these labels left one with the impression that Primitive Man lives within the realm of myth rather than of history, is obsessed with ritual, and lives constantly with ceremony. A

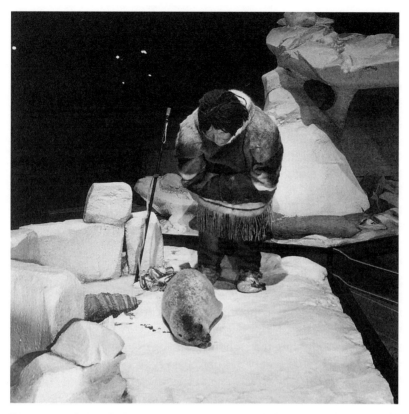

Figure 9. In this typical natural history museum display, a hunter, adapted to the environment, is able to make a living in nature.

spin through the Rockefeller Wing leaves one wondering, don't these chaps ever eat lunch?

At the museum of natural history, people in specific human societies do little except eat lunch or, more accurately, hunt it, gather it, and dry it for the winter (figure 9). The cavernous dim interior of the great and dated Northwest Coast exhibit at the American Museum of Natural History, influenced originally by Franz Boas, is cluttered with dark cases containing shallow, two-dimensional exhibits of multiple examples of horn spoons "for eating mashed berries" and dioramas of people drying skins and weaving blankets. Realistically rendered pictures near the ceiling depict particular societies' activi-

ties: ceremonial dog eating, weaving a blanket, preparing fish oil, gathering bark for food, house-building, holding the first salmon ceremony, and so forth. Ceremonial objects it has—masks, shields, rattles—but a good deal of the display is devoted to bows and arrows, harpoon points, fishing nets, and highly decorated clubs—not for shattering the skulls of enemies, thus insulting their most sacred part, but for "bashing halibut."

In the natural history museum we have not Primitive Man as aesthetic and mythical, but "typical" primitives, no less caught in a timeless zone, eking out a living in their appointed eco-niche. Not Man as aesthete, but Man as animal, spending time in the very animal effort to eat—that is the message of the natural history museum.

And so, if you want nature, the Garden of Eden, and the Childhood of Man, untouched by industrial pollution or filthy lucre, you go to the natural history museum, where you will find no guards, permission to take photographs, reams of children, toys and games in the museum shop, hamburgers in the cafeteria. If, however, you want history—*art* history—currently and in every respect enmeshed with money unfolding through time, you go to the fine arts museum, where you will find plenty of guards, no flash photos or tripods allowed, respectful adults, silk scarves in the museum shop, quiche and radicchio salad in the restaurant. It is no accident that these two types of museums come in pairs: the Field Museum and the Art Institute; the California Academy of Sciences and the de Young; the Smithsonian and the National Gallery; the American Museum of Natural History and the Metropolitan Museum of Art. Together they divide the universe into nature and culture.

NATURE AND CULTURE
IN NARRATIVES OF PROGRESS

The dichotomous structure of thought that places nature in the one slot and culture in the other has a long history in Western thought. Viewed as a synchronic opposition, this structure of paired opposites has remained remarkably constant for some time. Romans had Virgil's account of Arcadia; the Middle Ages had the idea of Paradise

across the sea, and Columbus by his third voyage believed he had reached it; the eighteenth century had the pastoral; "we moderns," as Nietzsche calls us, have the primitive—as Club Med calls itself, "the antidote to civilization." Each era has filled this zone of non-, or anti-, culture with a somewhat different content, because each era is different, and each one needs its own particular counterexample to tell itself what it is not and therefore what it is.

Viewed more historically, the distinction between nature and culture in Western thought began its modern form in the late eighteenth century and especially in the first half of the nineteenth century. The content of the culture side of the dichotomy began to fill with historical time, the notion of the human past as a continuous multistep progression leading "up" to the present. (Before then, "time" was much more episodic.) Archaeology, folklore, the discipline of art history, state museums of art, world's fairs, and the colonial nation-state were invented and flourished. All were informed by the notion of linear time, which formed the internal microstructure of the idea of progress.

The nature half of the conceptual opposition came to be occupied by the colonized peoples that Europe was dominating. The primitive lodged and expanded in that low place partly due to the solidification of colonial power in Africa and Asia, combined with the invention of world's fairs and state museums of art, industry, and natural history, which could exhibit narratives of progress for all to see. By the end of the nineteenth century, colonized peoples had been firmly ensconced in the popular-culture versions of these narratives; their place was at the low beginning, before history began.

If we think about how the dichotomy between Nature and Culture (or Nature and Civilization) was inscribed upon the self, we could say that Rationality had a high status in the nineteenth century, as did Calculation, while Emotion was linked to the Irrational and the Superstitious. If we think of this dichotomy as gendered, then the Male principle was in the civilized section, while the Female principle was linked to the emotional and irrational. If we think of "Race," the white European races were on the side of civilization, whereas the dark and colonized races signified irrationality, superstition, and so on, and appeared passive and effeminate to the virile colonizing white European male, bolstered by his own sense of

power and position in world history. These crisscrossed associations reinforced each other and were multiply determined (refer to figure 5). And by the century's end, even an individual's life-history could be construed as three progressive stages: the oral, the anal, and finally the peak of adult manhood, the heterosexual genital stage.

Many natural history museums were founded or formed their permanent exhibitions in the United States during the last quarter of the nineteenth century through the first quarter of the twentieth, which was also the height of public acceptance of the idea of social evolution. The turn of the twentieth century through World War I was also the brief period when colonial powers made the push that solidified and made final the configuration of colonies and powers that was to persist (after a little rearranging as a result of World War I) until the anticolonial revolutions of the mid-twentieth century. During those fifty-odd years spanning the nineteenth and twentieth centuries, Europeans believed most in the idea of progress and in the duty of Europe to civilize the dark, savage, heathen, superstitious races. (Rudyard Kipling's "The White Man's Burden" was written in 1899.) Like virtually everyone else, artists believed the Africans were uncivilized and irrational, as demonstrated by the formal qualities of their artifacts—which were completely antithetical to the harmony and proportion celebrated in the Renaissance canon. But unlike virtually everyone else, artists *celebrated* the irrational and intuitive at the turn of the century.

Avant-garde artists' celebration of and inspiration by the primitive as a magical resource for the modern was certainly radical and unexpected at the time; but it did not blur the boundaries or deconstruct the categories of nature and culture or of myth and history. The idea of the primitive continued to stand for the irrational, timeless, and natural in art-making and art-collecting circles, and came to be associated with the unconscious and the mythic as those ideas gained vogue in subsequent decades. The Cubists and many others were in the process of inventing the modern, whose contents and progressivist ideas began to fill the "culture and civilization" half of the nature/culture dichotomy.

The special twist for artists was that they wanted the modern to tap, to draw upon, to be inspired by the primitive, which in the twentieth century, it seems to me, was grafted onto the notion of the "natural self," or at least onto some aspects of interiority. Or per-

haps interiority was grafted onto the primitive. Either way, the invention and popularization of psychoanalytic and broadly psychological thought during the first half of the twentieth century also had a place for and drew upon received knowledge about the primitive. (Think of *Civilization and Its Discontents:* Freud did not celebrate the primitive or the natural, of course—quite the contrary; but he did think of civilization as repressive and unnatural, and he certainly thought of primitives as less than rational.) Since the invention of the novel and the modern autobiography as literary forms, Europeans had been organizing the individual life conceptually as a continuous story that unfolds from birth and ends in death, and had been imagining the "self" as a coherent single entity. Mapping what was in effect the idea of progressive stages onto this timeline of an individual's life—whatever the content of its stages (oral, anal, and genital; or other progressivist tales of psychological development)—had the effect of rendering "primitives," or indeed, any deviation from the presumed normal for the white male (say, for instance, the white female) as somewhat less than a full, rational human. Mappings of these sorts are probably the reason for the conviction in certain strands of psychoanalytic theory that distinguished primitives from moderns as less than rational, for they seek to change the world by performing operations on the body rather than on the world. Progressivist tales of psychological development that end in the highest form, the norm of the white male, are still with us, albeit in more muted forms that require considerable deconstruction to uncover.

As the twentieth century wore on, the primitive continued to stand in Europe for the irrational, the timeless and the natural, including the "self" unencumbered by repressive civilization, thus providing a kind of resource or warehouse of ideas and images that stood in contradistinction to European civilization. Artists drew on these as a rebuke to the civilized, whereas bureaucrats and colonial officials drew on them as support for the common sense that insisted on the necessity of repressing them. Both depended on the same dichotomizing structure of nature versus culture, which rested ultimately on the metanarrative of progress.

At the turn of the twentieth century, then, the story of progress with its dichotomizing but overlapping structures of nature/culture, rationality/intuition, modern/traditional, male/female, primitive/

civilized, and so forth, was at its height. By the turn of the twenty-first century, however, the idea of progress had suffered a variety of transformations, dissolutions, and reversals in Euro-America.

The watershed event that changed the status of the contents of the dichotomy occurred in the mid-twentieth century, when colonized peoples of Africa and Asia declared themselves independent and turned themselves into nation-states. By destroying European colonial hegemony and therefore all the knowledge-production that rested upon it, this event and the events it spawned ultimately made simple narratives of progress and social evolution untenable even at the level of popular culture.

One strand of late-twentieth-century challenges to the story of progress consists of efforts to deconstruct it (and the reified dichotomies it rests upon and reproduces) by showing that these often essentialized and naturalized categories are historically contingent, changing over time and with context. Challenges in this vein to the narrative of progress, regardless of how different they are from each other, are often given the all-purpose label "postmodernism." My own tale is a product of this late-twentieth-century deconstructive urge, but I am moved by such ideas without being possessed; consequently I have not written this book in a way that would instantiate the impossibility of telling any coherent tales at all, even at the level of the sentence. I keep the abstract issues implicit and focus on the substance of my argument, which is about the idea of progress and the kinds of primitive/ethnic art objects it has produced and in various guises continues to produce—because, while the idea of progress may have disintegrated into a pastiche of differing differences in some circles, the idea of progress was far from dead at the end of the twentieth century.

For one thing, it continues to have its defenders—a beleaguered but apparently increasingly influential aggregation of commentators. (And cigar-smoking seems to be making a comeback: is this related?) More important for my story about the art market, in some circles the nineteenth-century progress narrative has been turned upside-down in a vision I dub "New Age spiritual evolution," the marketing of which includes many signifiers of the natural. And most important of all, both for my story and for the world, is that its immediate reincarnation, the notion of "develop-

ment" in the third world, has been adopted with a vengeance by a variety of powerful nation-states and international bodies, as well as by its most obvious beneficiaries and promoters, the transnational corporations.

OTHER NARRATIVES OF PROGRESS

During the course of the twentieth century, I have asserted, the people who occupy "nature" slowly gained in stature in popular culture. Concomitantly, the conceptual space of culture, formerly called "civilization," looks less attractive than it did a century or two ago, even to those in its upper reaches. By the late eighteenth century, the conceptual space of culture and of nature had parted company, and the space of culture was filled with the idea of "civilization." By the late nineteenth century, that space was characterized by nineteenth-century Europeans as civilization, but it was also occupied by the notion of technological and scientific advance. By the late twentieth century, the idea of civilization had been more or less crowded out by, plainly and simply, the image of technology and the notion of a calculating rationality—more specifically, of advanced machines and capital flows controlled by greedy white men who occupy the higher levels of an economic stratification rather than (as in earlier centuries) the peak of civilization. In everyday common sense, the link between rationality and calculation draws support from the fact that, since the eighteenth century, rationality has been linked to the notion of calculation.[11] Insofar as calculation and profits are linked conceptually, rationality as an idea and force becomes linked to technology, which many view not only as the conceptual opposite of nature but as its literal and active destroyer.

In sum, the valences of culture and nature have changed radically and pervasively in the everyday experience of many Europeans and Americans, and that fact is reflected and perpetuated in some strands of "science" and popular culture. The major biological image produced by this shift in nature/culture valence is the distinction between right and left brains, which has been taken up with enthusiasm in popular culture. It is narrativized in many different ways, but it is in fact a structure (in the French sense, a pair of opposites that can be filled with various contents) that exhibits the same old di-

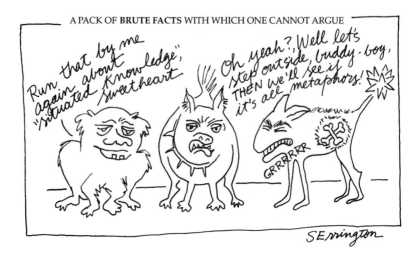

Figure 10

chotomies: intuition, nature, the female principle, the primitive, community, art, and poetry lodge in one half of the brain, whereas logic, hierarchy, the male principle, analytical capacities, and that sort of thing lodge in the other. The alleged difference in brain halves is pressed into service and promoted as an aid for everything from drawing a picture to organizing one's closet. The new stature of the "nature" half of the structure is apparent, too, in the fact that ecology movements abound, and people who are not particularly avant-garde take ethnic clothing and decor for granted. Nature gods and goddesses have sprung up or been recovered from obscurity, and people reenact pagan rituals to relieve modern stress. Alternative medicine has increased its market share.

Some scholars and syndicated curmudgeons who identify Western civilization with the rational/male/objective and whatnot— and who cannot imagine reasonableness apart from Reason, coherency apart from Logic, deep feeling instead of Emotion, accuracy and situated knowledge as an alternative to Objectivity, or persuasion with evidence as an alternative to Brute Facts with which one cannot argue—shudder that irrationality is taking over the world and Western civilization is being threatened (figure 10). Insofar as they consider those dichotomies and reifications pro-

duced by the metanarratives of progress and social evolution to be the essence of Western civilization, they are certainly right in their own terms. (I do, myself, think that the era when "objectivity" could be invoked by people in privileged positions in the knowledge-production system, and there's the end of discussion about the matter, is over.)

New Age
Spiritual Evolution

Along with so-called postmodernism, the late-twentieth-century response to the collapse of the progress narrative's story of social evolution that most raises the hackles of defenders of Western civilization is a counternarrative I call "New Age spiritual evolution," in which the female principle (and therefore the meanings that actual women are asked to bear, or claim for themselves) deserves special comment. A century ago, right-thinking middle-class American women were placed by men, and placed themselves, below men on the great scale of upward striving toward rationality and science; but they placed themselves very firmly indeed in the realm of culture or civilization (refer to figure 5).[12] By the end of the twentieth century, however, the irrational and the intuitive (long linked disparagingly to the natural and the primitive) were being claimed rather than rejected as characteristically "female" traits in some strands of popular culture. Consequently, women (insofar as they exhibit the female principle) run with the wolves and have a special ecological consciousness, are more intuitive, and are uninterested in math.

One of the ways in which the old dichotomous structure of nature versus culture is narrativized in popular culture is by turning the nineteenth-century metanarrative of social evolution on its head. The earlier version placed the official white European males' brand of civilization at the top, and the dark peoples who inhabit nature at the bottom; it celebrated reason and logic and denigrated emotion and intuition; and it distributed peoples of all classes, genders, and geographical regions on its scale. The newer version turns the older one upside down but preserves its dichotomous structures by reversing the placement of male and female princi-

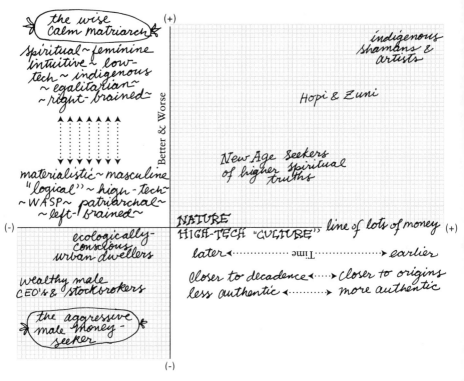

Figure 11. New Age Spiritual Evolution: The Metanarrative!

ples, reason and intuition, nature and culture, the primitive and the modern. This New Age metanarrative tends to be as reified and monolithic, as essentialist, as unidirectional, as humorless and un-selfconscious, and with as little breathing space for different stories as the older one.

In any case, I believe that the Hopi and Zuni of the American Southwest, who are matrilineal (which is often confused with matriarchal in popular culture), are enjoying such popularity right now because of this reversal, which I diagram in figure 11. The lowest category of spiritually unevolved beings in this narrative and therefore in my diagram takes the form of uptight wealthy white male stockbrokers and CEOs, enmeshed as they are in technology

and the pursuit of money. But it all works out harmoniously in practice, as befits the sensibility that produced this vision, because they, after all, are the ones who can afford to buy New Age art while on vacation in Santa Fe. The shift in valences between nature and culture probably has some relevance, too, to the popularity of Southwestern-style jewelry and the "Santa Fe style" of home decor, as well as to the marketing of the style of painting I call "New Age realism," which I touch upon in chapter 5. But I am getting ahead of myself.

I end this mapping of ideas of progress by mentioning its most important avatars, the narratives of nationalism and of economic development. Like the state in more ways than one, the idea of progress fails to wither away. Instead, it moves into new forms. Those new forms, like the nineteenth-century version backed by expanding European nation-states, are backed by state and economic power.

NARRATIVES OF
NATIONHOOD

The nation-states of Africa, Asia, and Latin America have lately embarked on nationalist self-constructions that follow the nineteenth-century European practice of projecting nationalist linear time deep into the past. European nation-states could do so because of the invention and perfection of scientific archaeology, which from its inception became a way by which nation-states could imagine themselves as natural entities, existing since time immemorial. Bogs, mounds, ruins, and fossils discovered within the nation-state's territorial boundaries were claimed as evidence of the ancestral greatness of the current nation. They became "national" treasures. National boundaries and an imagined "national character" and national glory could thereby be imagined as originating in the deep past—even though it is safe to say that Bog Men and their contemporaries did not think of themselves as protonationalists while they were alive.

The nation-state's projected existence into the historical past was asserted and made visible to its public in the late nineteenth century

by the erection of statues of putative protonationalists who lived before the invention of nation-states. France, for instance, was gripped with "statuemania," in Maurice Agulhon's (1981) term, erecting statues to express nationalist sentiments. William Cohen points out that in 1889, "Vercingétorix, the Gaul chieftain who had resisted the Romans under Julius Caesar, was given a monument in Bordeaux. Although the Aquitaine region was not known for resisting the Romans, he seemed an apt 'example of devotion and sacrifice to the national cause'" (1989: 505).

In the late twentieth century, nation-states seeking to create national stories while modernizing and developing turn archaeological sites within their territorial boundaries into tourist sites illustrating national heritage, which stand as visible and public projections of the idea of a bounded territory, a nation-state, existing from time immemorial. So, for instance, Rhodesia was named "Zimbabwe" after the ancient ruin called Great Zimbabwe. The citizenry of Zimbabwe regard Great Zimbabwe as the work of their ancestors. (When white colonists controlled the area known as Rhodesia, they had asserted that Great Zimbabwe was built by a noble race of Africans, now extinct, without living descendants.) In a much deeper projection of nationhood into the past, the national museum display for the tenth celebration of the Marxist revolution in Ethiopia featured the australopithecine remains named "Lucy" by Donald Johanson, which happened to be discovered within the territorial bounds of Ethiopia; "Lucy" became "the first Ethiopian." Or take the statue of Lapu-Lapu (figure 12), the chieftain who killed Magellan in 1521; it stands in front of the city hall of Cebu City in the Philippines as a tribute to the country's first nationalist—even though the Philippines did not exist as a nation-state until 1946, and the nation-state as an idea was barely dreamed of in 1521, even in Europe. These moves are similar to nineteenth-century France's claiming a Gaul resister of Romans as an early patriot, or Sweden's claiming Bog Men as early Swedes. Nation-states exhibit their national stories explicitly in state museums, whose internal narrative structures (the path the visitor is invited to take when walking through them) as well as the taxonomy of the museums (how they are periodized and the categories of objects they display) may be revealing. (I examine the case of Mexico's pre-

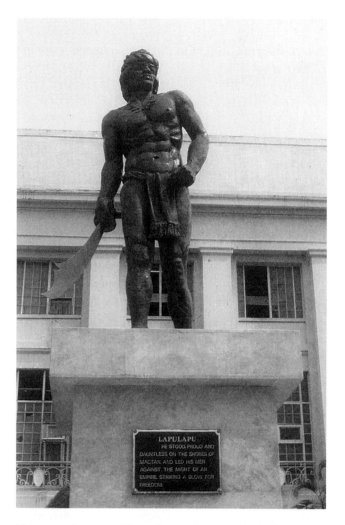

Figure 12. A statue of Lapu-Lapu, the man who killed Magellan, stands in front of the city hall of Cebu City in the Philippines as a tribute to the Philippines' first nationalist—even though the Philippines did not exist as a nation-state until 1946.

Columbian past, contrasting it to the United States' view of the Indians, in chapter 6.)

Nation-states use archaeology to project the national story into the past, but the line of national time must also move forever forward into the future. The story of the nation-state's forward movement in time is the story of national economic expansion and progress. Eric Hobsbawm views the advent of nineteenth-century European political imperialism as intrinsically linked to economic expansion. Ernest Gellner, whose political views are very different from Hobsbawm's, makes the connection even tighter, and more general:

> Industrial society is the only society ever to live by and rely on sustained and perpetual growth, on an expected and continuous improvement. Not surprisingly, it was the first society to invent the concept and ideal of progress, of continuous improvement. Its favoured mode of social control is universal Danegeld, buying off social aggression with material enhancement; its greatest weakness is its inability to survive any temporary reduction of the social bribery fund, and to weather the loss of legitimacy which befalls it if the cornucopia becomes temporarily jammed and the flow falters. Many societies in the past have on occasion discovered innovations and improved their lot, and sometimes it may even have been true that improvements came not as single spies but in battalions. But the improvement was never perpetual, nor expected to be so. Something special must have happened to have engendered so unusual and remarkable an expectation. (Gellner 1983: 21)

My point is simply that nationalist projections into the future can barely be imagined without the notion of economic "progress," and it is no accident that third-world countries construct themselves on both fronts (past and future) at once. Promoted by European and American ex–colonial powers during the Cold War, the economic versions of the progress story are promoted and promulgated by the national elites of "developing" nation-states and the industrialized nations' development agencies that advise them, as well as interna-

tional bodies such as the International Monetary Fund (IMF) and the World Bank.

"Modernization" (the term already seems badly dated) was the first postwar avatar of the idea of progress, and its intentions seemed to be benign. It had currency during the Cold War, when "underdeveloped" "third-world" countries (the term "third world" was invented in opposition to the capitalist first and the socialist second worlds of that era—see Pletsch 1981) sought to modernize, to "catch up" with, the industrialized and wealthy West, their former colonial oppressors. One of the ways they sought to do so was by remaining "nonaligned" and neutral in the Cold War, playing off the two major powers in order to preserve some independence. In the era of "modernization theory," debates were hotly conducted about the relation between "traditional values" and "traditional culture" and the imperative to "modernize": did all traditional culture have to be destroyed, or could some be turned to the modernization project?

The primitive artifact invented by this narrative was the "authentic" "traditional" (as contrasted to "modern") object, and it is no accident that the modernization narrative held sway during the golden age of authentic primitive art—that is, during the first two decades of the Cold War. During those years, the market for primitive art increased due to its newfound legitimacy (think of New York's Museum of Primitive Art, opened in 1957) and availability (World War II increased the number of airplanes and airline companies enormously by the late 1950s, heralding the new age of mass tourism by air).

But eventually development "theory"—to dignify it—replaced modernization as the way to name and think about the third world. This theory gives up on the idea of modernizing the natives and seeks only to modernize the economy of the countries the natives happen to occupy, which is quite a different, and much easier, enterprise. "Development" is therefore the name for the triumph of the idea of the "free market," for structural adjustment programs (SAPs), for the gross national product to stand as the measure of economic and political stability rather than any semblance of health and wealth being distributed throughout the population with some slight effort at equity. The development narrative has at its disposal more military power, more capital, and more technology than the modernization narrative, which now appears weak and feckless.

How did the change come about? The difficulty of "nonalignment" and political "neutrality" became more and more apparent during the 1970s and 1980s, as one "nonaligned" regime after another was displaced by a partisan one. A final coup de grâce fell upon the possibility of third-world countries maintaining economic and political neutrality with the collapse of the Soviet Union in the early 1990s. With the USSR gone as a symbolic and material resource for third-world countries, transnational corporations, their home offices in industrialized countries, became the only game in town. Further, by the late 1970s, the revolutionary heroes of the third world's anticolonial battles were dead or aging, and even their replacements were aging; the ideals they aspired to and fought revolutions to achieve—freedom from political and economic domination by European powers, often coupled with a theory of economy and society predicated on the desirability of social justice for all—had lost their aura and were only a memory to the young adults born after the revolutions.

The amount of capital invested by corporations in the exploitation of natural and human resources abroad is vast. Preserving their investments is critical to their survival in a global economy. Consequently, the political stability of the regimes that have given them permission to operate within their national boundaries (obviously, with enormous funds going to the elites of the regimes, ranging from taxes to less mentionable perks) becomes the highest priority. Any opposition movement to the governments in question—even for reform of political processes to make them more democratic; even for a slight distribution of resources or to make access to resources more equitable, stopping long before "socialism" can be seen on the horizon; even for the halting of state terror and torture—becomes suspect, because it is seen as a threat to the government's stability, hence to the foreign investments it guarantees. In these circumstances, and armed with neoliberal theory as well as other weapons, the nation-state's military acquires a new role; created to throw off colonial oppressors half a century before, the armies of third-world states in the late twentieth century assumed the function of suppressing internal dissent—often with helicopters and tanks supplied by the home governments of the corporations.

Why might there even be dissent or opposition? After all, urban elites often welcome "development," because they are the beneficiaries of (for instance) electricity from hydroelectric dams. People on

the bottom of the distribution structure may be less sanguine—even the urban lower classes, especially during the 1990s, which saw the widespread promotion of the onerous and poverty-producing SAPs. The hill tribes in remote areas whose farms and ancestors' graves were inundated by millions of gallons of water while they were relocated to yet more remote areas by hydroelectric dams may be even less persuaded of the virtues of development. They sell their precious objects or their everyday ones—their hand-embroidered shoes, say—because they need to eat; then they buy plastic shoes with the pittance they earned as day laborers on the giant roads being cut into the neighboring forest by a timber company. (I am not writing about a particular case here, just the general pattern.)

Just at the time the newer nation-states' revolutionary visions of nationhood have more or less faded, these countries have entered a new phase of nationalist state construction in the era of development. In nation-states where dominant elites of a single ethnic group or ideological persuasion assume the role of internal economic and cultural colonizer, the objects of remote minorities often become tokens of "the backward," which must be replaced in the regime of development. Consequently, "traditional" objects, as well as archaeological sites and ancient monuments, come to be claimed and displayed as exemplars of national heritage and folk art in the new nation-states' national museums and public culture. As for the type of primitive art invented, and liberated, by the regime of development: It briefly puts new authentic primitive arts and crafts on the market, as people sell off their hand-embroidered objects (etc.) to gain some money to eat (etc.), and those objects may find their way to the international market for ethnic and primitive authentic items (see chapter 4).

Ironically, the artifacts of peripheral peoples are sometimes celebrated as examples of national heritage at the same historical moment that the peoples who made the objects are being turned into the urban poor or the most menial workers in mining, oil, and timber industries. Thus in an utterly Baudrillardian move by national elites, the sign replaces the referent.

If the threatening jungle has transmuted into the friendly rainforest in Euro-America, one of the reasons for its newfound appeal is that it and the people who live within it are threatened with extinction due to policies implemented and justified by the development

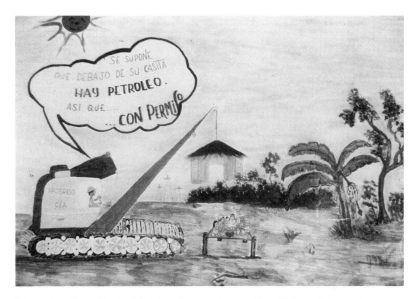

Figure 13. One effect of the development narrative. Driver: "Se supone que debajo de su casita HAY PETROLEO. Así que CON PERMISO . . . " ("There might be OIL somewhere under your itty-bitty house. So, EXCU-U-U-SE me!").

narrative. Locally, the policies may evoke protest or bitter humor (as in the cartoon reproduced in figure 13, drawn by someone in the early 1990s on the border between Ecuador and Peru). In Euro-America, the destruction of the forest and its inhabitants does not go unnoticed—the inhabitants may become "endangered peoples" (figure 14). Other narratives and markets are also set in motion; hence: not only nongovernmental organizations to protect the rainforest, not only eco-tourism, but also the sentimental marketing of factory-made objects that signify "nature."

These thoughts on the permutations of the metanarrative of progress and the kinds of objects (authentic primitive art and others) it has produced in the last two centuries are germane to the story of the death of primitive art and its various aftermaths that I tell in this book.

ENDANGERED
PEOPLES

ART DAVIDSON

FOREWORD BY RIGOBERTA MENCHÚ, 1992 NOBEL PEACE PRIZE LAUREATE

WITH PHOTOGRAPHS BY ART WOLFE AND JOHN ISAAC

Figure 14. The people who live within the rainforest have become endan-
gered peoples rather than ignoble savages.

PART ONE

•　　•　　•

THE DEATH OF AUTHENTIC
PRIMITIVE ART

1

• • •

Three Ways to Tell
the History of (Primitive) Art

At the turn of the twentieth century, when the idea of progress was at
its height, "primitives" were regarded as savage, brutal, and heathen,
and their imminent disappearance was thought generally to be a good
thing by the interlocking directorates of sites of public educational dis-
plays and knowledge production. The low regard in which colonized
people were held made it wildly radical of Picasso to take up and cel-
ebrate African masks as "art."

One of the most common ways to tell the story of how primitive art
entered the mainstream of art is thoroughly celebratory: it begins with
the mythical origins of primitive art in Picasso's and Vlaminck's "dis-
covery" and construes its subsequent history as one of being increas-
ingly appreciated by the public and by major museums.

The comic emplotment of the simplest versions of the discovery
narrative must, of course, be completely retrospective: in it, the au-
thor casts a glance back over the often confusing jumble of events and
causes of the past and sees a clear line leading to the present. The au-
thorial voice then tells a tale of triumph, ruthlessly excluding the un-
certainties and particular historicities of any given moment. Applied
to primitive art, the discovery narrative goes something like this:

> Picasso and Vlaminck found African masks at the flea market and
> recognized that they were Art. From then on, it was a slow steep
> climb for recognition, but due to the vision and taste of important
> collectors and the heroic efforts of enlightened curators, these extra-
> ordinary pieces now have a secure and enduring place among the
> arts we rightly celebrate.[1]

Here I want to give a more historical and secular account of how
primitive art entered the mainstream of art in this century. I am imme-
diately faced with a problem: the subject of my story ("primitive art") is
not a platonic category that remains constant over time, but one that

49

fluctuates in both form and content over the course of the twentieth century and hardly existed the century before. To tell the story of the fluctuation itself would require a serious historical exploration of what *l'art negre* actually meant to Picasso or to the Parisian on the street in 1905 (which certainly was different from the sorts of objects that eventually ended up in the Rockefeller Wing of Primitive Art in the Metropolitan Museum in 1982) and would require a careful exploration of the competing discourses concerning primitivism and art that occurred between those two points. Because I want to tell this story briefly as a precursor to its death rather than as the subject of the book, I have accepted the provisional existence of the category "primitive art," even though doing so means there will be anachronisms, on the grounds that we (the readers and writer) are curious about a conceptual object already real and constituted for us. Accepting the fact that we are situated temporally at the turn of the twenty-first century, I will cast a glance back over time to discover the "origins" and transformations of primitive art.

THREE WAYS TO TELL THE HISTORY OF ART

The emplotments available to me to tell a history of primitive art are derived from the emplotments available for telling the story of art in general. These fall into three major types: universal accounts of art derived from Hegel's view of the shape of (European) history; stories of discovery and appreciation; and finally secular accounts emphasizing the marketplace, fashion, and dominant and persistent ideas. Stories of art derived from the Hegelian narrative assume that art always existed; given its European focus combined with universalist pretensions, it poses nearly insuperable problems for telling a story about authentic primitive art. Stories of discovery likewise assume that art always was, but assert that certain kinds of art were not always recognized as such. This narrative of the history of authentic primitive art serves collectors and the art market best, since it allows space for change while asserting the timelessness and transcendent value of true art. Secular and market tales emphasize the changes in fashion and economic status of the objects being discussed. These stories, often in the ironic mode, treat art like any other commodity.

After explicating the ways each of these types of narratives treats primitive art and giving brief examples of the first two, I concentrate on explicating and refining a model of the third type by applying

some of Michael Thompson's insights from his book *Rubbish Theory* (1979) to the story of primitive art.

THE HEGELIAN NARRATIVE

The first type of tale is derived from Hegel's account of the universal story of the unfolding of Man's Spirit. In its purest form, this story moves inexorably from the Ancient World, to the Middle Ages, to the Renaissance, and then to the Modern World (as in the table of contents of H. W. Janson's *History of Art* [1962]). This story's enabling assumption is that art always already was and that its story always already was there for the telling. No historiography, no social history need intrude on this straightforward and blessedly simple tale. This narrative frame probably served writers of universal histories of art quite adequately in the mid-nineteenth century, when the genre originated in Germany (see Minor 1994).

It served less well in the late twentieth. The problem for a contemporary textbook writer using it is to incorporate objects that were not produced in the art-historical periods the Ancient World, the Middle Ages, the Renaissance, or the Modern World, and which therefore have no temporal or spatial location in that unfolding. Where can the other, non-Western, "arts" be inserted into the great timeline of European art? Two major strategies and several minor ones emerge from a perusal of art history survey texts.

One was invented by Helen Gardner, the first textbook author in the United States to make a serious and sustained effort to incorporate non-Western arts into a universal art history textbook based on a Hegelian frame. The strategy she developed (she uses it in the third edition of *Art Through the Ages*, and it is prefigured in earlier editions) follows the familiar sequence of stages (from ancient to modern, in four or five periods); within each major period she discusses European art of the time but also has sections on the arts of other non-European art traditions.[2]

Hugh Honour and John Fleming adopt the same strategy in all three editions of their widely used universal history of art (1982, 1986, 1991). The main narrative frame of their third edition consists of the standard four-part sequence of periods, interestingly enough almost identical to that of Janson's table of contents, albeit with different labels. The narrative moves from the Ancient World (called in

Honour and Fleming "Foundations of Art," covering prehistory to A.D. 300) to the Middle Ages (called "Art and the World Religions," from A.D. 300 to 1000), to the Renaissance (with a chapter setting the stage for it and one finishing it off with the Enlightenment, called "Sacred and Secular Art," from 1000 to 1800), and finally to the Modern World (divided into two parts, one for the nineteenth century, one for the twentieth).

Like Helen Gardner's narrative of periods in her third edition, Honour and Fleming's narrative periodizes art in the standard stages, but, different from other texts, it interrupts each stage with one or more chapters in which the focus of the narrative shifts from the geographical location of Europe to other times and climes. It is rather as though a person striding along on a clear path and looking straight ahead paused, once in each period, to look around and ask, "What's happening on other paths? What's going on over there?" These textbooks' complex structures, which were doubtless arrived at with much thought and agony, are clearly compromises between the necessity or urge to tell a single-story universal history of art whose geotemporal focus is Hegel's "Europe," on the one hand, and, on the other, to tell multiple stories from multiple traditions.

The second major strategy—a far simpler one—for incorporating non-Western arts into this grand Eurocentric but "universal" unfolding was adopted in 1933 by Joseph Pijoan in his *History of Art*, by E. H. Gombrich in *The Story of Art* (first published in 1950), and in the several editions of Janson's *History of Art: A Survey of the Major Visual Arts from the Dawn of History to the Present Day* (first published in 1962). These authors place the arts of primitive people with the magical beginnings of art proper, prior to history—that is, prior to Egypt and the ancient Near East. In *The Story of Art*, for instance, Gombrich called his first chapter "Strange Beginnings: Prehistoric and Primitive Peoples; Ancient America." These "strange beginnings" include the caves of Lascaux, from which the narrative moves quickly to the "magical" masks and images of contemporary "primitive cultures" as well as archaeological remains in the Americas. Janson's *History of Art* similarly begins with "Magic and Ritual: The Art of Prehistoric Man," which is the first chapter of the section entitled "The Ancient World" (Egyptians come next). Illustrations for the chapter's text run the gamut from Lascaux paintings and the Venus of Willendorf, to Stonehenge, to the sculptures of Easter Island, to nineteenth- and

twentieth-century masks and other items from Africa, Alaska, and the Northwest Coast of North America, and an undated picture of a "Sand Painting Ritual for a Sick Child (Navajo), Arizona."

The organization of these books is premised on the notion that there is a "primitive" mentality that exhibits "magical thinking" and that the contemporary "primitive" humans referred to in these chapters are "Stone Age people." The authors assume the tone of benevolent and omniscient guides throughout their texts, explaining the rationale for lumping together prehistoric paintings with the artifacts and ceremonies of living humans, all from widely divergent geographical and cultural locations.

Placing the arts of Asia, Africa, and Oceania in magical beginnings, thus freeing the narrative to address European art without stumbling on the long path to the present, is a tidy solution. Many other solutions to the problem are less tidy. A random survey of other, less-used textbooks reveals other strategies and tactics. Some ignore Africa and Oceania but place the arts of India, China, Japan, and Central and South America in the stage of ancient civilizations, wedged between the Romans and the Middle Ages; some clump all non-Western arts, from primitive to Far Eastern, at the very end of the survey or right before the twentieth century; some devote chapters to Far Eastern and Indic arts but mention primitive art only in passing and in relation to early-twentieth-century European art. The point is, the placement of non-European arts into the Hegelian story is unstable across textbooks. That instability is instructive: they do not fit conveniently, because the story was not laid out originally with them in mind.

Helen Gardner, as I mentioned, was a pioneer in the effort to incorporate non-Western arts into a universal art history textbook. The changes in the first three editions of her book (the ones she wrote; the fourth edition was edited by others) are instructive, both because the changes reveal a continual rethinking of the issue by an open-minded and warmly appreciative writer, and also because the changes reflect the state of knowledge and status about non-Western arts in the United States. (She obviously read assiduously in anthropology and kept current with the Museum of Modern Art's exhibitions of non-Western arts under the direction of René d'Harnoncourt.) It is interesting to note, however, that by the fifth edition— *Gardner's Art Through the Ages* (1970)—the authors, Horst de la Croix and Richard G. Tansey, abandon the rest of the world to concentrate

on "the art of Europe and its ancient antecedents, to the exclusion of the arts of Asia, primitive art, and the art of the Americas." The authors justify the exclusion on the grounds that these other areas deserve their own college courses and are now being treated in survey courses in their own right, and furthermore books dealing exclusively with non-Western arts are available.

In this they are certainly correct: These days, only writers of universal textbooks feel obliged to incorporate Western and non-Western arts into the same story. The most common way to give accounts of non-Western arts is as freestanding subjects in themselves: single-topic books about the nature of Islamic art, or Chinese painting, or whatever. In these books, Europe, European art styles, or changing European tastes in collecting can be brought into the account as an "influence" on the production of artifacts in a non-European area (for example, the European taste for porcelain stimulated the production of export porcelain production in China), but Europe's universalist story about its own art can be completely ignored. On the occasions when the story of, say, Chinese painting must somehow be brought into conjunction with narratives of European art—for instance, on the occasion of a major exhibit of that art—the account given is likely to take the form of the second major way of telling art's history, a narrative of discovery and appreciation.

THE DISCOVERY NARRATIVE

The discovery narrative celebrates primitive art's discovery and the increasing appreciation it has come to enjoy. Unlike the Hegelian narrative, the discovery narrative has the virtue of allowing for changes in taste and institutional valorization; but *like* the Hegelian narrative, the discovery narrative asserts and maintains the essential value of art itself as an ahistorical, transcultural, universally valid category of object. Not surprisingly, it is the one most beloved of collectors, dealers, and curators with a budget for new acquisitions.

A complex version of the discovery narrative can be found in the work of some of those few art historians and writers about art who have interested themselves in the social history of collecting and in the reception of various kinds of new arts into the European mainstream, such as Francis Haskell (see, for instance, Haskell 1976). However scholarly and perceptive these are, most are fairly narrow in histori-

cal scope, with the result that the reader can regard the vagaries of collecting, of taste, of pricing, or of revaluation of certain categories of objects as isolated incidents. In other words, the reader can assimilate the accounts piecemeal, rather than be forced to fit them into a totalizing history of art told as social history.

The most ambitious exception to the generalization I have just made is Joseph Alsop's *The Rare Art Traditions: The History of Art Collecting and Its Linked Phenomena Wherever These Have Appeared*, which was published in 1982. In it Alsop outlines the history of the expansion of the kinds of objects that count as art in the West as three revolutions in "ways of seeing," each of which has brought different (and usually more) sorts of objects into the category.[3] "It was the Italian Renaissance . . . that made the 'ancients' the grand exemplars, and the remains of classical antiquity the models of all art," he writes, and Greco-Roman copies formed a good part of what counted as antique art (7). "The downgrading of the Greco-Roman marbles that started with the electrifying appearance in London of Lord Elgin's loot from Athens" in 1814 forms Alsop's first "revolution in seeing" (10). His second "revolution" is the nineteenth-century Gothic Revival, which legitimated and transformed Gothic architecture into art, whereas previously it had been largely neglected or destroyed. Alsop's final "revolution" is the reassessment of the fourteenth- and fifteenth-century Italian painters, who previously were viewed not as "masters" themselves but as mere precursors to the High Renaissance. The three revolutions in conjunction, Alsop claims, constituted a "final rejection of the standards of excellence and error established by the Renaissance, and thus the final abandonment of the long-enduring canon of art resulting from the Renaissance" (13).

Alsop does not add a fourth revolution in seeing, but he does point to one when he writes, "The drama by no means ended [with the Italian primitives], however, for the twentieth century had a further, stranger tale to tell," and proceeds to tell about the revolution in taste that allowed primitive art to be accepted into the mainstream:

> With the former canon abandoned, in fact, all art gradually became equal—although some people's art has never ceased to be more equal than other people's. Group by group, culture after culture, the products of all the known non-Western cultures, whether surviving above ground or wrenched from the shelter of the silent earth, were scrutinized anew with altered eyes. Grimy archaeological finds and ob-

scure ethnographic specimens, curios from family whatnots, souvenirs of life on far frontiers, and loot from half-forgotten military expeditions to the remoter corners of the globe—all these came to be seen as works of art deserving the grave, minute attention of art historians, the angry rivalry of art collectors, and the more polite but no less cutthroat pursuit of museum curators. In the upshot, the descendant of the obscurest British officer who brought back bronzes from the sack of Benin in 1897 became a luckier man by far than the inheritor of the Greco-Roman marbles eagerly, expensively collected by one of the greatest Whig grandees of eighteenth-century England. And as these words are written, New York's Metropolitan Museum is building a whole wing to be devoted to "primitive art." (13–14)

Alsop is a believer in high art, and he believes that art has occurred rarely in the world—in fact, only in Europe and in China. But because social histories of art and collecting—even when told within the general ethos and worldview of the discovery (and appreciation) narrative—tend to provide rich, historically detailed information, they tend also to invite readings their authors did not necessarily intend. Joseph Alsop's monumental work is certainly among those that invite other readings. Alsop is very convincing, for instance, about the interconnectedness of art collecting, art history, and the art market, viewing them as "by-products" of an already constituted category of objects he regards as self-evident, "art." A more secular commentator would give these observations a contrary spin by asserting that art collecting, art history, and the art market constitute the phenomenon we name "art" rather than being its "by-products."

Secular Narratives

The third grouping of stories about art's history I call "secular." These have no teleology, no essential universal categories (such as art versus craft), and no assumptions about good and bad taste, the intrinsic qualities of a masterpiece, the genius of the artist, etc. The tellers of these tales characteristically have little or no investment (economic, psychological, or intellectual) in the conventional categories of art history and museology or in the objects they write about. Indeed, their sympathies and intellectual energies tend to be elsewhere, and the tellers often are using art objects as illustrations for more general theories they hold about other kinds of things and processes. In this third class of narratives, for instance, one might put

the large number of works that have been written in the last twenty years about the looting of archaeological sites, the repatriation of cultural heritage, the invention and fashions in historic preservation, the sociology of taste, the fluctuations in the art market, and so on. I emerge from this general camp of historians and social scientists, as does the anthropologist Michael Thompson, whose book *Rubbish Theory* provides, in my view, a very useful set of ideas for beginning to understand the art market and transformations in taste.

I now tell an entirely hypothetical tale of my own devising about rubbish becoming collectibles, and eventually decorative art, and even a form of unmarked art, inspired directly (though not in particulars of subject matter and narrative style) by Thompson's chapter called "Stevengraphs—Yesterday's Kitsch." This is a short and compressed story, but it serves as a model for what may happen during longer stretches of time. This model is relevant, I believe, to understanding how primitive art was constituted as an "art" object and could therefore enter the mainstream of art during the course of the twentieth century. After telling this paradigmatic tale, I outline Thompson's views on rubbish theory and then return to the case of primitive art.

HOW WIDGETS ENTERED
THE MAINSTREAM OF ART

Many objects move through a regular trajectory in which they begin as objects produced in quantity, go through several transformations, and end up as objects in a museum. Their stories go something like this:

Objects are made in quantity by hand or machine (Shaker boxes and Amish quilts, say, or glass paperweights, or toasters—call them widgets) and they begin a useful life containing things, covering people at night, holding down paper in a breeze, toasting bread, or whatever. But eventually they wear out or a new fad comes in, and they are stowed in the backs of drawers or in cardboard boxes to be sold at a garage sale. The stuff that doesn't sell is given to Goodwill. Since the widget is perfectly serviceable but not up-to-date, it sits on the shelf for a while. Nowadays, after all, people are buying more modern-looking widgets.

Eventually a Mrs. Smith buys a widget when cruising through Goodwill because she finds it charming, just like the one she had as a child; the very next week she comes upon two of them at St. Vincent de Paul. She buys them both and suddenly realizes she has the be-

ginnings of a collection. From then on she begins to seek out widgets wherever she goes. Within a few years she has 237 widgets, all of them different, and has special cases built for them. The local newspaper publishes a piece in their Home Style section called "Displaying Your Widgets to Best Advantage," featuring Mrs. Smith's collection. This piece brings her passion for widgets to a wide audience of people who remember there are widgets in their attics, which they promptly start offering to sell to Mrs. Smith by mail. By now, however, she has become quite discriminating, and wants only widgets of excellent condition and interesting design.

Thinking to facilitate her collecting and wishing to hobnob with like-minded enthusiasts, Mrs. Smith begins a mimeographed newsletter unpretentiously called "Widget Collecting." It keeps her in touch with other collectors, and, as a rather unintended consequence, it also helps to create a market, establish prices, and so on. The newsletter occasionally features the work of local belletrists who write nostalgic pieces about the uses of widgets in the old days; of amateur historians who write on the origins of widgets; of cognoscenti who have opinions about which widget designers are especially to be admired, expound on how widgets are much underrated as objets d'art, and so forth. Within a couple of decades Mrs. Smith's widget collection has grown to nearly a thousand pieces. Based on the subscription list of the newsletter, Mrs. Smith has created a Society of Widget-Fanciers, of which she is president. The newsletter has become the organ of the society and has become a bulletin. It is now printed instead of mimeographed, and people pay a moderate subscription to receive it and get notices of widget fairs and auctions of estates that include caches of widgets.

At this point Mrs. Smith's widget collection comes to the attention of a prominent and wealthy citizen named Mr. Doe, who upon seeing it becomes utterly entranced by the variety, the workmanship, the sheer beauty of widgets, which he had never noticed until seeing them amassed and well displayed. He buys the entire collection in one fell swoop for a very good price from the aging Mrs. Smith (much to the relief of Mrs. Smith's daughter, who thinks that entirely too much family capital is tied up in widgets).

Mr. Doe, whose connections are wider in the world than Mrs. Smith's, augments his collection with some truly remarkable and rare forms of widgets. He displays it prominently in his house, where his guests admire the charm and craftsmanship of old wid-

gets and denigrate the shoddiness of new widgets, which, though admittedly more functional, lack the vibrancy of design, the fine decoration, the history, the culture—the art—of the old designs. He becomes the publisher of the old, sporadically published *Bulletin of the Society of Widget-Fanciers,* appoints a professional editor, has it printed on glossy paper with full color photographs, and changes its name to the *Princeton Journal of Widgets and Teleology.*

When he dies, Mr. Doe bequeaths his widget collection to an art museum on whose board of trustees he sat, but only on the condition that the collection never be dispersed or de-accessioned and that it be housed in a special room. The curators are in a rage: widgets are Kitsch, not Art, they say among themselves. But their rage must be somewhat constrained by the fact that Mr. Doe is also giving money for a much needed new wing having no connection to widgets, although the funding for it is contingent upon finding a room for the widget collection. An internal institutional fight ensues in which two associate directors are fired and there is a reshuffle. Eventually the wing is built, the room found, and the Mr. and Mrs. John Kingston Doe Room of Widgets takes its rightful place in the temple of art. The curators continue to roll their eyes at each other when discussing at lunch the tact needed to deal with collectors, and they make delicate allusions to the widget collection. Oddly enough, the Widget Room proves a very popular draw for visitors.

Decades later, the Widget Room is a point of pride for the museum. John and Jane Doe's eclectic and generous taste is celebrated and admired, and a traveling exhibit—called Masterpieces from the Collection of Jane Beaufort Doe and John Kingston Doe—is organized to celebrate the Widget Room's fiftieth anniversary. New assistant curators are socialized into museum culture by being told in hushed tones of the vision of the last and great director of the institution, who accepted widgets as art and snagged the precious collection before anyone else knew it was to be worth anything.

Meanwhile . . . people are discarding *wadgets* without a thought. Wadgets, after all, are common and worthless, not even a collectible. In fact, mere rubbish.

RUBBISH THEORY

In *Rubbish Theory: The Creation and Destruction of Value,* Michael Thompson begins with the fact that objects (not just art objects) are

revaluated over time, and he proposes a theory of "rubbish" in order to explain how it happens. (Thompson's work is actually an extensive theory of objects, value, and social class, and he attaches it to mathematical catastrophe theory. I draw here only on the ideas most relevant to the way I want to construct a story about primitive art.)

Thompson begins by suggesting that we tend to classify objects into two major overt categories, which he calls "transient" and "durable." Those objects considered transient decrease in value over time and have finite life spans. Objects in the durable category increase in value over time and have (ideally) infinite life spans. Clothing and cars are "transient." They cost something, they are used, they wear out, they are sold for less than bought, and they are then thrown away. Ming vases are "durable" objects. Their value increases or should increase.

Thompson points out that the way we act toward an object relates to its category membership. We treasure, display, insure the vase; we use and eventually discard or sell the car. At the same time, how we act toward something also determines what its value is. Although it is not always so, it helps if the objects categorized as durable are in fact durable, not immediately subject to disintegration.

Now, people who have the most durables, he claims, also define what is durable, and so the question is how things ever change value:

> We can uncover the control mechanism within the system: the manner in which durability and transience are imposed upon the world of objects. This is perhaps the first stumbling block in presenting rubbish theory, for we all tend to think that objects are the way they are as a result of their intrinsic physical properties. The belief that nature is what is there when you check in is reassuring but false: the belief that it is made anew each afternoon is alarming but true. We have to recognize that the qualities objects have are conferred upon them by society itself and that nature (as opposed to our idea of nature) plays only the supporting and negative role of rejecting those qualities that happen to be physically impossible.
>
> The operation of this control mechanism would seem inevitably to give rise to a self-perpetuating system. Briefly: it is decidedly advantageous to own durable objects (since they increase in value over time whilst transient objects decrease in value). Those people near the top have the power to make things durable and to make things transient, so they can ensure that their own objects are always durable and that those of others are always transient. They are like a football team whose centre-forward also happens to be the referee; they cannot lose. (Thompson 1979: 9)

But, he says, we are all familiar with the fact that things do change categories:

> We are all familiar with the way despised Victorian objects have become sought-after antiques; with bakelite ashtrays that have become collectors' items; with old bangers transformed into vintage motor cars. So we know the changes take place, but how? The answer lies in the fact that the two overt categories which I have isolated, the durable and the transient, do not exhaust the universe of objects. There are some objects (those of zero and unchanging value) which do not fall into either of these two categories and these constitute a third covert category: rubbish.
>
> My hypothesis is that this covert rubbish category is not subject to the control mechanism (which is primarily concerned with the overt part of the system, the valuable and socially significant objects) and so is able to provide the path for the seemingly impossible transfer of an object from transience to durability. What I believe happens is that a transient object gradually declining in value and in expected life-span may slide across into rubbish. In an ideal world, free of nature's negative attitude, an object would reach zero value and zero expected life-span at the same instant, and then, like Mark Twain's "one hoss sha," disappear into dust. But, in reality, it usually does not do this; it just continues to exist in a timeless and valueless limbo where at some later date (if it has not by that time turned, or been made, into dust) it has the chance of being discovered. (9–10)

NON-WESTERN ART AND RUBBISH

Rubbish theory provides a way to conceptualize the categorization of art objects, including primitive art, and lays the foundation for a sociological and economic understanding of the continual revaluation of objects. The first step in applying it to this topic is to ask: What counts as rubbish when it comes to art, especially non-European art?

First of all, the term does not indicate that the objects so labeled are literally rubbish or garbage: they have not necessarily been discarded. Nor is it a value judgment: it does not mean that they are ontologically worthless. Rubbish consists, rather, of objects that do not fit, or cannot be accommodated within, the categories of objects that have been valorized and institutionalized within art history and the museum system.

An example is the tourist art made by Native Americans. In her article "Why Not Tourist Art?" the art historian Ruth Phillips recounts her discovery of these objects as art objects:

> I began this research with the full quota of standard prejudices in-
> scribed by my disciplinary training as an art historian during the
> 1960s and 70s. I sought out the rare and the old, the "authentic" and
> the unacculturated for presentation in teaching, exhibitions and writ-
> ten texts. Working in collections, however, I was regularly side-
> tracked by the pull of other objects . . . that lay alongside them on
> museum storage shelves. The glove boxes of birchbark and porcu-
> pine quills or the Hiawatha and Minnehaha dolls in fringed buckskin
> seemed to recall the roadside stands of childhood, to illuminate
> briefly the private lives of unknown strangers, to witness innumer-
> able small meetings across cultural boundaries. These objects were
> walled off, untouchable according to orthodox curatorial and discur-
> sive practices. Rarely exhibited or published, excluded from the
> canon, they have been shrouded in silence. (1995: 99–100)

The glove boxes, beaded purses, and pincushions she found were
not literally rubbish or garbage—after all, Phillips found them in the
museum's storage—but they were invisible to normal art-historical
scholarship. Or, for that matter, to anthropological scholarship: wit-
ness the labels in a display case I encountered in Chicago's Field Mu-
seum in 1986, which helpfully categorizes objects as "art," "decora-
tive art," and "non-art" (figure 15). Tourist art did not even make it
into the display case as non-art in 1986; it was beneath the level of
conscious attention. (As a matter of note, it appears to me that
"tourist art"—that is, objects made deliberately for the market by
third- and fourth-world people and made deliberately to signify the
"primitive" or the "ethnic"—is currently making an acceleratingly
fast climb out of the murk of invisible rubbish and becoming re-
spectable transient objects; some of it is shooting straight into the
durable class; but that story comes later in the twentieth century and
later in my tale.)

Tourist art, then, is rubbish from the vantage point of celebrants
and believers in authentic primitive art. In this analysis, transient ob-
jects would be the "lesser" arts, crafts, and decorative items that may
be discarded or sold when their useful or decorative life is over.

Objects that have been securely valorized as art, of course, have
made it into the category of "durable." Their value is believed by
Hegelians and many art historians (who often are Hegelians) to be
transhistorical and transcultural, and a bevy of conservators and re-
storers in the employ of collectors and museums seek to make the art
objects' physical perfection conform to their eternal conceptual worth.

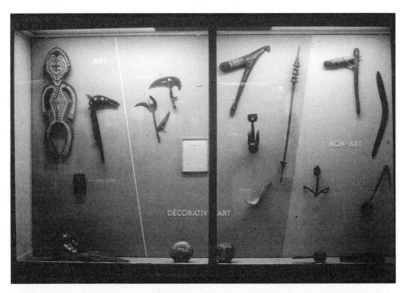

Figure 15. A 1986 display case in Chicago's Field Museum helpfully educates the public by defining (primitive) ART, DECORATIVE ART, and (miserable thing) NON-ART.

If the story of the discovery of primitive art were to be told in terms of rubbish theory, it would emphasize that the objects Picasso and Vlaminck discovered were rubbish, the flotsam and jetsam that surface in flea markets and hang on the walls of bars as decor; these objects were invisible to the art market and to most artists. To move out of flea market rubbish and become durable art, they had to become visible to major collectors and to the institutions whose exhibitions define what counts as art.

Rubbish theory provides a secular language of analysis for understanding the social processes within which flea market rubbish could be transformed into Metropolitan Museum durables and how this kind of durable object has continued to transform into other named varieties of marketable and collectable objects. Rubbish theory informs my account of primitive art during the rest of the book. But there is more to the story than market forces working to elevate rubbish into durables. Rubbish theory and accounts of the economics of taste do not provide in themselves an understanding of the cultural categories that lie behind and inside market processes, which shape historical process fully as much as markets do.

A BRIEF HISTORY
OF THE BIRTH AND RISE OF PRIMITIVE ART

The discovery by early-twentieth-century artists that pieces of invisible flea market rubbish were really art initiated the process that would eventually make such objects visible to a wide public as art. It was a critical moment in their transformation in status, enabling (but not immediately effecting) their conceptual and institutional move from rubbish to durables. And yet, had the discovery been made by artists but never been taken up by the art market, major collectors, and major institutions, it would have become a dead-end in the great line of art-historical time, constituting a passing fancy that was dropped. As it happened, dealers in modern art began dealing in objects from the African colonies as well, selling the two kinds of art side by side. Avant-garde collectors and artists and those in their circles decorated their houses with both.

In New York and therefore in the United States, the histories of the collection and promotion of modern art and of what was to become primitive art are highly intertwined. The collecting and patronage of the Rockefeller family; the solidification of the exclusions and inclusions of which objects were to be designated as "primitive art"; the legitimation of primitive art; the legitimation of modern art; and the institution of the Museum of Modern Art—all are enmeshed.[4]

FIRST PHASE

In the United States, the Armory Show of 1913 introduced New York to modern art.[5] By 1929 it had its own permanent installation space in the form of New York's Museum of Modern Art. One of MoMA's founders was Abby Aldrich Rockefeller, a promoter of modern art who was also collecting American folk art, both tastes very advanced for the time. MoMA was founded to educate the public and to exhibit the work of living artists, which had been found too avant-garde by the Metropolitan.[6] Modernism was established and legitimated at MoMA during this interwar period, and outreach efforts attained their peak of intensity during the years of World War II. A big push came in the 1940s. For instance, the show "We Like Modern Art" opened in 1941; exhibitions called "Understanding Modern Art" occurred in 1941, 1942, and 1943, along with "What Is Modern Painting?"

The major collector who made visible and legitimated objects from Africa, Oceania, and the Americas as primitive art was Nelson Rockefeller.[7] According to one account, he became an enthusiast in 1930 when, in Sumatra on his honeymoon, he was offered a knife whose handle was sculpted in the shape of a human head, to which was attached human hair: "He found it irresistible" (Saarinen 1958: 390). He acquired some pre-Columbian objects soon afterward, and in 1934 he met René d'Harnoncourt. D'Harnoncourt appreciated the artistic value of indigenous American artifacts, from both North America and Mesoamerica, and he organized an exhibit of them for the San Francisco World Fair of 1939, soon followed (in 1941) by another show at MoMA. With Rockefeller patronage, he became the museum's director in 1950.

Like modern art, objects made by colonized and conquered peoples were being valorized as art between the two world wars, with MoMA as a major venue. Exhibits there include "African Negro Art" (1935), "Twenty Centuries of Mexican Art" (1940), "Indian Art of the United States" (1941), and "Arts of the South Seas" (1946). The theme continued into the early 1950s with "Understanding African Negro Sculpture" in 1952 and "Ancient Arts of the Andes" in 1954. Each of these shows displayed objects from a single geographical area. Apparently these objects were not yet lumped together and displayed as a single kind of entity called "primitive art." By means of exhibitions and sales in art galleries, objects made by colonized peoples of Africa and Oceania, and eventually objects made by the native peoples of Mesoamerica and North America, were leaving the realm of invisible rubbish and entering the realm of visible art.

From about the second half of the nineteenth century to beyond the end of World War II, Europe and the Europe-derived cultures of the Americas stood for the modern, history, progress, and technological change and advances; the peoples colonized by European nations, most especially those with little industrial technology or writing, had come increasingly and then definitively to stand for the opposite of progress and rationality—for stagnation, superstition, and savagery. The dichotomy between European civilization and primitive savagery was generated by the metanarrative of progress, which gripped the imaginations of Euro-American colonial powers and the knowledge-producers of these nations during that century (from about 1850 to 1950) and continues to this day as "development

theory," which insists that all peoples of the world must modernize, else be left behind to wallow in their ignorance and superstition. In any case, the two significations, the civilized and the primitive, defined each other in classic Saussurean form; each had a value because its opposite existed.

How did avant-garde artists' appreciation of primitive art diverge from the dominant metanarrative? The art elite associated the primitive with the mythical and the magical, rather than the stagnating and the superstitious. Substantively, they may have been naming the same thing, and structurally they certainly were (that is, the opposite of the conceptual space occupied by "Europe"). The difference between the conservative, basically nineteenth-century, conventional, and bourgeois dichotomy between the civilized and the primitive, on the one hand, and the mutual definition of modern art and primitive art, on the other, during the first half of the twentieth century, was the valorization of the primitive in the eyes of painters. Primitivism and the modern art avant-garde formed each other's flip side, as well: each implied the other.

Certainly, the dominant, educated, as well as popular-culture view in this period was that the peoples who produced these primitive magical artifacts lived outside of history, without history. There was a great deal of political evidence to confirm this "fact." In the second half of the nineteenth century, Euro-American colonial powers had expanded and consolidated their holdings in Asia, Africa, the Pacific, and domestically in the Americas, making their last definitive push at the turn of the twentieth century. By the end of World War I, the colonial map took the stable form it was to have until it was disrupted by the anticolonial revolutions in the wake of World War II. Between the two world wars, the thoroughly defeated colonies, their external and internal political boundaries stabilized by European administration and force, had no "history," no "progress"—for the hallmark of history is change, and the colonies were static (albeit by fiat). Thus their structures appeared timeless, unchanging.

But what, one might ask, of the history of colonization itself? Does that not count as history? Until the mid-1980s, the history of colonization was written almost entirely as the history of Europe's colonial expansion, not the history of the defeated territories and people, who stood merely as the passive recipients of European history. (At most, the encroachments of colonial powers could cause these peo-

ple to deteriorate and become decadent, to be forced out of the authentic and pure existence of their ancestors.) And the colonies' nascent nationalist movements had not yet entered history (the sequence of events), which they would do at mid-century; nor had they begun to write their own nationalist histories (the narrative forms), although they would do so at mid-century and beyond.[8]

And so it was the received wisdom of governmental officials, anthropologists, historians, artists, and other educated people that colonized peoples of Africa, Oceania, and the Americas had no writing and had no history, but lived in a world of myth and magic. Thus it is not surprising that writers of art history textbooks like E. H. Gombrich and H. W. Janson, people whose education and sensibilities were formed in the interwar period, should place primitive art in the mythical realm prior to time and history, or that they should collapse the distinction between Lascaux paintings and the artifacts produced by Navajos.

SECOND PHASE

Judging from MoMA's post–World War II exhibits, modern art had been fully established by then; rather than educational outreach we find, sprinkled in with shows for contemporary artists, a number of retrospectives and the work of great modern artists.[9]

Parallel to modern art's secure establishment, primitive art's legitimacy crystallized institutionally with the 1957 opening of the Museum of Primitive Art (situated, perhaps significantly, directly behind MoMA on 54th Street). Nelson Rockefeller's collection formed its core. With the opening of this new museum, MoMA ceased exhibiting primitive art, with a single exception: in 1962 Michael Rockefeller's collection, "Art of the Asmat," was shown in MoMA's sculpture garden, under the auspices of the Museum of Primitive Art.

The Museum of Primitive Art was open for nearly twenty years, from the mid-1950s until the mid-1970s. These two decades mark the golden age of primitive art's legitimacy. The existence of so many wonderful objects, beautifully exhibited and celebrated in fine arts museums as art, attested to the unproblematic nature of the category of authentic primitive art. During the period, liberal and right-thinking people admired and celebrated it. Art historians and anthropologists discovered primitive art as a worthy subject of study, and an increas-

ing number of books and articles appeared on the topic. A few art history departments hired specialists in primitive art, and several Ph.D. programs in non-Western art were established and produced their first graduates; a number of major museums established departments and curatorial positions of primitive art. As an essential category, primitive art was almost unchallenged.

Not merely coincidentally, the first two decades after World War II were the period of American economic and ideological expansion into the newly independent countries of Asia and Africa, the former colonies of Europe. During this period, the United States promoted gradual, nonrevolutionary "modernization" in this newly invented "third world." Of course, the United States has never been keen on violent revolution abroad, but what is striking in this period is the extent to which the structure of historical and anthropological narratives about the "changes" in primitive art occurring during this period reflected the political notion that change can be peaceful, a kind of naturalized outgrowth of tribal people's greater contact with markets and desire to leave their old ways behind. Numerous articles and books about topics ranging from art to politics carried titles beginning with "Continuity and Change among the . . . "

The Museum of Primitive Art closed in 1972 to enable the collection's transfer to a new wing of the Metropolitan Museum of Art. With the opening of the Michael C. Rockefeller Wing of Primitive Art in 1982, primitive art became a member of the most exclusive club of high art in the United States: it had achieved the apex of legitimation, a place in the Met.

Two years after the Rockefeller Wing's opening, the Museum of Modern Art held its first show on primitive art since 1954, the 1984 exhibit " 'Primitivism' in 20th Century Art." I think its spirit was entirely consistent with the tenor of its other postwar exhibits of early modernists. Whereas MoMA's prewar shows of modern art had sought to legitimate it by promoting new art on the edge of established high art, its postwar exhibits included a number of single-artist retrospectives of established great masters of modernism. In the same way, prewar exhibits of non-Western arts at MoMA sought to establish the objects as worthy of art-historical attention, whereas the " 'Primitivism' in 20th Century Art" show was primitive art's own retrospective: William Rubin's introduction to the catalog, as well as the exhibit itself, relegitimized the place of primitive art in

the history of modern art by tracing the history of its influence. The show was a retrospective of a *category* of art, the Primitive, in effect tracing the history of an already established great master. It was about "Masterpieces of Primitive Art," the name, indeed, of the catalog issued by the Metropolitan on the opening of the Rockefeller Wing. In that winter of 1984, the category "primitive art" reached its zenith, which also marked the beginning of its end.

2

• • •

What Became
Authentic Primitive Art?

The fifty years between 1935 and 1985 saw the emergence and institutionalization of authentic primitive art. I mark this period's beginning with MoMA's 1935 exhibit "African Negro Art," whose catalog was written by James Johnson Sweeney, and its ending with the same institution's 1984 exhibition "'Primitivism' in 20th Century Art," whose catalog included an introduction by William Rubin.

James Johnson Sweeney wrote between the two world wars. At that time, primitive art was still in the process of being invented as a legitimate subtype of art, and Sweeney was one of its promoters. William Rubin wrote nearly four decades after the end of World War II, and, more significantly, after the world had been decolonized and primitive art had been firmly established as a legitimate subtype of art; the 1984 exhibition was a kind of retrospective legitimation of a category that was already well ensconced. Both Sweeney and Rubin restrict their legitimating gaze only to a particular set of objects, which they call "authentic primitive art."

Because the term "authentic" is bandied about almost indiscriminately today (as in "Authentic Museum Reproductions" and "The Look Is Authentic!"), I distinguish the authentic primitive art I discuss here as "high primitive art"—the kind the early modernists encountered and were inspired by, the kind that the Rockefeller family and Rubin himself collected, the kind that major museums show as real "art." I want, therefore, to frame my account of the discourses of authenticity, primitivism, and art that were materialized in those sorts of objects by quoting these two curators who, writing about the same sorts of objects, for the same institution, fifty odd years apart, struggled to define what constitutes "authenticity" in primitive art.

"AUTHENTICITY"

Sweeney's ideas, as expressed in his catalog to MoMA's 1935 exhibit on African Negro art, correspond extremely well to what James Clifford (1988d) and Sally Price (1989) criticize. Sweeney's serene view of what could be called the "African Antique" reflected the relatively untroubled and common view at the time—that authentic primitives lived in a glorious and harmonious age and once produced authentic primitive art, but they have become degenerate since the coming of Europeans. In his 1935 catalog, Sweeney confines the existence of real primitive art to the traditional days before history was visited upon the natives. The predecadent period for Sweeney was like this: "the standard of culture that doubtless obtained there and its results: a seemingly general prosperity; large, populous cities; extensive areas of land under cultivation; and orderly, peace-loving inhabitants keenly sensitive to beauty in their environment, habiliments, and art" (1935: 17).

This sounds a great deal like an eighteenth-century vision of the ancient Greeks, an ancestor race living in classical harmony. It expresses nostalgia for the community of the organic whole and for the sensitive "artists" working in "traditional" modes for "traditional" religious functions, untouched by the market, by filthy lucre, by the restless forward movement of history—the monopoly of the West—that will eventually destroy it.

If authenticity's bottom line for Sweeney is the absence of time and money, then the intrusion of time and money introduces history to the natives. Time—that is, change—and money, in this view, were introduced by the West in the forms of colonial power and demand for native objects. These encroachments induced people to sell their arts, and, eventually, to make objects solely for the market rather than for traditional purposes; eventually the encroachments undermined authenticity and promoted decadence: "Fine pieces were no longer being produced due to the decadence of the natives following their exploitation by the whites" (12).

The message is that once upon a time Africans were great artists, now they are commercial hacks; once they lived in harmony, now they live in decadence; once their work was pure, now it is polluted. Only *ancient* Africans, like ancient Greeks, stand as worthy ancestors; just as the ancient Greeks were ancestors of Art with a

capital A via the Renaissance's discovery of them, so too the ancient Africans are worthy ancestors to modern art via Picasso's discovery of *them*.

In 1984 sustaining a belief in the untouched primitive and authentic primitive art was difficult. Nonetheless, the authentic and the primitive remained tightly bound together and viable for William Rubin, at the time director of MoMA. Contrasted to the serene confidence of Sweeney's 1935 pronouncements, Rubin's prose in his introduction to the catalog for the "'Primitivism' in 20th Century Art" show is concerned, wary, and complex. He raises nearly every important objection that could be made to his own views, then dismisses them, evades them, or, after mentioning their importance, moves on to the next point without acknowledging their implications. It is a curious document.

Rather than pronouncing upon the nature of Africans in their antique period, Rubin feels obliged to define and defend the concept of authenticity itself. But he knows the notion is under attack. He makes an effort to define it in a footnote: "The question of 'authenticity' is too complicated to deal with here at length, but the following formula is useful. An authentic object is one created by an artist for his own people and used for traditional purposes. Thus, works made by African or Oceanic artists for sale to outsiders such as sailors, colonials, or ethnologists would be defined as inauthentic. The problem begins when and if a question can be raised—because of the alteration of tribal life under the pressure of modern technology or Western social, political, and religious forms—as to the continuing integrity of the tradition itself" (1984a: 76, n. 41).

The ideal authentic object for Rubin, just as for Sweeney, is one untouched, in the larger sense, by Europe: it is one "created by the artist for his own people and used for traditional purposes." In opposition to this authentic object is the art made for "outsiders," which is always taken to mean "Europeans." (The fact that objects might be made for trade with other non-European peoples does not occur to many commentators.)

Defining the authentic in this way of course rearticulates the classic dichotomy: the nonhistorical zone of authentic art, of "traditional" purposes, and of the primitive artist who serves "his" people by making art for them, on the one hand, and on the other, the time line of history, with its Europeans, money, secular market, invasions

by colonials, sailors, and ethnologists (but apparently not by art dealers, collectors, or curators on acquisition trips).

Rubin recognizes that to keep primitive art in a timeless zone untouched by history will be difficult, and he tries to deal with the problem in a footnote full of unresolved struggle toward a tidy resolution (1984a: 77, n. 68).

He begins by writing that we know little about authenticity, and admits that "extremists even claim that everything we take to be authentic tribal art was already influenced by the effects of contact with the West." ("Extremists" are apparently the anthropologists and historians who were busy in the 1970s historicizing the primitives.)

Then he refutes this idea by pointing out that while it may be true in some parts of Africa—for Africa is (he tells us) large and complex—nonetheless, "in most rural areas traditional animistic religions and the art that accompanies them still flourish largely unchanged." (Unchanged from what?)

But even in such rural areas, Rubin concludes, maintaining these traditional forms has become increasingly difficult "in the face of increasing communications and the multiplication of Western influences."[1]

More comments follow, including the liberal view that many admittedly older authentic pieces are not aesthetically interesting, whereas a great artist, he writes, working in the "transitional period" after contact with the West could make a truly great piece of art, even if it were not completely "traditional."

What is he leading up to, we wonder?

It comes in the next sentence: "An example of such an object is the Torres Strait mask obtained by Picasso in the 1920s. . . . it is an extraordinary work of art." (Picasso, the primitive modern master, recognizes a fellow master, a modern primitive. Provenance and artistic genius triumph again.)

How could this be? Rubin explains: "though dating from the colonial period, [the mask Picasso obtained] derives, nevertheless, from a period when traditional life in the Torres Strait remained largely unchanged." (Again, unchanged from what?)

If Rubin cannot save the purely authentic and traditional, he can introduce a "transitional" period before the culture and its artistry fall into total decadence. But admitting value to the historical artifact cannot be allowed to go too far: "A recent object in the style of the

Torres Strait made by a New Guinea artist for sale in the tourist shops of Port Moresby would be something else again."

"PRIMITIVISM"

One of the most common ways people talk about primitive art is by talking about "the primitive," a phrase and a concept that have had different valences in different eras. I point out in the introduction that categories generate their opposite, and that as late-nineteenth-century Europeans increasingly came to think of themselves as secular, rational, civilized, and technologically advanced, they almost necessarily generated an imagined "Other" that was savage, ignorant, and uncivilized; I suggest that this dichotomous structuring of thought was temporalized by the idea of progress, placing the colonized primitives who lived in nature prior to history. Although that was the latest twist, a discourse on the primitive versus the civilized—including the primitive in art—existed in Europe for nearly two centuries before primitive art was discovered by Picasso and others.

In her book on primitivism in art from 1725 to 1907, Frances Connelly argues that the primitive in art for two centuries occupied a conceptual space defined by being the inverse of classicism. Europeans did not name Bambara masks and Maori canoe paddles as art during the eighteenth and nineteenth centuries, but, Connelly argues, a vocabulary had long existed to label crafted objects that fell short of the classical ideal—terms like "grotesque," "ornament," "caricature," "hieroglyph," and "idol." "The grotesque and the ornamental," she writes, "were among those elements of physicality and disorder allowed to exist on the edges if controlled by centrifugal force of the center. They were the marginalia to the rational text, the darkness that fell just outside the aureole of the light of reason, the bestial, lusty satyr that by contrast heightened the proportional beauty and sober intellect of the Apollo. They were allowed to exist only in a controlled, subservient role, as an embellishment to the rational structure" (1995: 6, 13–14).

Connelly cites neither Ferdinand de Saussure nor Claude Lévi-Strauss nor Michel Foucault, but her argument, which I find highly plausible, could easily be recast in the terms laid out by these gentlemen. For Saussure, nothing can be known in itself—there are no positive definitions of things—but only as a contrast to something else.

To seek a positive definition of a word ("What *is* primitivism in art, really?") is fruitless; a word's meaning is defined by its place in relation to a system of contrastive opposite meanings. For Foucault, every category generates its opposite (for example, *la raison* generates *la folie* as its dark underside); this opposite creates a space, conceptual and sometimes literal, which is soon filled with institutions, objects, or humans which, Lévi-Strauss would point out, thenceforth provide empirical evidence for the category's real existence.[2]

To rephrase Connelly's point explicitly in these terms, in the eighteenth and nineteenth centuries, the aesthetic space of marginality and irrationality was occupied by a changing parade of "grotesque" and "decorative" items, including Trecento Italian, Polynesian, Archaic Greek, Egyptian, and Japanese.[3] Into this conceptual space of irrationality—the opposite of classical reason, balance, and harmony; the opposite of optical realism and the Renaissance canon—eventually flowed the artifacts made by dark and colonized peoples that were to become high primitive art.

In any case, the view that "Primitive Man" is irrational and through his art both expresses his superstitions and exorcises his demons seems to be very basic to the invention of the non-Western artifact as "art"; it was there at its inception, when Picasso was inspired not—he insisted (at least in this quote)—by these objects' formal characteristics but by their magical power:

> They were against everything—against unknown threatening spirits
> . . . I, too, I am against everything. I, too, believe that everything is
> unknown, that everything is an enemy! . . . women, children . . . the
> whole of it! I understood what the Negroes used their sculptures for.
> . . . All fetishes . . . were weapons. To help people avoid coming under
> the influence of spirits again, to help them become independent. Spirits, the unconscious . . . they are all the same thing. I understood why
> I was a painter. All alone in that awful museum with the masks . . .
> the dusty mannikins. *Les Demoiselles d'Avignon* must have been born
> that day, but not at all because of the forms; because it was my first
> exorcism painting—yes absolutely! (Picasso, in André Malraux's *Picasso's Mask,* quoted in Foster 1985: 45–46)

The irrationality of "primitives," whether given a positive or negative spin, was simply the prevailing view about them at the turn of the twentieth century and between the two world wars. Art historians understandably took it up as the dominant trope for under-

standing primitive art. The following passages reflect the view that Primitive Man is obsessed with fear and irrational superstition, and that his arts express it. In his 1959 textbook on art, Germain Bazin, chief curator at the Louvre, writes in the section entitled "The Arts of the Uncivilized Peoples":

> In the tropical zones, far removed from the great centers of civilization, peoples of negroid race who go about naked under the hot sun, living a primitive kind of existence, still give the work of art the sacred and magical meaning that it had in earliest times. These peoples form two great cultural groups, dispersed across Africa and the chain of islands scattered across the Pacific, from Australia to Madagascar and Easter Island.
>
> Though these races have no known historical relationship, they hold in common an aesthetic notion which exalts the painted or sculpted form into a revelation from the Beyond, a *sign* fraught with supernatural powers. This is true not only in the case of ancestral images, fetishes and totems evoking beneficent spirits and evil demons, or the masks used for ritual dances and ceremonies, but also in the case of objects of everyday use whose stylized patterns have symbolic value. . . . ; for primitive man lives at all times in contact with the beyond. . . .
>
> This art is also characterized by having no *history*.

Bazin's general history of art was first published (in French) in 1958. Eleven years later, the British art historian Sir Kenneth Clark published *Civilisation* and participated in a BBC-sponsored television series of the same name. In the following passage, he juxtaposes pictures of the head of the Apollo Belvedere and something labeled merely "African mask," and comments:

> An even more extreme example comes to mind, of an African mask that belonged to Roger Fry. I remember when he bought it and hung it up, and we agreed that it had all the qualities of a great work of art. I fancy that most people, nowadays, would find it more moving than the head of the Apollo of the Belvedere. Yet for four hundred years after it was discovered, the Apollo was the most admired piece of sculpture in the world. . . .
>
> Whatever its merits as a work of art, I don't think there's any doubt that the Apollo embodies a higher state of civilization than the mask. They both represent spirits, messengers from another world— that is to say, from a world of our imagining. To the Negro imagination it is a world of fear and darkness, ready to inflict horrible punishment for the smallest infringement of a taboo. To the Hellenistic imagination, it is a world of light and confidence, in which the gods

are like ourselves, only more beautiful, and descend to earth in order
to teach men reason and the laws of harmony. (Clark 1969: 2)

We should recognize that Bazin's and Clark's sensibilities were
formed between the two world wars, when this view of the primitive
prevailed in popular culture and, it appears, among art historians.
(This view was not the prevalent one among anthropologists, among
whom other ideas about "the primitive" were gaining hold, partly
due to the practice of doing fieldwork; but that is another story.)[4] But
lest one imagine that this view of primitive art and with it Primitive
Man is completely outdated in art history, it is worth reading Thomas
McEvilley's (1984) critical review of MoMA's exhibit " 'Primitivism' in
20th Century Art." In it McEvilley castigates William Rubin and Kirk
Varnedoe, the curators responsible for the show, for appropriating
these artifacts as art rather than what they "really" are, religious arti-
facts; he suggests that the museum labels should have provided
ethnographic context that reveals them as such. He tells us what he
thinks Primitive Man's religion is in this remarkable passage:

> In their native contexts these objects were invested with feelings of
> awe and dread, not of aesthetic ennoblement. They were seen usually
> in motion, at night, in closed dark spaces, by flickering torchlight.
> Their viewers were under the influence of ritual, communal identifi-
> cation feelings, and often alcohol or drugs; above all, they were acti-
> vated by the presence within or among the objects themselves of the
> shaman, acting out of the usually terrifying power represented by the
> mask or icon. What was at stake for the viewer was not aesthetic ap-
> preciation but loss of self in identification with and support of the
> shamanic performance. (McEvilley 1984: 59)

Sally Price (1989) includes the just-quoted passages by Clark and
McEvilley and documents many other views of this ilk in her book
Primitive Art in Civilized Places, especially in the chapter called "The
Night Side of Man." The attitudes and serenely confident views ex-
pressed in quotes of this sort were very deep in art-talk about the
primitive, and they persisted for the better part of the twentieth cen-
tury. Primitivism still prevails in the United States in the 1990s, but it
seems to me that it now strikes quite a different note. People promot-
ing primitive art (and its descendants, ethnic arts and tribal arts of
various sorts) sound increasingly New Age. Rather than imagining
drug-besotted natives dancing around flickering fires and terrified of
the spirits, New Age primitivists imagine an ecologically conscious

people in tune with the Goddess, living in harmony with nature, op-
erating more on intuition than logic, more in touch with the right
sides of their brains than the industrialized moderns (who have be-
come estranged from that part of their brains in the course of becom-
ing civilized and greedy). New Age primitivism is practiced by peo-
ple who visit Egyptian and Mesoamerican pyramids as well as
Stonehenge and other prehistoric sites in order to collect the cosmic
rays that gather there, and by people who conduct rituals in the kivas
of Pueblo Indians in the Southwest (much to the latter's annoyance).
(Of course, many people who in other aspects of their lives are not
particularly New Age are also deeply interested in the primitive and
the authentic, and are interested in buying and collecting its tokens.)

It seems to me that both these attitudes—the one that views Primi-
tive Man as obsessed with ritual and terrified of spirits, and the one
that views Primitive Man, or in this case more likely Woman, as living
harmoniously with nature and in touch with higher realities—are
each other's flip sides. Indeed, sometimes they are simply the same
thing put in a different light: who can doubt that intuition and having
a dominant right brain is anything but a positive spin on irrationality
and superstition? Both New Age primitivism and the older kind make
the same moves that Edward Said (1978) implied were the moves of
"Orientalism": dichotomizing, otherizing, and essentializing.

Those, then, are the core ideas in the discourses of the authentic
and the primitive in relation to authentic primitive art. Being both
authentic and primitive is not, however, enough to make an object
into art. That requires a metamorphosis.

"ART"

The vast majority of objects found in fine arts museums were not cre-
ated as art, not intended by their makers to be art. André Malraux
(1949) wrote extensively on this topic, pointing out that many of the
objects we count as art underwent a "metamorphosis" to become art:
they were originally other things. These objects are counted as art be-
cause they were claimed as such at a certain historical moment.

Following Malraux's notion, I distinguish here between "art by
intention" and "art by appropriation."[5] Art by intention was made
as art, created in societies and eras that had a concept of art approx-
imating what we now hold. Art by intention consists paradigmati-

cally of the kinds of objects created in the Italian Renaissance as art. Art by appropriation consists of the diverse objects that became art with the founding of public fine arts museums at the end of the eighteenth century and continuing throughout the nineteenth. More and more objects gained status as art during the nineteenth century and entered museums; one thinks especially of religious objects, like Byzantine icons and Christian triptychs, but there were many more.

PORTABILITY, DURABILITY, AND SIZE

It is true but obvious that the objects in the Rockefeller Wing at the Met are "art by appropriation." To say that only begins to open up the topic. What counts as a work of art? What deep aesthetic and conceptual schemata form a filter through which uncountable "primitive" and "authentic" artifacts have passed, allowing only a few to be selected as art objects? And how are these objects transformed by display, framing, and other practices into art objects?

The assemblage of so many masterpieces in a museum, Malraux wrote in *Museum Without Walls,* conjures up in the mind's eye all the world's masterpieces. "How indeed could this truncated possible fail to evoke the whole gamut of the possible?" he asks. "Of what is it [the museum] necessarily deprived?" He answers: "Of all that forms an integral part of a whole (stained glass, frescos); of all that cannot be moved; of objects such as sets of tapestry which are difficult to display; and, chiefly, of all that the collection is unable to acquire. . . . From the eighteenth to the twentieth century what migrated was the portable" (1949: 16).

Thus, one factor for selecting what is to be art is portability; relative to portability is size. Too small, and the item becomes insignificant. Too large, and it becomes costly to transport and difficult to display. It is no mean feat to transport thirty-foot carved poles from Irian Jaya to New York, and it requires a collector or museum both wealthy enough and determined enough to do it. To become art, these portable objects must be displayed, and to be displayed, they must be accommodated in a suitable space. Art was invented simultaneously with collecting, and the two are inconceivable without each other. The market for monumental pieces is exceedingly limited, even if people praise them extravagantly as magnificent art. (Whose living room

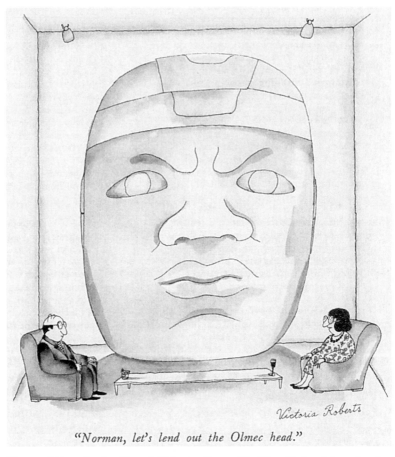

"*Norman, let's lend out the Olmec head.*"

Figure 16. Drawing by Victoria Roberts; © 1990 The New Yorker Magazine, Inc.

could accommodate an Olmec head?—even if it could be bought [figure 16].) To become art, these portable objects must be displayed; to be displayed, they must last. One consequence is that objects selected for display are best made of durable materials. (If they are made of precious materials, like ivory or gold, all the better.) Many potential pieces of primitive art, made in the mainly tropical climates from which primitive art pieces are drawn, are composed of soft materials or a combination of soft and hard materials: flowers and woven palmleaf offerings, baskets, bamboo, bark cloth. These more ephemeral materials tend to disappear before the objects can be turned into art.

Those made of a combination of soft and hard parts tend to lose the soft ones, with profound epistemological and aesthetic consequences. It was standard practice among art dealers in the 1920s to strip African artifacts of their soft and fibrous parts, rendering them starkly modern-looking and preserving or creating a particular aesthetic (see Rubin 1984a). One type of piece often treated that way is the reliquary figure from Gabon. The Center for African Art in New York displayed several of these pieces in a 1984 show of "African Masterpieces from the Musée de L'Homme," including one that retained its "basket decoration." The catalog points out that "We usually see Kota reliquary guardians stripped of their baskets and decorations, looking abstract, minimal, modern. . . . As seen here, where the bottom is inserted into its basket, the entire reading of the figure is radically changed." The catalog continues with a spirited defense of the aesthetic of the basket, praising the "complex texture of twisted leather thongs and basketry [which] gives the base a restless vitality and interest" and the "feathers attached to the back of the head [which] further animate and complicate the figure's shape and texture." The paragraph ends with the wishfully triumphant proclamation that a "simple, minimal object has become a composite form—playing shapes, colors, and textures against each other" (Vogel and N'Diaye 1985: 148, item 66).

Maybe. But I suspect that the hierarchy of permanence will continue, in spite of the restless vitality of raffia, because it is overdetermined: soft materials deteriorate, requiring special care (the few masks with leafy bases shown in the Rockefeller Wing are grouped together in temperature-controlled cases); they may look messy on a coffee table; their commodity value as well as their display value is lessened if they deteriorate.

Perhaps most deeply, there is an unstated and largely unconscious link in the West between the permanent and the civilized, the durable and high civilization and arts, made explicit, handily enough, by Sir Kenneth Clark in *Civilisation*. He regards the urge toward permanence and the (alleged) correlative urge toward making objects of permanent materials to be a hallmark of the civilized. According to Clark, civilized societies show themselves to be such by locating themselves within history, partly by making objects that endure:

Civilisation means something more than energy and will and creative power. . . . How can I define it? Well, very shortly, a sense of perma-

nence. The wanderers and invaders were in a continual state of flux.
. . . And for that reason it didn't occur to them to build stone houses,
or to write books. . . . Almost the only stone building that has sur-
vived from the centuries after the Mausoleum of Theodoric is the
Baptistry at Poitiers. It is pitifully crude. . . . But at least this miserable
construction is meant to last. It isn't just a wigwam. Civilised man, or
so it seems to me, must feel that he belongs somewhere in space and
time; that he consciously looks forward and looks back. (1969: 16–17)

In a few sentences he equates civilization, sedentary existence
(read: agriculture rather than hunting, gathering, or nomadic pas-
toralism), permanent structures (and by extrapolation other objects
that are made to last—not wigwams), and a sense of history, of locat-
ing oneself in time. Although the objects in the Rockefeller Wing
would probably be dismissed out of hand by Lord Clark and by
most art-historical students under the sway of the Italian Renais-
sance—indeed, that was part of the problem the Rockefellers had in
getting primitive art into the Met in the first place—it is no accident
that the ones chosen here are among the most enduring. They are at
least on the road to permanence, which is more than can be said
about a piece of music or a sand painting, or even a basket or an in-
tricately woven leaf-and-flower offering.

The importance of portability and durability as criteria of art is
confirmed if we look at the practices that have produced modern
forms of non-Western arts derived from prior, evanescent art forms.
One example is the Navajo sand painting. Navajos made intricate
designs in the sand, which, in the course of the curing ceremony
were sat upon and stepped on, hence erased. In the course of the
twentieth century, various people had the idea of preserving the de-
signs, first by painting them, and eventually by applying sand to a
board with a thin coating of glue. At that point the designs became
both durable and portable, able to be moved to new locations (col-
lected and sold) and hung on walls as art (Parezo 1983). Something
analogous happened among the Australian Aboriginals, who draw
ancestral designs in the sand, paint them on bodies, and paint and
incise them on bark, rocks, and a few other materials. Only those on
permanent materials (rocks and bark) are kept between ceremonies,
often hidden from view in caves and other secret stashing-places.
Bark paintings for a number of decades stood as "Aboriginal art"
and were sold as such in shops in Sydney and Canberra. But Aborig-

inal art really gained a market and a place in the world art scene when Aboriginals began painting ancestral designs in acrylic on canvas (see Williams 1976, Sutton 1988, and Morphy 1991).

Art by intention—those objects, paradigmatically framed paintings, that were created in order to be sold, collected, and hung on silent walls—is also portable by intent. Its portability greatly facilitates its collectability and its ability to be commodified. Durability also makes its collection, display, and commodification more convenient than would otherwise be the case. (One need not ask which came first, art's durability or its commodifiability, to acknowledge the convenient correlation.)

Primitive art, then, is usually of the size and durability that money can transport, dealers can store, and collectors can conveniently display. Thus emerges a hierarchy of primitive art substances, in which Benin bronzes, ivory masks, and hardwood sculptural forms predominate over ritual figures made of leaves, disintegrating fabric, deteriorating tapa cloth, fraying baskets, breakable pottery.

Framing "Art"

Art by intention is framed, literally or figuratively. We owe the literal frame, which is derived from the wooden triptych, to the Renaissance invention of portable, salable canvases that needed protection. The literal frame increases the portability, durability, hence commodifiability, of the object.[6]

The eighteenth century took the idea of framing further than the literal frame by distinguishing art from craft and separating the fine arts into five types: painting, sculpture, architecture, music, and dance.[7] M. H. Abrams (1985) traces the social practices in the eighteenth century that separated "art" from life, ending in Kant's articulation of the theory of the purely aesthetic object with no useful function but to be contemplated. By the end of that century, then, all five "fine arts" became useless contemplatible objects and required the frame—whether a picture frame, a pedestal, or a stage—to function as a boundary between the piece of art and the world, setting off art from everyday life, from social context, and from mundane utility. The frame pronounces what it encloses to be not "real" life but something different from it, a representation of reality. Thus at the end of the eighteenth and first part of the nineteenth century, music and

dance, which are activities, were turned into aesthetic objects by framing them (with stage or platform) and separating them from the audience, which then contemplated them as distant spectacles, as the art connoisseur contemplated the painting on the wall. The audience does not participate in the performance but only views it.

Art by appropriation, by contrast, is not born in a frame, so to speak. It becomes art by *being* framed, by being removed from a context of use and performance (in the linguistic sense of being activated). Here it is worth remarking that—although not all human societies have produced what I would call "art" (at least when being meticulous, I would prefer to confine the word to objects conforming to the cluster of associations and practices articulated at the end of the eighteenth century in Europe)—all human cultures have what Ernest Cassirer (1955) called "symbolic form": artifacts, activities, or even aspects of the landscape that humans view as densely meaningful. Further, human beings have several sensory capacities: we see, hear, taste, smell, touch, and have "haptic" or "kinesthetic" empathetic capacities. Very few symbolic forms are cast in a single sensory medium: an audience hears drumbeats while looking at masked dancers and perceiving their movements with kinesthetic empathy; people doze and smoke clove cigarettes and munch on snacks while sitting in front of shadow puppets and hearing gamelan music. Only mechanical reproduction allows us to separate our sensory modalities and utilize a single capacity to listen to a symphony while we wash dishes. But some of the multiple media in which nonmechanically replicated symbolic forms are cast are temporally evanescent: sounds, smells, tastes, muscular exertion, and kinesthetic empathy do not last. Masks and all the rest of these objects slough off their evanescent—their performance—contexts on the way to New York, retaining only the durable part that can be set aside in a frame or on a pedestal. By the time they become primitive art, then, the mask and the ancestor figure look a lot more like sculpture than they look like something that needs a performance to activate their meanings.

Sculptural Qualities

Even now, painting and sculpture stand as the epitome of fine arts for both museum curators and for museum-goers—in spite of the eclectic and universal nature of "art" in the late twentieth century. Certainly at

the time that primitive art was being discovered or invented at the turn of the twentieth century, prior to the work of Duchamp, Christo, and others, the two forms were paradigmatic; and painters and sculptors were the ones who discovered primitive art and used it for inspiration.

Regarded as a deep schema or paradigm or pattern rather than as an already obvious object, a painting is a portable, flat, usually rectangular thing with some iconic content. Such objects are relatively rare in the history of the world. Persian miniatures and Japanese and Chinese screens and brush paintings are the closest candidates to approximate this schema outside the Western tradition, and it cannot be an accident that these items have long entered dealership circles as high forms of non-European art.

The peoples of Africa, Oceania, and the Americas—the regions that produced what became primitive art—produced very few objects corresponding to that schema. They did produce, however, three-dimensional objects in durable materials that can be grafted fairly easily onto the schema of sculpture, the second paradigm of fine art. It can be no accident that the vast majority of objects exhibited in the Rockefeller Wing and at other fine arts museums can pass for (and pass as) "sculpture."

ICONICITY

A feature of both painting and sculpture in the Renaissance canon was a special form of iconic signification. The Italian Renaissance reinvented and rationalized a certain type of iconic signification, perspectival illusionistic realism, or what David Summers (1987) calls "optical naturalism," the geometrical representation of virtual space. Considered in the context of the history of the world, optical naturalism is a peculiar type of iconicity: it attempts to depict precisely the way something *looks*.[8] Between the fifteenth and eighteenth centuries optical naturalism emerged and crystallized as part of the definition of art in Europe. In the nineteenth century, objects that had a recognizable iconic content but yet fell short of the optical naturalism achieved in academic painting were called primitive—including everything from the Italian primitives (so called because they worked prior to the full rationalization of perspectival techniques), to Henri Rousseau (primitive because not academically trained), to Japanese prints (primitive because not sufficiently opti-

cally, perspectivally, realistic). What eventually became primitive art in the twentieth century was simply grotesque in the nineteenth. The niche of the primitive in art was occupied by others.

That space began to be occupied by *l'art negre* (African Art) at the turn of the twentieth century, when the Renaissance canon appeared to collapse completely, admitting as "art" the "distortions" to optical naturalism represented by Cubism and African masks. Curiously enough, it did not collapse entirely. A vitiated or updated version of optical naturalism remained a part of the criterion of what is allowed to count as art: that is iconicity, pure and simple. Objects from Africa, Oceania, and the Americas that resemble something recognizable— most notably, a person, a person's face, or an animal—are more likely to become primitive art than are objects that are decorated, even beautifully, but have little or no iconic content.[9]

The criterion of iconicity intruded legally in the 1930s, and not just concerning primitive art. It seems that the Museum of Modern Art was trying to import abstract European sculpture for a show on modern art. But according to Paragraph 1807 of the U.S. Tariff Act and a definition made in 1930, sculpture, to be imported as art rather than as either raw material or utilitarian objects (on which there was a 40 percent duty), had to be "imitations of natural objects, chiefly of the human form . . . in their true proportion of length, breadth and thickness." Apparently sculptures by Alberto Giacometti, Jean Arp, Joan Miró, and other modernist artists at the time did not qualify. The previous year MoMA had had a similar problem with primitive art, but in that case it was compounded by the fact that several of the items were declared utilitarian or worse.[10]

Iconicity remains an unstated and even repressed criterion for the identification of what counts as art. This remains the case today, even after the advent of *objets trouvés,* Abstract Expressionism, and the like. The catalog *Masterpieces of Primitive Art,* put out when the Museum of Primitive Art collection moved into the Met but before the Rockefeller Wing had opened, for instance, sorts the objects into "faces," "figures," "animals," and "abstractions." This organizational schema asks the viewer to see these objects as representations, as though their meanings lay primarily in their iconic content— revealed especially in the residual category, "abstractions."

Iconicity is the hidden specter that continues to haunt primitive art: it is not absolute but lurks at the edges of collecting and catego-

rization. Much commentary on non-Western arts, for instance, calls them "stylized" or "abstract," terms that make sense only if one imagines that the natural or obvious way to depict the world is in a style of optical naturalism. With very few (but enlightening) exceptions, this observation is as true of anthropologists as it is of art historians and museum curators. I offer two illustrations.

Bill Holm, retired curator of the Burke Museum in Seattle, has written a useful book on how designs are made and applied by stencil to items like Northwest Coast blankets, totem poles, hats, and bracelets. In a section called "Degrees of Realism," he divides designs into three types, depending on whether the animal or animals depicted on a piece are very little distorted or separated ("configurative"), are distorted and split somewhat but still recognizable ("expansive"), or are "so distorted . . . that it is difficult or impossible to identify the abstracted animal or the exact symbolism of the parts" ("distributive") (Holm 1965: 13). Holm's categories may be useful for some purposes, but even to raise "degrees of realism" as an issue suggests that readers share an implicit notion that art is primarily mimetic. His categories are loosely based on Boas's 1927 classification, which divided Northwest Coast art into "symbolic" (because it stood for or referred to something outside itself) and "decorative" (which he characterized as "meaningless," because it did not apparently refer to something outside itself).

Here is a second example. In the 1984 MoMA exhibit "'Primitivism' in 20th Century Art," Giacometti's *Tall Figure* (1949) was juxtaposed with an elongated figure from Nyamwezi, the label claiming that both of them "rejected realism." The label makes no sense as a historical statement: how could one of the pair reject realism when its makers never tried to achieve realism in the first place? The only way that sense can be made of it is if we recognize the implicit assumption, a very deep one in Western art-thought, that art seeks to make optically naturalistic copies of "reality." The logic apparently is that if some African artifact is really art, *ipso facto* it must seek to imitate reality. If it does not, it must be because the artist rejected his self-evident mission.

In short, the naturalistic prejudice—the idea that art (whether flat or in the round) *means* by resembling something in the world and that it strives to do so in a way as optically realistic as possible, even if it does not always achieve it—is very deep. In the nineteenth century, optical naturalism or at least a degree of naturalism formed the explicit or im-

plicit criterion by which a non-European image or artifact was judged to be art at all, and, if it was, its quality or type. In the twentieth century, anthropomorphic and recognizable objects are chosen as art over those that are not: a mask, with eyes and mouth, is more paradigmatically "primitive art" than is a slit gong or a kava bowl, however ritually meaningful they might have been, and however smooth, elegant, and therefore "modern" the lines of the latter are.

I think it possible that the domination of the mimetic theory of meaning within the discipline of art history—that something means by representing something outside itself, and that its mode of reference is iconic, which in turn constitutes the object as a mere representation or model of the world rather than part of the world—is due to the dominance of Renaissance studies in the discipline of art history, especially as exemplified by the view of Erwin Panofsky (1955a). Meaning, he wrote in his well-known paper on the subject, can be pre-iconic, iconographic, and iconologic. Paintings' iconic contents, in turn, are illustrations of prior texts. And yet, if an object means in a way different from iconically, the whole method of interpretation, taught to generations of art history students, collapses—thus the difficulty of conventional art history as a discipline in dealing with twentieth-century Western arts, pre-Renaissance arts, and non-Western arts generally, all of which may have iconic content but very few of which imagine themselves to be primarily *about* mimesis.

In any case, the mad search for iconic meaning in primitive art was brought home to me in December of 1984 when I took the docent tour of the Rockefeller Wing and the docent and I came upon a Sudanese object. It hung on the wall, was horizontally long, and it appeared to have a beak of sorts. This, the docent said, was a "butterfly mask." Their art is very sophisticated, she said, but it is entrenched in traditional wisdom; this butterfly mask is well carved and painted, and we think it was used in initiation rites in the Spring. Why, she asked rhetorically, is it in the shape of a butterfly? She said that we do not know but think that it might have been to welcome Spring.

I objected that it has a beak; how do we know it's a butterfly?

That's not all there is to it, she continued. Their intention is not to make something that looks like a butterfly: their art is conceptual, it's about invisible concepts. For instance, she said, moving to a case with a carved male and female figure from Dogon, this is a Primordial Couple (. . . and note the long, cylindrical slender shapes char-

acteristic of the style of the Western Sudan). The man carries a quiver and the woman has a baby on her back. That shows that he is the progenitor, she the nurturer. Moreover, his hand is holding his penis and his other arm is around her. They had no writing, but by means of such statues they were able to express invisible concepts like the cooperation between the sexes.

I wondered what Spring was like in the Western Sudan,[11] and what sorts of concepts were not invisible, but even that was way ahead of me. That first object did not look like a butterfly to me; in fact, I wasn't sure it was a mask. It reminded me of the old joke "If I had some ham, I could have some ham and eggs, if I had some eggs": If it is a butterfly, it's a splendid example of a butterfly mask, if it's a mask. But then again, perhaps it is a bat, and then what would one make of it?—and why, I wonder, does it have a beak? Unless the beak really represents a penis, in which case it is well on its way to being a visual representation of the invisible concept of the cooperation between the sexes. This mask (if it is a mask) is a particularly beautiful and well-executed carving of a butterfly with a beak; conversely and alternatively, it is a singularly poor rendition of a bat.

HIGHER REALITIES

In a witty passage that addresses the question of what becomes primitive art, Arthur Danto explicitly rejects the idea that formal qualities alone make an object into art. To make this point he imagines two tribes, the Pot People and the Basket People, who make identical pots and baskets. But Pot People invest pots with a great deal of meaning, which Danto writes about with ingenious and amusing detail. "Lying at the cross point of art, philosophy, and religion," he concludes the passage, "the pots of the Pot People belong to Absolute Spirit. Their baskets, tightly woven to insure sustained utility, are drab components in the Prose of the World" (1988: 24). The opposite is true of the Basket People, of course. In sum, "artifacts" consist of "objects whose meaning is exhausted in their utility. . . . They are what they are used for, but artworks have some higher role, putting us in touch with higher realities; they are defined through their possession of meaning" (31).

Happily for Danto's point, a very large proportion of the objects in the Rockefeller Wing have ceremonial uses in their original con-

texts, such as ancestor poles from the Pacific, totem poles from the Northwest Coast of America, and masks and reliquary figures from Africa. Objects such as these have uses and functions in their own societies, but those functions are outside our experience of usefulness and can therefore be grafted onto the sacred-useless category of art with more ease than can objects like cooking pots or grain grinders. Everyday functional items are for the most part left out. (Of course there is an occasional exquisite ladle, reminiscent of a Brancusi in its radical simplicity.)

Here is a selection of labels from artifacts in the Rockefeller Wing:

"The Asmat celebrated death with feasts and rituals that both commemorated the dead and incited the living to avenge them."

Dogon figures with raised arms *"allude to the communion between heaven and earth. The sculptures sometimes wear pendants, representing covenant stones that identify priests of totemic ancestor cults. Large containers often with a horse's head and tail are used to hold sacrificial meat during annual ceremonies commemorating the Dogon myth of creation."*

"Nowhere is the complexity and variety of Kuba design more apparent than in the plush textiles that men and women of high rank wear as wrapped skirts on ceremonial occasions."

Fijian clubs, *"favored weapons in the 19th century,"* were *"intended to shatter the skulls thus not only causing death but insulting the sacred part of the body."*

From the Solomon Islands, *"the finest examples of shell-work are certain ceremonial shields, a small number of which were made in a brief period in the 19th century."*

The terms "ceremony," "ritual," "rite," "initiation," "sacred," "sacrificial," "ancestor," and "totemic" occur again and again in Rockefeller Wing labels; the objects chosen for display are overwhelmingly "ceremonial" objects. If something apparently utilitarian is displayed, such as a bowl, it is nearly inevitably a "ceremonial bowl," as likely as not used by high-status people. I was interested to note that the museum labels and the catalog of MoMA's 1984 "'Primitivism' in 20th Century Art" show even used the completely discredited term "fetish." (Curiously enough, a very similar figure to the one in the MoMA primitivism show labeled a "fetish" appeared in the show go-

ing on concurrently at the Center for African Art; but there it was called an "oath-taking figure.") Nowadays, I would have thought, the term is confined to department stores, such as a display I came upon in Gump's in San Francisco selling "Zuni Fetishes—*In The Traditional Fetish Style.*" Ritual objects, high status, and rarity all tend to imply each other in the labels of high primitive art.

There is no reason to suppose that these labels are incorrect or even really misleading—although these days anthropologists seldom use terms like "totemic ancestor cults," as though what "totemic" means and what "ancestor cult" means were transparent, which they are not. My point, rather, is that these objects are drawn overwhelmingly from the realm of the "sacred" as contrasted to the "secular." Then, too, the lack of cultural specificity of the labels, the use only of the English language (ritual, ceremony, initiation, etc.), the failure to explicate the purposes and sociology of these "ceremonies" (initiation into what? by whom and for whom? ritual in order to do what?) leave the casual visitor with the distinct impression that Primitive Man is obsessed with ritual, or, at least, that primitive art expresses higher realities.

Part of the reasoning that underlies the selection of ritual objects as art rather than more mundane items, it seems probable, is the eighteenth-century distinction between mere craft and high art. Applied to the selection of non-Western objects, the distinction between high art and utilitarian craft tends to mean that obviously functional items (especially if they are undecorated) do not qualify as art. In an exhibit case (since removed) near the entrance to the ethnographic rooms at the Field Museum in Chicago in 1986, I came upon labels distinguishing between "Art," "Decorative Art," and "Non-Art." "Art" was described like this: "Art objects differ from society to society, but they tend to be concerned with making visible the supernatural and the intangible. In so doing, art may render more manageable some of the terrors and uncertainties of life."

The selection of ritual objects over utilitarian ones as primitive art is undoubtedly multiply determined. For one thing, ritual use links an object to the transcendent, a way that art in general (not just primitive art) is validated rhetorically. For another, art and craft were separated from each other at the end of the eighteenth century, and anything with an immediately obvious utilitarian use runs the risk of being categorized as mere craft, whereas objects used for ceremonial purposes from other traditions appear nonutilitarian to people who do not use them and are more likely to be regarded as transcendent

and therefore make it into the category of art. And finally, the talk about higher realities shades off into the talk that has been character-ized as "primitivism." It is their imagined or presumed link with the higher realities (Absolute Spirit or Cosmic Energy or Gaia or the Goddess) that allows some objects, even from places far from the Re-naissance in space and time, to be claimed as "art."

FORMAL QUALITIES, OR DOES IT LOOK MODERN?

A great many sorts of objects have been displayed, collected, sold, and valued by individuals as primitive art. Between the two world wars and into the 1950s, one of the most important ways art historians and museum curators talked about, hence selected, certain kinds of objects over others to become authentic primitive art was according to their "formal qualities." In practice this could not help but mean, more or less (but usually more), how closely the objects approximated the for-mal qualities, the "look," of high modernist art. The formal-qualities discourse claims these objects are valuable aesthetically, divorced from any of their uses or meanings in the societies that produced them. This point of view is well known and was insistently articulated in pre–World War II exhibits at MoMA of non-Western artifacts. *African Negro Art,* the catalog for MoMA's 1935 exhibit, was a paean of praise to the formal plastic qualities of African (read: modern) art; in his concluding paragraph to this catalog, James Johnson Sweeney as-serts that taking into account anything at all about the history, cul-tures, or contexts that produced African art is positively dangerous— a more clear and present danger to "us," he writes, because we know so much more than Picasso did about African cultures:

> In the end, it is not the tribal characteristics of Negro art nor its strangeness that are interesting. It is its plastic qualities. Picturesque or exotic features as well as historical and ethnographic considera-tions have a tendency to blind us to its true worth. This was realized at once by its earliest amateurs. Today with the advances we have made during the last thirty years in our knowledge of Africa, it has become an even graver danger. Our approach must be held conscien-tiously in another direction. It is the vitality of the forms of Negro art that should speak to us, the simplification without impoverishment, the unnerving emphasis on the essential, the consistent, three-dimensional organization of structural planes in architectonic

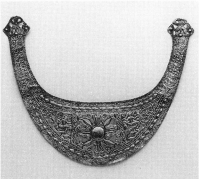

Figure 17. One of these two gold chest ornaments from Sumba, Indonesia, looks like "art" because of its formal simplicity, which is congruent with a modernist aesthetic (*left*); the other (*right*) is more likely to be classed as "decorative art."

sequences, the uncompromising truth to material with a seemingly intuitive adaptation of it, and the tension achieved between the idea or emotion to be expressed through representation and the abstract principles of sculpture.

The art of Negro Africa is a sculptor's art. As a sculptural tradition in the last century it has no rival. It is as sculpture we should approach it. (1935: 11)

A few years later, different authors emphasized the same theme. The catalog for the 1941 MoMA exhibit "Indian Art of the United States" asserts: "In theory, it should be possible to arrive at a satisfactory aesthetic evaluation of the art of any group without being much concerned with its cultural background. A satisfactory organization of lines, spaces, forms, shades and colors should be self-evident wherever we find it" (Douglas and d'Harnoncourt 1941: 11). (They go on to explain that in practice, however, we are saved from many errors by knowing something about the culture that produced the object. For a more complete account of this exhibit, see Rushing 1992.)

An object's formal qualities (how closely it approaches a modernist aesthetic) persists as a criterion that filters high primitive art from crafts, however "authentic" the latter may be. Take, for instance, the two pieces of jewelry shown in figure 17—both of them

Figure 18. On the reverse side these postcards announcing gallery shows read: *(left)* "My Shield Is My Canvas: Design and Form in Tribal Shields and Weapons" and *(right)* "A Study in Art Aesthetics: The Vertical in Tribal Composition."

chest ornaments, both made of gold, both from Sumba, Indonesia. One of them looks like modern art; the other looks like a gold chest ornament. Or examine the postcards shown in figure 18, announcing exhibitions at one of San Francisco's "best" galleries of art of Africa, Oceania, and the Americas. One of them construes the shield as a "canvas," the other concerns "the vertical in tribal composition."

A decorated ritual object that has become high primitive art has two relevant qualities: its participation in the sacred and its formal plastic qualities (to use art-talk). And indeed non-Western objects entered the realm of primitive art by two roads: by their formal aesthetic qualities (that is, how closely they approached the aesthetic of high modernism) or by their expressiveness of shamanistic exorcistic power. In practice, these two are often merged in the same objects: it is no accident that the Mask or the Reliquary Figure or the Totemic

Ancestor Figure stand as paradigmatic examples of the highest, most authentic, primitive art.

A case study in how high primitive art is constructed curatorially was MoMA's 1984 exhibit "'Primitivism' in 20th Century Art." It merged these two readings, formalist and mystical, of the authentically primitive, depending on whether one read the show backward or forward. (That was not, of course, the stated intent.) The show was laid out in three sections, which the visitor passed through sequentially.

The first section showed what I call high primitive art—those pieces, or ones like them, that influenced the Cubists, Surrealists, and other modernists. The second section, called "Affinities," juxtaposed examples of primitive art with examples of modern art, each object revealing a presumably remarkable and strange affinity with its paired opposite. The last section, called "Modern Primitives," consisted of the work of contemporary Western artists who are influenced by "the primitive."

The exhibit's stated intent was to reveal the connections between primitive art and the modernists, most especially Picasso. Entering the exhibit, the visitor could read a plaque with a rather defensive (but in my view entirely legitimate) message from MoMA's director William Rubin insisting that the exhibit was not, after all, about primitive art in its ethnographic context but about its importance to modern art and modern artists. (Such an exhibit would indeed have been an interesting one. There is no reason whatsoever to insist that these objects should be understood within their cultural context if one is interested in their meanings to Cubists and Surrealists. But that was not, in fact, what the exhibit was about.)

The first part of the show was about how the formal qualities of African artifacts made them appealing to Cubists, while Oceanic artifacts appealed to Surrealists. The museum labels were insistently formalist: a Melanesian object explored "negative space" with great sophistication; another piece revealed "frontal symmetry."

The exhibit's middle section, the soon-to-be-notorious "Affinities" room, paired various non-Western artifacts with European twentieth-century objects reminiscent of them in formal terms. Depleted of historicity, anything that is similar visually to anything else is indeed visually similar to anything else. To that there can be no objection. The

museum's explanatory labels failed to explain what, other than the context of their display (a possibility never admitted by the labels or catalog), could have brought such similarities into being.

The third and final section of the show contained the work of contemporary Western artists who are "primitivists." The room's introductory plaque stated that primitivism these days is less inspired by the formal qualities of actual objects, the way they look, than it is by Primitive Man's myth, ritual, and religion—hence the absence of actual primitive art in this room. It featured contemporary sculptures by Euro-American artists with bits of feathers and other items that signify the primitive. The visitor could infer that the primitive *now* is defined by a spirit or attitude rather than by the formal qualities of certain objects.

Reading chronologically and historically, a visitor strolling through MoMA's primitivism show moved forward in time, from past to present, beginning with Picasso and friends early in the twentieth century, passing through a lesson in purely formal relations, and ending with contemporary primitivist artists. But the same stroll was also a journey through mythical space, one that takes us backward through time to our origins. It moved from a specific point in historical time, the early twentieth century (the exhibit's first part), into the realm of pure form and spirit (the "Affinities" section), and finally to the mythical realm of the purely authentic (the last section), where the spirit of the primitive rather than the "look" of objects informs the creation of art. Read as myth rather than history, the sequence narrated the story of the search for modern art's origins, taking us away from mere form and deeper into spirit. If the spirit of Classical Greece was the worthy ancestor of Art with a capital A in the Renaissance, the spirit of Primitive Man, this exhibit in effect said, was the worthy ancestor of modern art in the early twentieth century.

HIGH PRIMITIVE ART

High primitive art is not a set of specific objects but a prototype that defines the term "primitive art." Just as some linguists claim that when we say the word "bird," we have in mind a prototype of a bird (it resembles a robin), in the same way, I believe, when we say "primitive art" our basic prototype is high primitive art. Other objects sold

as or exhibited as "primitive art" gain their legitimacy or fail in it by their closeness or deviation from high primitive art.

If the category prototype "bird" looks more or less like a robin, what does the category prototype "high primitive art" look like? The starting point from which to understand the prototype is the fact that objects of a certain sort gained legitimacy as art as part of high modernism; they migrated into the category of art due to their place in the narrative of art history.

The highest of high primitive art, then, the first tier or basic core of objects that define the prototype, consists of objects that actually did influence, or look as if they might have influenced, the likes of Picasso and Vlaminck: they are African; they were "collected" by the turn of the twentieth century; they are in the shape of a mask or ancestor figure, to wit, an anthropomorphic form in a certain range of size; they are made of wood; they are ritual objects rather than utilitarian ones (the mask, not the grain grinder; the ancestor figure, not the basket).

Just as the prototype bird may look a lot like a robin but is not actually any particular robin, the prototype of high primitive art *looks* like the kind of thing that could have influenced Picasso and Vlaminck, but need not actually have done so; it *ought* to have been collected by the turn of the twentieth century, but may not have been. In other words, the prototype is defined by an idea and a "look" rather than by any particular material exemplars that fit it.

The slippage is necessary and inevitable. For one thing, the pieces that actually influenced Picasso or hung in his living room are valuable to collectors because of their provenance, but they may not have been the finest examples of their kind; Picasso is reputed to have said, "You don't need a masterpiece to get the idea." Nonetheless, "fine, old" pieces that also look like the things Picasso might have been influenced by, but are "better" than the things he looked at or owned, are fully prototypical.

Second, one can be sure that plenty of objects that have been displayed in the most prestigious museums were made and collected too late to have influenced major modernist artists, but it is difficult to document these matters. Fortunately, the analyst seeking to define what high primitive art prototypes look like could simply look into the second section of the 1984 MoMA primitivism show, the "Affinities" room, which contained examples of pieces of primitive art bearing a supposedly uncanny resemblance to modern art. (Since they were se-

lected *because* they bore an uncanny resemblance to modern art, the juxtaposition was more canny than not.) In effect, the "Affinities" section showed museum-goers how high primitive art ought to look.

Also in the innermost core of the prototype are wooden sculptures from Oceania that could have influenced the Surrealists and might have been collected prior to about 1940. (The paradigmatic object in this part of the inner core is the *malanggan* from New Ireland.)

If the prototype of a bird looks like a robin but is not actually a robin, some exemplars of birds that do not deviate greatly from it consist of blue jays and swallows; they are immediately recognizable as birds by people who know the prototype. Second-tier high primitive art, the blue jays and swallows of this genre, is a deviation from the prototype, but even conservative collectors and curators recognize it as authentic high primitive art. The Rockefeller Wing of the Metropolitan, in my view, displays mostly this second-tier high primitive art. Geographically, the definition has expanded to New Guinea (Asmat, Sepik) and to Mesoamerica (pre-Columbian); the expansion in materials is to pottery and gold in the case of Mesoamerica, and to feathered and raffia'd figures in the case of New Guinea and the rest of the Pacific.

Another kind of object is now coming onto the market, as well, largely since the 1970s, that is often sold as "authentic": to wit, "ethnic art." I am thinking of the large numbers of beautiful and finely crafted objects and textiles that have been made available to the market in the last couple of decades due to changes in third-world nation-state policy toward foreign investments and internal minorities, and due to revolutions and the displaced peoples and the objects which, in desperation, they sell. Revolutions, displacements, and other disruptive events liberate objects from the contexts that produced them. At galleries and boutiques and from private dealers, one can now see old silks and purses and caps and elaborately worked boxes from parts of China, where Euro-American entrepreneur-sellers can now go; ayurvedic medicine apparatuses and chests from Sri Lanka; textiles and temple decorations and ancestor figures in abundance from Indonesia; or huge quantities of old silver jewelry from Morocco, Ethiopia, and other northerly areas of Africa. Often these objects are not labeled as "primitive"—it is out of fashion to say the word "primitive" in any context, and besides, these objects are often from literate, hierarchical societies (whose cultures count as "high" rather than as "primitive" in traditional art-object classification). The word "ethnic,"

rather, often signifies merely that they are non-Western. They are sometimes labeled "crafts," but more usually "arts," which seems to signify differently from the singular "art." (The semiotic burdens borne by the term "primitive art" and the term "ethnic arts" are very different.) But they are sold as "authentic," which is used by one large emporium of "Tribal, Ethnic, and Folk Arts" to mean that they were made and used "pre-1940s." One does not know, of course, when they were made or used, but they were liberated onto the market fairly recently. I consider these sorts of "authentic ethnic arts" to be a kind of third tier of the prototype authentic primitive art, perhaps the ducks and chickens—this analogy is getting a little stretched. All these items have a place in the primitivesque objects market, and dealers and customers of each seek to promote them as authentic and as art/s.

The categorization of particular kinds of objects in particular kinds of display sites and market venues is of course contested; one could develop a kind of sociology of knowledge based on who narrativizes which objects and how. Curators of high European art long regarded even what I call high primitive art with dismay and thought it out of place in museums of high art (witness how long it took to admit primitive art into the Metropolitan). Now other contestations are occurring. Curators and dealers of modern art, especially the classics, readily admit Benin bronzes and African masks into the realm of art, but are firm in the opinion that American Indian baskets are not art, though they may be quite valuable craft. Owners of galleries of traditional "quality" primitive art may insist that Navajo rugs and old Pueblo pottery should be regarded as art, but they draw the line at mere "curios" like post–World War II Zuni fetishes, recently made Alaskan stone carvings, and Southwestern silver jewelry made explicitly for the market (not to mention beaded tea cozies and pincushions inscribed "Toronto Exhibition 1905"). Dealers in contemporary Native American arts and crafts, for their part, may welcome hybrid objects and new designs, insisting that these too are art—after all, Euro-American artists make objects for the market and use whatever materials they want, why not a Zuni? And so forth.

Each of these hypothetical but nonetheless representative positions is embedded in different discourses and economic positions, and each has different stakes in the outcome of the various stories that are told.

The kinds of objects that are made for the market by ethnic minorities within North America, or by fourth-world peoples within third-world countries, most of which became independent at mid-

Figure 19. Objects once made for the market used to be denigrated as "tourist art" but now are "beautiful investments."

twentieth century, are currently sold as contemporary ethnic arts, authentic Indian jewelry, genuine Mayan folk art, and so forth. They stand to the prototype authentic primitive art perhaps as emus and cassowaries do to the prototype bird. Objects of this sort used to be denigrated as degenerate "tourist art," but now are taking their place as legitimate forms of arts, crafts, and decorations (figure 19).

Finally and briefly, I must mention the vast market in kitsch, reproductions, and spin-offs of authentic primitive art, even though I have run out of birds to compare them to. There is some question in my

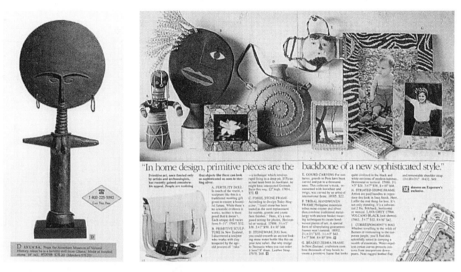

Figure 20. Which is more "authentic"—a factory-made museum reproduction of an "authentic" object of "primitive art"(see *left:* "Akua'ba is a fertility doll from Ghana. Made of bonded stone") or an object hand-made (presumably by an "authentic native" somewhere), which refers only loosely to a generalized "primitive" (see *right:* "FERTILITY DOLL: In much of the world, a sculpture like this is a traditional wedding gift given to ensure a bountiful future")?

mind whether museum reproductions of high primitive art would rate higher or lower than home decorations made new by hand and that refer only loosely to a generalized primitive (see figure 20).

What is clear, however, is that all these objects, their markets, their dealers, and their collectors, gain legitimacy and comprehensibility by the fact that they are anchored by the prototype authentic primitive art. High primitive art stands to the rest of the market in primitive art more or less as Renaissance painting stands to the rest of the art market. It exemplifies the category. Its existence in major museums anchors the market.

3

* * *

The Universality of Art
as a Self-Fulfilling Prophecy

At this point I want to interrupt my story of the birth and death of authentic primitive art in order to address those many people who believe that while authenticity and the primitive may be historically contingent constructions, art is an enduring universal. Such art universalists are offended by the idea that the deep schema of art (consisting of attributes like portability, iconicity, and so on) acts as a screening device that filters the world's countless objects, allowing only a small number of them to be counted as "art"—on the grounds that my implication is incorrect, even if my facts are right. My implication is that the schema screens objects and therefore those that pass through it become art, whereas their view is that art preexists the screening device, which merely identifies and sorts wheat from chaff, art from non-art. Such people will say (this is a composite of many conversations I have had), "Of course art has some characteristics that let us recognize it as art. How else would we know what we're talking about? You've identified what we mean by 'art'! How could it be otherwise?" And that is a good point, although I think it is not the whole story. Art universalists then ponder the topic more deeply. After a few minutes of furrowed brow and deep thought, they struggle to define why art is universal, and how we can tell it from non-art. In the end, they pronounce, it is not portability, iconicity, and all the rest of it that define an object as art, but its "transcendent quality."

Arthur Danto (1988) made precisely this distinction between "art" and "artifact" when he wrote about the values his imaginary Pot People and Basket People assigned to their respective (and identical) pots and baskets; not formal qualities, but transcendence, he asserted, differentiates art from the "prose of the world" (24).

In the view of many art historians, curators, collectors, and cognoscenti, it is transcendence that ultimately defines a work as a piece of

art.[1] The rest of it—portability, size, sculptural qualities—is merely historical accident for them. And since all humans, as members of a culture if not as individuals (who may be rather slack in this regard), feel themselves to be occasionally in touch with the Divine (locally construed, of course), virtually all societies make something recognizable as art. Quality differs, of course—some of it is crudely made, and its materials are various—but quality is not a defining feature of the category; the defining feature of the category is the spark of transcendent spirit.

My position is that we humans are amazingly inventive, and we make and have always made things that we imbue with meaning, as befits creatures having both opposable thumbs and consciousness. Human artifacts are admirable. They are ingenious. They are dense with meaning. They are worthy of deep study. But on the whole, I think that it neither dignifies these objects nor does their human makers a favor to call these things art. I take art to be a much smaller class of objects; indeed, I take art to be not a class of objects with fixed characteristics, but a set of historically specific ideas and practices that have shifted meanings in the course of the centuries. Objects that show a spark of transcendence, as well as ones that patently do not, can become art, certainly, by being separated from their original uses, framed, and exhibited—as we can see by observing not just butterfly masks with beaks from the Western Sudan, but also a bicycle seat and handlebars mounted to resemble a bull's head and horns, a urinal signed R. Mutt, and photographs by Walker Evans reprinted and re-signed. One would be hard put to find in these objects common attributes; their status as art consists of the idea of art and the practices and institutional contexts of display that have made them into it. And they really become art: art by appropriation, art by invention, and art by the repositioning of found objects are existentially art just as much as art by intention is. To say that (which is to say there is nothing else, that the world is all that is the case) is different from saying that they always were art, and only had to be discovered as such.

I also think, on the whole, the notion that art is a panhuman universal is a pernicious idea, which has on balance done more harm than good. That does not make it untrue, although I believe it is.

How could the idea that art is universal and transcendent, that it preexists its social construction, be refuted? Perhaps one could iden-

tify some transcendent objects from Africa, Oceania, and the Americas *in situ*, before they became art, to see how much overlap there is between them and the objects that enter international art markets and museums as art, and to see whether a plausible and smooth story can be told about how the one was converted into the other.

I hang my explication on one of the most famous stories about how transcendent objects become art, the one put forth by Walter Benjamin in "The Work of Art in the Age of Mechanical Reproduction." The issue I want to address is how (some) "cult objects" (Benjamin's term for objects with "aura," which I take to be another name for "transcendence"), but not others, became and become absorbed into the category of art. This telling requires identifying what we mean by each of those categories as social and historical practices, and it requires an account of the power of the market and the force of cultural categorization. I conclude this exercise with comments from a brochure about primitive art I picked up at Macy's in San Francisco in 1982, which describes the ethnic art Macy's buyers gathered in the Amazon.

"TRANSCENDENCE"

The first problem is to identify transcendent objects. That is actually not so easy. Following Danto on Pot People and Basket People, I am assuming that transcendence is locally attributed and that the higher realities are identifiable by local beliefs and practices. Locating transcendent objects, then, requires understanding something about how people locally construe their objects. Sometimes it is even difficult to figure out what is an "object."

For instance, in an article comparing a Malay and a European account of the coronation of the Brunei Sultan Muhammad Jamalul Alam in 1918, Donald Brown (1971) nicely points to the two writers' different interests in what he calls "material objects."

The Malay account of the 1918 coronation described in great detail the seating arrangements and things such as "vessels, candles, flags, weapons, umbrellas, certain colors, etc.," which were used to denote the status of participants. These items were not of intrinsic interest as objects to the Malay writer, and many were expendable (their type and quantity bore the message, not their material substance); but the Malay writer was attuned to them because they sig-

nified the various participants' ranks. The Malay writer also paid attention to the royal or state regalia. State regalia in the hierarchical pre-nation-state polities of Southeast Asia defined the center of the realm, standing to it as, in Brown's view, the Constitution to the United States or the Magna Carta to Great Britain.

By contrast, the European's account of the same coronation also noted the seating arrangements, although not in nearly the detail the Malay one did, but did not mention the candles, flags, and other paraphernalia. The European writer gave more space in his description to the Sultan's gold crown and its weight. Brown points out that the gold crown, although part of the state regalia, was perhaps the least important item in it.

Which are the transcendent objects here, and which are mere material? The candles, umbrellas, vessels, and the like are obviously indexical signs of rank; their materiality and intrinsic value are not at issue. But rank in these societies was deeply connected to the idea of immaterial power (called *kesaktian*, from the Sanskrit *sakti*), the power to harm and the power to bring prosperity and fertility to one's dependents. Should we count, then, the visible, material signifiers of rank as transcendent? Or can transcendence be hierarchized, with some objects more transcendent than others?

I suspect one would have equal trouble in examining any society's transcendent objects deeply. But let us press on, for the sake of argument, to try to salvage transcendence.

WALTER BENJAMIN'S STORY OF ART

Walter Benjamin did not write about transcendence (after all, he was a Marxist and anti-Hegelian), but he did write about "cult objects" that have "auras," and so provided us with characteristics that would allow us to identify "cult objects" in different societies. Benjamin was not concerned with primitive art; he was writing about European art, taking into account the fact that many of the precious objects on display in museums of fine arts in Europe were religious and ritual objects from Europe's past. He tells a story that asserts that "works of art" have their origins in cult objects (which I take to be roughly equivalent to ritual objects, and to transcendent objects, and to objects that have a local connection with higher realities). In his account in "The Work of Art in the Age of Mechanical Reproduction"

(1969) Benjamin postulates a panhistorical category "works of art" with two poles of value, the cult value and the exhibition value. Works of art have "auras," he claims. Aura diminishes continuously and unidirectionally, from the aura-saturated cult item to the aura-depleted exhibition item. It never fully disappears in works of art, according to Benjamin, but—we learn in the course of the essay—their auras have declined in the modern age, particularly with the advent of mechanical replication through photography and films. In more detail, and emphasizing the parts of the story that concern my points here, Benjamin's story goes like this.

Originally, he writes, "the earliest art works originated in the service of a ritual—first the magical, then the religious kind." As an example, Benjamin mentions an ancient statue of Venus, made an object of veneration by the Greeks. He calls such works of art "cult objects." Cult objects had an "aura," which Benjamin defines as "a unique phenomenon of distance, however close it may be," and goes on to point out that "distance is the opposite of closeness. The essentially distant object is the unapproachable one. Unapproachability is indeed a major quality of the cult image" (1969: 243, n. 5).

The cult value originates in the work of art's sacred status for its community of worshippers; the piece may be beautiful, but it need not be, and it need not be often seen: "What mattered was their existence, not their being on view." Benjamin goes on: "The elk portrayed by the man of the Stone Age on the walls of his cave was an instrument of magic. He did expose it to his fellow men, but in the main it was meant for the spirits." Similarly, albeit historically later, "Madonnas remained covered nearly all year round; certain sculptures on medieval cathedrals are invisible to the spectator on ground level" (1969: 224–25).

Benjamin very usefully distinguishes between a work of art's cult value and its exhibition value, which are sometimes in conflict. Works of art with cult value have powerful auras, but, gradually, his story goes, works of art were liberated from ritual practices. Nonetheless, many works of art were fixed in place or restricted in use, this fixity helping to preserve their auras. Eventually, it seems, works of art became more mobile, and that seems, in his account, to have tipped the scale toward making works of art valued primarily or largely because of their exhibition value: "It is easier to exhibit a portrait bust that can be sent here and there than to exhibit the statue

of a divinity that has its fixed place in the interior of a temple. The same holds for the painting as against the mosaic or fresco that preceded it" (1969: 225). Although works of art always retain some aura, secular works of art are made to be viewed, and have been designed and worked to be aesthetically pleasing. Their exhibition value rather than their cult value is primary.

In sum, the story Benjamin tells depends on the use of a panhistorical category, "works of art." Without it, he could not tell a unidirectional story about the change in status of works of art, from cult object to secular work of art with aura as well as exhibition value and finally to multiple copies depleted of aura and uniqueness.

Incidentally, a contemporary reader of Benjamin's essay is struck by the complete absence of a mention of commodification, which in recent years has loomed large in the analysis of objects, images, and images-as-objects, a trend that Benjamin's essay helped to inspire. But what I want to make use of for the moment is Benjamin's very useful distinction between the cult value and the exhibition value of a work of art.

CULT VALUE VERSUS EXHIBITION VALUE

Benjamin, although regarding both cult objects and art objects as one kind of thing (works of art), nevertheless imagines works of art to have two poles of value, their cult value and their exhibition value. These two poles of value are very different, even contradictory. The cult object need not be beautiful but need only exist, whereas secular art objects are made to be exhibited and are preferably both beautiful and well preserved. Benjamin implies that the conflict is even more extreme: being on view may help turn cult objects into secular objects—after all, allowing them to be up close instead of distant lessens their aura.[2]

Even though a very large number of works of art in Western museums consist of (former) cult objects, such as religious paraphernalia looted from cathedrals, we do not usually notice the contradiction between their cult and exhibition value, because, Benjamin writes, "this polarity cannot come into its own in the aesthetics of Idealism. Its idea of beauty comprises these polar opposites without differentiating between them and consequently excludes their polarity" (1969: 244, n. 8).

This statement strikes me as a brilliant insight. When contemplating what we call works of art, we usually do not notice the contradiction between these two poles, or, as I would put it, between these two categories (cult objects and art objects), because they are reconciled in Hegelian idealist aesthetics.

Cult objects and art objects ought to be regarded as different kinds of things, I believe, because the concepts and practices that constitute each are quite different. Rather than imagine, as Benjamin does, the panhistorical category of works of art with two poles, defined by the object with cult value on one end and the object with exhibition value on the other, let us imagine two classes of objects: the cult object and the work of art. Each is made for different purposes and is used socially in different ways. If we imagine our topic not as one phenomenon but as two socially constructed and separate categories, the story we are obliged to tell about them will necessarily be different. It will not be a continuous one about changes in value, but a disrupted one of categories that impinge on each other and intersect in certain political and market conditions. I begin with the idea of the cult object, the object with an aura.

CULT OBJECTS

AURA

What Benjamin calls the cult object has, in the society that produced it for local ritual purposes, an aura—it is unapproachable, distant even when near, and should be treated with respect. It need not be exhibited; it is enough for it to exist. Consequently, it need not be in good repair or be beautiful or finely worked or made of valuable materials. Indeed, since it is not exchanged for money, and possibly not exchanged for anything at all, its value cannot be determined by some criterion outside itself.

It is not difficult to find objects that by these criteria should be called cult objects, in many different societies and historical periods. In Indonesia, for instance, one of the most general categories of objects that could be called cult objects is *pusaka*. *Pusaka* means, roughly, treasured objects inherited from ancient times. *Pusaka* are things like gold family heirlooms and jewelry, believed to be inhabited by spirits or saturated with the soul of the ancestor; carefully worked textiles, used only for marriage exchange, not for everyday

use; or puppet figures, used in performances directed to a spirit au-
dience but around which humans are allowed to gather as well. The
things called *pusaka* are often believed to be inhabited by spirits, and
offerings may be made to them regularly, or they may be removed
from their shrines and ceremonially cleaned on set occasions. These
are objects with auras; they are treated with respect. They may sel-
dom be seen in public, but when they are, it tends to be on set or pre-
determined occasions. They are removed from their resting places
with care, and sometimes prayers and incense are used to ensure
their safety when they are taken out.

In what follows I often mention three particular sorts of Indone-
sian cult objects. One consists of the regalia of a kingdom—its gongs,
its flags, its gold boxes for betel nuts, jewelry, its *keris* (swords of a
particular type), and so forth. These were extremely important in the
state systems of island Southeast Asia and continue to be important
in various ways, although with the advent of the nation-state they
have no official political place. (In some areas they are, however, be-
ing reclassified as objects of national heritage.) The second type of
cult object I refer to consists of the textiles used in Eastern Indonesia
when marriages were (and continue to be) arranged: often intricately
and beautifully woven of silk, they were gifts from one bridal party
to the other. Third, I want to mention the *tau-tau* of Toraja-land, the
mountainous southeastern peninsula of Sulawesi (formerly called
Celebes). When a person dies in Toraja-land, his or her descendants
wait until they have sufficient funds and social credits (as opposed
to debits) to put on a mortuary ceremony. (The burial of the corpse
could have taken place months or even years before.) Tau-tau,
wooden figures that stand for the deceased, are made on these occa-
sions; after the ceremony, they are placed high on the Toraja cliffs,
usually quite far away from the village.[3]

BEAUTY

When Western collectors are making judgments about beautiful ob-
jects but are purposefully not using the Renaissance canon as a crite-
rion of beauty, fine workmanship and valuable materials tend to
stand in for the attribute "beautiful." By that criterion, many Indone-
sian cult objects are beautiful, for many are finely worked and made
of valuable or rare materials. Textiles for ceremonial occasions may

be woven with costly and hard-to-work materials, like silk with gold or silver thread; their designs may be enormously complex and meaningful. *Keris* were ideally forged of nickelous iron found in meteorites, and the forging process was fraught with spiritual as well as physical dangers. Cult objects in Indonesia are often intricately worked, a sign of their value to the people who made them.

Yet they need not be so. Consider, for instance, the royal regalia possessed by the rulers and courts of the historical Indic states of the area, places like Bali, Java, and the Bugis-Makassar areas of South Sulawesi. The regalia consisted of a collection of objects said to have descended from the Upper World with the founders of the first dynasties of each realm, and augmented by subsequent rulers. This collection of objects might include not only ancestral gold jewelry and betel-nut boxes, but also ancient tattered silk flags, skulls or teeth, porcelain from China (sometimes in disrepair), and a generally motley collection of things (to Western eyes). Yet these were the sacred regalia of the realm, on which its prosperity and peace were thought to depend. All were cult objects, but only a few were made of costly materials and only a few would strike either Westerners or the people of these realms as beautiful, a criterion profoundly irrelevant to the reason they are revered.

VALUE, IMMOBILITY, AND RESTRICTED EXCHANGE

Many cult objects are located in a fixed place from which they are almost never moved (they are kept in a family's ancestral house, or they stay in the temple, or they remain high in the cliff).

An example of an immobile cult object is the tau-tau of the Toraja. After the mortuary ceremony, these effigies are placed in nooks in high cliffs, then left many years to deteriorate. They, and the ancestral bones placed with them, may be removed from time to time for ritual cleansing and then put back, but they are not displaced. Their destiny, as it were, is to stay still forever, slowly deteriorating.

Another type of cult object that was largely immobile was the royal regalia of the old kingdoms. These objects usually stayed at the royal residence and defined the kingdom's center. On ceremonial occasions, they might be paraded with great pomp and care. In some kingdoms, they were regarded as having curative powers, and

might be moved, again with pomp, around a realm or district that was experiencing an epidemic or drought. Thus they were physically nearly immobile; when they did move, it was with a great to-do and with a prescribed protocol.

Metaphorically, the movement of an object is exchange: objects that are used in or for exchange could be said to move figuratively as well as literally when they are exchanged for something else. Many cult objects are barely moved physically, and their metaphorical immobility is all but guaranteed by the fact that they are not for exchange. Other cult objects may be exchanged, but not freely: they participate in "restricted exchange." That is to say, in normal times they may be exchanged only for certain types of objects that locally are considered comparable, and only on set occasions.[4]

An example of restricted exchange of cult objects in Indonesia is the textiles used in the marriage ceremonies of many societies in Eastern Indonesia. In an article on these textiles, Ruth Barnes (1994) tells us that in Sunda, textiles are used both for wearing and for ceremonial exchange (at marriage). Certain threads of ordinary cloths must be cut to make them wearable; but if the textiles are to be used for ceremonial exchange, those threads are not cut. The uncut threads both prevent the marriage cloths' being worn and are, as well, a sign of their distance from everyday uses. Their sole use, for which they are crucial, is to be exchanged on the occasion of marriages ("Without cloth we cannot marry!" they say). But these ceremonial textiles are exchanged for only one other sort of item: elephant tusks.

In sum, cult objects are either unexchangeable or they were exchangeable for a very restricted number of other types of ritual objects considered their peers; and although they might be finely worked, their value does not lie in their "beauty."

DURABILITY

The cult items from Indonesia mentioned above tend to be made of durable materials, although the objects are not necessarily kept in good repair, at least from the vantage of, say, a fine arts museum conservator. (They *are* cared for, of course, by being given offerings or by being removed from their resting places for ritual cleansing on set occasions.)

But many human societies' cult objects are not preserved or con-
served. Many societies' rituals are not about revering or conserving
old things but about re-energizing human life. Consequently, many
ritual or cult objects must be made anew for the appropriate ritual.
That is one of the reasons that they are purposefully made of tran-
sient materials. The Walbiri of Australia, for instance, placed some of
their potent designs for rituals on hard and permanent materials
(stones), which were saved in between rituals. Other designs were
traced on the ground, and in the course of dances they would be de-
stroyed; or they were painted on people's bodies. The skin was
called the "ground," and the designs placed on it wore off or were
washed off, disappearing much as the designs traced in sand.

Other societies make cult figures for a particular occasion, using
either transient or durable materials, and then discard them in a
heap, which is often regarded as ritually dangerous and much to be
avoided—like the people of Karavar in Papua New Guinea, who
make *tubuan*, masks and dancing costumes, then discard them in a
special area in the forest that is tabu to approach.[5]

The various Amazonian societies from which artifacts were col-
lected by Macy's San Francisco for its seventh-floor (home furnish-
ings department) exhibition and sale in 1982 apparently had a simi-
lar practice of making ritual objects anew for ceremonies and
therefore discarded used ones. A brochure I picked up at Macy's de-
scribes the challenging and perilous journey on the Amazon River
the buyers took to obtain the objects, which were apparently
snatched from the jaws of profitless disintegration just in the nick of
time: "Timing was a key factor. The travelers wanted to arrive after
certain ceremonial rites practiced by the Indians. Special masks, cos-
tumes and religious pieces were created only for these occasions
then discarded afterwards. Macy's team wanted to recover as many
of these one-of-a-kind artifacts as possible" (figure 21).

(PRIMITIVE) ART OBJECTS

If a cult object is one that is fixed in place or that participates in very
restricted circles of exchange and one that need not have exhibition
value (need not be beautiful or finely worked, need not be in good
repair), an art object is the opposite.

The ethnic art collected by Macy's from the Amazon for sale in
their San Francisco home furnishings department in 1982 was not,

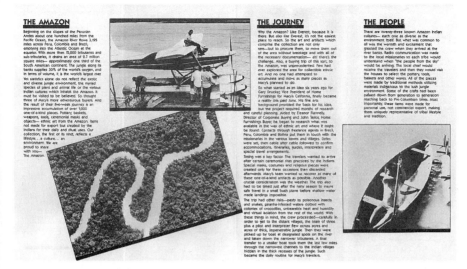

Figure 21. Macy's brochure for its Amazon collection underlines the challenge of obtaining these "one-of-a-kind artifacts."

admittedly, high primitive art, and it would be roundly rejected, no doubt, by curators of major museums in charge of the arts of Africa, Oceania, and the Americas. Nonetheless, several familiar themes made an appearance in this sale, so it can serve as a useful case to show how objects not intended as art may begin the long slow journey of transformation into art.

Durability is important in an art object: objects had to be rescued from the deteriorating heap in which they had been cast. Presumably the objects were cleaned up to look attractive in a living room, as well. Their point is to have exhibition value. Here is another passage from the brochure (note the appearance of iconicity, and the ghostly appearance of the individual artist):

At first glance, the visual impact is awesome. The colors, ranging from muted tones to brights, dramatically blend art with nature. Yet each piece is an individual expression rich in tribal lore. Zoomorphic and anthropomorphic motifs are prevalent. And a common visual theme on many of the pieces is the river itself. Consider the decorative water vessel. Its effigy is a schematic of the Amazon River; the tributaries and channels form a maze-like map about the circumference. Atop some of the vessels, a portrait, perhaps, of the Indian artist himself. (figure 22)

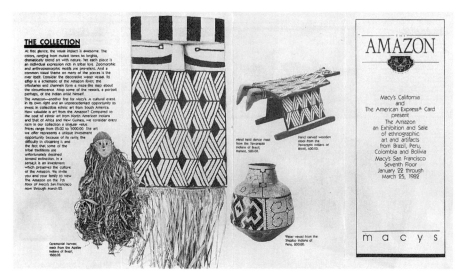

Figure 22. Macy's Amazon collection brochure calls attention to the "unique investment opportunity . . . an investment which preserves the culture of the Amazon."

The brochure explains that the work of art has monetary value:

> The Amazon—another first for Macy's. A cultural event in its own right and an unprecedented opportunity to invest in collectible ethnic art from South America. How valuable is art from the Amazon? Compared to the cost of ethnic art from North American Indians and that of Africa and New Guinea, we consider every item in our collection a singular value. Prices range from 25.00 to 5000.00. The art we offer represents a unique investment opportunity because of its rarity, the difficulty in obtaining it and the fact that some of the tribal traditions are unfortunately destined toward extinction. In a sense, it is an investment which preserves the culture of the Amazon.

Part of this ethnic art's monetary value is due to its "rarity," and it will soon become rarer: "some of the tribal traditions are unfortunately destined toward extinction." (The death of the artist increases the work's value.) Acquiring objects from people whose tribal traditions are heading for extinction is construed as a virtuous act: "In a sense, it is an investment which preserves the culture of the Amazon." (The logic by which acquiring these objects from Macy's is a way to preserve the culture of the Amazon is rather like the woman

saying to the waiter in a *New Yorker* cartoon, "I'll have some fish, while the poor things are still around"—but never mind.)

The other parts of the brochure are designed to convey not so much that the works in question are art—a point that is, if anything, a little weak here—but that they *are* authentically primitive, made by primitive people and not made for the market. Part of the value of the objects, the brochure claims, is that they were difficult to obtain. As proof, it describes in detail "The Journey" with its "pesty to poisonous insects and snakes, piranha-infested waters dotted with colonies of crocodiles, unbearable heat and humidity and virtual isolation from the rest of the world. With these things in mind, the crew proceeded—carefully." (It goes on.)

The people are bona fide primitives, although missionaries had arrived there first; that turns out to be a convenience, since the missionaries have radios: "Radio communication was made to the local missionaries so each tribe would understand when 'the people from the sky' would be arriving." Oddly, given the missionary presence, the Macy's buyers seem to have usurped from the Heavenly Host a place in the sky in local cosmology. No mention is made of how this is reconciled with the New Testament.

Though primitive, the natives are friendly: "There are twenty-three known Amazon Indian cultures—each one as diverse as the environment itself. But what was common to all was the warmth and excitement that greeted the crew when they arrived at the river banks. . . . The local chief would receive the travelers and then they would visit the houses to select the pottery, tools, baskets and other wares."

Although the word is never used, these objects are authentic, because they were not made to be sold: "All of the pieces were made by traditional methods utilizing materials indigenous to the lush jungle environment. Some of the crafts had been passed down from generation to generation reaching back to Pre-Columbian times. Most importantly, these items were made for personal use, not commercial export, making them uniquely representative of tribal lifestyle and tradition." And again: "And the result of their five-week journey is an impressive accumulation of over 1,000 one-of-a-kind pieces. Pottery, baskets, weapons, tools, ceremonial masks and objects—ethnic art from the Amazon. Items not made for export but created by the Indians for their daily and ritual uses."

THE UNIVERSALITY OF (HIGH, PRIMITIVE) ART
AS A SELF-FULFILLING PROPHECY

If we look at the ideas and practices that (in my view) constitute cult objects and art objects, the overlap is not great between them. But what about the Hegelian notion that its transcendent quality ultimately defines a work as a piece of art, rather than mere practices?

To understand the difference between cult objects and art objects, we can ask the question, "What happens when cult objects, unapproachable and sacred, sometimes ugly, often deteriorating, fixed spatially or movable only in very restricted circuits of exchangeability, meet the category of Western art?"

The brief answer is that objects that conform to many of the deep schemata that help constitute the definition of art will be selected for the art market as "art." Others will be left behind, regardless of their cult value or transcendent qualities.

What is left behind, as it were, may be equally cult objects. In Sunda, Indonesia, for instance, both textiles and elephant tusks were cult objects, exchangeable for each other in marriage ceremonies (see Barnes 1994). Textiles tend not to become the highest of high primitive art (they are too close to craft as opposed to art, according to the eighteenth-century separation of what constitutes "fine arts"). Yet beautifully worked textiles, dense with symbolic designs, threaded with valuable metals, used for ceremonial purposes, can and do enter the art/rare objects/precious things market, whereas elephant tusks, their indigenous-exchange counterparts, are likely to be left behind, when art is being collected.

Why? Because there are textile museums and textile aficionados in Euro-America, but no museums of elephant tusks. (There may be aficionados of elephant tusks, but if so they are likely to keep it secret.) Nor do we have museums of "objects once upon a time exchanged for textiles in various cultures." The tusks may become curiosities or antiquities, but their chances of becoming art are low, and of becoming high primitive art are negligible.

In short, transcendence and cult value are not sufficient to transform an object into art. It must have exhibition value. More than that, it must conform in large part to the deep schemata laid out in chapter 2. The vast majority of what becomes art, whether from medieval Europe or from other sources, is portable (paintings preferred to mu-

rals), durable (bronze preferred to basketry), useless for practical purposes in the secular West (ancestral effigies and Byzantine icons preferred to hoes and grain grinders), representational or at least iconic (human and animal figures preferred to, say, heavily decorated ritual bowls), and so forth. The selection process is also a hierarchizing process. Many objects will be called to the market, but only a few will be chosen as the highest of primitive art, and the others will be ranged around them in tiers of value that replicate eighteenth-century distinctions between high and low, hard and soft, ritual and useful, anthropomorphic and decorative.

The notion that art is a universal expression of the human spirit and is almost everywhere to be found becomes a self-fulfilling prophecy. Firmly believing the truth of the proposition, and deeply appreciating the beauty and transcendent artistic value of some (but not all) artifacts produced by humankind, collectors and dealers search the world for art. And they find it.

4

. . .

The Death of Authentic Primitive Art

For many decades, dealers have been searching the world for primitive art and finding it. Yet by the end of the twentieth century, many dealers, journalists, curators, collectors, and art historians believed that the era of the production of authentic primitive art—indeed, of "authentic" "primitive" objects of any ilk—was over. Collectors and dealers agreed that the supply of the real stuff was running low. As the owner of an ethnic arts jewelry store in Palo Alto, California, put it when I interviewed her in 1990, "It's all going downhill. These people used to lead such beautiful lives, and now they have pink plastic shoes. They used to have beautiful clay pots to haul water, but now they use plastic. It's cheaper, it doesn't break, it's lighter, so you can understand it, but it's sad. So everything *real* is going up in price, because they're not making it anymore."

The death of authentic primitive arts and crafts has a venerable history. Authentic primitive art is not being produced anymore, the story goes, because the cultures that produced it are "dead." (Apparently it was ever thus: "primitives" have been "disappearing" in the English-speaking world for at least several centuries.)[1] The overarching story line about the decline of the authentic concerns the penetration of colonialists, of the market, and therefore of history, which brings about degeneracy and inauthenticity in the primitives and their artifacts. In the past (the story goes) the natives produced beautiful, curious, finely worked, ingenious, admirable, and therefore collectible things; their current productions, by contrast, lack the admirable qualities of craftsmanship and genuineness, and often rareness, that earlier ones had. "Fine pieces were no longer being produced due to the decadence of the natives following their exploitation by the whites," as James Johnson Sweeney put it in 1935 (12).

As cultures "die," the price of the artifacts they formerly produced rises. Joseph Alsop (1982) traces the demise of (authentic)

primitive art and its rise in price directly to the demise of the cultures that produced it:

> On the most superficial level, it is a truism of the art market that the works of a dead but still-admired master are more valued than the works of a master still alive and currently productive. Death limits the supply; the law of supply and demand begins to operate; and so $2,000,000 comes to be paid for a Jackson Pollock, significantly described as one of the last of Pollock's major works to be available. In the same fashion, collectors', museums', and the market's interest in American Indian artifacts has been growing rapidly for a good many decades. Yet it seems most unlikely that this would be the case if the West were still dotted with trading posts where an illegal bottle of rotgut could still be exchanged for admirable examples of quill work and beadwork, featherwork, blankets, pottery, woodcarvings, and the like. While that was the situation, no one was interested in Indian artifacts except for a tiny number of ethnologically minded persons. (22)

In short, the supposed death of the culture has been a factor in the increased price of objects that are genuine, old, and rare. The process described by Alsop is like the reverse of the story of the goose that laid the golden egg: in his story, the egg turns to gold only after the goose dies. It is a no-win proposition for the goose. If the goose were to be magically raised from the dead, its egg would lose its luster. Alternatively, if the goose were to squawk about how it is not dead but to complain that its feathers had been plucked, it would be reviled for giving up its essential goose-iosity—or ignored or discredited, whatever it takes—to keep that goose quiet and maintain the value of the egg.

To say arts and crafts have "died out" makes it seem that social change toward modernity (such as a society's adoption of a cash economy or a world religion, or its participation in the nation-state and indirectly in the global economic system) is a natural process, analogous to biological processes of birth, growth, and death. The implicit notion behind metaphors like this one is that world history is going somewhere—toward modernity—and that cultures and societies that do not step onto the road leading toward modernity will be left behind and disappear. In this narrative, marginal, small-scale societies in out-of-the-way places must not stand in the way of progress and should gladly adopt the benefits of modernization—else be left behind in their materially deprived state.

HOW "AUTHENTIC" OBJECTS
STILL COME ONTO THE MARKET

In spite of the "death" of the cultures that produced authentic primitive art, the very best galleries and shops in primitive art claim to have a supply of it. They claim that their "best" pieces are indeed "authentic"—"fine, old" pieces that are not being made anymore. These pieces, it is said, were made by the native artists for their own people, not for the market. Yet if the goose is dead and no longer laying eggs, where does the supply of authentic primitive art come from?

It is my impression that it emphatically does not come from the areas that formerly produced it. Few dealers and almost no collectors (it is my impression) go to, say, Africa to find their authentic primitive art. They do not go to Africa to get their stock because what they want "is not being produced anymore." And because fakery is rife. And last but not least, because the areas that formerly produced primitive art are no longer colonies of European powers but are within the territorial boundaries of nation-states that became independent around the mid-twentieth century. Many of these countries now have regulations that prevent the removal of objects of national heritage, often defined as objects a certain number of years old, which inconveniently enough often coincides precisely with the cut-off date for authenticity. Consequently, even if some desirable and certifiable objects of authentic primitive art could be found *in situ,* they could not be legally exported from many countries.[2]

Therefore, the "fine, old pieces" of legally salable authentic primitive art are objects that are already in circulation, the things that were imported to Euro-America decades ago and that continue to circulate among private collections, dealers, and museum collections. Dealers trade objects with each other, seeking the special piece for a special collector. Or they go to Europe for estate sales (when, say, the descendants of a private collector find themselves less enamored of primitive art than the collector was); and they cultivate the still-living collectors who were actively acquiring it in the 1920s and 1930s and who can be expected to give their fine, old pieces to a museum or sell them before they die. And they go to auctions at Christie's and Sotheby's.

Illegal authentic primitive art, or what passes for it, is a not-so-different matter. Areas of the world that originally produced authentic primitive art continue to produce what looks like it: ancient forms

are newly produced and artificially aged, for instance, so that it appears that fine, old pieces are still being liberated rather than invented. And the looting of archaeological sites, particularly in Mesoamerica, continues apace. (Indeed, artifacts illegally obtained from archaeological sites have a special panache, since they are obviously old and authentic.) And occasionally the curators of national and local museums in former primitive-art-producing areas, guardians of their national heritage, collude in thefts from their museums and facilitate the export of the stolen objects to wealthy collectors and museums. In other words, something more than a trickle and less than a flood of authentic primitive art continues to augment the extant store of authentic primitive art that is already in circulation.

That said, however, I want to deal with a much more salient way that "authentic" objects—albeit not the highest forms of authentic primitive art—continue to come onto the market.

For several years running I attended the Tribal and Folk Art Exhibition, an emporium held annually in Marin or San Francisco, noting the categories of objects on sale, the regulations in force, and the marketing rhetoric, and I interviewed and observed a number of dealers and collectors/browsers. This fieldwork gave me some insight into the continuing appeal of "authenticity" and the processes by which "authentic" objects continue to be brought from exotic places and marketed. After all, in spite of the death of the highest forms of Rockefeller Wing–type primitive art, lesser "authentic primitive" objects are in demand. Dealers continue to scour the world for them, collecting "authentic" objects and often promoting them as art upon their return to Europe or the United States. Why? Because, to paraphrase Marx and Engels, the need for a constant supply of new objects to sell chases the art market over the whole face of the globe.[3]

This large annual show of tribal and folk arts contains a tremendous mixture of objects, from Amish quilts to North African jewelry, from gold ancestral house figures from Eastern Indonesia to nineteenth-century cowboys' stirrups, from finely crafted Japanese chests to carrying-baskets from the hill tribes of the Philippines. Many of these things are low on the hierarchy of art—many are useful or decorative (relegating them to craft status), many are made of low-prestige materials like fabric or low-grade silver, many are made by anonymous women rather than named men—but they are

all touted as "authentic." The emporium's claim of "authenticity" is that all objects must be made prior to the 1940s. (Whether they were or not is not the point.) In the "tribal arts" section of the show (which does not contain Native American or cowboy items or folk art from Euro-America), the idea is that the objects were made by people for their own use rather than for the market; hence items made explicitly for the current market are excluded. I was most interested in investigating the objects coming from island Southeast Asia, especially Indonesia, since I happen to know something about that part of the world. What has happened to Indonesia's artifacts on the market can serve as a microcosm for processes that, in varying ways and in differing decades, has been going on since the decolonization of the world in the mid-twentieth century.

Indonesia is currently a source of a kind of third-tier high primitive art—objects made for local use, sometimes with ritual functions, but in any case made with traditional materials and craft skills and not for the market. Much in evidence at the annual emporium were ancestor figures and gold jewelry from the Lesser Sundas, the string of islands to the east of Bali, whose inhabitants until recent decades were largely animist rather than practitioners of a world religion. Clearly ritual objects, and of a durable and precious material, these things may well be called "Primitive Art" by dealers, with the full authority of the capitals in their voices (rather than the more modest "ethnic arts" with which the emporium is largely filled). One dealer in Indonesian art remarked to me that his best customers were collectors of African art, because they were accustomed to paying tens of thousands of dollars for authentic fine old pieces; by comparison, "authentic fine old pieces" from Indonesia are a stunning bargain.

These objects have only recently come onto the market, and one might wonder why. They could have been available several decades ago, between the two world wars, when cognoscenti were collecting primitive art and the Dutch were the colonial power in the area. But they were not in vogue then, and it is worth explaining, or at least speculating, as to why.

Items from this archipelago, the Dutch East Indies, never did influence major modernists in the plastic arts. For one, the Netherlands was not a hotbed of modern art in 1900, and artifacts from its colonial possessions could not therefore be "discovered" and validated by an

avant-garde artist working in Amsterdam. The characteristic arts of this archipelago are based on sound and movement—gamelan music, trance dances—or consist of textiles and gold jewelry, which are "minor" arts, and neither iconic nor sculptural.[4] Then, too, the sensibilities of the Indonesian archipelago very much favor highly ornate and densely elaborated designs of the sort Margaret Mead once pronounced "overbusy." This is not a modernist aesthetic. Then, too, Java and Bali would have a hard time qualifying as "primitive" or "tribal," with their influences from India (a "high" civilization because complex and literate) and Java's adoption of Islam several centuries ago. (The adoption or expression of a world religion in artifacts mitigates their primitiveness in the hierarchy of primitive art.)

The parts of the Dutch East Indies that could have qualified in contemporary sensibilities as more "primitive" (animist societies, largely not literate, some living by hunting and gathering rather than agriculture) were Javacentrically called the "Outer Islands" and were relatively ignored by the Dutch (relative to Java, where the infrastructure and economic exploitation were intense); the infrastructure which might facilitate travel to these places was minimal, and consequently there was little traffic connecting them to world object markets.

Like most of the rest of Asia and Africa, Indonesia became independent in the mid-twentieth century. Like many other newer countries during the Cold War, it strove to maintain nonalignment or neutrality during the 1950s and beyond, particularly under leaders who had led revolutions against the colonial powers. Indonesia's first president, Sukarno, did not encourage either foreign investment or tourism.

The massive liberation of Indonesian objects onto the market came about during the 1970s and 1980s, when huge numbers of textiles, gold jewelry, pieces of temples, wooden ancestor figures from places like Nias (off the coast of Sumatra) and the interior of Kalimantan (Indonesian Borneo), as well as from Java and Bali, were put on the international object market. This came about due to the policies of General Suharto, who came to power in the mid-1960s and created a political program he called the "New Order," which, by the mid-1970s, was well in place. General Suharto's New Order consisted of an aggressive policy of modernization, based largely on the intensive exploitation of the forests of Sumatra, Borneo, and Su-

Figure 23. This advertisement holds out the promise of authentic treasures.

lawesi, and the extraction of oil, the mining of minerals, and, not least, cultural tourism (figure 23).

The nation-state penetrates its own remote areas in the endless search for natural resources, whose discovery and exploitation in the thickest jungles, the deepest seas, the highest mountains, the most arid deserts have become technologically possible only in recent decades. And many third-world nation-states, seeking both foreign exchange and to construct a national identity from the cultural patchwork of inhabitants they inherited from the colonial power they threw off, promote cultural tourism. In the context of easy, cheap, and rapid international travel, cultural tourism may aid both these goals. Thus to the endless search for natural resources (minerals, oil, timber), and the endless search for human resources (cheap labor), is added the endless search for cultural resources—exotic and colorful peoples and their ritual artifacts. Beginning in the mid-1970s Su-

harto's New Order brought even peripheral peoples living deep in the rainforests of Borneo and on remoter islands, and of course their artifacts, into close contact with the state apparatus, and consequently with roads, tourists, and the art market.

Governments promote cultural tourism partly in order to increase foreign currency, which may be necessary for the government to repay its debts to the World Bank and other such agencies. Ideologically, however, cultural tourism is also part of a larger system of modernizing by bringing education and national consciousness to out-of-the-way peoples and bringing them into the global economic system in which the nation-state itself has become an actor. The enterprises brought by governments to peripheral areas tend to be very capital-intensive for the exploitation of the local natural resources. The more out-of-the-way the major structures and infrastructure for the enterprise, the less educated the local people are likely to be. And so local people tend to enter these businesses on the periphery and bottom: they become the workers who dig the roads, not the engineers. They become a rural proletariat in their home region. Similarly, when major traffic in cultural tourism occurs in remoter regions, which may gain more infrastructure to support it (electricity, airline routes or roads), and major hotels are built, tourism is removed from local hands and local homestays. At that point, local people, if they are not entirely displaced, enter the service sector: they bus the dishes, carry the bags, care for the hotel grounds. Again, they become a rural proletariat in their home region.[5]

Oil, timber, and mineral exploitation tends to be in out-of-the-way places; but why should cultural tourism also effectively seek remote areas? After all, government policies promote tourism in general, and they may promote cultural tourism, but they probably do not explicitly promote cultural tourism in remote and undeveloped areas.

The penetration of the tourism market to these places probably has its impulse in the tourist's endless search for "unspoiled" cultures and beaches. Thus tourists tired of Bali's Kuta Beach, with its crowded shops and beer-swilling youths, move up the eastern coast for unspoiled beaches, or they seek greater cultural authenticity in Ubud. Tourists declaring Bali to be too crowded with tourists make their way with more difficulties to Lombok and Toraja-land, where rituals are still colorful and major international hotels have not yet

been built. (But tune in same time, next year.) Those discouraged by the sight of other tourists in Lombok and Toraja-land press on to Irian Jaya and Kalimantan (West New Guinea and Indonesian Borneo). The authentic continually recedes here, too, and drives the market to more and more obscure and difficult places, which soon become well known and comfortable.[6] (As an ad in my files from the Oberoi Hotel in Bali puts it, "We know what you want Bali to be.")

The first tourists to a remote area are those most desirous of the authentic and unspoiled, those willing to take an uncertain airplane that goes once a week between tiny islands and comes back if it can get gas, and they camp on the beach or stay with a family. Like other tourists, these people want tangible tokens of having been there. It is my impression that these travelers are more enamored of the authentic than are the people who take cruises to luxury hotels once tourism is well established, and their souvenirs must by the same token be more authentic. They want to buy objects, either ritual or useful, that are in everyday use. Often they are able to buy at least some of the things they desire. Sometimes this experience turns them into dealers, for, having bought a cache of something appealing, or seeing a source for it, they get the idea that they can finance their trips for pleasure by selling these things in the United States or Europe; and their enterprise grows (figure 24).

In the early 1970s small-scale dealers could go to the markets in urban centers in Central Java and pick up large amounts of attractive things—antique *kebaya* (a kind of blouse) or old jewelry—but soon the Bloomingdale's buyer arrived and bought a gross of them, cleaning the market out of the most obvious and plentiful items. Meanwhile, a market was developing for the last authentic textiles, boxes, jewelry, *keris*, ancestor effigies, and the like. These began to come increasingly from the Outer Islands. The most intrepid Euro-American dealers still make the tiresome journey themselves to the remoter outer islands if they speak Indonesian (and money speaks nearly as well as broken Indonesian), but they often pick up their stock in Bali, for the market's contact points for items flowing in from remote areas of Indonesia consist of the antiquities shops in Kuta Beach in Bali or the very prestigious shops of major hotels. Or the dealers have a local contact, who stays on the spot while the dealer returns to Europe or the United States to the retail market. This local contact, Indonesian

Figure 24. Tourists often become dealers to support their travels, as suggested by this flyer picked up in Berkeley in the early 1990s.

by citizenship and of course fluent in Indonesian, may be someone half in, half out of, a remoter society due to acculturation, heredity, or religious conversion. The "half-in" part means the person knows what is available, is in contact with distant kin or other associates, is fluent in the local language or in Indonesian, and is aware of how to get things done in the circumstances. The "half-out" part means the local contact has little or no psychological investment in the local sacred objects or the local economy, and yet a fair idea of what is in demand on the other end. (This is only one model, of course; the arrangements are nearly as various as the dealers.)

Why, one might ask, do people part with their authentic, traditional objects? I outline a few reasons below, but here I mention only two. One is that the tremendous discrepancy in wealth between these people and outsiders means that an offer becomes difficult to

resist when cash is needed. Second is that people do not always part with their objects willingly. Sometimes the objects are stolen. New infrastructures for tourism and development bring not only tourists but dealers in objects and antiquities and thieves, local or from other regions, who can make an anonymous and fast getaway in a way unthinkable if they had to trek through a tropical rainforest or take a slow boat with a local crew.

THE DEATH OF AUTHENTIC ETHNIC ARTS

The process just outlined—the penetration of the state apparatus into remote areas, and other processes of "development"—initially increases the number of authentic objects from the region in question into the international object market, as happened in Indonesia in the 1970s and 1980s. But the process that initially increases the volume of the objects on the market is the same one that, over the subsequent years, brings about an end to authenticity in the primitive art of a given region. The paths are multiple, each historical circumstance differs somewhat from the next, and the process is in principle neither unidirectional nor irreversible (see Graburn 1976b for some possibilities, though the book is not cast in those terms). But here are some possible paths.

One possibility: The cult objects are stolen and cannot be replaced, either because they are unique valuables or because the costs of ritual process are too great. In Toraja-land, for example, the making of *tau-tau* figures is fairly labor-intensive, but the real expense is the mortuary ceremony for which they are made (not to mention the fact that mortuary ceremonies are conducted only for people who have actually died). In other words, authentic tau-tau cannot be easily produced because the rationale for their production is embedded in particular social practices and meanings.

Another possibility: The ritual is still practiced, but the local society's participation in a money economy makes the people newly aware of the cost of labor to make (carve, weave) these objects. Since they value the objects not for the labor involved but for other reasons, they consequently find it convenient to make cult objects for their own ritual uses more quickly than they used to. They sell the old objects, or the objects are stolen. They make new cult objects,

which are authentic in the sense of being serviceable and used as ritual objects. But the newer ones are not so fine or beautiful as the older ones. If these more recently made ritual objects also get into the art market, they are pronounced "of inferior quality."

Another possibility: People once produced cult objects for their local ceremonies and rites, but they convert to a world religion—Christianity or Islam—and thenceforth have no use for these things. The objects are sold or discarded, and no more are made. (Massive numbers of ritual objects were of course destroyed by missionaries in the nineteenth century and, in some places, well into the twentieth; in that case, the artifacts were not liberated onto the art market but became rare instantly.)

Yet another possibility: People retain some of their craft skills used to produce cult objects, but they then start using them to produce objects for the object market (tourist art, souvenirs). Tourists from abroad always want souvenirs; Indonesian tourists (and there is considerable domestic tourism in Indonesia) must have *oleh-oleh*, a small gift from a distant place, to bring back to friends. Local people may (if they are able) turn their craft skills to producing small inexpensive objects as souvenirs and *oleh-oleh*. Those craft skills that can be used to produce objects that sell as souvenirs continue to be practiced; those that do not, "die out."

The advent of so much development, in short, has had the effect of opening Indonesia to the international primitive-art-and-curio market—both because local, sometimes sacred, artifacts suddenly become visible to dealers and are in demand as authentic, and also because these artifacts have become far more accessible than they once were to dealers and thieves. The depredation due to the art market has brought about an ironic reversal in Toraja-land, the mountainous area of Sulawesi where people carve tau-tau and, after having used them in mortuary ceremonies, place them in the high cliffs with other figures as guardians (figure 25). During the 1970s and 1980s many of the tau-tau were stolen to be placed as commodities in the international art market, a situation brought about directly by the policies of Suharto's New Order. A number of things have happened to the sacred sites as a result of the thefts.

One is that newer, unceremonialized figures have been carved and placed in the cliffs of one area, giving tourists the impression that all is well in the ritual life of the society.[7] Indeed, the text of the

Figure 25. The cliff at Lemo in Tana Toraja in 1975.

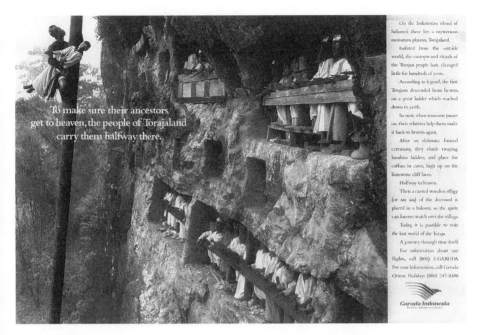

To make sure their ancestors get to heaven, the people of Torajaland carry them halfway there.

Figure 26. This advertisement fails to mention that the tau-tau in this picture are fakes, which were placed there by decree so that tourists would see what appeared to be a pristine site rather than one denuded of effigies.

advertisement shown above (figure 26) reads like a handbook in primitivism, construing the Toraja as a lost Shangri-la existing outside time:

> On the Indonesian island of Sulawesi there lies a mysterious mountain plateau, Torajaland. Isolated from the outside world, the customs and rituals of the Torajan people have changed little for hundreds of years. According to legend, the first Torajans descended from heaven, on a great ladder which reached down to earth. So now, when someone passes on, their relatives help them make it back to heaven again. After an elaborate funeral ceremony, they climb swaying bamboo ladders, and place the coffins in caves, high up on the limestone cliff faces. Halfway to heaven. Then a carved wooden effigy (or tau-tau) of the deceased is placed in a balcony, so the spirit can forever watch

over the village. Today, it is possible to visit the lost world of the
Toraja. A journey through time itself.

The historical circumstances of the Toraja, both for the last several
centuries and in the recent past, are quite different from the centuries
of isolation claimed in this ad. To deal only with the recent past,
when it became obvious in the late 1970s that Bali would soon reach
touristic saturation, the tourism ministry of Indonesia began pro-
moting Toraja-land as a secondary destination. At that time it had
few tourist facilities and was a perfectly miserable twelve-hour bus
ride from South Sulawesi's main airport, so more facilities and a bet-
ter road had to be constructed; then the tourists were channeled
there. During the next ten years, tau-tau began to disappear from the
cliffs, much to the sorrow and anger of the Toraja. In the late 1980s a
German tourist, outraged that he had spent hundreds of marks to
visit an untouched primitive society only to find the supposedly
pristine cliffs denuded of ancestor figures, threatened to sue the min-
ister of tourism for false advertising. To avoid that sort of thing in the
future, the regional governor ordered new tau-tau to be made and
placed in the balconies. Now most tourists don't know the difference
(Volkman 1990).

At another site, Lemo, the descendants of the people memorial-
ized with the tau-tau, after having suffered several thefts, have now
enclosed a low cliff balcony with steel casements, which they lock at
night when no one is around to guard the ancestor figures (figure
27). These balconies now resemble nothing so much as little jails.
"Pa'jaga dijaga," remarked one descendant ruefully to me: "The
guardian is [now] guarded."

On the retail end of the authentic primitive art market, other tales
are being told. In an article about tourism, the anthropologist Toby
Volkman mentions being in an art gallery in New York that exhibited
a tau-tau. It was labeled merely "Toraja: Figure." Having lived in
Toraja-land, Volkman knew that tau-tau are not "art" and were not
made for exchange; she knew, consequently, that all tau-tau on the
market have been stolen and spirited out of the area. She also knew
well the pain these thefts cause the living Toraja people. But when
she asked the gallery owner about the provenance and meaning of

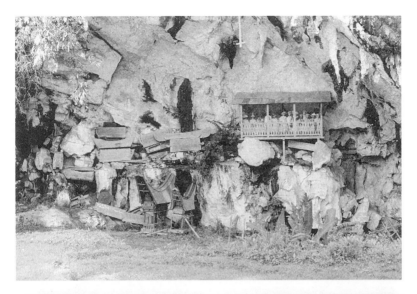

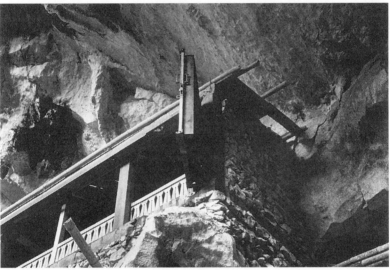

Figure 27. A low cliff balcony at Lemo in 1975 *(top)* and in 1989 *(bottom)*. The later photograph shows the balcony reinforced with steel casements, which are locked at night in order to guard the ancestor figures.

this particular sculpture, he assured her: "The culture isn't really living anymore" (1990: 89).

The gallery owner's ingenuousness seems obviously related to the way the metanarrative of modernity constructs "the primitive" as "the past." Just as was the case in nineteenth-century evolutionist visions of the progress of human history, living peoples and cultures are still considered archaic, a kind of pristine primitive in touch with the earliest stages of humankind's evolution as a whole. People of archaic civilizations may still be living, but they are "caught" in a previous era of time. (Think of the many descriptions of non-Western peoples as "Stone Age people entering the twentieth century.") Thus living peoples are classified as already "past," ready to disappear at any moment and charted for death. Nothing can be done in the way of artificial respiration, and hastening their demise by collecting their authentic artifacts can be no great crime.

Holding the belief that "the culture is dead" or that crafts "die out" as a natural process has certain obvious psychological benefits for dealers, collectors, thieves, and governments, enabling them to ignore the fact that the looting of cult objects may in fact hasten the culture's demise in the sense that it may force the people of that society to alter their practices considerably, not to mention that the loss of their cult objects may cause them a great deal of pain. It also allows dealers and collectors not to attend to the processes that brought the objects onto the market in the first place. Understandably, then, many dealers and collectors, who may well never have been to the societies that are the sources of the objects they deal in, tend to think that these societies are defunct.

Pause for a Screed

The biological metaphor of "dying out" is not an apt one. It *is* a convenient one: such a belief, held by policymakers, disguises to themselves as well as to foreign governments, foundations, and agencies the fact that these societies and their crafts and cult objects undergo changes as a result, sometimes merely as a side effect, of government policies.

To imagine that the cultures and ways of life of marginal or impotent peoples who now find themselves (rather to their surprise and

often dismay) within nation-states "disappear with the coming of modernity" is rather like saying that tropical rainforests disappear with the coming of modernity, as though invasive grasses moved in and replaced dripping wet, densely growing flora of its own accord, as part of a natural and inevitable process beyond the reach of human agency. Saying that rainforests disappear with the advent of modernity obscures the fact that they are cut down by lumber companies in collusion with the government of the nation-state in question or are burned down by the extensive fires that can occur because of clear-cutting.

Change is a historical and intentional process, not a natural process. In the path of the ideology of modernization, ways of life do not disappear of their own accord but are made to disappear by particular policies or by their unheeded side effects. Like the idea of art, the modernization narrative is a self-fulfilling prophecy, once it has been taken up by postcolonial nation-state governments and their foreign advisors. For, when the right people believe that intensive capital investment for timber, oil, minerals, dams for hydroelectric power, and the like, is inevitable, and when the development is to take place in formerly obscure and undesirable places, and when it requires the displacement of sparsely settled unschooled peoples coded in official rhetoric as backward and in need of modern amenities, the process of modernization indeed becomes inevitable.

Except that, as everyone knows, the marginal minorities do not modernize by joining the local middle class, such as it may be. They modernize by joining the urban poor of the cities as rickshaw drivers, prostitutes, cigarette-sellers, or in other occupations that allow them to live on the margins of hunger and disease.

But, as everyone knows . . . "You can't stop progress."

The upshot, in any case, of the varying paths to modernity is that intricately worked cult objects are no longer being produced or are produced in very small quantities compared to the demand for them. In other words, after the initial burst of artifacts liberated onto the international object market, all "traditional" objects become rarer.

Because of the laws of supply and demand, the increasing rarity of traditional objects raises their price. That statement includes even decorative arts like textiles and jewelry, as long as they are hand-made and traditional. As the owner of the "ethnic arts" jewelry store in Palo Alto said, "Everything *real* is going up in price, because they're not making it anymore."

5

• • •

Authenticity, Primitivism,
and Art Revisited

The scarcity of "everything *real*" encourages the production and re-classification for the market of artifacts that materialize older cate-gories but in different configurations. New types of artifacts rush in to fill the preexisting conceptual spaces of the authentic, of the ethnic/natural/primitive, and of art (or the art-like), in various permuta-tions and combinations of those three attributes. Commodification operates in classic rubbish theory form: objects and classes of objects formerly invisible ("rubbish") become transient objects, that is, com-modities; and some transients become durables. The marketplace, the politics of cultural and artistic revivals, and scholarship all pro-mote and legitimate these newer productions and reclassifications.

THE TRANSFORMATION
OF ARTIFACTS MADE FOR THE MARKET

During the golden years of authentic primitive art (roughly the thirty years following World War II), artifacts made explicitly for the market lay below the threshold of visibility. Authentic primitive art objects were thought to be made for higher spiritual purposes, preferably magical ritual ones. Thus the "decorative art" and "non-art" in the Field Museum's instructional display case mentioned in chapter 1 (see figure 15) were both authentic and primitive (because they were not made for the market), even though they were not *art;* and tourist art did not even appear in the case—it did not even rate as "non-art" in 1986; it was invisible rubbish.

All that is changing. Artifacts made by third- and fourth-world peoples explicitly for the market in forms and designs that signified the primitive or the ethnic used to be made largely for the tourist and souvenir market; invisible in the high primitive art market, they

were disparagingly called "tourist art" and were regarded as rub-bish. Now, however, people on the fringes of the global economic system are making artifacts deliberately intended to be art and delib-erately intended to enter the high primitive art market, and they are enjoying considerable success. Such artifacts are still made in forms and designs that signify the primitive and the ethnic, and these arti-facts have become highly visible. Moreover, the status and meaning of so-called hybrid objects are being revaluated, with the result that even older tourist art is gaining stature. In short, if in its golden years authentic primitive art materialized the juncture of the discourses of authenticity, primitivism, and art, in the same period tourist art ma-terialized authentic primitive art's shadow side—inauthentic com-mercial kitsch. Now that the discourses have changed, the object and its shadow have all but disappeared.

TOURIST ART LEAVES THE REALM OF RUBBISH

Increasingly since the 1980s, several factors have conspired to create at least a window of opportunity for artifacts made for the art and souvenir markets by third- and fourth-world peoples to emerge from the limbo of invisibility and to begin being taken seriously as either transient or durable, celebrated and institutionalized.

The beginning of tourist art's visible ascent as a topic for scholar-ship might be dated at the publication of Nelson Graburn's *Ethnic and Tourist Arts* in 1976. A landmark in its climb was the exhibit and the 1986 catalog by Ralph Coe called *Lost and Found Traditions: Native American Art 1965–1985*. The moment of publication of *Lost and Found Traditions* was, significantly, the mid-1980s, just as the schol-arly attack on the idea of authenticity and on the alleged ahistoricity of "tribal" and "primitive" peoples was helping to valorize "hybrid" objects that could be located in time. These hybrid artifacts incorpo-rate machine-made "Western" elements and are often made for the market, rather than for local ritual purposes. Coe's *Lost and Found Traditions* opens with this statement: "While considerable interest has been focused in recent years on traditional American Indian art, little attention has been paid to contemporary/traditional American Indian Art." Coe goes on to opine that "All too often contemporary Indian arts and crafts have been dismissed as pale reflections of

once-great art forms now gone forever, like a drum gone silent. It is as if the Indians of old had departed from these shores, leaving nothing behind except an artistic heritage frozen in the past." Yet, he continues, "the contrary is true. This project [the exhibit 'Lost and Found Traditions'] shows that their past is more than an occasional reference point for today's Indians, and that there is a legacy alive and active to this day" (1986: 15).

One sees in these lines the beginning formulation of a new story, one that will make hybrid artifacts made for the market both visible and valorized.

The exhibit "Lost and Found Traditions" showed hybrid items par excellence,'like tennis shoes and baseball caps with elaborate beadwork. Their moment as art, however, was brief and probably is over. More powerful forces are at work to sort handmade-for-the-market objects into the familiar, pure categories of art versus craft.

FOLK CRAFTS VERSUS HIGH ETHNIC ART

Indigenous peoples whose livelihood was modified or destroyed in the course of their contact with the global economic system have historically, at least for several centuries, supplemented their material subsistence by turning to the production of items for sale. That is nothing new. But what will become craft, what art, in the new regime that legitimizes the selling of objects by people of Africa, Oceania, and aboriginal America?

Even though they participate in the newer authenticity and primitivism discourses in some of the same ways (about which more in a moment), it is my impression that artifacts made for the market by third- and fourth-world people, often anonymous women, from soft materials and for decorative or useful purposes, become transient craft objects rather than high art durables. These things are "ethnic arts" or "ethnic crafts," marketed in glossy catalogs that come to one's house in bulk mailings or are available in marketplaces in their countries of origin.

By contrast, artifacts made for the (art) market by third- and fourth-world people, usually named men, from the traditional materials of European art—especially paint and canvas, and the harder materials used for sculpture—for no useful purpose other than to

Figure 28. Third- and fourth-world artists working in high-art formats (like acrylic on canvas) produce art by intention, which enters the market on the high end.

hang on walls or perch on pedestals, are art. Indeed, they are art by intention. I call this genre "high ethnic art" (see figure 28).

One thinks, for instance, of the long-established fine arts traditions among Native Americans of the Southwest; of the revival of Northwest Coast arts during the 1970s, fully established with the apparatus of fine arts galleries in Vancouver and Seattle by the early 1980s; and of the major exhibition of Australian Aboriginal work at the Asia Society in New York in 1988, displaying "Dreamtime" images painted on canvas with a brush and acrylics rather than on bark with a stylus. These art movements are also, indeed often, expressions of and vehicles for cultural revivals and politics.

Objects of this sort are increasingly embedded in discourses of high art, in which the genius of the individual artist, the influences

he (or she, but usually he) has had or will produce, the individual piece's style, and so forth, occupy a large rhetorical place.[1] Yet the artists producing high ethnic art walk a fine line: if their work materializes only the category of art and loses any claim to be primitive and authentic, it risks being pronounced merely "derivative." I have heard that judgment passed on artists of the urban centers of Asia—Jakarta, Singapore, Bombay, Bangkok, Hong Kong—who work in paint on canvas in styles and subject matter not immediately identifiable as ethnic or exotic. For the same reason, it is very difficult for promoters of easel arts from the third world to find a museum venue for temporary exhibitions of these works in the United States: fine arts museums reject them because they are "derivative," therefore "uninteresting," while natural history museums reject them because they are not "traditional." ("Traditional" artifacts made by the descendants of the people whose material artifacts inhabit natural history museums, by contrast, tend to be welcome, as natural history museums strive to honor such artifacts belatedly by installing them in temporary exhibits as "art.")

What makes these newer "ethnic" arts and crafts "authentic"?

AUTHENTICITY REVISITED: THE CASE OF THE SOUTHWEST

"Authenticity" more and more designates, I believe, that the artist is an authentic Australian Aboriginal, Native American, or whatever. In the United States, legislation has been passed to guarantee this; airport gift shops, for example, are legally obliged to label things as (for instance) "Southwest Style Jewelry" or words to that effect, rather than as "Authentic Navajo Jewelry," unless they are made by authentic Navajos. Authenticity has been transferred from the object to the author.

The issue has become pressing. With all the art-making for the market going on, and with images signifying the mystical and primitive becoming suitable subject matter for art and craft objects, and with artists from Africa, Oceania, and aboriginal America making art by intention at the same moment that other artists are turning to primitivist subject matter for their own productions, and all at the point when objects participating in the discourses of authenticity, primitivism, and art are gaining market share—what counts as authentic is becoming more and more of a problem.

When William Rubin (1984a) defined the authentic object as "one created by an artist for his own people and used for traditional purposes," he understandably did not spell out all the components of this notion. Tourists collecting Northwest Coast Indian art implicitly do, however, and a researcher in tourism studies, Karen Duffek (1983), found that non-Indian buyers of Northwest Coast art used several main criteria to judge authenticity. One was the item's quality; another was whether the artist was Indian; another was the degree to which the object looked traditional (in design) and how it was produced; and finally whether it was made for the market. Authentic primitive art for both William Rubin and for Canadian tourists would be of high quality, produced by a pure Indian, of traditional design, handmade, and made for traditional purposes. These notions—the purity of the ethnicity or race of the object's maker, the fact that the pieces are made by hand and one at a time, that the object's style identifies it as linked to a particular tribe or culture, and that it was not made for a market—all rest on the assumption that these artifacts have always been made the same way, with the same tools, for the same purposes, and with similar designs.

Upholding such criteria of authenticity is hardly feasible in the American Southwest, where many of the techniques and materials most associated with the area—silver-working, beadwork, rugs— were introduced at well-known points in history. Consequently, the usual criteria for authentic primitive art are impossible to sustain, and each criterion is being legislated. Deirdre Evans-Pritchard provides a historical account of this legislation in her dissertation "Tradition on Trial: How the American Legal System Handles the Concept of Tradition" (1990), where she argues that the major issue and most vexing problem in defining authentic Indian art is deciding who is an Indian. As Evans-Pritchard points out, "Whether [the buyers are] serious collectors or souvenir hunters, buyers' reasons for purchasing particular Indian art pieces have many permutations. For instance, Indian art may be evaluated as a cultural symbol, an investment, a souvenir, a fashion accessory, and/or an expression of personal taste. However, almost everyone who buys Indian art is influenced by the fact that it is Indian" (1990: 134).

The problem in establishing what counts as "authentic" American Southwest Indian art, if one uses the criteria established for authentic primitive art from Africa and Oceania, is that some of the

most "traditional" Native American arts and crafts were made possible due to the introduction centuries ago of tools and materials by the Spanish. Further, in the nineteenth century these items gained a market. In the late nineteenth century, the newly built train system into the Southwest allowed and promoted tourism with its concomitant demand for souvenirs and authentic items; and the establishment of American Indian collections within natural history museums in the late nineteenth century set off a rage for collecting authentic pieces by both museums and individuals.[2]

Three events significant for Southwest Indian art occurred in the twentieth century. One was the establishment of the Santa Fe Indian Market in the early 1920s, which provided a context and market for the self-conscious production of objects created both as art and as craft. In fact, the objects there are called "art-crafts." Another was the establishment of two places where American Indians could learn to produce art in the various media used for fine arts in Euro-America. First came the Art Studio at the Indian School at Santa Fe in 1932, where Indian children, encouraged by Dorothy Dunn, learned to draw using new media, often depicting scenes of Indian village life. Later, the Indian Art Institute supported by the Rockefeller Foundation (established in Santa Fe in 1962) gave adult American Indians the materials and context to learn to become artists in the Euro-American mode. New contexts and materials to work with and new models meant that Southwestern Native Americans began producing objects self-consciously made as art. A few individuals, like the potter María Martínez, became famous and were known as artists although they worked in what have traditionally been considered craft media.

A third significant event was the valorization and institutionalization of traditional, authentic Southwest Indian art. Promoted as America's own primitive art, this high primitive art from the American West gained respectability largely due to the efforts of René d'Harnoncourt working in conjunction with the Rockefeller family. (It was his effort that resulted in the Museum of Modern Art's show "Indian Art of the United States" in 1941.)

This history made and makes it difficult for the market in authentic primitive art, subtype Southwestern, to draw a precise line between where high primitive art ends and degenerate tourist art begins, or where high contemporary primitive art ends and high

contemporary craft begins, or where high primitive art made by tra-
ditional artists ends and high contemporary primitive art made by
certifiably ethnic artists begins.[3]

The stakes in issues of authenticity are high. For one thing, there is
the politics of cultural identity. Because art styles are seen as (stable)
expressions of the ethnicity and character of the group that produced
them, locating just where an object's authenticity lies has become
increasingly important in recent decades. Native Americans and Ca-
nada's First Peoples want to control the construction of their cultural
identities rather than have them controlled by others, and they want
to control the market that traffics in tokens of their identity rather
than have it controlled by others. They want to have the main say in
determining who legitimately makes arts, crafts, or art-crafts with
Indian themes, and who therefore speaks legitimately through these
creations as a voice of Indian identity.

The matter is also economic. Probably nowhere is the issue of au-
thenticity more explicitly and self-consciously linked by its produc-
ers and its dealers to the market than in the Southwest United States.
"With the increased popularity of Indian art, the question of who is
really an Indian and what is truly authentic Indian art comes up
again and again," begins an article in the journal *Indian Market* called
"Taking Another Look at Phony Indian Art" (Weisberg 1989). A 1985
U.S. Commerce Department report, the article points out, "estimated
that 10 to 20 percent of the Native American handicrafts sold in this
country were actually imported imitations." The issue is acute in an
area where imports from Taiwan in the form of things like money-
clips with a plastic "turquoise" inset, machine-made silver bracelets,
and so forth, already engulf the souvenir market. If items like this
could be sold legally as "genuine authentic Indian handicrafts," an
important source of income in a generally economically depressed
area would be undermined or lost. (These objects *are* sold, by the mil-
lions, but they cannot be called "Indian" due to recent legislation.
Obviously they signify "Indian," however, and can function as sou-
venirs of the Southwest because of it.)

The issue of authenticity cannot be solved easily by reference to
"blood," although major efforts are made to do just that. "Blood" is a
problem because many members of Tribe X have married members
of Tribe Y or married non-Indians, and their descendants may be
only half, a quarter, or an eighth, or less, "pure" Indian. And many of

these "racial" mixings have been going on for many centuries, due to the presence of the Spanish and later Mexicans and "whites" in the area. A way that legislation has tried to deal with the issue is to say that to be defined as an "Indian" a person must have tribal affiliation; but tribal affiliation is also a legal matter, and different legally defined tribes have different criteria of "purity" of "blood" for membership, ranging from a half to a sixteenth. Moreover, not all tribes are legally recognized, and some people claim that they are pure Indian but from a tribe not legally recognized. Then, too, until recently it was not particularly lucrative or culturally approved to be an Indian, and a number of younger people who now would like to claim membership in a tribe find that their parents or grandparents married "out" and let their tribal membership credentials lapse. A few decades ago it was more desirable in California, for instance, to be a Mexican than a Maidu.

The issue of style is another problem. The fact is, people all over the world borrow designs, copy them, modify them. Styles and techniques do not express some collective Ur-essence of a people. Yet particular techniques, media, and styles have come to signify the essence of a tribe's work, and their identification with a particular group is the artifact's main selling point. A work of art or writing can be patented by an individual in the United States, but can a tribe patent a design or technique? So far it has not come to that, but tune into law cases in the next few years to see what happens.[4]

The question of what "handmade" ought to mean is yet another issue. Peter Vajda, as president of the New Mexico Indian Craftsperson and Dealers' Coalition, comprised mainly of non-Indian dealers, objected to the original wording of a bill to protect Indian arts and crafts that would have had the effect of making most Indian jewelry illegal. Apparently that was because it was so stringent in its definition of "handmade" that it would have made the use of machine-made jewelry findings (such as hinges, clasps, and earring stems) unacceptable, as well as the use of gems cut by non-Indians. The thinking behind the law was apparently to protect handmade items as more authentically Indian than machine-made ones; but, obviously, insisting on purely handmade items in the late twentieth century would deeply inhibit current art-craft production for the market. The issue then becomes an almost medieval scholastic question about whether "handmade" is an absolute, essential condition, or

whether it is an adjective whose meaning varies with historical cir-
cumstance. The New Mexico Indian Craftsperson and Dealers'
Coalition implicitly opted for the latter position: "In a plea for more
realistic regulations, Vajda pointed out that Indian jewelry is not a
pure but an evolving art form that has been heavily influenced by
the materials and ideas of other cultures. The use of silver, for exam-
ple, was introduced by the Spanish" (Weisberg 1989: 50).

A refrigerator magnet I purchased at the Heard Museum shop in
Phoenix in 1991 speaks to the kinds of compromises being worked
out concerning the manufacture and sale of "handmade" "Indian"
artifacts, which this item purported to be. It is in the shape of a
miniature Pueblo pot about an inch across. It is actually a hollow
half-pot, sliced through the middle vertically, and backed with more
clay to form a flat surface onto which a dime-store magnet is glued.
It is clay, made in a mold, and handpainted by a certified Southwest
Indian. The design is Pueblo. The magnet glued to the pot was ma-
chine-made, perhaps in New Jersey or Taiwan. My refrigerator mag-
net is a certified genuine Indian handicraft (else the Heard Museum
would not have sold it). If it had been made of plastic, or had basket
designs rather than pottery designs, or if it had been molded by
other than a certified Indian, or if its paint had been applied using a
decal, it would not have been acceptable as a handicraft. Very subtle
these days, authenticity.

PRIMITIVISM REVISITED

Handmade objects made by authentically ethnic producers partici-
pate in the primitivism schema in a variety of ways, mainly by visual
reference. The most obvious and basic way to evoke the primitive or
the ethnic is to depict scenes of traditional village life. Dorothy Dunn
in the 1920s encouraged the Indian children in her art school in Santa
Fe to paint traditional scenes of their lives, partly because she be-
lieved those ways of life were passing away and should be celebrated
and memorialized. Walter Spies, in teaching the Balinese to use pen
and ink wash on rectangular paper in the 1930s, encouraged them to
paint traditional Balinese village scenes.[5] Hmong refugees in the San
Francisco Bay Area have been encouraged to embroider for sale story
cloths depicting village scenes from their homes, now destroyed, in
Southeast Asia. And so forth. This strategy is so basic that, if one were

positing stages that the arts of Africa, Oceania, and the Americas had to go through to reach a market, this would be the first.

A second way of evoking the primitive and authentic is by transforming ephemeral ritual media into durable forms that can be sold. That strategy allows designs usually or formerly used in ritual performances and destroyed in the course of the ceremony to be modified and applied on durable materials, thus allowing their commodification. Southwestern sand paintings, for instance, formerly painted on the sand and destroyed in the course of the ceremony, can be put on a hard backing and hung on the wall, thus becoming salable art. Australian Aboriginal designs, which must be re-made for each ceremonial occasion, can be painted on canvas with acrylic. Northwest Coast designs, used formerly for family crests and totem poles and all manner of things, can be cast in different media (gold, silver, silkscreen, marble) and become both high and decorative art.[6]

A third way is by placing traditional designs on new media, an extremely common craft-making practice whereby traditional skills (like Hmong embroidery or Toraja wood carving) can be applied to new objects that can be sold. For instance, Toraja designs, formerly carved and painted on granaries, are applied to house walls and items like tablecloths and wooden boxes (figure 29).

A fourth way is for the artist to evoke or refer to the natural, the primordial, the pure, and the mythical and link this with an ethnic group, sometimes his or her own.

Although all four of these strategies refer iconically to the primitive in some way, I want to draw attention to this last one because it seems the loosest, most generalized way to signify visually a set of ideas about the primitive. At this point I want to pull anchor and abandon my moorings in the authentic to take a side trip into two tributaries of authenticity and primitivism, which I call "New Age primitivism" and "The Look Is Authentic!"

New Age Primitivism

For many collectors and ordinary consumers, the kinds of objects known as primitive art or ethnic arts are the material signifiers of a cluster of related ideas about an imagined Other, an Other who lives in a world of meaning that contrasts with the modern, industrialized, secular world. Perhaps the most pervasive and long-lasting of

Figure 29. Toraja designs, once carved and painted on granaries, are now used in a variety of ways, including on tablecloths and painted walls.

the rhetorical devices and cluster of ideas that construct "authentic" and "primitive" "arts" and "crafts" is the notion that the primitive Other lives closer to nature than do we who lost our innocence when we left the original Garden of Eden, became secular adults, and started producing industrial wastes and eating breakfast-objects from fast-food chains in polluted cities. Whatever one wishes to name the yearning for Otherness and its tokens (primitivism or pastoralism or a desire for authenticity), its appeal is obviously profound and enduring.

Mixed with the late-twentieth-century inclination to appreciate something by possessing it and mixed with New Age readings of rock art, pyramids, kivas, and the like, this yearning has produced a pervasive, sincere, ambivalent, and highly commercialized and usually generalized nostalgia for a harmonious primitive world which, if it had existed in the first place, would indeed be disappearing in the late twentieth century. I call this variant of primitivism New Age primitivism. It produces its own unique style of art. The art world knows about academic realism, it knows about socialist realism, but here is a new topic for study: New Age realism. It is always art by intention. The artists are sometimes Native Americans, sometimes not. The subject matter tends to refer to Native Americans of the Southwest, although Plains Indian headdresses sometimes make an appearance. The center of this movement is in Santa Fe.

Artworks in the New Age realism style (usually paintings) typically feature a Native American item or person in the center foreground, rendered in an almost academically realistic hard-edged style. This person or item may rest upon a ground of sand, but often exists in a vague and ill-defined location, visually reminiscent of illustrations of outer space; around the central person or item float symbols, fraught with an undefined but heavy significance, that seem to straddle the Here and the Beyond; and the whole is generally rendered in the Day-Glo colors of unmixed acrylics.

The Look Is Authentic!

A taste for the generalized primitive rather than for a particular form of ethnicity is common, and in some buyers it can be satisfied by purchasing something that signifies the natural and ethnic without actually being produced by hand or by someone with ethnic credentials. To

quote from my 1990 interview with the owner of an ethnic arts jewelry store in Palo Alto, California, who understood this market, although she held it in contempt and did not cater to it: "People who are interested in tribal art just for the sake of fashion buy it for the look, not for its integrity. It's like people who buy posters instead of art—they want to have the *look* of a Van Gogh in their room, not a real Van Gogh."

I call this type of commodity "The Look Is Authentic!" named after an advertisement in my files for petroglyphs (so called), whose copy reads: "The look is authentic! Fragments of primitive cave art are recreated through a unique process that gives them the texture and detail of the real things. A distinctive accent for a wall or tabletop."

It used to be only museum stores that advertised: "Own a Piece of History! Authentic Museum Replicas"—as one in my files reads. It always puzzled me. What is modifying what here? Is the museum authentic, or is the replica, and if the former, what does that mean, and if the latter, what does *it* mean? Is the replica an authenticated copy of an authentic object in the real museum? Or what? But these existential questions are passé. Apparently people want just an authentic *look*.

The popularity of the Santa Fe style and the discovery of the glamour of the Southwest have spawned many glossy catalogs selling this authentic primitive look. An ad labeled "Dances with Beads" is worth quoting for its evocation of romantic primitivist themes in the service of selling a T-shirt decorated with puff inks:

> A Sioux woman would have worked by flickering firelight, the long winter nights passing like so many bright beads between her nimble hands. Here, in the buckskin color of a prized pony, the sun-washed blue of Father Sky, a hand-dyed, front-detailed t-shirt inspired by her lavish handiwork. Artistry so exquisite, so convincing, the fact that these bright "beads" are actually puff inks comes as a bit of a surprise. Slip into this bedazzling all-cotton t-shirt now and feel the centuries disappear.

Objects whose look is authentic can be made anywhere, by anyone, of any materials from anywhere, using any manufacturing methods. One advertisement in this vein for a rug said to be inspired by a Navajo design reminded me of a sign I saw at the Toyota dealer. The Toyota sign asked, "What is an American car?" pointing out that parts are made one place, assembled in another, sold in another. The rug in question, advertised in a glossy catalog that came to my house, was

called a "Navajo wool dhurrie . . . inspired by an original Navajo pattern. . . . Made of the finest quality New Zealand wool . . . in India."

ART REVISITED: EVERYTHING BECOMES ART

If the question of authenticity is vexing and if the primitive has become a look (a natural-looking look, to be sure), the definition of art (as contrasted to craft) remains surprisingly stable. Not that the same objects fill the category as filled them a century ago, or fifty years ago, or twenty-five years ago: more and more types of objects are upgraded rhetorically by museums, appreciators, collectors, scholars, producers of objects, and dealers in order to honor them by associating them with art. The rhetorical strategies that accomplish this feat are quite predictable, if not straightforward. Here I give a reading of one humorous advertisement and two museum temporary exhibits.

Baskets of Leisure

The narratives that objects are embedded in sometimes influence the categories, sometimes reflect them, but always reproduce them. Take this ad (figure 30) for a set of baskets made in Thailand and sold by the J. J. Peterman company:

> In the beginning, baskets worked for a living. Just check with every third person living on the outskirts of Beijing (anytime during the last thousand years).
> Then there are these baskets. Are they the end of a long line of evolution of the ultimate basket? Of course not. Evolution never ends.
> But what is clear is that these are so refined, so well-bred, they don't actually *need* to work anymore. They just sit there on four legs and allow you to admire them.

These few short paragraphs do a lot of work. This narrative of basket leisure evokes not only the poles of craft and art; it also evokes the distinction between manual labor on the one hand and leisure on the other; consequently, it evokes the difference between the laboring classes, who work for a living, and the leisured classes, who are so refined and well bred they can just sit there. Further, the ad is trying to bring a formerly utilitarian object—a basket, which in times of yore would be non-art—into the realm of art. These baskets are upwardly mobile.

Evolution.

In the beginning, baskets worked for a living. Just check with every third person living on the outskirts of Beijing (anytime during the last thousand years).
Then there are these baskets. Are they the end of a long line of the evolution of the ultimate basket? Of course not. Evolution never ends.
But what is clear is that these are so refined, so well-bred, they don't actually <u>need</u> to work anymore. They just sit there on four legs and allow you to admire them.
They are beautiful even empty. No poppy pods required. No flipping silver 2-inch minnows fresh from the Yalu needed. No dung or mud or quartz or goose down or turtle shells or orange skins necessary.
You don't even need to fill them with sheet music.
One thing you do need. A room in a house that needs something special.
Set of 3 handmade Thai baskets. Inside lacquered black. Outside lacquered classic orange-red. Tight and finely woven split bamboo.
Sizes: small (12-1/2" diameter x 15" high); medium (17-1/2" diameter x 17" high); large (20" diameter x 20" high).
Price: $135, set of three.

Figure 30. The baskets in this ad have "evolved" past any practical use; instead, they are just to be admired.

From Anonymous Craftsmen to Named Artists: The Case of Tuareg Jewelers

A temporary exhibit (January to May 1991) at the de Young Museum in Golden Gate Park, San Francisco, self-consciously addressed the demise of the notion of authenticity (original version). Installed in "Viewpoints," a space for temporary exhibits at the de Young, it featured "Saidi Oumba and Andi Ouloulou: Tuareg Artists of the Sahara." The point of the exhibit, we were told at the beginning, was to raise questions about the anonymity of traditional artists and to question the way they have been romanticized and viewed as existing only in the past. Throughout the show, labels spoke of the Tuareg in the present tense. An oft-repeated label declared, "The name of the artist was not available or was not recorded," drawing the viewer's attention to its absence rather than assuming that anonymity is the natural condition of these sorts of arts and crafts. A point was made, too, to include items that revealed the Tuareg are connected to the world economy. The label for a blouse hung in the

first room told us it was made with "machine lace" and "synthetic thread," and explained that using imported materials is common. The exhibit's explicit intention was

> to dismantle some misconceptions about the work of African artists—particularly the Western stereotype of the nameless "primitive tribal craftsman." Rather than maintaining a timeless traditional style, Saidi's and Andi's work reveals an ongoing creative process based on their artistic responses to an ever-changing world. Yet, in their absence and by representing them using only clothed mannequins, objects, photographs, and labels, we must also question whether we too are stereotyping or misrepresenting Andi and Saidi. (Seligman and Werner 1991)

The show occupied two rooms. The first one introduced the artists and Tuareg history and made some points about the exhibit's point of view. Entering this first room, the visitor saw mannequins wearing the actual clothing of Andi and Saidi which, a label indicated, they agreed to sell in order to increase their reputation. To the right of the entrance hung bright color photographs of the couple, along with historical information about the Tuareg and the place of the artist within the society. To the left of the entrance stood a case with books on the Tuareg in various languages and dates (1830 and 1926 were visible) and a *National Geographic* magazine (1979), featuring on its cover a turbaned Tuareg wearing sunglasses. (Is that "romanticization"?) The label for the case read: "Whether writing in French, German, or English, most authors have tended to focus on the nomadic Tuareg as the noble warrior, wearing his distinctive indigo-dyed turban and billowing robe and riding on a white camel through the desolate Sahara. Photographers have provided a similar romanticized view of the Tuareg."

The second room of the show consisted largely of jewelry, the craft that Saidi and Andi practice, explaining its role in Tuareg life and ending with tourist art. In this room, jewelry was linked to the magical—certain kinds of jewelry are used to increase fertility and protect from evil powers. (That is entirely appropriate, as art but not craft is associated with the magically powerful. This rhetorical move helps to establish that what appears to be jewelry, usually designated craft or decoration, is linked to transcendence.) But jewelry is also an indicator of wealth and status, and its place in the economy

was made explicit in a wall sign: "In addition to the aesthetic and protective function of jewelry is its economic role; it is acquired during periods of material well-being and sold or traded during periods of financial stress. For the Tuareg, silver jewelry is equivalent to a portable bank account. The collecting of large amounts of Tuareg jewelry by outsiders during the past decades is directly related to the economic hardships caused by continuing droughts."

Photographs, labels, and the last display case addressed the Tuareg's conscious adaptation of themselves and their wares to the market. One picture showed a Tuareg looking at a color photograph of a Tuareg in a European magazine; another showed men examining magazine photographs of objects "with tourist appeal." The display case included some obvious examples of tourist art, like a letter opener with a traditional design in its handle. The information on the wall read: "Westerners have difficulty seeing past the exotic image of the Tuareg and continue to focus on important symbols such as camels and the desert environment. What is seen as typical and romantic from a Western point of view is commercialized and frequently returned to the Tuareg through illustrations.... These printed images serve as a direct reinforcement to the enterprising men to dress in 'traditional' garb in an effort to benefit from increased tourism. Production of a souvenir is only a step away."

The argument of this exhibit is summarized explicitly in the last two paragraphs of the pamphlet available at the exhibit. The penultimate paragraph sets up what "romanticization" means to the guest curators: unnamed artists without clear status, living in a static society, where change means the end of tradition: "Andi and Saidi are excellent, but certainly not unique, examples that demonstrate the inaccuracy of the view commonly held by many Westerners that 'folk' and 'primitive' arts are produced anonymously by makers who have little identity or status within their society. Westerners have long maintained that such cultures are static, reflecting 'traditional' styles. This view often runs parallel to the idea that change in these societies must mean cultural and artistic death."

The last paragraph provides the argument against what the guest curators construe as the romanticized view and states the one put forward in the show: "Andi and Saidi, along with most of Tuareg society, continue to innovate, and their art evolves. Their existence and

survival, as that of all artists, must be seen and understood against the reality of changing social and economic conditions."

To put all this in somewhat different terms, the guest curators set up the romanticized view as something akin to the Sweeney-Rubin authenticity concept. (Also, incidentally, the show lumped historical and anthropological works as "romanticization," apparently on the grounds that noticing that the Tuareg lived in a desert environment and rode camels is to romanticize them; the *real* work of the Tuareg, it would appear, is to make art, an activity apparently irrelevant to other features of their way of life.) The guest curators' counterargument is to assert that Tuareg have named artists (just like us) who work for a market (just like us), who wear garments made with imported materials (just like us), whose market in art fluctuates with world conditions (just like us), and who willingly participate in constructing themselves and their art objects in response to the market. In sum, these two Tuareg are construed as individual genius-artists (just like ours). The exhibit has the additional agenda of honoring Tuareg productions by showing that what has mistakenly been called craft is really art.

From Authentic Primitive Artist (Anonymous) to Named Artist: The Case of the Master Carver, Zlan (Attributed)

Even authentic primitive art (old style), whose badge of authenticity is its anonymity, can be converted rhetorically into a more mainstream type of art, as seen in another temporary exhibit at the de Young Museum in San Francisco. This strategy of transformation elevates the non-Western maker of objects to an artist and prepares the conceptual ground for situating the objects in the line of art-historical time.

It was called "Four Dan Sculptors: Continuity and Change" and was on view from September 1986 to February 1987. The show was a tribute to one "master carver" named Zlan of what is now Liberia and to the students he taught. The two-page article on the show in *Triptych*, the de Young's magazine for members, immediately places three of the artists, Zlan, Zon, and Dro, into a market context. It begins with Zon, describing his apprenticeship to Zlan. By the third

paragraph, the two men carve a mask and go "to Tapita to carve for the Dan Paramount Chief Waipapee. They made 'a lot of money,' all of which Zlan kept, as well as the tools made by Zon. Zon returned to Nuopie and, as the only carver in his region, discovered that his newfound skill was in demand. He never again left Nuopie. When a chief or anyone else wanted to commission a carving, he or she came to Zon. The price was agreed upon in advance" (Johnson 1986–87: 10). This and other passages emphasize, in effect, that making art objects for a market is itself "traditional."

Part of the point of the exhibit was also to show that sculptors are known by name: each piece had a label identifying its artist. Giving names to the sculptors had the effect of removing their productions from the anonymous realm of the timeless tribe and promoting them into something analogous to the individual Western *artiste*, concerned with fame, reputation, and money. Curiously, the Ur-artist and master carver Zlan, whose presence as master teacher was the rationale for the show, did not have a single piece in the show that was not labeled "Zlan (attributed)." The absent presence, I reflected, hovered in these attributions; and that was certainly chic. But I wondered how much convincing conventional art history can be written using that kind of material.

Finally, each piece's label listed materials, the way Western art is labeled "gouache on paper" or "acrylic on canvas." This practice was presumably intended to domesticate the exotic by treating these objects like understandable and uncontested art rather than as tokens of exotica. I found the effect quite the reverse, however, in labels like "WOOD AND SHOE POLISH" or "WOOD, PLASTIC INSERTS FOR TEETH." Some of the materials nearly leapt out of the confines of the genre: "WOOD, PAINT, PORCELAIN, COWRIE SHELLS, FUR, HIDE, VEGETABLE FIBER" and "WOOD, PAINT, PORCELAIN, CARPET TACKS, METAL HOOKS, RED BEADS."

In the two exhibits just mentioned, art and primitivism have come full circle. These exhibits, both created in the mid-1980s, responded directly to criticism voiced around that time about authenticity and primitivism. They tried to historicize and deromanticize the notion of primitive art and artists. In this sense, these shows are clearly part of the 1980s trend in anthropology, and cultural criticism generally, to locate all humans, not just Europeans, in time and to see humans, whatever their society, as individuals with agency and voice, rather than as anonymous in the largest sense.

Yet the general effect produced by these exhibits is far less revolutionary and innovative and deconstructive than they pretend, or believe themselves to be. They take for granted that there is an intrinsic difference (rather than a historically situatable origin and construction) between arts and crafts and between artists and craftsmen; that it is better to be an artist; that the market is everywhere, a condition of life. The time these exhibits construct rhetorically is art-historical time—not the time of social history or world events or colonial economics or collecting history, any one of which would have been more interesting. "History" means only "art history," that line of time in which great artists influence subsequent great artists and some of their productions are of higher intrinsic merit than others.

Thus artifacts produced for the market by fourth-world people, objects once ignored and "shrouded in silence," as Ruth Phillips (1995) wrote, formerly invisible rubbish to the eye of art, are gone, replaced with transient objects and durables intended to be bought and sold or at least exhibited in museums as art. Are there any intrinsic limits to what can become art? Joseph Alsop has suggested that "the concept of art itself has more and more tended to extend to almost anything bearing the mark of the human hand. In some circles, preindustrial farm tools, called 'by-gones' by English collectors, have even come to be treated as a branch—a humble branch, no doubt, but still a branch—of folk art" (1982: 22). He is probably right. Anything "bearing the mark of the human hand" is subject to being recast discursively as a form of art: folk art, decorative art, high art, ethnic art, art-to-wear, great archaeological art finds, artistic national heritage.

It is in everyone's interest for these objects to be art. Art brings high prices to the artists and dealers; it brings prestige to the artists and their community; it may bring greater prestige to the nation-state in which the artists perforce find themselves. And art, like other categories, can be inscribed retrospectively on objects produced in the prehistoric but nonetheless national past.

PART TWO

• • •

AND OTHER TALES OF PROGRESS
*Nationalism, Modernization,
Development*

The scarcity of "everything *real*" sets in motion the production and reclassification of art-craft objects that can be commodified in the spaces of the "authentic," the "primitive," and the "ethnic" in the marketplaces of Euro-America. But it sets in motion quite a different reaction in the world of museums, both in Euro-America and outside it: the urge to preserve traditional objects. Preservation efforts seek to guard "beautiful" "old" "traditional" objects rather than allow them to deteriorate where they were produced. This impulse to preserve comes from two main quarters.

One consists of collectors and museum curators in Europe and North America. Their views are often very straightforward: that preserving the past (in the form of old objects) is a good in itself either because it is "art" (and as such deserves to be saved) or because it is a valuable example of "traditional culture" (and as such deserves to be saved). These objects ought to be preserved for future generations—but often not in or by the societies that produced them, because there they will be disvalued, stolen, or neglected, and the facilities for preservation are inadequate. Museums and private collections in Euro-America should become their repositories. At a future time, the argument goes, the producers of these objects will be glad that someone preserved their heritage. (This is more or less the Elgin-marble argument, and it has been thoroughly debated in many contexts.)

The other major impulse to preserve comes from the curators and government officials of the postcolonial nation-states. That is because the descendants of the sorts of people who made the sorts of objects that became primitive art in the West at the beginning of the twentieth century (colonized peoples of Africa and Oceania, and

159

aboriginal minorities in the Americas) have become, the former two since midcentury, people who live within nation-states, rather than being the colonial subjects of European powers or the people living in the path of a nation-state's frontier expansion. They are the Australian Aboriginals, the *indigenas* of Latin American countries, the "domestic minorities" on reservations in North American countries, the "tribal minorities" in many African countries, the "hill tribes" of Southeast Asia. The identification of artifacts with the peoples who made them in the past as expressions of national or ethnic genius, along with the assumption that the archaeological remains lying within a nation-state's boundaries are expressions of the nation-state's ancestral predecessors, deeply affects their valuation as objects. These artifacts and archaeological finds become part of a people's or a country's "heritage," which is "beyond price."

Many nation-states, especially those outside Europe and North America (where nation-states went through analogous processes in the nineteenth century), are currently involved simultaneously in promoting "modernization" and creating stories of nationhood and national heritage. To that end, a fad of building national theme parks and establishing or refurbishing national museums has swept across the world in the last few decades; new or improved state museums are filled with old and new artifacts and archaeological remains discovered within the nation-state's territorial boundaries. In the context of the national narratives displayed in the museums, national theme parks, and achaeological sites turned into tourist attractions, artifacts produced long ago or by marginal peoples have become "national heritage" and "folk culture." Because part of the story of the nation is the story of the unfolding of the modern and of development, these peripheral peoples and their artifacts tend to continue to occupy the space of the "traditional" and the unmodern.

6

. . .

Nationalizing the Pre-Columbian Past in Mexico and the United States

The notion of time as a continuous progression, the notion of the nation-state, the discipline of archaeology, and the notion of art— including folk art—all had their modern origins in the late eighteenth century and developed into something like their modern forms in Europe and the Americas during the nineteenth. But they played out differently in different countries and historical circumstances.

Mexico's course of action regarding its folk and its archaeological ruins paralleled Europe's in some respects. The country became independent in the wake of the French Revolution and the Napoleonic wars: initiated in 1810, independence was confirmed in 1821. Like many European nation-states, Mexico's government established a national museum system rather soon after its independence, in 1831; it had sections for antiquities, natural history and artifacts, and a botanical garden.[1] Yet during most of the nineteenth century, the country was preoccupied more with wars than with forging national identity, especially for the masses.

The state-sponsored creation of a Mexican national identity to be displayed in museums, using both archaeological remains and the crafts of peasants, began in earnest with the Mexican revolution of 1910, whose success was firmly established by 1920 with the presidency of General Álvaro Obregón. One of General Obregón's first acts in office was to commission the archaeologist Manuel Gamio to excavate Teotihuacán, and to order "Dr. Atl" to convene conferences on *artes populares*, that is, folk crafts (Rubín de la Borbolla 1986; and see Atl 1922 and Gamio 1986). These two elements—archaeology and the crafts of living peoples—became equated in the Mexican national story as past and present manifestations of the Mexican na-

tion, because the people who produced these crafts were regarded as the living descendants of the people who had built the great temple complexes excavated by archaeologists. Indians, both ancestral and contemporary, became crucial elements in Mexican national self-construction.

In Mexico, then, indigenes and their architectural productions (especially those of the Valley of Mexico) were claimed as ancestors, hence as "self" rather than "other," by the elite of New Spain from the seventeenth century on (see Florescano 1993). These claims played an important part in New Spain's resistance to Spanish rule and the establishment of the nation-state of Mexico with La Independencia of 1821, as well as in Mexico's internal struggles throughout the nineteenth century and certainly in the twentieth, with the nationalist self-consciousness brought about by the Revolution of 1910. This policy of self-conscious nationalist construction eventually resulted in the current national system of state-sponsored museums.

MEXICO: ARCHAEOLOGY AND HISTORY

Mexico's National Museum of Anthropology, a huge and magnificent structure opened to the public in 1964, stands in Chapultepec Park not far from the Museum of History, which is housed in Chapultepec Castle. Both are administered by the Instituto Nacional de Antropología e Historia (INAH). On its ground floor, around the enormous patio, the National Museum of Anthropology displays artifacts gathered from the great pre-Columbian Mesoamerican civilizations; above each archaeological room, on the second floor, lies a corresponding ethnographic room, containing representations (using mannequins, miniature houses, and artifacts of daily use) of the "living descendants" of the pre-Columbian peoples who produced the artifacts displayed in the spaces directly below. In the museum shop visitors can buy books and guidebooks about both archaeological ruins and living *indios* and can buy both reproductions of archaeological artifacts and items of *artes populares* or *artesanías*, the crafts made by peasants and Indians. In sum, in Mexico the word *"antropología"* comprises both what is called "ethnography" and what is called "archaeology" in the United States, be-

cause in Mexico its subject matter is considered to be two aspects, pre-Columbian and current, of the same thing: the folk or nation of Mexico.

The Museum of History, housed nearby in the old residence of the Emperor Maximilian, takes the realm of history as its subject, and history begins with the conquest of 1521. It continues to the present, although it effectively ends with what is usually taken as its climax, the Revolution of 1910, which helped establish the current government and ruling party.

These two realms, archaeology and history, are joined institutionally and symbolically in INAH because the official and also general view in Mexico is that it is a mestizo society, combining both the Indian and the Spanish—not just genetically but as elements of national character. Archaeology and history are represented in the state museum system as two halves of a whole: that whole is the narrative of national time, stretching from the earliest inhabitants of the New World who crossed the Bering Straits to the present-day administration of Mexico, still in the hands of the ruling PRI, the party that eventually emerged victorious from the Revolution of 1910.

The United States has nothing quite comparable to Mexico in the way of an official, self-consciously national story exhibited in a federally funded and directed museum system, although the Smithsonian would be the nearest analogue. Nonetheless, major museums in the United States also reveal an implicit taxonomy that divides the cosmos into two halves: those halves are nature (the realm of minerals, fossils, animals, and "Primitive Man," because "he" lives in nature, outside of historical time and subject to different laws) and civilization or culture (the realm of chronological time, of cause and effect, and of the unfolding of progress, both technological and spiritual).

The indigenous peoples of the Americas are represented in the museum systems of both Mexico and the United States and play a part in the national stories of each country—though their places are very different in each. National and nationalist stories are narratives, told in books of history and books of art; but they are also told in the form of museum displays and arrangements that appropriate the past in the form of artifacts of conquered and dead peoples. Here I

explore some differences in the representation of American indigenes in the museums of the national past in these two countries. My immediate theme is the different progressivist stories implicitly told in the two museum systems, and what American indigenes' artifacts are asked to signify within them. My larger theme is the suppression of historicity in the interests of progressivist time in national stories involving colonized peoples.

MUSEO DE LA CIUDAD DE MÉXICO

A useful place to begin an analysis of official government views of Mexico's national past and of indigenes within that story, a story that incorporates both archaeology and history, is the Mexico City Museum. The logic of this museum is to create a continuous story of Mexican history from prehistoric times to the present by focusing on the unfolding of events in a single place, the Valley of Mexico. Here the Aztecs had their empire's capital, which Hernán Cortés destroyed and the Spanish rebuilt as the capital of New Spain, and here the capital of the nation-state of Mexico is now located.

The museum's first floor is devoted to archaeology. The first rooms explain the location and geological formation of the valley. We then see a chart depicting the migration of humans into the Americas. Next, a large chart describes "the succession of cultures in the valley of Mexico": on the lowest level of this sign are the first people; above it, the preclassical archaic period; then, Teotihuacán; then, Tenochtitlán; and finally and highest, Colonial Spain.

In the next room, we see pictures and diagrams of the urban precursors of "El Splendor de Tenochtitlán," including and especially "Teotihuacán: Antecedente Urbanistico de Tenochtitlán." As we will come to understand, the fate of Teotihuacán in the official story is to be a precursor of Tenochtitlán (figure 31). In subsequent rooms, México-Tenochtitlán is founded in 1325 by the sign of the eagle that carried a snake, the symbol that appears on the Mexican flag, and as we move through several rooms we see the splendor of México-Tenochtitlán (figure 32). Pictures of the codices hang on the wall, murals show us the panorama of the valley (now no longer merely geographical but fortified and with ceremonial complexes), and diagrams reveal the social organization of the Aztecs.

Figure 31. In official versions of Mexican history, such as this one in the Mexico City Museum, the fate of Teotihuacán is always to be the antecedent of Tenochtitlán.

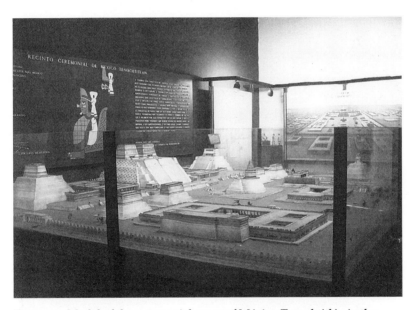

Figure 32. Model of the ceremonial space of México-Tenochtitlán in the Mexico City Museum.

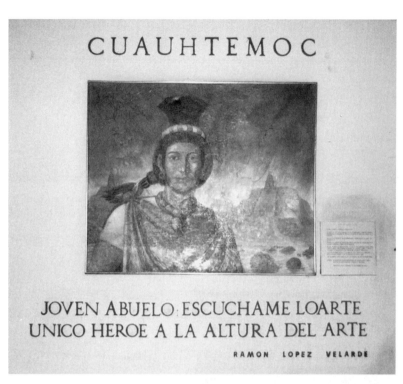

CUAUHTEMOC

JOVEN ABUELO ESCUCHAME LOARTE
UNICO HEROE A LA ALTURA DEL ARTE

RAMON LOPEZ VELARDE

Figure 33. Cuauhtémoc, who resisted Cortés, is cast as the first hero of the Mexican nation in the Mexico City Museum.

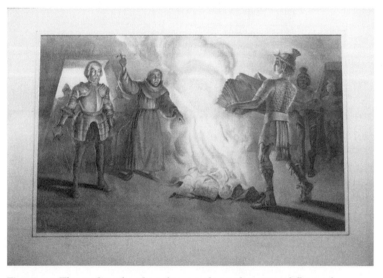

Figure 34. The realm of archaeology ends on the ground floor of the Mexico City Museum with the burning of the codices by the Spanish.

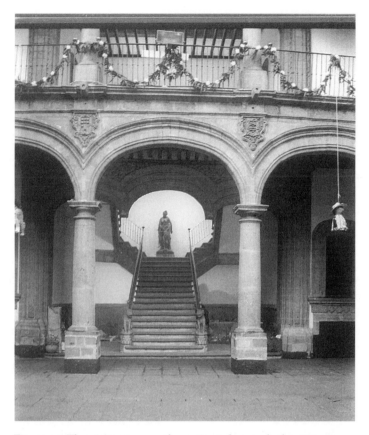

Figure 35. The visitor crosses the patio and ascends the stairs to enter the realm of history on the second floor of the Mexico City Museum.

Then comes the conquest of 1521, with pictures of Montezuma as well as Cuauhtémoc (figure 33), the burning of the codices (figure 34), followed by New Spain's Plaza Mayor with the viceroy's palace and the cathedral. With the codices burned and the Aztec ceremonial complex displaced by the Plaza Mayor, the realm of archaeology ends.

The realm of history proper now begins. The population of the realm of history consists almost exclusively of white Christian men, mostly in rather stiff collars, and to see it we must move up the stairs to the second floor (figure 35). It may be significant that the first room in the history section is a *capilla*, a reconstruction of a chapel from a private home. Mexico may be the root of culture in the Americas as the first sign in the history rooms tells us, but this

culture is completely European: the printing press, architecture, and so forth stem from this root, exhibited in the first section of the realm of history. With the exception of a few clearly Mexican contributions to this society's architecture (as in the basilica of a church; see figure 36), everyday life in "splendid" New Spain is European. History unrolls in the progression well known to all Mexican schoolchildren: independence (with its precursors celebrated), the restoration of the republic after Maximilian's ouster, the reformation under Benito Juarez, and the culminating event, the Revolution of 1910 (figure 37).[2]

THE TWO REALMS

As depicted on the ground floor of the Mexico City Museum, the realm of archaeology is inhabited by Indians of both sexes, who grow maize and tomatoes in a volcanic land and are involved in a complex and hierarchical social and political organization. They build great ritual complexes that clearly progress toward and culminate in Tenochtitlán. They are nameless until the realm of archaeology closes and intersects momentarily with the beginning of the realm of history; at that point two named Aztecs appear, Montezuma and Cuauhtémoc.

The realm of history on the second floor is the realm of Europeans, many with names; Indians make almost no appearance. We see nothing of the system of haciendas or the condition of Indians, that is, nothing of how Europeans make a living in this volcanic land. And although presumably Indians convert to Christianity, we see little of the activities of the Church.

Separated on the two floors of the Mexico City Museum, the two realms of *la arqueología* and *la historia* do not interpenetrate. And, like nature and culture in the United States, each has a museum to itself as well, in Chapultepec Park.

History is housed in Chapultepec Castle. In the castle itself, history is represented with some complexity; but the schoolchildren's version of the realm of history can be seen in El Caracol, "The Snail," a circular building located in the approach to the castle. The building's spiral ramp leads down the line of time as the visitor passes tens of miniature dioramas depicting important historical events. These dioramas reveal very much the same progression, actors, and causes that children learn about in their school textbooks or what

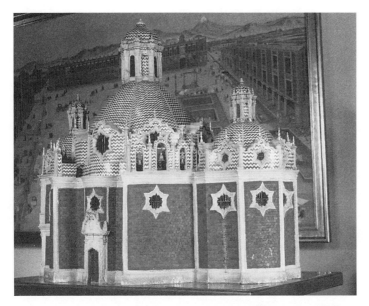

Figure 36. This clearly "Mexican" basilica architecture is an exception to the emphasis on Spanish upper-class life in the depiction of the "splendor of New Spain" at the Mexico City Museum.

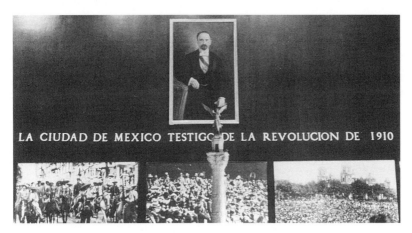

Figure 37. Mexican history culminates in the Revolution of 1910 at the Mexico City Museum.

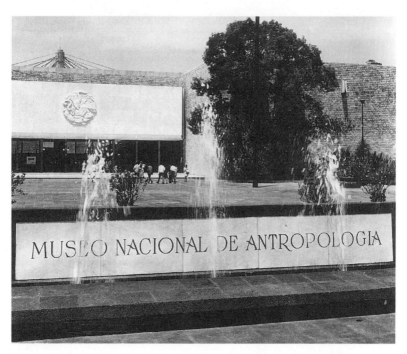

Figure 38. Entrance to the National Museum of Anthropology, Mexico.

they would learn if they went to the Mexico City Museum: the actors of history are male, white, Christian, and they are primarily occupied in political intrigue that will eventually result in La Independencia, La Reforma, La Restauración, and finally La Revolución. It seems clear that the most important phase of La Historia lasts about a hundred years, running more or less from the immediate precursors of La Independencia to La Revolución.

La Arqueología is elaborated in far greater detail and magnificence, in the National Museum of Anthropology than it is in the Mexico City Museum, but it is structured in much the same way: as a progressive line running from the antecedents of the peoples of Mexico, to Teotihuacán, to its climax in Tenochtitlán.

MUSEO NACIONAL DE ANTROPOLOGÍA

The visitor enters the National Museum of Anthropology by way of its truly monumental approach and bank of wide steps (figure 38). Once inside (figure 39), the visitor finds a museum shop on the left

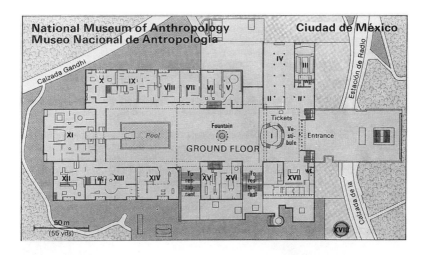

I Sala del Resumen
(Film, etc., displays)

II Special exhibitions

III Auditorium

IV Recent excavations

V Introduction to Anthropology
An outline of anthropology and its auxiliary disciplines; models, dioramas, maps, displays, etc.

VI Cultures of Meso-America
Hunting (weapons, game animals), development of agriculture, population, rituals (forms of burial, festivals, music), cultural achievements (numerical system, calendar, script, medicine, architecture, painting).

VII Sala de Preistoria
(Prehistory)
Migration over the Bering Strait, development of the hunting and collecting cultures (human and animal fossils), beginnings of agriculture in the Valley of Mexico.

VIII Sala del Período Preclásico
(Pre-Classic or Formative period)
Development of pottery and other crafts; good examples of the figures from Tlatilco, particularly the female figures known as the mujer bonita; the "Acrobat Vase"; model of the Cuicuilco pyramid.

IX Sala de Teotihuacán
Classification of the different phases of this important culture on the basis of artistic techniques, particularly in pottery; sculpture (Xipe Tótec from Tlamimilolpan, Chalchiuhtlicue, Huehuetéotl); reconstruction of the "Paradise of Tláloc" fresco; masks.

X Sala de Tula
(Toltec Classic period)
Stelae, Atlas figures, sculpture (Chac-mool), pottery.

XI Sala Mexica
(Aztec Post-Classic period)
From the coming of the Chichimecs to the fall of Tenochtitlán: Calendar Stone ("Stone of the Fifth Sun"), Stone of Tizoc, codices, maps, magnificent sculpture (Coatlicue, Xochipilli), diorama of the market of Tlatelolco.

XII Sala de Oaxaca
(Zapotec-Mixtec culture)
Pottery from Monte Albán, stelae, urns, masks, Mixtec jewelry.

XIII Sala de las Culturas del Golfo de México
From the early Olmec material to the El Tajín culture and the Huaxtec excavations: pottery and stone sculpture from La Venta, hachas ("axes" – ceremonial objects), palmas and yugos ("palms" and "yokes" – stone objects, probably connected with the ritual ball game), stelae, objects made from jade.
Outside: colossal sculpture.

XIV Sala Maya
Stelae, stucco heads, terracotta figures (particularly fine examples from the island of Jaina), copies of the famous Bonampak frescoes, Atlas figures and delicate stone carving from Chichén Itzá.

XV Sala de las Culturas del Norte
(Cultures of northern Mexico)
Grave goods, everyday objects, pottery, material from Casas Grandes.

XVI Sala de las Culturas del Occidente
(Cultures of western Mexico)
Fine terracotta figures from Jalisco, Nayarit and Colima, which give a picture of daily life in the period before the arrival of the Spaniards; Tarascan material.

XVII Salón de Venta
(Museum shop)
Publications, transparencies, handicrafts; reproductions of exhibits; guides to the Museum.

XVIII Monolith
The gigantic figure known as Tláloc, but probably in fact his sister Chalchiuhtlicue.

Figure 39. Ground floor plan of the National Museum of Anthropology.

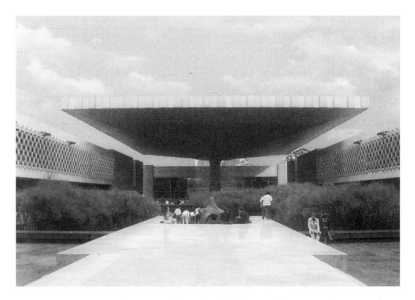

Figure 40. The "great parasol" *(above)*, which partially covers the central patio of the National Museum of Anthropology (viewed from the Mexica Hall), and its supporting column *(opposite)*.

containing not only guidebooks, reproductions, and videos of archaeological objects and sites, but also *artesanías*, arts and crafts of peasants and Indian groups along with books about them. On the visitor's left is a space for temporary small exhibits (mainly concerning folklore and living cultures). In the front center of the entrance hall is a small theater where a twenty-minute orientation to Mexican archaeology can be viewed.

To continue on to the main patio and exhibition halls of the museum, the visitor is required to pay an admission charge at the entrance to the right of the theater. (This was one of the few official museums in Mexico that charged admission in late 1989, when I visited it, and I wondered whether it was not in order to oblige visitors to enter at the beginning of the narrative that is about to unfold.) The archaeology halls surround a giant, open rectangular patio, partially covered with a "a great parasol from which light and water fall," its column "covered with reliefs that repeat the themes of the official rhetoric" (Paz 1972: xx; see figure 40).

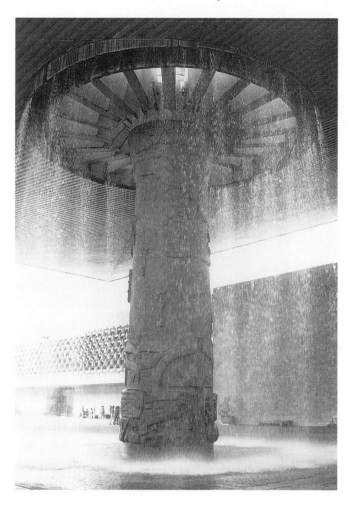

If visitors begin at the entrance and walk counterclockwise around the periphery of the great plaza, as the layout encourages them to do, they will recapitulate, in walking, the well-known unfolding of the realm of archaeology: Mesoamerica as a geographic place, followed by the story of origins and "preclassic" civilizations, then Teotihuacán, followed (with a brief interlude for the Toltec) by the Mexica of Tenochtitlán (better known to English-speakers as the Aztecs). The Mexica are clearly the culmination of the unfolding nar-

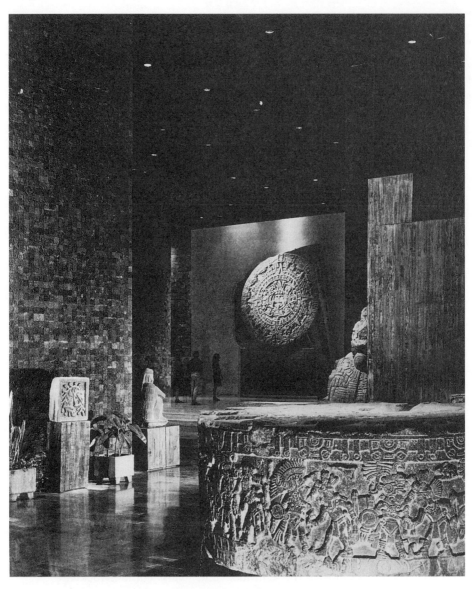

Figure 41. The Aztec calendar stone, center and focus of the Mexica Hall at the National Museum of Anthropology.

rative of archaeology, and their hall is placed in the commanding position of the rectangular patio (numbered XI on the floor plan in figure 39). The centerpiece of the huge central room is the Aztec calendar (figure 41), flanked by other monumental pieces, all dramatically lit. The inscription at the hall's entrance declares:

En tanto que permanezca el mundo,
no acabará la fama y la gloria de México-Tenochtitlán

As long as the world endures,
the fame and glory of México-Tenochtitlán will be unending

After the climax at Tenochtitlán of the journey through archaeology, visitors continuing to walk counterclockwise will reach the other ancient cultures of Mexico, those of Oaxaca, the Gulf of Mexico, the Mayas, and northern and western Mexico areas. Unfortunately, unable to be inserted in the great story of the antecedents of Tenochtitlán, they are placed like an inconvenient but important afterthought on the other side of the patio.

Like the lower and upper floors in the Mexico City Museum, the two floors in this museum indicate earlier and later time. But the second floor here contains not "history" but ethnographic exhibits of living peoples, each exhibit corresponding to the geographical region whose archaeological productions are on view below. Far better (in my opinion) than many ethnographic dioramas in museums in the United States, those in this museum deliberately mute realism: the clothing, tools, and accoutrements are, in fact, apparently real, taken from the village or market, but the mannequins are stylized, and many backdrops are starkly bare or merely gesture toward realistic models (figure 42). Nonetheless, these ethnographic exhibits have many of the same problems as ethnographic dioramas in the United States. The indigenes depicted here live in an eternal ethnographic present, without change, without governmental policies, without internal colonial history.

The sole exception to the two-floor arrangement in this museum occurs at the grand hall of the Mexicas of Tenochtitlán, which rises to the height of two stories. Visitors can look down into the great hall of the Mexicas from the walkway linking the second-floor ethno-

Figure 42. Ethnographic display on the second floor of the National Museum of Anthropology.

graphic exhibits that flank it (figure 43). By failing to locate the descendants of the Mexicas in a single Indian group, region, or set of language speakers (as is done for all other pre-Columbian civilizations that produced artifacts on display on the ground floor), the exhibition asserts that modern Mexicas cannot be located in a single group in Mexico: Mexicas have as descendants all Mexicans, who are their heirs.

In this respect, the Mexican nationalization of the deep past strikes me as quite different from many national stories of the past, which often cast early heroes of epics, say, as protonationalists—even though the nation-state itself had not been dreamed of at the time the hero was supposed to have lived. True, there is a slight inclination to see Cuauhtémoc as a protonationalist because of his resistance to the Spanish, but the overwhelming thrust of the official view of the past is, rather, not that Aztecs were protonationalists but that Mexicans are present-day Aztecs.

Why are the Aztecs the ones glorified as the ancestors of Mexicans in the National Museum of Anthropology? Why not the Mayas, for instance?

Figure 43. Here, the photographer peers through the glass of the second-floor walkway above the Mexica Hall at the National Museum of Anthropology. Unlike the other archaeological halls, the Mexica Hall has no second floor (and thus no display of the ethnographic present directly above the archaeological past). Instead, the visitor on the second-floor walkway becomes, in effect, the ethnographic present of the Mexica: Mexican visitors on the second floor occupy the symbolic space of living Aztecs.

Octavio Paz asks and answers this question at some length in *The Other Mexico: Critique of the Pyramid* (1972). His argument is poetic, complex, and inflamed, written in the aftermath of the government massacre of students on October 2, 1968. The gist of it is that Mexico's polity and society form a great truncated pyramid, culminating at the Valley of Mexico. From there the Aztecs dominated the surrounding peoples; there the Spanish colonials replaced the Aztecs by building the capital of Nueva España directly on the Aztec ruins; there the Spanish were in turn replaced by independent Mexico (whose capital likewise was at the Plaza Mayor), and eventually by the PRI after the 1910 revolution. Paz argues that in important respects—especially domination—all the rulers that established themselves at the site of the Aztec capital were ideologically continuous with it. He singles out the National Museum of Anthropology as the symbolic expression of this continuity:

> The visitor strolls enchanted through hall after hall: . . . all the diversity and complexity of two thousand years of Mesoamerican history presented as a prologue to the last act, the apotheosis-apocalypse of México-Tenochtitlán. . . . This exaltation and glorification of México-Tenochtitlán transforms the Museum of Anthropology into a temple. The cult propagated within its walls is the same one that inspires our schoolbooks on Mexican history and the speeches of our leaders: the stepped pyramid and the sacrificial platform. (Paz 1972: 110)

The dominance and glorification of the Aztecs in the museum and in national life do seem to me something of a puzzle; even Diego Rivera (see Braun 1993) preferred objects from the Central Valley over those from other areas. One might hazard a few suggestions, besides that of Octavio Paz, to explain this glorification.

One reason is that the Aztecs stand most visibly as the indigenes who suffered the conquest and subsequent colonial rule. After all, it was they who were conquered, and they whose capital city was destroyed. A second reason is that the Spaniards literally displaced the Aztecs by building their capital on top of the Aztec capital in the Valley. When La Historia replaces La Arqueología in the national story, it does so by displacing it spatially, by building the capital of New Spain on the ruins of the center of the Aztec empire. Similarly, when New Spain was displaced by independent Mexico in 1821, the capital of Mexico remained in the Valley. Events that count, events that

matter, take place at the same site and are continuous with what went before. And finally, the point of the Mexican national story of the past, and of much rumination by Mexican writers in the decades after the Revolution, is that the "Mexican" is neither a Spaniard nor a pure indigene but a mestizo. Enrique Florescano has told us (1993) that since the seventeenth century, the elite of what would become Mexico claimed the indigenous past as "self," as part of its own identity. The Valley of Mexico, where Spain displaced but mingled with the indigenous populations, is the most visible site of the creation of the mestizo.

The overall effect of the Museum of Anthropology is to glorify Aztecs, who become the center, the unmarked category, from whose implicit point of view the past and present are organized into a coherent narrative. Insofar as people of regions outside Mexico D.F. assert an identity different from that of the abstract citizen, they are *"indios,"* "ethnics," the "other," the objects of ethnography, and the objects of government policies rather than their creators.

THE UNITED STATES: NATURE AND CULTURE

Neither "folk" nor Amerindians figured prominently in early versions of national identity in the United States. The American Revolution occurred in the late eighteenth century, before the nineteenth-century European romantic view of the folk, the peasants, and nature had gripped the imaginations of builders of nation-states. The U.S. Declaration of Independence and Constitution are Enlightenment documents, cast in the language of rights and contracts—the U.S. national identity was not based on a romantic nationalism, at its inception, at least, that looked to roots, soil, and national character to define itself. (But see Hinsley 1993 for nineteenth-century developments.)

The idea of a folk and a national heritage became increasingly important in the United States in the course of the nineteenth century, but as ideas they were quite divorced from Amerindians.[3] Simultaneously eliminated and nostalgicized by the late nineteenth and early twentieth century, Native Americans did not enter, figuratively or genealogically, into the ancestry of the ruling elite of the United States; they were not regarded by the ruling elite at the turn of the century as "self," as part of its own immediate or even remote his-

tory.[4] Hence the indigenous peoples of North America and Meso-america simply do not figure prominently in most museum displays relevant to national stories in the United States.[5] For nationalist stories in the United States, one goes to pioneer and history museums and villages, like Sturbridge Village and Colonial Williamsburg, or, for a really progressivist and nationalist story, to the Smithsonian Institution's Air and Space Museum.

For the first half of the nineteenth century, Amerindian artifacts were hardly collected by institutions; but with the westward expansion and conquest of the American West, artifacts from "vanishing" peoples were collected in great numbers for various purposes and eventually were installed in natural history museums. (The basis of the Smithsonian's ethnographic collection, for instance, consisted of the items assembled for the 1876 world's fair in Philadelphia, celebrating the centennial of American independence.) Exhibited both in world's fairs and in natural history museums as the material culture of lower and earlier forms of society, these artifacts stood as evidence from the past, from an early "stage" of human development whose human exemplars would soon disappear.

Amerindians' artifacts entered the museum system of the United States at two main sites: first in museums of natural history and later in museums of fine arts. The great collections of Amerindian artifacts construed as ethnographic objects and material culture were made and installed in natural history museums at the end of the nineteenth century and the beginning of the twentieth. Amerindian artifacts construed as primitive art were assembled largely in the second quarter of the twentieth century by collectors like the Rockefellers and the Blisses. These objects and ones like them came into their own as primitive art—that is, collecting them ceased to be avant-garde and they became institutionalized officially as part of the story of modern art—after World War II, with the establishment of New York's Museum of Primitive Art in 1954 (opened to the public in 1957), and, eventually, the transfer of that collection to the Metropolitan Museum's Rockefeller Wing of Primitive Art, opened in 1982. In their former incarnation, the objects were used to signify people close to nature and practical concerns; in their latter, they are asked to signify Man's transcendent spirit, which everywhere produces Art.

MUSEUM STORIES: UNIVERSAL AND LOCAL

By "national stories" we generally mean those in which a ruling elite speaks for the entire nation; these stories invent, appropriate, or construe the past in such a way that the past results in the speakers, who see themselves as standing for the nation. Consequently, the historical experience of the elite and its representations of itself to itself, which sometimes bear a direct resemblance to each other, are relevant to understanding the shape and meanings of the national stories the elite constructs at a particular point in time. I want to sketch very briefly the different experiences of the elites of the United States and Mexico with respect to indigenes, especially at the time the two countries' major museums were being founded.

Like Mexico, the territory that would become the United States was colonized by European powers in its early centuries. After the American War of Independence in the late eighteenth century, the victors spent much of the nineteenth century in expansion westward. In the process of moving from Atlantic to Pacific, they displaced or exterminated peoples who had lived there for centuries. At the turn of the twentieth century the United States became an overseas colonial power when it defeated Spain and acquired the Philippines, Cuba, and Puerto Rico.

From the last quarter of the nineteenth century through the first quarter of the twentieth, the United States was at the height of both its internal expansion into the American West and its external expansion as an overseas colonial power. Significantly, this was just the period when major museums were being founded, funded, acquiring objects, installing displays, and setting policies that would endure nearly a century. Representations of the conquered and colonized peoples that were constructed in these museums, as well as at world's fairs and even in zoos (see Horowitz 1975 and Bradford and Blume 1992), not surprisingly told a story about "lower" peoples that helped to justify and reflect the place of the United States among world powers. The patrons and organizers of these institutions at the turn of the twentieth century in the United States had neither reason nor motive to construe the colonized primitives as anything but Other, whose proper place in the line of time was at its low beginning.

The conditions in which these universalist stories were produced, in Europe as well as in the United States, were those created by ex-

panding economic empires throughout large parts of Africa, Asia, and Oceania, and the conquest of "lower" peoples. The alibi of these stories, to use Roland Barthes's term, was the justice and inevitability of this conquest, by means of the assertion that these stories are objective accounts of the way history (from social evolution to art) unfolds. These progressivist tales would have defeated their own purposes if they had been proposed as local stories, or even as Eurocentric ones. Moving from primitive and uncivilized nature to the high civilization of art and history, the progressivist tale told in U.S. museums at the turn of the twentieth century was general and European-derived, not explicitly American, hence not narrowly national.

By the same token, museums of natural history and of fine arts do not tell a national story; they tell a story of universally valid knowledge. These stories and the museum displays they inspire promote themselves as universal and dispassionate, pancultural and panhistorical, accounts of the way things really are, everywhere and always. The claim implicit in these museum displays was that the promulgators of these stories—the elites that founded, funded, classified, and arranged museums and world's fairs—stood as the end point of History; and further that that claim was not an interested parochial or national claim, but was a disinterested objective statement, and so was the knowledge it generated. Amerindians had no special place in the story of objective knowledge or the unfolding of Man's spirit by virtue of having lived in the American territory; Amerindians, like Africans and Pacific Islanders, fell indifferently where objective knowledge concerning them dictated.

The case was very different in Mexico. As with the United States, the territory that was to become Mexico was colonized by a European power: Spanish envoys conquered the Valley of Mexico and displaced the indigenous elite. Spanish rule lasted three centuries; Mexico's independence from Spain came only a few decades after that of the United States from England. Yet unlike the elite in the American colonies, the Spanish colonial elite of New Spain stood as proto-Mexicans nearly from the beginning, because "Spaniards" born in New Spain, even if of pure Spanish blood, counted not as *peninsulares* (of the Iberian peninsula, hence true Spaniards) but as *criollos* (creoles), and therefore were barred from highest office in the colonial government. This fact alone provided the elite with a grievance against Spain and provided a motive early on for

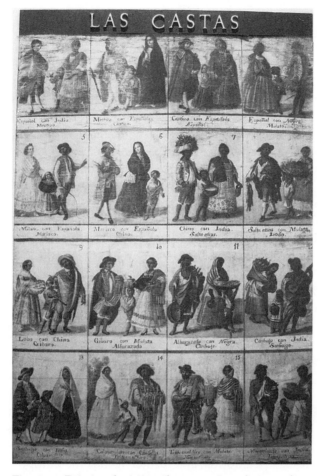

Figure 44. Painting depicting "las castas," gradations of caste (or color) in the mestizo population (hung in the last room of the ground floor of the Mexico City Museum).

the criollos of New Spain to identify themselves as different from Spaniards.

Moreover, the colonial expansion into the territory of the indigenes by the elite of New Spain proceeded by marriage and conversion as well as by force and enslavement; the inhabitants of New Spain represented "race" to themselves as a gradual hierarchy of mixtures, from pure white Spanish to the darkest Indio at the bottom, with apparently infinite gradations between them (figure 44).

This representation is very different from that of the race system in the United States, which tends to collapse gradations of color and differences of parentage into one great dichotomy, white versus black.

Thus the elite of New Spain was differently placed with respect to *indios* from the analogous case in the British colonies of North America because from an early time the Mexican elite regarded itself as the New World "other" against Spain. The claim that the indigenous past was part of the "self" of that elite seems clearly to have begun its life as a means to resist Spanish rule: to assert and confirm that criollos, and eventually and much later mestizos and indios, were "Mexicans."

The elite of New Spain/Mexico occupied from an early time, then, the dual position of Europeanized elite and New World other resistant to European rule. And so, whereas in a sense it is true to say that the "Spanish" elite of New Spain conquered and colonized Mesoamerica, the statement is too simple, because the genetic and symbolic lines between conqueror and conquered, colonizer and colonized, were blurred far more than in the analogous European-instigated expansion in the United States. The elite of Mexico stood both as colonized by Spain and colonizer of its "own" territory and social inferiors.

After independence was achieved in 1821, Mexico's elite hardly had the peace to expand and construct a nation on the European model; most of the nineteenth century was spent in resistance: against Spain, then against the United States in its expansion through Texas to California, and further against the European effort to install Maximilian as emperor of Mexico. By the late nineteenth century, the country had its own internal oppressor in the form of the dictatorship of Porfirio Diaz. But the Revolution of 1910, unlike some earlier changes of the guard, was not merely the equivalent of a palace coup; the Revolution of 1910 ousted the Porfiristas by mobilizing large numbers of peasants on the promise of land reform and other reforms, and these people had to be accommodated and brought into the nation-state's political process in some way. So the elite's authority after 1920, when victory was consolidated, was based on its authority to speak for the Mexican nation, construed as a mestizo nation with a glorious archaeological past and an authentic folkloric present—thus General Obregón's immediate commis-

sioning of Manuel Gamio and Dr. Atl to excavate pyramids and collect folklore and folk arts.

Therefore, the claim that the indigenous past was the "self" of the Mexican elite, begun as an expression of resistance to Spanish rule, became through the triumph of the Revolution the claim that criollos, mestizos, and indios were all "Mexicans," a unified people, a whole. The stories that the victorious elite in these conflicts told itself and instituted in its museum system after the triumph of the Mexican people (so to speak) in the Revolution of 1910 concerned its resistance to colonial oppression and the emergence of the Mexican nation, and the two stories are linked as one.

The criollo-mestizo elite's claim that indios are some form of its "self" and that it can speak for them, however, had a very different valence when the authorial voice belonged to a party in power, as it did after the Mexican revolution, than it did when the elite consisted of a handful of criollos in the early nineteenth century chafing under Spain's colonial rule. In the newer circumstances it became a voice of symbolic hegemony speaking from the center *for* the periphery, rather than a voice of resistance *from* the oppressed periphery. It is this hegemonic voice we see instituted and revealed in the National Museum of Anthropology and its Aztec-centric display.

The preoccupation of Mexico, then, has been resistance against various encroachers and the creation of a national identity, partly as a means of resistance and partly to consolidate victories. Mexico was not a colonial power overseas and had no need for panhuman stories placing itself at the peak of all human history. It was enough to tell a local story. And so, even though it is startlingly long and spans many centuries (beginning with the arrival of peoples in the Western Hemisphere and proceeding through the Revolution), the focus of this national story is narrow in the sense of being explicitly local: it is about Mexican nationhood rather than a universal story about everyone, everything, everywhere. By the same token, the teaching of art history and the taxonomy of the national museum system are also local stories, and they are periodized exactly the same way. Art history is not structured there as the unfolding of a Hegelian universal, the whole of it taught from a single text. Rather, the art history student takes separate courses, with separate textbooks, on pre-Columbian, colonial, nineteenth century, and modern art.[6] The museum system echoes the same categories, the same periodization:

pre-Columbian in the Museo Nacional de Antropología; colonial art and history in the Museo del Virrenato; the art of independent Mexico (nineteenth century) in the Palacio de Bellas Artes; post-Revolution twentieth-century art in the Museo del Arte Moderno.

Both the United States' universal story of objective knowledge and universal art and Mexico's local story about the emergence of the nation-state, exhibited in their respective museum systems, are linear and progressivist. Both are implicitly and explicitly historical accounts because both use the line of time as their frames or mode of organization.

Oddly, however, both place indigenes within a timeless zone, impervious to historical events. In U.S. museum displays, the timeless zone of Primitive Man lies "before history," as many textbooks have it, before the coming of the White Man disturbed the idyll of Man living peacefully and harmoniously within Nature. In Mexico, the timeless zone exists at the other end of the line of time. There the line of national time stretches from the beginning of human time in the New World, when the Bering Straits were crossed, to its climax in Mexico with La Revolución. This line of time has no room for an Other that exists prior to the arrival of Europeans and history, for in this story the Americas were populated from the beginning with the national Mexican "us," the ancestors of Mexican citizens. Representations of *los indigenas* in Mexico cannot live in a zone prior to history or prehistory, as they do in the United States, for no time prior to national time exists. Having no spot at time's beginning or before it began, they are pushed forward into a different timeless zone: in the Museum of Anthropology, they inhabit the eternal present, existing as Living Mayas or whoever.

These representations of indigenes living outside time and historicity suppress historicity in two senses: they suppress the actual historical conditions in which these peoples live now (which might be as urban poor, marginal farmers, powerless minorities who are the target of modernization schemes, powerless minorities sitting on minerals in places totally undesirable until recent technology made extraction feasible, and so on, to name a few of the more common circumstances in which they live throughout the world); and they suppress the historical events by which these peoples' artifacts

were collected and came to be the ones represented in museum displays.

Indeed, a curious feature of museum displays all over the world, not only in Mexico and the United States, is to represent indigenes, who have become "ethnic minorities" within national systems of self-representation in many countries, as part of a timeless national heritage whose living exemplars have disappeared or are in the process of disappearing because of modernization. Simultaneously attacking the way of life of the living peoples while celebrating that way of life as an emblem of national heritage and a commodifiable tourist attraction, has become a standard move on the part of governments throughout the world.

The heir of nineteenth-century progressivist tales is the modernization narrative, the story that everyone is on the road to modernization and they must change, and accept change, or be left "behind." It incorporates both the story of social evolution and progress to a higher technological state, and the story of the nation-state, which continues its revolution and its unfolding by achieving greater heights of education, trade, and material progress (measured by gross national product rather than by the equity of income distribution). That story is seldom displayed in museums.

7

. . .

The Cosmic Theme Park
of the Javanese

All polities are "imagined," Benedict Anderson claimed in his influential book on nationalism (1991). That does not mean, he asserts, that political communities are imaginary or that their self-imaginings are to be distinguished as "genuine" or "false"; but they are to be distinguished by their different "styles" of imagining themselves. He contrasts two major styles of imagining a political community: the nation-state, on the one hand, and "the great classical communities" such as the Ummah Islam, Christendom, and the Buddhist world, on the other. Each type of polity imagines the shape of its sovereignty differently. Anderson devotes the book to explicating the nation-state, and he uses the "great classical communities" only as a foil, for the sake of contrast. Yet the contrast he sketches is striking.

The nation-state's sovereignty, he writes, "is imagined as fully, flatly, and evenly operative over each square centimetre of a legally demarcated territory" (26); consequently, the *map* with its bounded, flat, and clear shape becomes a characteristic emblem of the nation-state. The shape of the sovereignty of "great classical communities," by contrast, was circular and hierarchical. "All the great classical communities conceived of themselves as cosmically central," he writes, and their "fundamental conceptions about 'social groups' were centripetal and hierarchical, rather than boundary-oriented and horizontal" (20, 22).

The classical communities that existed prior to the nation-state (both colonial and independent) in Southeast Asia were the so-called "Indic states"—the great Buddhist polities in what are now Myanmar (Burma) and Thailand, and the Hindu-Buddhist polities of the islands of Bali and Java, which are now within the territorial borders of the Republic of Indonesia. Their self-imagining conformed nicely to Anderson's characterization of classical communities.

The Indic states of Southeast Asia imagined themselves as circular spaces, modeled on the realm of the Buddha. At the center of the realm of the Buddha is the Lord Buddha himself in his palace. The Buddhist universe surrounds him equally on all sides. Bodhisattvas and beings who have attained enlightenment sit closest to him. Less and less enlightened creatures exist at further and further distances from the center. On the extreme periphery lie animals, hungry ghosts, and demons. Humans are in between. Those humans who seek to follow the path of the Buddha to enlightenment must dissociate themselves from the world of violence and desire that ordinary humans live in. The path they must follow leads them symbolically from the periphery toward the center.

Translated into political imaginings, the center of a Southeast Asian Indic state was the kingdom. The surrounding peoples and territories were less and less central: the further from the center of power and prestige an individual, social stratum, or tributary state was located in space or social relations, the less important and more peripheral, literally or figuratively, it was. Consequently, the symbolic dimensions of "inner" and "outer" feature prominently in the state symbolism of these historical polities.

The Buddhist universe is always represented as radially symmetrical, a squared circle, a circular square. The name for this radial configuration is "mandala." In Buddhist iconography, the mandala is represented as a series of concentric circles or squares, or both, which are symbolically equivalent. (In some Buddhist representational traditions, squares represent earth; circles, heaven.)

Southeast Asian Indic states represented themselves to themselves with circular, radial, and conical images, like the royal umbrella and the banyan tree, which symbolically shade, protect, and encompass the underlings gathered beneath them. And these polities often likened themselves to mountains (such as Mount Meru in Java or Bali's sacred mountain, Gunung Agung), symbols suggesting a polity immobile in space and unchanging in time.

We can imagine these two ideal types of polities (the modern nation-state and the Southeast Asian kingdom) as constituting different spatial orderings of political meanings. One is flat, both territorially and socially (in the sense that its public consists of equal citizens), as well as spatially and legally homogeneous (Oregon is as fully a legal part of the United States as is New Jersey). The other ideal type is mountain-

shaped and spatially and socially differentiated, with the most important political and social density at the center; its symbolic geography consists of concentric circles that gradually melt into each other at their invisible borders, spreading infinitely outward.

The contrast between these two spatial orderings is also temporal. The nineteenth-century European nation-state increasingly linked itself with the idea of human progress, a notion of history predicated on the assumption of unidirectional and open-ended change. The Southeast Asian Indic state (its court/center, to be sure) imagined itself as existing within an unchanging cosmic order. In the worst of times (rebellion, war, invasion, famine), it could become de-centered—obscured, or unfocused, or replaced by a rival center. These misfortunes would mean that this particular "exemplary center" had become less exemplary than before; but the mandala-structure of the universe, kingdoms included, did not change.[1] In imagining themselves, different types of polities use different symbols and different semiotic technologies in order to represent themselves to themselves, and, by representing, try to produce and reproduce themselves as they believe themselves to be. The map, the census, and the museum, Benedict Anderson claims, are characteristic representations of nation-states' styles of self-imagining. As the Republic of Indonesia moves into advanced nation-building and self-construction, it, like other nation-states, models itself partly on European conceptions of nation-states (bureaucratic procedures and categories it learned from the colonial power that ruled it) and uses the emblems of self-imagining characteristic of nation-states. But it imagines itself also as the heir of its glorious past, whose expanding political destiny was interrupted by the hiatus of colonial oppression but whose current government seeks to restore the glory of empire.

HYBRID FANTASY ARCHITECTURE

Far more than its neighbors Malaysia and the Philippines, Indonesia is engaged in a project of national self-imagining displayed in what I call "hybrid fantasy architecture." My aim in naming this type of building is not for the sake of creating a taxonomy: hybrid fantasy architecture of the type I want to point out here may indeed overlap with other genres. Nonetheless, it does seem to me that the hybrid architectural fantasy is an emerging genre in the world now, suitable

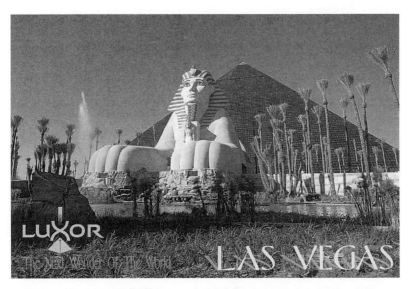

Figure 45. The Luxor hotel-casino in Las Vegas, which resembles an Egyptian pyramid, is a fine example of hybrid fantasy architecture in the United States.

especially for airports, hotels, and perhaps national and cultural theme parks. This style has three salient characteristics: (1) it exists on a grandiose scale, (2) it is made possible by heavy capital or state power, and sometimes a combination of both, and (3) it refers iconically to other architectures but serves functions different from the originals.[2] In the United States, the paradigmatic exemplars of hybrid fantasy architecture are the themed hotels and gambling casinos of Las Vegas—the Luxor is a fine example (figure 45). It is truly gigantic (far larger than an Egyptian pyramid, its ads tell us), it cost millions of dollars to build and maintain, and it looks something like an Egyptian pyramid but is in fact a hotel and casino.

For the sake of clarifying and refining this style, I want to distinguish it from kitsch, fascist, and postmodern architecture. An example of pure kitsch is the "Big-Duck" type of structure (figure 46) decried by Robert Venturi, Denise Scott Brown, and Steven Izenour (1972). Big-Duck architecture substitutes "for the innocent and inexpensive practice of applied decoration on a conventional shed the rather cynical and expensive distortion of program and structure to promote a duck" (163;

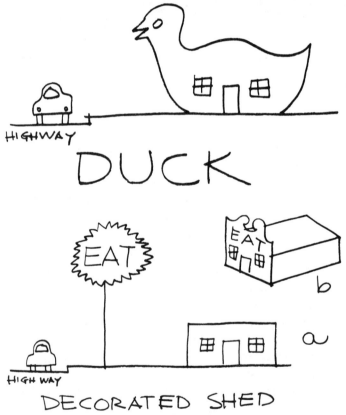

Figure 46. An example of "Big-Duck" architecture in Long Island *(top)* and sketches *(bottom)* from *Learning from Las Vegas* illustrating the difference between two basic types of architecture.

see also 87–103). If architecture must be placed into only one of two categories, the decorated shed (consisting of ornament placed upon a conventional building) and the Big Duck (consisting of a building in the shape of something else), what I call hybrid fantasy architecture is obviously a type of duck: it is itself ornament, rather than a shed with cunning decor. It deviates from the ideal Venturi-defined Big-Duckness in two respects: its programs refer only to other architectures (not to ducks, etc.—not that it, any more than the Big Duck, would ever be mistaken for the original); and it exists on a huge scale made possible by heavy capital or state power or a combination thereof.

In these respects, it is reminiscent of fascist structures built in Nazi Germany: the Zeppelinfeld Stadion designed by Albert Speer was gigantic; embracing and reflecting Hitler's interest in Roman imperial architecture, it refers visually, if loosely, to it. The Great Altar of Pergamum inspired it, according to its designer, but it was a sports stadium, not a temple (see Scobie 1990: 87 and Watkin and Mellinghoff 1987). Both fascist and hybrid fantasy architecture are gigantic, measured on a human scale; thus they bespeak power, even when (like the Las Vegas Luxor) they are sometimes ostensibly humorous or playful. What distinguishes hybrid fantasy from fascist architecture—although this is only a matter of degree—is first that hybrid fantasy structures quote the original more directly than fascist ones do (indeed, Nazi fascist architecture was more like a decorated giant shed than a giant duck). Second, hybrid fantasies may be intentionally or unintentionally somewhat comic, linking them to a kitsch sensibility, whereas fascist architecture is merely chilling.

Finally, whereas postmodern architecture in the manner of Charles Moore also refers to other architectures, and may be large and expensive, and may even be quite light-hearted, its quotes often combine to form a pastiche rather than a coherent programmatic whole. The state-sponsored and capital-intensive hybrid fantasies I am pointing to here are much closer in sensibility to kitsch and to fascism, which have often been partners, than to postmodern architecture's intelligence and playfulness.

In this chapter I examine two examples of Indonesia's state-sponsored fantasy architecture—the national theme park "Taman Mini" and the international section of the Hatta-Sukarno Airport at Chengkareng, both just outside the nation's capital, Jakarta. The architectures they refer to iconically are Indonesia's "traditional" struc-

tures. This fantasy architecture is an expression of the hybrid visual discourse produced by a national impulse to construct nationhood from the remains of imagined and sometimes imaginary empires, supported by international capital in the service of local military power.

TAMAN MINI:
BEAUTIFUL INDONESIA-IN-MINIATURE PARK

My first case in point is Taman Mini Indonesia Indah—"Beautiful Indonesia-in-Miniature Park." Opened to the public in 1977, Taman Mini is a national cultural theme park lying on the outskirts of Jakarta.

When I first heard the name "Taman Mini" but before I visited it, I assumed that it meant "Miniature Village," and I expected slightly reduced models of houses, rather like those at Disneyland. In fact, the houses are approximately life-size in the section of the park where the cultures of Indonesia's provinces are represented. The "mini" part of Taman Mini is not so much its individual elements but rather the fact that the whole of Indonesia has been shrunk to a government-controlled park, in which the unruly elements of yesteryear are shown in their cleaned-up versions, nicely arranged into government-designated provinces, each "ethnic group" depicted by its "typical" house—the whole of it framed by giant signifiers of "Bali" and "Java." In Taman Mini, not Indonesia but "Indonesia" is made visible and available to both domestic and foreign tourists, who may traverse the miniature and fantasized nation-state of "Indonesia" without leaving the environs of the capital of Indonesia.

Approaching it, the visitor first passes under giant arches in "Balinese" style (figure 47), then comes to an enormous plaza (figure 48), the Alun-alun Pancasila (the Plaza of the Five National Principles), on whose other side (and framed by the Plaza) is the gigantic Audience Hall "dubbed," as John Pemberton points out, "in *Javanese* rather than Indonesian, the Grand-Place-of-Importance Audience Hall (Pendopo Agung Sasono Utomo)" (1994b: 249). The Audience Hall evokes a Javanese noble's house due to the shape of its roof, known as a *joglo*, although this particular joglo is grotesquely oversized.

Moving on, the visitor passes through a section of food-stalls and by the huge movie theater and arrives at the ethnic-groups section of the park. An artificial lake with islands in the shape of the Indonesian archi-

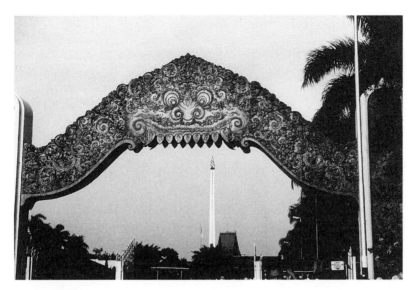

Figure 47. To enter Taman Mini, the visitor passes this giant arch in "Balinese" style.

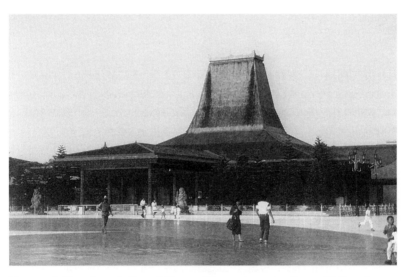

Figure 48. The gigantic Grand-Place-of-Importance Audience Hall at the entrance of Taman Mini with its oversize Javanese-style roof.

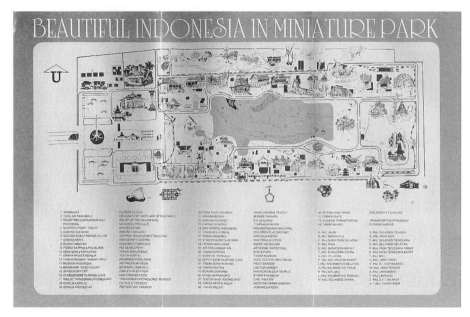

Figure 49. At the center of Taman Mini is an artificial lake with islands in the shape of the Indonesian archipelago. Around it lie miniature provinces, each containing "typical" houses.

pelago lies at its center, forming a map of the nation-state (figure 49). Indonesia's stunning cultural diversity is represented in the surrounding plots, one for each of the administrative provinces, each with a house or houses "typical" of the "ethnic groups" of each province.

If the map, the census, and the museum, as Benedict Anderson claims, are characteristic representations in nation-states' styles of self-imagining, then Taman Mini gives visible form to the Indonesian nation-state's self-imagining as tidily as if it had been designed by following a set of general rules.

The national *map* lies at Taman Mini's center. Maps emblematize and naturalize the boundaries of the nation-state. To illustrate the concept of a nation-state as a bounded entity, Ernest Gellner asks us to picture an ethnographic map before and after the age of nationalism, likening the first to a painting by Kokoschka, "a riot of diverse points of colour . . . such that no clear pattern can be discerned in any detail," whereas a political map of nation-states more resembles a

Modigliani: "There is very little shading: neat flat surfaces are clearly separated from each other, it is generally plain where one begins and another ends, and there is little if any ambiguity or overlap" (Gellner 1983: 139–40).

Like nation-states, the ethnic groups within the state have clear boundaries. Bounded ethnic identities, like bounded and clearly demarcated territorial borders, are the creation of the nation-state. One of the impulses that produced taxonomies of ethnicities was the colonial nation-state's practice of making a census for categorization and control of the populace. Writing about the British in India during the nineteenth century, Bernard Cohn (1987) has outlined the process by which the colonial power in effect invented taxonomies of bounded ethnicities and racial/cultural types by classifying the peoples it governed by location, language, physical type, and custom; such representations of typical specimens then entered into ethnographic atlases, and, eventually, ethnographic museums and world's fairs. By these means, categories of tribe and ethnicity became reified as objective knowledge, taken for granted as naturally occurring. By the mid-twentieth century, when most nation-states of Africa and Asia came into being, "ethnic" difference had been totally naturalized and appeared to be part of the very structure of the world. Benedict Anderson points out that the newly independent nation-states of Asia and Africa that threw off their colonial oppressors in the mid-twentieth century nonetheless often adopted intact the colonial bureaucratic taxonomy of ethnic identity as well as the regional governing divisions whose rationale was often based upon them.

The parade of typical houses of the ethnic groups that compose the national park-museum of Taman Mini's "Indonesia," then, reflects the *census* sensibility—for it requires a decision as to where cultural boundaries lie between adjacent ethnic groups and which ones are important enough to be represented in the park.

Taman Mini is a form of the *museum*, a variation on the open-air historical museum. The first of these, Skansen, was invented at the end of the nineteenth century in Sweden in order to preserve that nation's architectural heritage, which was fast disappearing as the country became more urban and industrial. As a type, the open-air museum merges with the cultural or historical park, which contains structures that exemplify and emblematize different cultures, historical periods, and even scenes (for example, the "Main Street, U.S.A." display at Disneyland). In Taman Mini, houses emblematize the typical, generic, and timeless architecture

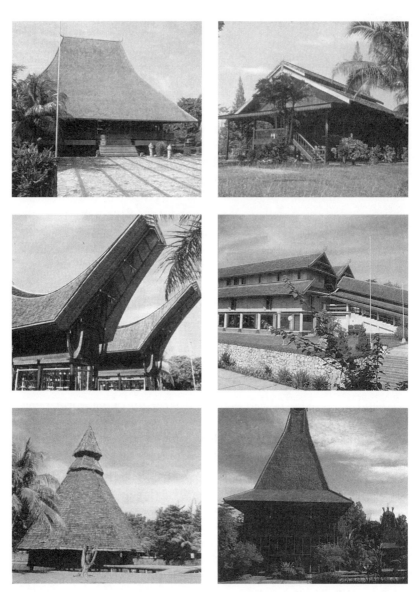

Figure 50. In Taman Mini, "typical" houses signify the timeless essence of Indonesia's constituent "ethnic groups."

of Indonesia's constituent ethnic groups, rather than display historical periods or particular structures from different regions (see figure 50).

A NOTE ON MINIATURE WORLDS

Inspired by the example of Sweden's Skansen, the first open-air national historical park (founded in the early 1890s), European nation-states built nations-in-miniature during the subsequent decades as ways to "materialize the nation," to use Orvar Löfgren's phrase (see Löfgren 1993 and Hofer 1991). The open-air cultural theme park and historical re-creation are common forms of the museum, a type of didactic entertainment. Some are built with official state monies and purposes; some are simply money-making and advertisement ventures. Such open-air museums and their variants use different architectural styles to represent different, bounded cultures and historical periods. Whether they are literally miniature or not, many cultural and historical parks could be categorized as "miniature worlds," since they try to re-create the experience—or merely the look—of a world of the past or in a distant place; and many are intended to preserve at least the image of a traditional world that is imagined to be disappearing, featuring architecture to emblematize either historical periods, nation-states, or ethnic groups.

While the genre of the miniature village looks surprisingly uniform in its conventions, this overt similarity masks many covert dissimilarities. The theories of display, representation, and layout obviously differ among miniature worlds depending on their purposes. Some are advertisements, in effect, for products (like Lego-Land in Denmark); they may be privately owned or foundation-owned attractions whose stated purpose is to educate, as well as to make enough money to maintain themselves (like Colonial Williamsburg); others are state-owned and state-maintained enterprises with an explicit connection to the promotion of national virtues or identities. Taman Mini fits into the last of these categories.

One issue for representational strategy is what, if any, period of time is represented. At Skansen houses from different historical periods, from the fourteenth century onward, were physically transported and placed next to each other in a park in Stockholm. A stroll through Skansen is a stroll through Swedish history—but not linearly, and various low-key amusements supplement the history lesson. Hawaii's Polynesian Cultural Center, owned and run by Brigham Young Uni-

versity, features different Polynesian island cultures (now most are nation-states, although that is underplayed in the park); they are represented by their "typical" houses, which are built to scale by Polynesians. The time period featured appears to be the mid-1800s, when missionaries had spread across the Pacific and female Polynesians were consequently wearing muumuus rather than exposing their breasts and had learned the craft of quilting. (I infer this from the sale of quilting kits and muumuus at the park's shops.) At EPCOT Center's World Showcase in Florida, temporal periods are inconsistently represented in the display of eleven nation-states ringing an artificial lake. Each country is emblematized architecturally by a distinctive, usually grand, structure, scaled to conform to the others—thus, Japan is represented by a pagoda, Mexico by a pyramid. Temporality is inconsistent in this display because it is irrelevant: the point is not to show historical periods but to portray the generalized essence of the nation-state in its full eternal typicality. The alternative, then, to representing a particular historical era is to represent the eternal essences of the "typical," whether country or culture, a plan also pursued at Taman Mini.

Sometimes the structures of the open-air museum are original buildings brought together and juxtaposed, as in Skansen; from this perspective, historic districts preserved intact, at least in their facades, are a form of the open-air museum. Sometimes the buildings are reconstructed to be completely accurate materially, like Williamsburg Colonial Village in Virginia; sometimes they are simulations that look very similar to the originals but differ in materials—like Disneyland's "New Orleans Square" or the Field Museum's reconstruction of the marketplace of Bora-Bora in its installation called "Traveling the Pacific."

A building's size has a semiotic dimension, because the scale of buildings in relation to the human body implicates phenomenological meaning. We tend to perceive smaller structures as toys or for children; they at least present themselves as unthreatening. Examples are Madurodam of the Netherlands, where the visitor wanders like a giant among knee- to waist-high representations, and Disneyland's five-eighths scale, whose rationale is said to be to make children feel comfortable. Full-scale meticulous reproductions (in both scale and other respects), like Williamsburg or the Polynesian Cultural Center, tend implicitly to claim historical or cultural accuracy and therefore educational value. Larger than full-scale buildings are, at the least, impressive. No consistently oversize themed cultural or historical park comes to mind as an example, probably because

hugely oversize buildings tend to signify power, often the power of the state or the power of capital (as in fascist architecture and in Las Vegas). Miniature worlds may also be inconsistently scaled, but large enough to be impressive, like most of the emblematic buildings in the World Showcase section of Disney World's EPCOT Center.

At Taman Mini, scale representation is inconsistent. In the main section of twenty-seven provinces with their ethnic groups' house styles surrounding the lake, it is fairly consistent and fairly life-size. But gigantism is in evidence at the entrance, with its huge plaza and gigantic Audience Hall, featuring a rather distorted but fully recognizable Javanese-style roof. And miniaturization is in evidence at Taman Mini in the replica of Borobudur and in some of the Toraja houses and cliffs.

In spite of their differences, at a general level miniature worlds all seem to resemble each other loosely, and indeed, at a general level, they do. Yet to "read" these parks as cultural artifacts, as signifiers of meanings, which are always partially local, requires us to unpack the local politics and epistemologies that produced them. The historical origins and current maintenance of national theme parks and state museums, for instance, are embedded in specific states' nation-building efforts: the ways the state chooses to materialize itself given its concepts of the nation-as-a-whole, the shape of the past, the place of the folk, modes of legitimizing power, and so on.

As in the cases just mentioned, Taman Mini's signifying medium consists of diverse architectural styles. Unlike these other cases, Taman Mini exists within the cultural and symbolic context of island Southeast Asia, where the house features large in the production and reproduction of "traditional" cultural forms; and it exists within the political context of the Republic of Indonesia, where the military regime of General Suharto with his New Order politics drew heavily upon traditional architectural forms to project and construct national self-imaginings. Understanding how the house can be read in these other contexts will enable a deeper reading of Taman Mini as a political text of nationalist self-representation.

THE HOUSE IN INDONESIA

Indonesia is a place not only of spectacular natural beauty but of spectacular built structures—think of the soaring rooftops of the clan houses of the Minangkabau of Sumatra, the temples of Bali, the royal courtyards of Central Java. Their extraordinary appearance is matched

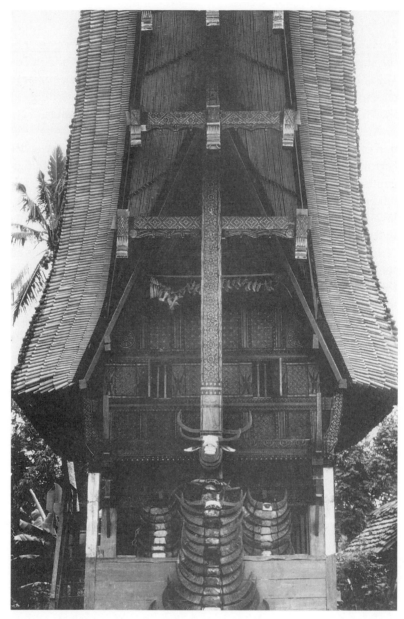

Figure 51. Tongkonan are painted and incised with signs of wealth, status, and fertility and festooned with horns of water buffalo.

by their cosmic significance.[3] The term "house" in many of the local languages signifies not just a physical structure but an extended social grouping, whose symbolic center has its physical locus in or at the structure, which provides a ritual site for its ceremony and self-imagining. It is not surprising that Claude Lévi-Strauss (1982) calls the social formations of Indonesia "sociétés à maisons" (house societies).

Even ordinary-looking structures, like the rectangular houses on stilts of the Buginese of South Sulawesi, are built as microcosms of the universe, with three levels corresponding to the lower, middle, and upper worlds, as well as a navel post at the house's cosmic center where the house-spirit hovers (S. Errington 1979).

Among the more famous and striking examples of architectural cosmography are the *tongkonan* of the Toraja of South Sulawesi (figure 51). Looming out, their roofs are supported by poles festooned with the horns of water buffalo slain at mortuary ceremonies, their meat long since divided in complex networks of debt and prestige. Granaries and house fronts are decorated with painted and incised signs signifying wealth, status, and fertility. These were usually "clan houses," often rivaling each other in a ceremonial cycle. Although people slept in them, tongkonan were not primarily living spaces; they were places to store valuables, to place corpses prior to the mortuary ceremony (sometimes for many months), and to be visible emblems of the center of the clan.

The house, in sum, was and continues to be a densely meaningful sign—a palpable, indeed, a live-in and walk-through sign—that ties together cosmos, kinship, the relations between the sexes, hierarchy, and the inscription of directions on the body and in social geography (such as up/down, right/left, and center/periphery).

The House as Sign of Ethnic Identity

Perhaps understandably, in modern Indonesia the "typical" houses of different ethnic groups have come to signify that ethnicity. In cities, for instance, restaurants serving regional food often advertise themselves with a sign in the shape of the region's characteristic house shape. Probably hundreds of small restaurants throughout Indonesia call themselves "Rumah Makan Padang" (*rumah makan* means restaurant; Padang is a city in Sumatra) and hang a cutout silhouette of a Minangkabau house over the door.

Figure 52. In the Toraja district, the shape of the tongkonan clan-house appears everywhere.

In the Toraja district, the house has also become a kind of floating sign whose signifying medium and social function vary but whose signified is always "Toraja-ness" and "typical." The sign appears everywhere: as the shape of ceremonial pig-carriers, as grave-markers, as roadside neighborhood-watch shelters, as freestanding monuments, as emblems for government propaganda, as entrances to hotels and to churches, on T-shirts, on telephone books (figure 52).

In a rhetorical move that Roland Barthes had already thought of, Toraja-style architectural elements are used to signify "Toraja-style architecture." In the hotel complex called "Toraja Cottages," the ho-

Figure 53. The Maranu Hotel in Toraja-land.

tel's two-story buildings that contain the guest rooms (which are entirely European-style in other respects) are topped by enormous Toraja-style roofs, which necessitates, of course, distortion of the shape and size of the traditional roof.

The central government of Indonesia, likewise, uses bloated forms of local architecture for government buildings. The fundamental form of these buildings is of course derived from European models (as, in theory at least, is the structure of the bureaucracy; but see Taylor 1994b). In Toraja-land, Toraja-style roofs, stretched and expanded in shape and size, top these typically enormous government buildings. Buildings like the Maranu Hotel, run by the government airline Garuda—a huge structure topped with a "local" roof—clearly signify the central state in its local manifestation (figure 53).

Toraja people are currently signifying themselves as "Toraja" as well by making architectural references to tongkonan in the houses they build as their own dwellings. Traditional tongkonan, as I mentioned, were not really living spaces. With development has come electricity and indoor plumbing, as well as notions that interior architectural spaces can be lived in. Now Toraja are beginning to build the larger rectangular houses in the lowland Bugis style (without their

Figure 54. Now Toraja are adding tongkonan elements, especially the roof shape, to ordinary structures.

cosmic significance, one presumes), adding elements to those houses derived from tongkonan architectural forms. The inventiveness is stunning. Toraja-style roof-shapes loom out from ordinary rectangular houses; or people may put Toraja-style granaries, real or miniature, in front of their rectangular houses; or they create whole entrances and doorways that evoke the front of a tongkonan but lead to an ordinary building (figure 54). My favorite Toraja house is a magnificent structure built by a Toraja who made his fortune logging the tropical forests of Central Sulawesi. He has built more or less what William Randolph Hearst would have built, if Hearst had been a Toraja (figure 55).

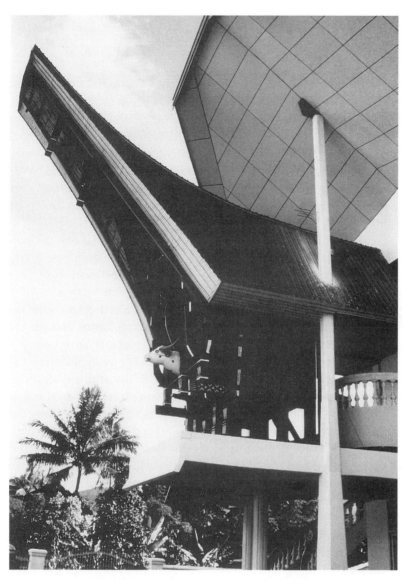

Figure 55. A particularly grand house with a tongkonan-shaped entrance.

THE HOUSE AS A SIGN OF THE NATION

"What is the difference between a language and a dialect?" goes the joke. Answer: "A language *is* a dialect . . . with an army and a navy." The standard high-status house form of Central Java might also have become a signifier of ethnicity if history had been different from what it was. But history was not different from what it was, and the Central Javanese *pendopo* (audience hall or ceremonial pavilion) with its distinctive roof-form called the *joglo* is increasingly becoming the language of the nation-state rather than the dialect of ethnicity.

Timothy Lindsey, drawing upon Prijotomo's (1984) comprehensive study of Javanese architecture, calls it "that quintessentially Javanese architectural motif, the seemingly endlessly mutating pendopo (pillared pavilion)," which in its simplest form is "a foursided pyramidical roof supported by central columns and with additional support provided by further, smaller columns around the perimeter. From this simple model, endless variants have been developed" (1993: 167). Standing to the front of the living quarters, the pendopo was the space where people of status and influence received petitioners and visitors, and where performances of music and dance could be held. It is shaded but open and protecting, the architectural equivalent of other signs of Indic kingship and high status, such as the banyan tree, the royal umbrella, and the sacred mountain (see figure 56). These are all radially symmetrical spaces with high centers that symbolize the encompassment of lesser, dependent beings by and under the high-status being at the center of the space.

As Suharto's New Order government embarked on its hybrid fantasy architecture project in the early 1970s, it looked "back" in time for its iconography to the region's Indic states. In principle and in theory, any of several might have been chosen. The grandest of recent Indic states in the geographical region that was to become the nation-state of Indonesia were Yogyakarta and Surakarta in Central Java, Cirebon on the northern coast of Java, and Klungkung or several other kingdoms in Bali. Central Java had emerged as the definitive center of Javanese culture during the nineteenth century as a result of a mutual construction by the rul-

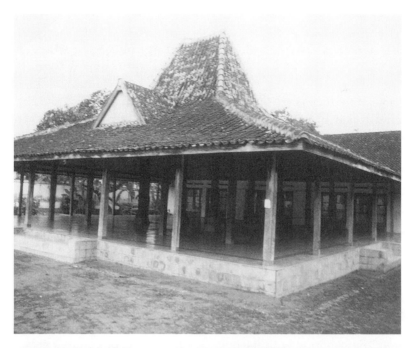

Figure 56. The *pendopo* is the whole structure; the *joglo,* its roof. The top view is of the pendopo from outside; the bottom view is from inside the pendopo looking up into the underside of the joglo.

ing aristocrats of the cities of Yogyakarta and Surakarta, and Dutch Java-centered rule of the East Indies (see Pemberton 1994a). The nineteenth-century elevation of Central Java (rather than some other former Indic state) as the preeminent spiritual and cultural center of what became the Republic of Indonesia has been embraced and maintained for reasons that are overdetermined. Most recently, under Suharto's New Order, it was promoted as the country's symbolic spiritual center. Not insignificantly, the icon chosen by Suharto's political party, Golkar, was the spreading banyan tree, an image of kingship in Southeast Asia's historical polities.

The pendopo with its distinctive roof shape, the joglo, also signifies the Indic mandala, the symbol of expansive power of centered kingship. This type of expansive center countenances no equals: it must be in conflict with them until one is defeated and absorbs the other as a deferential subordinate. But it is not exclusionary: it gladly incorporates diversity as inferiority and dependence upon itself. The pendopo with its joglo covering is the opposite of a clan house, tied to other and potentially equal rival clans, or houses, in a perpetual cycle of competitive ceremonies, exchanges, and marriages. Perhaps in part because of the centrist and encompassing ambitions of the kingship it represents—to be above rivals and encompassing them—the joglo is used increasingly in Indonesia to signify the general and unmarked rather than the particular, the ethnic, and the partial.

Near the pool at the Toraja Cottages hotel complex, for instance, is a bar shaded by a joglo roof. The hotel's dining room, likewise, is topped by a joglo, and its interior ceiling imitates the look of being under a joglo—complete with Central Javanese colonial Dutch-style lamps (figure 57).

By the same token, the joglo may be emerging simply as the unmarked category of roofs that indicate national Indonesianness. Especially in Java, there is a tendency now to use the joglo as the roof of choice to indicate any government space or property, such as the kiosks in a market put up and owned by the government. The seismograph I came upon while wandering on the restored Borobudur monument in Central Java is topped with a joglo,

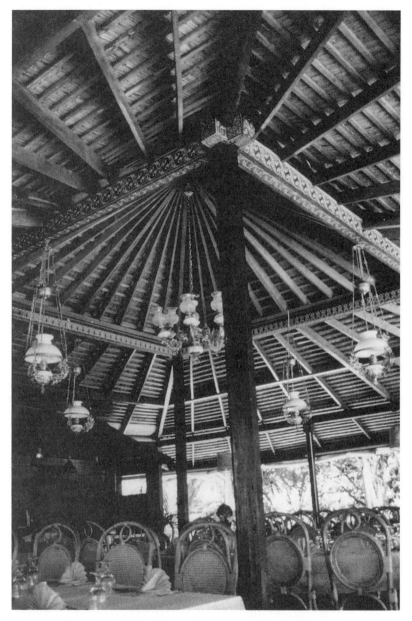

Figure 57. The ceiling of the hotel dining room of Toraja Cottages is designed to emphasize that the building is topped by a joglo.

Figure 58. Joglo-shaped cover of a seismograph encountered at the restored Borobudur monument in Central Java.

clearly signifying that it is state property and should not be tampered with (figure 58).

TAMAN MINI AS INDIC COSMOGRAPH

Back at Taman Mini, the wild semiosis of the provinces is tamed and controlled by the domesticating and nationalizing techniques of the map, the census, and the museum, the three characteristic representations of nation-states' styles of self-imagining; these characteristics

make it obvious that Taman Mini was imagined by and for a nation-state. Yet some of Taman Mini's other aspects evoke the Indic classical communities that imagined themselves as cosmically central. If one were looking for an analogous set of three self-representations characteristic of the Southeast Asian Indic state, I would suggest the *genealogy*, the *state procession*, and the *cosmograph*—all of which Taman Mini also displays.

Southeast Asian rulers and nobles claimed legitimacy for their high status and inherent spiritual potency as due to their divine origins, expressed and tracked by their *genealogies*. Yet individuals could sometimes be blessed directly with divine energy and political potency, an overwhelmingly grand gift called *wahyu*. Thus in times of political unrest, leaders emerged whose earthly origins were humble but who clearly were blessed directly from the sources of cosmic energy and political potency. In those cases, this divine blessing bypassed inheritance. (The possibility of *wahyu* falling directly from the source of energy and good fortune explains, in contemporary Indonesia, the fact that some highly unlikely people have attained great status, wealth, and power.)

The factual and historical origins of Taman Mini strike most Western observers as distinctly uninspired. First, it is loosely modeled on Disneyland. (Mrs. Suharto, whose idea it was to create Taman Mini, claimed direct inspiration from Disneyland.) Second, building the cultural park required that a space of about 100 hectares in the densely populated outskirts of Jakarta be cleared of hundreds of inhabitants; they were compensated inadequately, in their view, for their land, and sought legal help and publicity; anti-Mini protests spread across Indonesia in the early 1970s. The protests were to no avail, since military power backed the "private" foundation run by Mrs. Suharto. Thus Taman Mini's rather pedestrian historical origins *could* be told as a tale of state violence against its citizens in order to build a local version of an international corporation's theme park.

Countering these facts about Taman Mini's secular genealogy, the Suhartos have asserted the park's spiritual origins and authenticity as a sacred site with two rhetorical political countermoves that strive to bypass the historical facts and to sacralize the site as though it were a direct gift from above. One is Mrs. Suharto's divine inspiration in creating the park, noted in Pemberton's account of Taman Mini:

In late August [1971], Mrs. Soeharto published an official rationale for the cultural park's proposed design and purpose. Opening with the patriotic salutation "Freedom!" the First Lady described a sudden inspiration she had during her recent visit to Disneyland, "I was inspired to build a Project of that sort in Indonesia, only more complete *(lengkap)* and more perfect, adapted to fit the situation and developments in Indonesia, both 'materially' *(materiil)* and 'spiritually' *(spirituil)*." (1994a: 152)

Pemberton notes that "Mrs. Soeharto's account of how she was 'inspired' *(diilhami)* with the 'Beautiful Indonesia' Project concept appeals to a sense of divine inspiration and blessed mission."

A second and more sustained rhetorical countermove has been the Suharto regime's effort to sacralize Taman Mini's Central Javanese-style buildings by transferring the *kramat* qualities (the sacred and potent energies) from the originals in Central Java (the royal palaces of Surakarta and Yogyakarta) to the structures at Taman Mini. Again, John Pemberton's account of Taman Mini— indeed of the idea of "Java" itself in the imagination of Jakarta's Javanese elite—offers a stunning and persuasive account of the temporal and spatial displacements made to *kramat*-ize and authenticate this and other national projects. His account of Taman Mini gives special attention in this respect to the huge Audience Hall with its joglo-style roof at the entrance plaza, the Yogyakarta palace in the Javanese province section of the park, and the Indonesia Museum (added to the park and dedicated in 1980). Efforts were made to turn *these* structures, rather than the palaces and temples they were modeled on, into the "originals." Pemberton comments, "With its exaggerated roof and durability of design, the Audience Hall would, perhaps, escape the quotation marks around 'Beautiful Indonesia' by establishing itself as an original source, a cultural center of reference for future generations, the new locus of cultural inheritance."

The *kramat*-izing of these structures took place through *processions* and ceremonies of various sorts. For example, the dedication of the Audience Hall in 1975 took the form of a royal procession:

Moving toward the Audience Hall one confronts the Indonesia Portal (Gapura Indonesia), an entrance normally kept locked, as the guidebook explains, yet opening for grand rituals *(upacara-upacara kebesaran)*. Such was the case during the 1975 dedication of Mini when guests paraded through the Indonesia Portal on their way to the Au-

dience Hall and observed mass folk dances on the frontal plaza. . . . Lest the resonances of royal aspirations be lost on those attending Beautiful Indonesia's dedication, an offering was made on ritual behalf of the Audience Hall with Imelda Marcos planting a banyan tree—*the* emblem for Javanese royalty as well as the logo for the New Order's dominant political organization Golkar—in Mrs. Soeharto's orchid garden at Mini. (Pemberton 1994a: 160)

On a similar note, when I visited the Indonesia Museum at Taman Mini, the grand entrance portal to the building was ostentatiously locked with a large chain and lock—it is used only for ceremonies, said a nearby guard—making it necessary to stoop down to enter through a small, low door to the side of the main entrance. This entrance device converts ordinary visitors into humble penitents, by obliging them to bow toward the structure upon the act of entering. In contrast to the large locked entrance portal, this diminutive doorway is, in effect, the servants' entrance to the sacred space.

Finally, Taman Mini's arrangement, as I show below, forms a *cosmograph,* an image that is structured like the cosmos and should therefore be read as a microcosm of it. Southeast Asian Indic cosmographs depicted the structure of the cosmos, ultimately based on the Buddhist universe, which was always a centered, radially symmetrical, and hierarchical space. Like the Buddha in his realm, the ruler sat in the sociopolitical hierarchy at the center and peak of his human realm, with lesser beings ranged around him in graded concentric tiers. City layouts and temples were constructed to replicate and therefore teach and constitute this centered political and social arrangement—structures like Angkor Wat in what is now Cambodia, and Borobudur in Java. These cosmographs were the icons and emblems by which the courts of Southeast Asian Indic states gave palpable form to themselves as centered, unmovable, hierarchical— encompassing lesser, tributary entities.

The prime feature to note about the Indic cosmograph in its transformation to a nationalist layout in Taman Mini is that it is a centered space, surrounded by a compliant, orderly, and lower-status periphery. I describe Taman Mini as a cosmograph by beginning with the periphery, that is to say, the ethnic groups that compose the nation, which are given visible form in the numerous house types displayed in the park. I then point out that the arrangement of the cultural park, with its central axis ringed by a supporting and orderly pe-

riphery and Taman Mini's architectural framing (which features sig-
nifiers of "Java" and "Bali"), assert the centrality of Javanese over-
lordship within the national cosmograph design.

THE ORDERLY PERIPHERY

When European states transformed themselves into *nation*-states
during the course of the nineteenth century, they discovered/
invented "the folk." The notions of the folk and of popular culture
born in Europe in the late eighteenth and early nineteenth centuries
contributed to the ideological basis of the romantic nationalism of
the then-emerging continental European nation-states. It was at that
time, writes Peter Burke, "when traditional popular culture was just
beginning to disappear, that the 'people' or the 'folk' became a sub-
ject of interest to European intellectuals" (Burke 1978: 3). The earliest
well-known enthusiasts of the folk, Herder and the Grimm brothers,
were Europeanists rather than nationalists, Burke tells us; but he
goes on to say that the more general impulse to explore folk songs,
folk costume, and folktales was closely associated with nationalism,
as European linguistic and political communities struggled to imag-
ine themselves in the course of the nineteenth century as national en-
tities that could become national states as well. The notion that the
nation-state should be a unified community with a single language
and a shared "racial" and "cultural" heritage dates from this period.

Orvar Löfgren points out that as nation-states made efforts to "ma-
terialize" and make themselves visible to their own populace and to
the other nation-states, certain cultural forms became standard, were
seen as especially national, and therefore had to be found in all nation-
states; a prime example is the production of national folk cultures.

> The dress of the peasantry was synthesized into national costume and
> displayed at folk dance performances, which became an important way
> to stage national distinctiveness and cohesion. This symbol danced
> everywhere—at school speech days, in patriotic parades, at interna-
> tional exhibitions, and during state visits. It became especially important
> in Communist Eastern Europe, not least after Joseph Stalin's declaration
> that folk dance performances were important tools in the display of offi-
> cial national socialism. Throughout Eastern Europe and the Third
> World, this manifestation of distinctive national character and pride was
> created on the Soviet pattern. Every factory, school, or local council was
> supposed to have its own folklore ensemble. (Löfgren 1993 [3–4]:163)

If, as Benedict Anderson (1991) suggests, the nation-state became a "module" with certain characteristics that had to be imitated by aspiring states or nations that wished to become nation-states, a nationalist version of the folk was clearly a component of the module. What place, then, do the folk or their analogue have in Indonesia's national self-imagining, whose public expressions are controlled by Jakarta? The analogue of the folk in this instance consists not just of peasants but of the "ethnic groups" of the nation-state. We will look in vain for romantic nationalism of the nineteenth-century European sort in Indonesia. For one thing, finding unity at the level of language or culture is prima facie impossible there. It is a country of great heterogeneity in almost any terms: religion, indigenous political forms, natural resources, ecological habitat, and local languages; therefore no simple appeals to unity on the grounds of uniformity will do.

State ideology, then, has tried to make a virtue of necessity: the country's motto is "Unity in Diversity." The strategy that emerged during the reign of General Suharto, especially visible in the state system of provincial and subprovincial museums that have been planned and built since the 1970s, was to assert (visually, in exhibits, and in other ways) that each ethnic group and province is distinctive and unique, yet each is equivalent and equal to other ethnic groups and provinces.

Provincial museums, for instance, usually have a mandatory "Nusantara Room" featuring "comparisons" with other provinces, often revealed in the form of bride-and-groom dolls dressed in wedding clothes. (The word *nusantara* means "archipelago" and is often used as a poetic term for the nation-state of Indonesia, which consists of thousands of islands.) At Taman Mini some of the ethnic houses are open to the public. In them are displayed articles of costume and culture typical of that ethnic group. An almost universal feature of these displays is a pair of dolls wearing "typical, traditional" wedding clothes. These exhibits seem to argue that custom is costume, that differences are superficial, and that, in the end, there is "unity in diversity." Paul Taylor (1994b) has called this exhibition strategy of asserting equivalence in visual form the "Nusantara concept of culture." The intended message of these "comparisons," he writes, is to assert: "We are distinctive as a province, but we are one with the rest of the archipelago" (81).

This comparison strategy of exhibiting culture contrasts radically with the nostalgic and romanticized version of the folk and the past that is visible in a place like Skansen in Stockholm, or in Deerfield Park in Michigan, or in "Main Street, U.S.A." at Disneyland. In those venues the folk and the past can be idealized because cultural/regional diversity is not a threat to the state: there the past can be yearned for as a kind of sacred origin-point. A second and entirely different model of the folk is the Stalinist model, in which regional diversity cannot be entirely suppressed and therefore has to be acknowledged during nation-building. In polities that adopt the Stalinist model of the folk, the regions or ethnic groups tend to be a living threat rather than a dead past suitable for nostalgia; in this model, the central regime chooses to control its regions symbolically and often literally by controlling its official manifestations. Suharto's New Order regime chose the latter model, and not just in museum displays. A vividly explicit article by Amrih Widodo (1995) reveals how village rituals in Java were micromanaged during the New Order, removed from the control of villagers, put under the control of the central government, and cast into forms it designated.[4]

The Nusantara concept of culture seems to be Indonesia's solution to the problem of how a nation-state consisting of diverse populations can imagine the symbolic grounds of its "unity" as a single moral and political entity. Clifford Geertz, writing in the early 1970s about the "new [but even then aging] nations" of Africa and Asia, articulated this problem. He suggested that nationalism goes through four phases, in the last of which, having triumphed and organized themselves into states, countries find themselves "obliged to define and stabilize their relationships both to other states and to the irregular societies out of which they arose" (Geertz 1973a: 238). Now, several decades later, the same statement could still be made: "Now that there is a local state rather than a mere dream of one, the task of nationalist ideologizing radically changes. . . . It consists of defining, or trying to define, a collective subject to whom the actions of the state can be internally connected, in creating, or trying to create, an experiential 'we' from whose will the activities of the government seem spontaneously to flow" (Geertz 1973a: 240).

Exhibiting Nusantara-style cultural equivalents mystifies by disguising the economic and political nonequivalence of the island of

Java, where a good 60 percent of the country's population lives and which contains the overwhelming majority of the economic and communications infrastructure. Inevitably, given the overwhelming population of Java proportionate to that of other areas, and coupled with the far greater opportunities there for secondary education and beyond, the bureaucracy and military are overwhelmingly Javanese. The governors of all the provinces, who are appointed from the center, tend to be Javanese. Jakarta, the capital, is on Java, as is Bandung, the center of commerce and manufacturing. As a consequence, the island of Java is not an equal among equals economically and politically but is much more comparable to an internal colonial power, with the Outer Islands sending raw materials to be processed in Java, and Java reciprocating by sending a ruling elite to keep order in the Outer Islands.

FRAMING THE NATION

Taman Mini's typical houses lie in "provinces" arranged around a central artificial pond, itself containing an island map of the nation-state.

A centrist organization is not *necessary* for a cultural theme park. The only other one I can think of is the World Showcase at Disney World's EPCOT Center, where a rather round and quite large body of water is surrounded by buildings symbolizing various nation-states. The water there contains no representations and apparently serves mainly utilitarian functions. It serves to focus a visitor's attention on the structures at its periphery (the "nation-states"), since one can barely see to the other side of the artificial lake; and, of course, it serves as a kind of people-mover and crowd-control device, since it strings people out rather than bunches them up, encouraging them to stroll in a single direction (either one), visiting different nation-states sequentially on their way around it. And, finally, nightly fireworks are exploded above it.

The centrist organization of Taman Mini, by contrast, places at its pond's center a map of the nation-state, transforming (if we take EPCOT Center as the original which was transformed) the central body of water from an empty but useful space (for fireworks) into a useless but symbolically full place. It moves the focus of the park from the periphery to the center, which the visitor

can view from a cable car passing from one end of the park to the other. Taman Mini's centrist organization thus recalls the Indic states' way of imagining the polity as a stationary and orderly circle, in which people and objects lie in a secure hierarchy arranged statically around the kingdom's high center.[5] Taman Mini's symbolic center consists not of royal regalia, a banyan tree, or a palace constructed on a central axis, but a map of the Republic of Indonesia surrounded by representations of ethnic groups that reflect, support, and illustrate its glory. The map represents the whole.

But then, as we have seen, so does the joglo.

The joglo, in fact, is a framing device and a signifier of national identity. I mentioned that the joglo is coming to mean public space and even national space. The "national" is that which encompasses; "ethnic groups" are increasingly occupying the status of the encompassed.

The most overt framing within Taman Mini is my favorite structure there, the representation of Borobudur, the ninth-century Buddhist monument in Central Java. Taman Mini's miniature Borobudur, measuring about six feet in diameter, is sheltered by a joglo; a glass case surrounds it, and it rests on a pedestal on yet another hillock and is surrounded by a fence that is sometimes locked. Surrounded by a fence, approached by steps, guarded by sculptured lions, sitting on a double pedestal, encased in glass, miniaturized, and covered by a joglo—it is very clear, I would say, that Borobudur is *under control* (see figure 59).

Taman Mini itself is framed by icons of "Bali" and "Java." The visitor approaching Taman Mini moves under giant arches of a "Balinese" theme. Bali cannot be ignored in any state representation of Indonesia. For one thing, Indonesia would be unrecognizable to a good part of the international tourist world without Bali; for another, Bali looms large in the national economy because of the foreign currency generated by tourism to the island. Understandably, then, Balinese themes are second only to the pendopo/joglo theme in the iconography of national identity at Taman Mini and, as we will soon see, at the Chengkareng airport. The architectural feature used to represent Bali, however, is not its typical house, temple, or roof, but the gate or doorway, guarded by a face at the top of the arch. The per-

Figure 59. Borobudur appears in miniature at Taman Mini, where it is sheltered under a joglo *(top)* and encased in glass *(bottom)*.

vasive use of a Balinese gate theme for transitions in Indonesia's modern hybrid mandala architecture is worth commenting upon. It is doubly curious.

First, Bali is not a gateway to Indonesia: it is the main destination for tourists. Curious, then, that the most pervasive signifier of Bali should be a welcoming entrance that leads to somewhere else. Further, although Indonesia signifies "Bali" for most tourists, Bali does not signify "Indonesia," much less "Java." Curious, then, that at Taman Mini, passage through the Balinese-style arch-gates leads eventually to "Indonesia" in miniature, and directly and immediately to the giant plaza featuring the Grand-Place-of-Importance Audience Hall.

This plaza and its Audience Hall form the second framing device of Taman Mini, and they signify Java. Of this structure, Pemberton comments, "The immense pavilion is an exaggeration of Central Javanese aristocratic house design. Its roof—the real focus of Javanese architectural attention—extends almost straight up rather than gently out, and gives the potentially intimidating impression of uncontrolled growth" (1994b: 249). Massiveness everywhere historically has signified state power. The Grand-Place-of-Importance Audience Hall with its Javanese-style roof is the most swollen building of hybrid fantasy architecture in the park.

Taman Mini, not being a polity or a community, is not an "imagined" community; but one might say that it is a fantasized community—which is not a community at all, since no one lives there, but the fantasized image of a fantasy polity, an imaginary Indonesia: its symbolic structure and iconography map a fantasy of a conflict-free and cleaned-up version of the nation-state. Taman Mini is not a "model of" Indonesia (to invoke Geertz's term), but a "model for" Indonesia—for Indonesia as it ought to be, in the dreams of the New Order government. It depicts a fantasy polity, where ethnic difference is tamed and reified into equivalent and decorative difference, classified into orderly provinces that are controlled and made beautiful by the power of the state. As General Suharto said in 1977 at Taman Mini's official opening, "Taman Mini consists of a small Indonesia that provides a picture of big Indonesia in a way that is complete and perfect."

Figure 60. Joglos are the roof of choice at the Hatta-Sukarno Airport at Chengkareng, near Jakarta.

THE COSMIC AIRPORT
OF THE JAVANESE

The use of the joglo as an architectural element reaches some sort of peak at the Hatta-Sukarno National Airport at Chengkareng, where joglos are, needless to say, the roof of choice (figure 60). The passenger boarding area is designed around long, open-air walkways, whose ceilings and vertical elements resemble the interior of the pendopo, complete with Javanese/Dutch-style chandeliers (figure

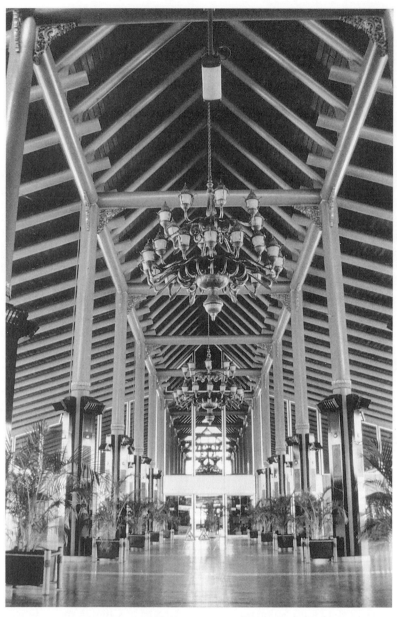

Figure 61. Long walkways modeled on the interior of the pendopo lead to passenger boarding areas at the Hatta-Sukarno Airport at Chengkareng.

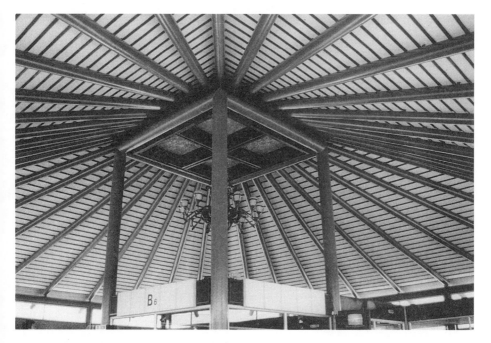

Figure 62. Airport passenger boarding areas topped by joglo-style roof.

61). (The elongation of the pendopo space, which ought to be radial, is made necessary by the walkway function, but the reference is unmistakable.) Open ramps branch off the main walkway, each one leading to a waiting room in a circular shape, each waiting room representing a pendopo, with its joglo-style roof and the recognizable interior form (figure 62). Gateways, apparently inevitably, feature Balinese themes (figure 63). Everywhere giant *kala* heads atop gateways evoke Balineseness and signify entrances.

The Outer Islands are not entirely absent: a bit of the decor of each circular waiting room has an outer island as its theme, in the form of a presumably characteristic decorative motif running around the space above the windows and below the ceiling. In the South Sulawesi room, of course, it is a Toraja-style carving.

The hierarchy of signs at the airport is transparent: the Central Javanese joglo covers and encompasses all; Bali is the second most important; and finally, the Outer Islands, whose interior structural in-

Figure 63. Gateway with "Balinese" theme: the escalator to the airport restaurant and shop before entering the open-air walkway.

tegrity is totally dismantled and whose identity nearly disappears. What remains of them is a motif, attached to an alien structure for which it is nothing but decoration. The Chengkareng airport figures an Indonesian world in which Javanese overlordship is complete. It has absorbed all diversity as its inferiors and expanded to fill the world . . . at least, until it is brought up short at the edge of its national boundary.

How does this hybrid fantasy architecture signify "modernity" and "progress"? In it designers consciously recycle traditional forms to new uses or make new structures in modified traditional patterns, adapting their shapes, sizes, and functions for new uses. These hybrid forms effectively domesticate the built landscape for tourists, al-

lowing it to be read as traditional and colorful without provoking or requiring physical discomfort or mental inconvenience. As a visual and architectural regime, these grandiose hybrid forms allow the nation-state to incorporate "the past," "the sacred," and "the kingly" in a way that nationalizes and modernizes it. Part of what development consists of, then, is the adaptation and conscious modification of traditional forms to the uses and functions compatible with a global economy and nation-state governmental form.

8

· · ·

Making Progress on Borobudur

A political community seeks to educate its public, whether citizens or subjects, in its own cosmology of space and time. One of the most important of the semiotic technologies available historically to a political regime for communication about itself was architecture. We can read state architecture as rhetorical structures in order to understand how the state conceptualizes itself and what it wants to convey to the public. The state-sponsored museum and the world's fair, for instance, were nineteenth-century inventions by European nation-states, sites for public instruction in the idea of progress and the relations between civilized Europe and the colonized primitive.

Palaces in the great historical Buddhist polities of Southeast Asia, by contrast, were modeled after the idea of the mandala, representing a cosmic mountain with the ruler of the kingdom, a microcosm of the Buddhist realm, located symbolically at the cosmic center. Angkor Wat is probably the best-known example of an architectural mandala; another spectacular example is the royal palace complex in Bangkok. Javanese royal architecture, with its *joglo*-roofed *pendopo* (a square pavilion with open sides, where supplicants could gather to pay tribute and make requests to the lord of the realm), was less spectacular but equally cosmic in its message.

Borobudur, a monument built by a ruler of the Sailendra dynasty in the ninth century in Central Java, depicted the same cosmic meaning, although it was not a ruler's palace but a Buddhist structure for aiding meditation. In its original incarnation, monks and pilgrims slowly made their ways to its top by circumambulating its terraces, in the process symbolically dissociating themselves from the everyday world and moving toward enlightenment. No longer a Buddhist meditation tool, Borobudur is now one of the two major Monumen Nasional (national monuments) within Taman Wisata Candi Borobudur dan Prambanan (Borobudur and Prambanan Temples Tourist Park). The park was created under General Suharto's development and na-

tionalization plan (his "New Order"). In Borobudur's current, nation-alized incarnation, tourists climb straight to the top to enjoy the view.

One of the reasons Borobudur's resocialization (from Buddhist meditation tool to national monument) holds special interest for the study of nationalist appropriations of the past is that Borobudur is shaped like a mandala, a sacred circular diagram, like the Buddhist realm itself. At the same time, the icon of General Suharto's political organization (known as Golkar) is the banyan tree. Like the royal umbrella that shelters underlings, like the high-peaked and stable mountain, like royal palaces built on a circular axis, and like the cir-cular representations of the Buddhist universe itself, the banyan tree is an ancient symbol of Indic kingship, circular and encompassing.

The nationalization of Borobudur in the late twentieth century pro-vides some insight into how two distinct styles of imagining the polity, far apart in space and time—European nationalist progressivist time and the temporally and spatially wishfully-immobile mandala sym-bols of Southeast Asian Indic states—can be made to commingle, and what sorts of symbolic regimes of public culture may emerge.

SOME THOUGHTS ON THE RHETORIC OF SPACES

One aspect of the rhetorical function of architecture is, simply, how it looks and what it refers to. So, for instance, Carl Schorske (1979) out-lined the battle between liberals and conservatives in nineteenth-century Vienna, manifested by the fight over whether the new civic building should be neoclassical or neo-Gothic. In a similar vein, I discussed in chapter 7 how Indonesia's hybrid fantasy architecture refers visually to other, older architecture.

What struck me about Borobudur and its nationalist conversion, however, was not a change in the way it looks but a change in the way it is used. In its early days, monks and pilgrims slowly circum-ambulated its terraces; in its current incarnation, tourists climb straight to the top and look at the view. This fact prompted the thought that a second way that architecture can be read as a rhetori-cal structure is by exploring how its spaces are experienced by users or visitors, particularly their phenomenological experience of mov-ing through the space and understanding their movement within it.

In this chapter I explore this second way of reading architectural rhetorical strategy. In doing so, I am very loosely inspired by Erwin

Panofsky's (1955b) "The Theory of Human Proportions as a Reflection of the History of Styles." In it he argues that Egyptian art was constructed using an absolute and unvarying canon of proportions that did not acknowledge the subjectivity of the person depicted, of the viewer of the finished work, or of the artist, whereas the perspectival art developed in Greece and perfected and rationalized in the Renaissance acknowledges all three. Although my project here is different from Panofsky's, the gist of it is to think of architectural forms as inspiring, as well as reflecting, different constructions of subjectivity.[1]

In *Ageless Borobudur* (1976), the Dutch archaeologist A. J. Bernet Kempers asks the reader to think about the differences between what he calls "static" and "dynamic" spaces:

> Spaces become dynamic when by their very nature they "force" anyone entering them to proceed in a certain direction—as though through a passage, up a flight of steps, along a succession of interconnected rooms. The movement may be movement just for itself without any specific focus for the eye or aim for the walk. On the other hand, the movement may lead to a statue, an altar, or some important element forming the spiritual or architectural culmination of the entire complex.
>
> Thus a space can be "dynamic" and a "path," and can take various forms. One is straight, leading directly to the goal. For instance, upon entering the Greek temple one can see, without difficulty, the sacred image at the end of a long, unimpeded path. (177)

Bernet Kempers's interesting invitation leads me to think about the issue of Borobudur's "dynamic space" and how it has been partially converted into a perspectival space in its incarnation as a national monument. Several possibilities come to mind when we think of the relationship between the conscious subject and the sorts of systems of sight and experience that the built environment promotes or invites.

Two "static" temple spaces immediately suggest themselves: Egyptian pyramids and Mesoamerican pyramids. Egyptian pyramids were constructed as burial mounds; though they have inner chambers, they were sealed off precisely to prevent people from entering or using them. Presumably they were intended to stand as stable and eternal, existing in themselves without reference to the viewer. For people who could see them from afar, they were distant markers of greatness; but as spaces, they do not invite the viewer to approach or "interact" with them. Mesoamerican pyramids, by contrast, were apparently constructed as stages for ceremonies to be performed on the giant steps ascending to the temple at the top. Rituals

were enacted on the frontal steps by priests and their attendants, as ceremonial spectacles for the massive crowds gathered at the base.

Other kinds of structures may form a path or construct a point of view. Perspective as a symbolic form[2] separates the viewer from the viewed and defines the relation between them using visual cues (for example, vanishing lines, overlapping, or change in size, all organized with the position of the viewer in mind). I return to the notion of perspective after introducing spaces constructed as paths and exploring Borobudur as a Buddhist path.

Spaces may be constructed as paths that invite the viewer to penetrate them and interact with them. In the English garden, the viewer moves from place to place along a preset path, delighted and amazed by the splendid views around the corner or at a hillock's summit, the prospect often focused or anchored by a bit of garden statuary. The landscape has been constructed for the viewer's pleasure.[3]

One of the oldest forms of space-as-path may be the labyrinth. It invites the viewer/actor to enter and reach the central goal by traversing twists and turns and avoiding dead ends, so it serves to confuse and test as well as to invite penetration. The conscious subject constructed by the labyrinth is not the viewer but the hero.

But I want to consider at greater length a very different kind of path, the Buddhist path to enlightenment, which Borobudur provides for the devout pilgrim. Borobudur as a Buddhist path assumes and is predicated upon a Buddhist cosmos. At the center of the Buddhist universe sits the Lord Buddha. His realm surrounds him equally on all sides. Arranged in tiers of enlightenment, less enlightened creatures, including ordinary humans, exist at further and further distances from the center: bodhisattvas sit closest to him, demons inhabit the extreme periphery.

The beings in a Buddhist universe may choose to stay on the periphery, in their various incarnations as humans, beasts, hungry ghosts, demons, and the like; or they may seek enlightenment. In seeking enlightenment, they move symbolically away from the periphery and toward the center, toward Buddhahood, in the process shedding their tight associations with the lower worlds of the violent and lustful periphery. This is the path that Borobudur's architecture and icons construct. Beginning at the monument's bottom, the meditating monk or pilgrim followed a gentle path of terraces around the periphery, slowly winding up and inward to the monument's upper reaches. A large stupa lies at its very center and top, at the location of

the Buddha himself in the Buddhist cosmos.[4] So, unlike the Sun King at Versailles, the pilgrim at Borobudur could not occupy the symbolic center of the space. A human seeker of enlightenment may approach the top but cannot reach the center, a place reserved for the Buddha, or, rather, for nothingness, for that which transcends form and individuality.

Borobudur, then, is a "dynamic" space that invites the participation of the conscious subject who visits it. It is a site that was intended to be climbed. Buddhist pilgrims presumably wound their way up slowly, meditating on the numerous friezes that line the walkways of the lower terraces, and in so doing, symbolically reenacting the ten stages of enlightenment of the Buddha and dissociating themselves from the worldly existence below.

Here I explore and contrast two strikingly different "lives" of Borobudur: first, as a Buddhist monument and meditation tool; second, as a Monumen Nasional and Obyek Wisata, a national monument and official visitors' attraction. Each involves different practices and uses of space and implies different systems of vision, approach, and enclosure.

BUDDHIST BOROBUDUR

Twentieth-century archaeologists, art historians, and Buddhologists have studied Borobudur extensively. Drawing on their work, especially that of A. J. Bernet Kempers (1976) and John Miksic (1990), and following Claire Holt, in whose 1967 book *Art in Indonesia* I first encountered Borobudur, I turn now to a much more detailed explication of the spatial structure and iconography of Borobudur as a Buddhist mountain, mandala, and path to enlightenment.

Indic religions—various forms of Hinduism and Buddhism— spread throughout both mainland and island Southeast Asia during the first millennium A.D. Most of mainland Southeast Asia remains Buddhist now. Archaeologists and historians tell us that the "Indo-Javanese" period of island Southeast Asia lasted for about three centuries, from the mid-seventh to the mid-tenth. Borobudur's foundations were laid around A.D. 800 during the Sailendra dynasty.

Rulers in Buddhist polities were the patrons of religion, and as meritorious acts they commonly ordered the building of monasteries and refurbishing of holy sites; so it is reasonable to assume that

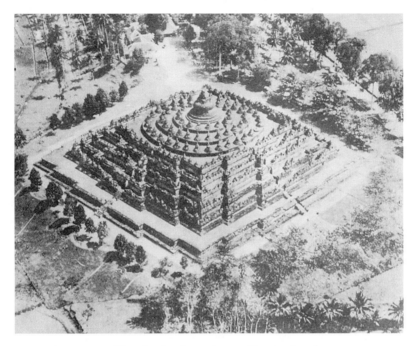

Figure 64. A view of Borobudur from above, allowing it to be seen as a whole and from a distance.

Borobudur was built under orders of the ruler as an act of piety and devotion, to be a sanctuary and meditation place for monks. Some Buddhologists and historians of old Java have also speculated that Borobudur, shaped like a cosmic mountain, was built partly in an effort to help stabilize the sometimes shaky world (Central Java is an earthquake zone), since sacred mountains in myths of the area are believed to do just that.

STRUCTURE

We can understand the structure of Borobudur most easily and clearly by observing it through three illustrations that were unavailable to the monks and pilgrims who used it. One of the most reproduced photographs of the monument, taken from a helicopter or low-flying plane, allows us to see it as a whole and from a distance (figure 64). It creates perspective where none was intended or imag-

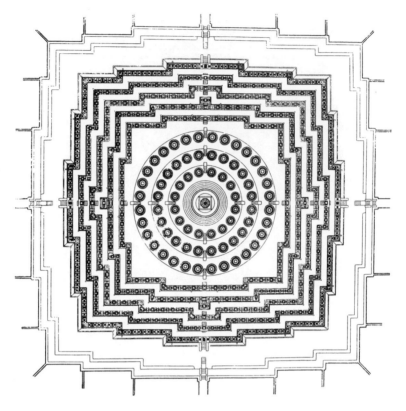

Figure 65. A ground plan clearly shows Borobudur's mandala structure.

ined by the builders. The photograph lets us see that it consists of various layers with a center, and that it is uncovered, open to the sky. A ground plan makes Borobudur's mandala structure clear (figure 65). We can see a large square platform on the extreme periphery enclosing five concentrically square shapes (walkways, as it happens), topped by three concentric disks and a round/squared center. A vertical cross-section of Borobudur clarifies the ground plan even more (figure 66). The outermost square is a platform that could accommodate processions of several people abreast. The next five square platforms are narrower walkways with high walls. The following three round platforms have no walls. On them sit *dagobs*, stupa forms, that consist of perforated domes each containing a statue of the Buddha. At the top is a central stupa.[5]

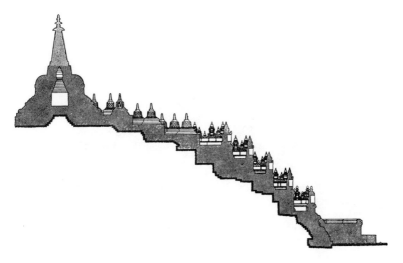

Figure 66. A vertical cross-section of Borobudur.

Borobudur has no interior spaces, and it is open to the sky; but it has walkways in several tiers on its periphery, the lower ones enclosed by high walls, that monks and pilgrims once used to circumambulate the mandala. They ascended from one square platform to the next by a set of steps. The monument has four sets of steps, one in the center of each side. Having the four sets of stairs in that configuration, rather than just one set, maintains the monument's symmetry; but we can presume that monks did not enter the monument from any of the four approaches equally, for the eastern approach is the most auspicious, and the narratives on the lowest terrace's panels begin at that gate and proceed clockwise.[6] Arched stone portals, each guarded by a carved *kala* figure, span the steps leading from each lower terrace to the next higher one (figure 67). Such symbolically protected gateways marking vulnerable entrances to sacred structures are entirely typical of sacred architecture in this part of the world. Throughout the Buddhist world, mandalas and other sacred structures have these guardians at the entrance gates to prevent the unqualified and uninitiated from passing through them and penetrating to their innermost sacred spaces.

Borobudur's structure, in sum, consists of an accumulation of walled walkways, many heavily decorated, open to the sky, shaped

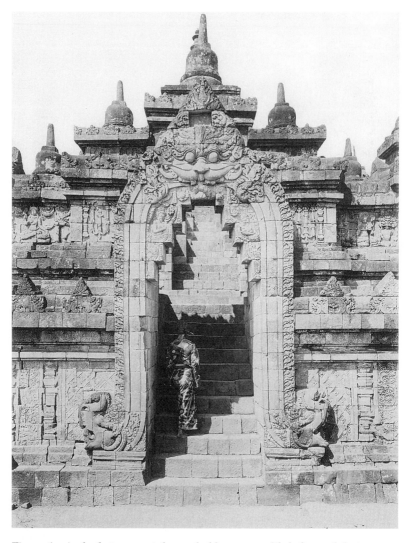

Figure 67. Arched stone portal guarded by a carved *kala* figure (photo circa 1911).

into a gently ascending symmetrical pile, its symmetry based on circles and squares with a common central point. The walls of the lower, quadrangular terraces are higher than those of the highest one, and the uppermost, disk-shaped platforms have none.

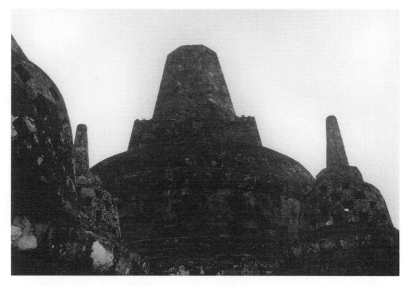

Figure 68. Borobudur's upper terraces and the central stupa.

COSMOLOGICAL MEANINGS

Archaeologists have pointed out that Borobudur is a form of stupa, or burial mound, with no interior space. Its shape and iconography suggest several meanings, each tied in multiple ways to Buddhist cosmology. It can be read as a cosmic mountain, as a replica of the Buddhist universe, as a mandala, or as a yantra. The meanings overlap.

Bernet Kempers (1959, 1976) reads the monument as a picture of the Buddhist universe. In Buddhist cosmology, the universe has three major divisions. The highest is abstract, formless, and immaterial—the Arupadhatu, literally "without form"; the next lower is the sphere of forms, the Rupadhatu; and finally there is the realm in which humans live, "the lowest sphere or Kamadhatu, the phenomenal world, dominated by lust and death," as Bernet Kempers succinctly puts it (1959: 44).

Bernet Kempers reads Borobudur's upper terraces as depicting the ultimate abstract reality and the Arupadhatu, in which the abstract is becoming slightly visible. This is represented by the central stupa (figure 68) and by the dagobs of Borobudur's highest,

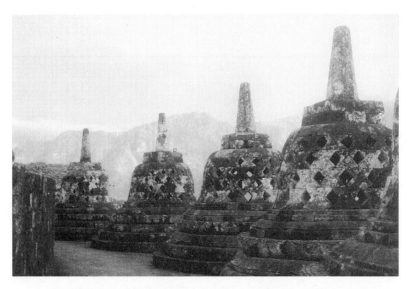

Figure 69. Dagobs of Borobudur's highest terraces.

Figure 70. Buddhas, enclosed by the stone lattices, are partly visible, partly hidden.

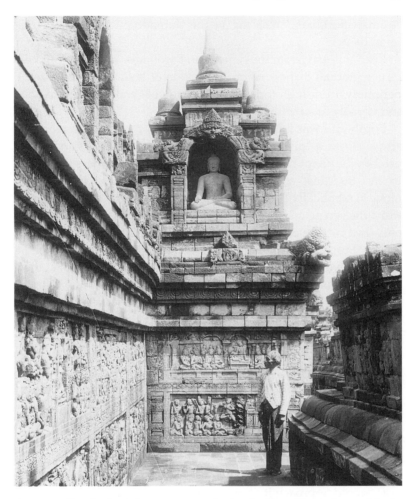

Figure 71. Borobudur's lower terraces depict the Rupadhatu, the world of forms (photo circa 1911).

disk-shaped terraces (figure 69). The Buddhas, enclosed by the latticed dagobs, are partly visible, partly hidden from sight (figure 70)—suggesting, perhaps, barely discernible presences, straddling the visible and invisible worlds (suggests Bernet Kempers 1959: 44). Buddha figures sitting in the high niches of the square lower terraces' balustrades represent the Rupadhatu, the world of forms (figure 71); and the Buddhas around the lowest balustrade are

"human Buddhas," residing in the Kamadhatu though not pol-
luted by it.

Read this way, from the center out, Borobudur represents and de-
picts a gradual dispersion or diminution of holiness from center to
periphery, from high to low, from intangible and formless to solid
and densely filled with form.

Borobudur was not merely a representation of the cosmos; it was
also a yantra, a "mystic diagram" based on quadrangles and circles
used by the adept to aid meditation (see Bernet Kempers 1976: 180).
In the Buddhist cosmos, humans seeking enlightenment must
move symbolically from the violent and unconscious periphery to-
ward the serene and mindful center. Borobudur is constructed not
only as a picture or replica of the universe but also as a path that
guides humans in their efforts to attain greater enlightenment.
From the vantage of a human on the worldly periphery, then,
Borobudur forms a universe with a built-in path. The universe can
be entered and climbed, following a circling movement that allows
one to move gently and gradually toward the top. Borobudur's
meaning as a yantra is better understood experientially, from the
point of view of a circumambulating monk, rather than from above
and as a whole. To understand it as a yantra, we must approach it
by tracing the monk's approach and ascent from the bottom and
periphery.

Borobudur as a Path

When Borobudur is approached from afar at ground level, as a pil-
grim would approach it, it gives the impression of being a segment
of a sphere—"a spherical object emerging from the earth or else, to
borrow from a Buddhist text in a similar context, an air bubble rest-
ing on water" (Bernet Kempers 1976: 32).

The monument itself is symmetrical; but the preferred, auspicious
approach for humans is from the east. Religious processions of vil-
lagers, as well as monks and pilgrims, could circumambulate the gi-
ant stupa by walking on the lowest, widest, bottom terrace, which is
unwalled, open to the surroundings, and not protected by a gateway
with a kala head. This seems to be the most profane and worldly
walkway, the link between the central, highest peak of Borobudur,
its graduated, lower periphery, and the yet more peripheral world

that surrounds the center that the monument itself defines. People walking in processions, like individual meditators, no doubt kept their right shoulders toward the stupa's middle "in agreement with the direction of the sun," *pradakshina* (clockwise, we would say).

Interestingly enough, this lowest platform and walkway was a late addition to Borobudur. Before it was added, panels had been carved around the monument's base, which the walkway now hides, and they would have been visible to villagers who came to the monument. The panels depict the type of cause-and-effect morality that is the crudest and simplest sort of moral lesson for a Buddhist; it makes sense that they would have been placed as the lowest and most basic series of illustrated lessons at Borobudur. They show people performing good and evil deeds and being rewarded and punished. For instance, they show "as punishment for cooking fish and turtles, the cooks are thrown into a cauldron in the Pratapana hell. Flayers of sheep are condemned to have their heads sawn through in the Kalasutra hell. Even smoking rats from their hole is a sin, punished by being crushed between huge rocks in the Samghata hell" (Miksic 1990: 66).[7]

In contrast to the processions that took place on that lowest, open terrace, the journeys of individual monastics and pilgrims were solitary or perhaps in small clusters. They would begin their meditation by ascending to the first walled terrace, climbing the steps and passing under the first gate with its carved guardian figure. It seems unlikely that meditators reached the top in a single day; and we do not know whether they were examined between terraces or between stages, on the ground, though it seems likely that some sort of permission may have been required to allow them to continue their slow contemplative journey toward the top.

At the first and lowest level (after the open processional platform), the meditators would find themselves in a rather narrow walkway with high walls, densely carved with four series of narrative panels, two on each side of the walkway, one upper and one lower. (See figure 71 for the general effect and scale.) Three of these depict *jataka* and *avadana* stories, the former telling of acts of self-sacrifice performed by the Buddha in his early incarnations, the latter also showing heroic deeds, though not performed by the Buddha. These can be compared, writes Miksic, to animal fables, fairy tales, romances, and adventure stories and were used "to teach Buddhism's simplest concepts to less sophisticated devotees" (71, 72).[8]

The most prominent panels, however, are those in the upper series; they illustrate the life of the historical Buddha, Siddhārtha Gautama.

Having circumambulated this first walled terrace, probably more than once, and having absorbed its messages, the pilgrims would move up the steps and, continuing to move in agreement with the direction of the sun, would meditate upon the friezes of the next highest square gallery—again, a path surrounded by high walls ornamented with pictorial panels. Having circumambulated it, they could traverse it again or could move up to the next terrace, again circumambulating, again repeating that terrace or moving up to the next level of walkway.

These next three terraces depict a more refined theme than the one narrated lower down: here the pilgrim follows the travels of a young man named Sudhana in his search for wisdom. The literary work on which it is based is called the *Gandavyuha*, "The Structure of the World Compared to a Bubble," and, comments Miksic, its narrative interest does not compare to the tales in the lower gallery—"no adventures or romances, just repetitive visits to various teachers, alternating with mystical visions experienced by Sudhana and others" (127). Further, the text on which it is based uses abstract language, making it difficult for sculptors to illustrate. One can imagine, Miksic writes, that pilgrims who had understood the lessons of the first gallery were now expected to apply themselves for more technical and intellectual studies.

The concluding episodes in the highest square gallery, the pilgrims found, consisted of reliefs from the *Gandavyuha* "in which the Buddha himself tells Sudhana that all Bodhisattvas, monks, and the great disciples are elated and applaud the vow which he and Samantabhadra have made." Pilgrims who reached this stage of instruction, Miksic continues, "No doubt . . . now identified themselves with Sudhana, and felt that by their perseverance, they too had given all the Buddhas cause for joy" (144).

Emerging into a clear space after the long journey of contemplation, study, and disengagement from worldly attachments, the meditator reached the highest square terrace, where three tiers of circular terraces rest. Suddenly the walls are lower, there are no pictorial panels, and the meditator becomes aware of open sky and space (figure 72). No narrative diverts the eyes or occupies the mind. The only representations consist of the large latticed dagobs, each enclosing a barely visible Buddha. The pilgrim has entered the sphere of form, the Rupa-

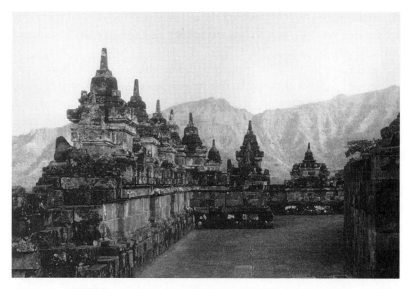

Figure 72. The highest square terrace at Borobudur, where the lower walls allow awareness of open sky and space.

dhatu (see figures 69 and 70). Beyond the dagobs lie only the great central stupa—the squared circle, the circled square, the center of the universe, the Arupadhatu, the beyond-form or without-form, where narrative has been stilled, where iconography has been surpassed.

No visitor to Borobudur who has circled through even a few of the lower terraces, hemmed in by high walls, assaulted by a profusion of representations, can help but feel a sense of release upon entering the superior sphere. As Claire Holt (1967) writes, you need not be a Buddhist or a mystic to experience the grandeur of silence in this superb void.[9]

In moving from bottom to top a meditator replicates the path of the ten stages of the enlightenment of the Buddha. One begins by passing through depictions of the world of lust and violence, of cause and effect, of comprehensible narrative. Then one moves to abstract ideas not embedded in narrative. Then the walls drop, the representations cease, and one reaches the circular open terraces, embracing sky and landscape both. For the informed Buddhist pilgrim, who understood the panels and the stories as well as the layout of the Buddhist cosmos, the intellectual experience of the iconog-

raphy and narratives paralleled the experiential movement from the dense, hemmed-in, icon-filled periphery to the open and formless power of the center.

We do not know what pilgrims did at the summit. Miksic suggests that perhaps they laid offerings around the edge of the great central stupa (1990: 144). And we do not know how pilgrims descended, though it seems likely that they proceeded down as they wended up, slowly spiraling in a clockwise movement. Moving straight down, like climbing straight up, would be equally unthinkable. And to reverse directions, moving counterclockwise, would be to adopt the movement of death, against the movement of the sun.[10]

Only one more thing need be added, for my purposes here, to this account of Borobudur. Like the Buddhist universe itself, Borobudur is symbolically an unbounded space. As Bernet Kempers puts it, "absolute partition lines and boundaries were not recognized by the architects of Central Java" (1976: 18). The monument embraces and links itself to the surrounding countryside with its lowest open platform, which forms an intermediary area where processions of villagers and new adepts could circumambulate. At the same time, the natural world of flora and fauna from the surrounding countryside symbolically penetrates and invades the monument's lowest terraces, for, although the first walled terrace cuts off the outside world visually, nonetheless the countryside is present in the form of its representations—carvings of plants, animals, and humans. Bernet Kempers describes this continuity: "At first the outside 'vegetable' world from which a Borobudur visitor is temporarily cut off seems to penetrate into this explicitly 'denaturalized' atmosphere of the sanctuary, spreading all over the walls and balustrades in the shape of lotus flowers, tendrils and leaves, carved in stone. In-between are figures of animals, curved and curled-up to look like bulbs of the plants surrounding them" (1976: 20). Like the Buddhist cosmos that it depicted, Borobudur melted, unbounded, into its periphery, the universe itself.

The conscious subject that Borobudur was intended to construct is one of selflessness, a dissociation from the world and its petty attachments and desires, an immersion with the absolute potent nothingness of the universe that does not suppress an individuated "self" but rather dissolves it.

BOROBUDUR SLIDES INTO RUBBISH,
THEN IS RECLAIMED AS ART

Although tourist brochures as well as scholarship almost universally emphasize Borobudur's original and therefore "authentic" purpose, it is now virtually never used for that purpose—not only because most Javanese profess Islam, but also because the government banned its use by Buddhists for ceremonies. It is clear that Borobudur has metamorphosed into an entirely different kind of object—analogous to the transformation of masks and ancestral effigies into primitive art.

How did that happen? At first glance, the practice of collecting seems fundamental to the process whereby objects become art by appropriation. Portable objects are collectable, and therefore are easily resocialized in new practices of display and classification. The practice of collecting seems so fundamental to the different lives that objects can lead that Philip Fisher (1992) suggests a distinction between portable objects, easily resocializable and more likely to have several lives, and immobile objects, which struggle against the collection of themselves—things like ruins, massive monuments, architecture, famous gardens, scenic views. Of course, even huge stable objects *can* be collected: the Cloisters or the London Bridge can be dismantled and then reassembled in New York or Arizona in new incarnations. At a less epic level, nonportable objects can be collected symbolically as drawings or postcards or miniature models. Generally, however, very large objects and landscapes are sites, not commodities. Fixed, heavy, and stable, they resist collection.

Borobudur is one of the most stable of objects—as unwieldy as an Egyptian pyramid and more complex to reassemble. Since this monument is truly monumental—2 million cubic feet of stone, about 1,500 pictorial panels, about 1,200 decorative ones, making 27,000 square feet of carved stone surface, and 504 Buddha images in the round (Holt 1967: 42)—it "resists" or "struggles against" being collected in a literal sense.[11] Nonetheless, through the centuries it has had several different "lives."

Borobudur's foundations were laid around A.D. 800, during Central Java's "Indo-Javanese" period, which lasted from the mid-seventh to the mid-tenth century. In the following centuries, this area of Central Java adopted Islam. We presume that that is the reason that Borobudur and a nearby Hindu temple, Prambanan, fell into disuse and disrepair.

These two monuments entered history (the narrative) with their appearance in Thomas Stamford Raffles's *History of Java,* first published in 1817; they were identified as "Antiquities," called Bóro Bódu and Brambánan. Raffles recognized these structures as Indian and pre-Islamic, and it was clear from their state of ruin that they had not been used for religious purposes for many years. Bernet Kempers explains their ruined state:

> When a sanctuary in a tropical country is abandoned and left to its fate, it will sooner or later fall prey to the forces of nature. Earthquakes or other natural disasters may help destroy it; earth, lava, lahars (streams of mud) and other materials running down from neighbouring mountains or rivers may cover it; plants, shrubs, and trees will begin to grow on it, thus inviting cattle and goats to tramp on it. Moreover, if by chance certain elevated parts of the building happen to have escaped burial, and loose stones protrude, people from neighbouring villages will come and start carrying such stones away. The stones may wind up as mortars, parts of walls, tenons, and so on. (1976: 191)

In this state, Borobudur had literally slid into rubble, and it was as invisible as "rubbish." Yet this state of disrepair was deemed desirable in the late eighteenth and early nineteenth centuries—these were romantic ruins, perfect for sensibilities of the time, as Raffles's illustration of Prambanan attests (figure 73). Raffles ordered some reconstruction and uncovering, and more was done later in the century. From this state it could be rediscovered as a piece of art with value and could begin its journey into a new category—art.

The first complete reconstruction using modern archaeological methods was done in the first decade of the twentieth century by Th. Van Erp, the Dutch government archaeologist. A picture taken in 1907 shows that it really was a ruin at the time (figure 74).

Van Erp's reconstruction stood for nearly seven decades, during which time Borobudur was studied intensively by archaeologists and came to be a tourist attraction in a sleepy sort of way. In 1973 when I visited it for the first time, one could take a bus on dusty roads from Yogyakarta, climb on the monument, and buy soft drinks and a few slides and postcards from the vendors surrounding it.

But archaeologists were concerned about deterioration due to water leakage and increased tourist use, and Suharto's government wanted to make it into a major tourist attraction and to glorify the national heritage. International opinion and funds were mobilized to re-

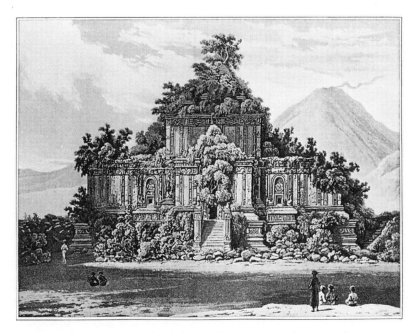

Figure 73. A picturesque illustration of the large temple at Prambanan (drawing circa 1817).

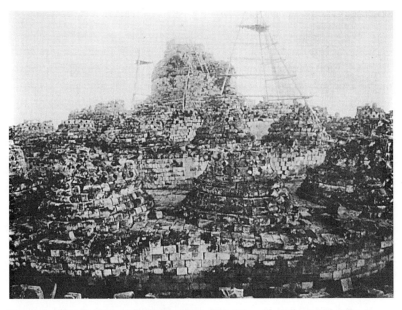

Figure 74. Borobudur at the beginning of Dutch archaeologist Van Erp's reconstruction (photo taken 1907).

Figure 75. An advertisement for Borobudur as a tourist site.

reconstruct Borobudur. For about ten years, with funds largely from UNESCO and supervision by a team of Japanese engineers, Borobudur was taken apart, cemented and plumbed, and put together again. It emerged triumphant in 1982 as a national monument and a major tourist attraction within Suharto's New Order Indonesia (figure 75).

BOROBUDUR AS NATIONAL MONUMENT

Monuments are usually too large to be collected, too large to be transported and displayed in museums. But they can be claimed, thus "collected" in the larger sense of possessed, with the symbolic act of enclosure by a power that has the right or ability to enclose. Extra structures can be built around the site, which assert the symbolic presence of the new owner and the owner's right to control the space, and which invite visitors to read the space in new ways.

In the case of Borobudur, enclosing and nationalizing the site has done different, but overlapping, symbolic work for the Indonesian government, on the one hand, which instituted the change, and for domestic and foreign tourists, on the other. By enclosing and controlling Borobudur, the Indonesian government lays claim to Borobudur as a specifically *national* treasure, a specifically *national* "heritage." At the same time, the enclosing of Borobudur makes it into a museum and art object simultaneously, for having a neutral space drawn around it isolates it from use and performance and thereby allows the visitor to recognize that this thing being visited is art, not life.

NATIONALIZING A SITE:
CLEARING, DISPLACING, ENCLOSING

In the early 1970s, before their refurbishing, Borobudur and Prambanan lay unmarked among their surrounding villages; they were part of normal everyday life, accessible to domestic and foreign tourists, villagers, and hawkers of snacks, sweets, and postcards. The restoration placed them as the main attractions inside the Taman Wisata Borobudur dan Prambanan.

To create this tourist park, the people in the surrounding area were forced to move off, the area was leveled, a fence was put around it, and various government structures (tourist information, dance stage, area for small vendors) were made at the entrance. The people who were forced to move off were compensated for their land, though, as usual, there were complaints that it was insufficient; where they were to move was a problem, since Central Java is among the most densely populated areas in overcrowded Java. A contemporary newspaper article anxiously compared the clearing to the displacement of peasants that occurred in 1973, when people where forcibly evicted from their houses and fields on the outskirts of Jakarta to make way for Taman Mini Indonesia Indah (Beautiful Indonesia-in-Miniature Park). Riots erupted in protest as peasants were forced off the land at gunpoint, and students were mobilized against the government in one of its first serious challenges. In spite of the parallels, riots did not occur at Borobudur.

The area around the monument was leveled and readied to become the storage and working area for the reconstruction itself. This process effectively erased one of Borobudur's former lives, that of archaeological site, when workers uncovered a variety of objects of interest to archaeologists. But no provision had been made for that possibility, the official restoration schedule was adhered to, and no archaeological work was done.[12] The area was eventually paved over after serving as a work site.

The tourist park is enclosed. Near the entrance vendors (who rent space from the government) sell food and souvenirs; a little farther on lies a magnificent open-air theater where dance-drama, usually from the Ramayana, is performed on full-moon nights; there is also a tourist kiosk with books, guides, and souvenirs, and then the new grand promenade walk leading to Borobudur begins.

What symbolic work does this enclosure and promenade do?

This new enclosure marks "public" and "national" space, drawing a line around it symbolically and literally (with a fence). The boundary makes an admission fee possible, because now an authority controls the entrance. (The admission fee is actually very small, and the majority of tourists are Javanese Indonesians. The dance-drama tickets are fairly expensive.)

The landscape aesthetics created by this enclosure and single entrance also construct spaces and provide visual clues that allow foreign tourists to read the monument in familiar ways.

For one thing, Borobudur becomes a work of art. Art is not a quality intrinsic to an object but is in the eye of the beholder. The beholder's eye can be encouraged to see an object as art if the piece is put into a context that allows us to read it that way: objects (like jewelry, door lintels, kava bowls, ancestor figures, headdresses, masks) not created as art can be transformed into art by being put onto pedestals, isolated from their fellows, enclosed in vitrines, and placed in a museum. The spatial reconfiguration announces an object's status as art even to the casual viewer. Although many of the objects that are classed as art and displayed in fine arts museums in Euro-America were once religious objects, that existence must be cleared away if they are to become art: so once a triptych is displayed in a museum, one ceases to light candles in front of it. The art object lives in a clear conceptual space—cleared of use and performance.

The transformation was completed when, with the new tourist park's opening, Suharto announced that Buddhist ceremonies could no longer be held at Borobudur. (They were obliged to take place at a nearby temple called Mendut.)

André Malraux makes the point that separating an object from the world and assembling it next to other "art objects" encourages the viewers in the intellectual activity of comparison and classification. To mark off Borobudur is to invite it to be mentally reclassified and compared to other objects in that class: other national monuments, other Buddhist structures, other tourist attractions. UNESCO's help also promotes this sort of reclassification, for UNESCO has helped restore only important, world-class monuments, a category Borobudur has now joined. The reconfigured and bounded space makes something else possible: a single approach to the monument, now marked by a grand promenade.

Borobudur as Facade

Borobudur in its former incarnations resisted being read as a facade at the end of a long approach. One came upon it rather suddenly, for there was no cleared space around it that would enable a long approach, or that would even allow one to stand back and see it as a whole from a distance—except from a great distance, in which case it resembled, as Bernet Kempers put it, a sphere rising from the earth or an air bubble resting on water. And its very circularity resisted allowing it to be read as a facade.

Borobudur still resists being read as a facade at the end of a long path, but a photograph by Marcello Tranchini captures the perspectival view of the new Borobudur intended by the new designers. To get the picture, the photographer apparently used a wide-angle lens and stood in the middle of the plantings that divide the new promenade to the monument. The view from this angle and distance allows the planted trees visually to block Borobudur's circular shape—both the gradual drop on the vertical sides that would allow it to be seen as a partial sphere rising from the earth and the horizontal roundedness of the monument. This double cutting-off visually mitigates Borobudur's roundness and promotes its being read as an object at the end of a straight line. This kind of perspectival vista

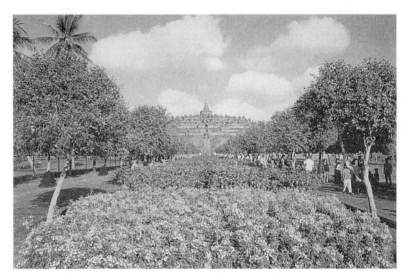

Figure 76. Tree-lined promenade framing vista of Borobudur.

turns the visitor into the subject and Borobudur into an object—an *obyek turis,* to be precise (figure 76).

THE VIEW FROM BOROBUDUR

But the more common perspectival view at Borobudur is not from outside the monument looking at it but from *on* the monument looking down. It is a rare visitor who circumambulates Borobudur the way the monks presumably did. Visitors usually climb straight up, occasionally turning around to see the view (figure 77).

To move straight up the side of the monument, a person must pass under successive gates carved with guardian kala heads. Because they are entrances into a structure, gates are its penetrable weak points. For that reason gates and entrances and thresholds of mandalas and palaces and temples need supernatural protection, like Borobudur's carved kala heads.

The Balinese have a different solution to the problem of demons penetrating their sacred structures. To understand it one needs to understand the differences in the ways that humans and demons conduct themselves, both in speech and in movement through space.

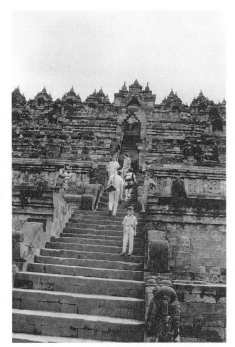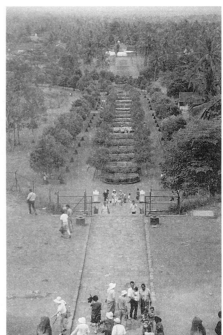

Figure 77. Visitors now usually climb straight up the stairs *(left)*, occasionally turning around to see the view *(right)*.

In Bali and Java, humans (when they are being most human, most refined, and most spiritually powerful) are indirect and circumspect in their speech, restrained in their gestures and movements. Demons and monsters, by contrast, have no self-restraint: they go straight for their goals in a direct line, metaphorically or literally, an indication as well as a cause of their inability to move to a higher realm and leave behind their uncontrolled desire. In Bali (and possibly in pre-Islamic Java) demons are said to travel in straight lines, in contradistinction to humans, who are indirect, even circuitous, and can negotiate corners and circles.[13] Balinese gateways, therefore, are commonly constructed in a way that foils demons. A courtyard wall will have an opening to serve as an entrance; a few feet inside the opening, parallel to the outside wall, another short wall is built. A human can easily negotiate the barrier to get inside the courtyard, but it confuses demons.

The guardians at Borobudur's gates, placed there to ward off straight-line-moving demons and other morally inferior beings, have recently been singularly unsuccessful in preventing impetuous beings from going straight to their goal. And their goal, of course, is to climb straight to the top and see the view. This direct movement up and down the would-be yantra is the characteristic movement of tourists. It gives them a view of the surrounding area, allowing them to reenact or reinstantiate a habit of seeing that has been developing in the West since the Renaissance.

THE VIEW AS SYMBOLIC FORM

Rather than dissolve the "self," the idea of perspective that was rationalized and perfected in the Renaissance institutes it. Perspective as symbolic form is predicated upon the idea of an individual subject, around whom and for whose gaze the picture plane is organized.

The perspectival organization of the picture plane was perfected during the Renaissance, but it was not long confined to two dimensions. Soon after its adoption for flat surfaces, a "point of view" was built into architectural and landscape vistas, as well. Palladio's Teatro Olimpico (built 1580–84) stands as an early and superb example of an interior space with a single privileged point of view—reserved for the ruler, who sat in the middle (see Murray 1963: 230).[14] This type of constructed perspectival space is static in that the placement of the viewer and the viewed is assumed to be fixed; it is constructed for and around the viewer (see figure 78).

During the following centuries in Euro-America, perspectival views were built into the exterior environment as well as interior spaces and have since become a commonplace in architecture and landscape design. One type of perspectival space locates the viewing subject at the landscape's center, the most striking example of which is the view from the palace at Versailles. Versailles constructs the landscape, indeed the world, as an extension of the viewing self. Vanishing lines, built into the scene with paths and topiary, define the view's perspective. The equivalent view from the center (the Sun King's perspective) available to twentieth-century consumers is from the top of high buildings at night, sipping a cocktail—such as from the bar at the top of the Hancock Building in Chicago, which provides an unimpeded view from the center, complete with vanish-

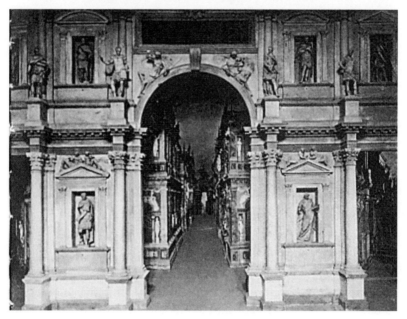

Figure 78. Palladio's Teatro Olimpico: diagram of the stage and seating plan *(top)* and the view of the stage from the ideal subject-location *(bottom)*.

Figure 79. View from the top of the Hancock Building in Chicago.

ing lines defined by lighted streets stretching to infinity (it seems) across the flat midwestern land (figure 79).

A different way that perspective can be built into the landscape is to use a building as a facade and to link the viewer to it with a path; the path defines the space between subject and object, inventing a perspectival relationship between them. One thinks of the Spanish Steps in Rome, built in the eighteenth century, which invite the viewer to see the space as a line and the buildings behind it as a facade. Or one thinks of the grand approaches to many English country houses, which again function as vanishing lines that end at the flat front of the house, which becomes in effect a facade or a back-

drop. A more recent example in city planning includes the boulevards that all lead to the Arc de Triomphe in Paris. The arch is not the *goal* of the boulevards but is, rather, a visual anchor that allows the viewer to be oriented in space. It functions as a facade by attracting, then focusing and stopping, the viewer's line of sight.

An irony of perspective in landscape is that perspective as symbolic form actually resides in the eye of the beholder: consequently anything can be seen perspectivally and as a view, even if the landscape has not been purposefully built with visual cues in order to promote that way of seeing. (Of course, the habit of viewing things perspectivally is doubtless trained into conscious subjects by the wide availability of perspectival views deliberately constructed.) The Alps were for the first time appreciated as a "view" when the Romantic sensibility was linked to the habit of viewing things as though they existed for the eye of the beholder, whereas previously they had been considered mainly an obstruction (Clark 1969).

It is worth noting that in the early eighteenth century Joseph Addison articulated one of the charms of "the view" as a way for the conscious subject to construct the surroundings as property. Addison comments on the refined sensibility of the "Man of Polite Imagination," who takes more pleasure in the sight of landscape than its actual possession—although, interestingly, this gaze makes anything he sees into his symbolic property. "This Man of Polite Imagination," Addison writes, "often feels a greater Satisfaction in the Prospect of Fields and Meadows, than another does in the Possession. It gives him, indeed, a kind of Property in everything he sees."

A ninth-century Buddhist pilgrim at Borobudur would not climb straight up Borobudur to look around at the view, but contemporary tourists, both Indonesian and foreign, tend to do precisely that. That is only one of the ways that Borobudur has been transformed from a Buddhist yantra (meditation tool) to a national monument and international tourist site.

THE VIEW FROM THE CENTER

Approaching the top and center of Borobudur, the meditating pilgrims or monastics perhaps laid offerings around the edge of the great central stupa (Miksic 1990: 144). But it is certain that meditators

could not reach the dead center and the highest point. They could not occupy the symbolic center of the cosmos they believed they lived in, and thus they were prevented from situating themselves like the Sun King viewing his gardens at Versailles.

Even now, contemporary Javanese are reluctant to put themselves in the center of a centered space. The pendopo, for instance, is a centered space when experienced from the interior, because the rising peak of the joglo is visible from underneath (see figure 56 in chapter 7). The person who occupied the center of the pendopo by standing or sitting directly under the roof's peak would be claiming higher status than anyone on the periphery. Even now, Javanese avoid walking directly across this central spot, and certainly would not sit in it. To do so would be considered extremely arrogant.

The mid-nineteenth-century European tourist apparently had no such compunctions; in 1864 a teahouse stood at Borobudur's summit to refresh visitors who had made the exhausting climb (figure 80). This symbolic placement of the teahouse in the very center of the cosmic mountain placed the tourist in a position akin to the Sun King at the center of Versailles. The modern tourist is prevented from attaining the very summit, of course, because the central stupa has been restored. But the arrogance of even imagining perching on the peak of the Borobudur's central stupa while eating tea and cakes is beyond fathoming even for most contemporary Indonesians, and certainly would have been for ninth-century Buddhists.

The teahouse at the summit of Borobudur reveals tangibly what Mary Pratt (1992), in her book about several centuries of European travel writing, refers to as "imperial eyes," or the "monarch-of-all-I-survey scene," apparently borrowing the phrase from lines attributed to Alexander Selkirk: "I am monarch of all I survey / My right there is none to dispute." One cannot help but think again of Addison's suggestion in the early eighteenth century (quoted above) that the prospect or view provides an even greater satisfaction to the man of sensibility than does actual possession—it "gives him, indeed, a kind of Property in everything he sees."

POSSESSING BOROBUDUR

In the present era, Borobudur can be possessed symbolically in other ways as well. In its new life, it conforms to two modes of possession

Figure 80. A teahouse stood at Borobudur's summit when this picture was taken in 1866.

mentioned by Walter Benjamin in his famous essay on mechanical reproduction: by being viewed up close and by being possessed through physical replicas.

When Borobudur was a Buddhist yantra, it was approachable only through careful preparation, study, and along a given path. This

relative unapproachability, this symbolic distance between the meditator and the Arupadhatu (formlessness, enlightenment) represented by the monument's upper reaches, is what Benjamin calls the "aura," which remains "distant, however close it may be" (1969: 243, n. 5). People who believe something to be sacred hesitate to approach it physically. Even if they touch and handle it, they do so with a feeling that it is distant from them—from a different plane. In his essay on mechanical reproduction, Benjamin claims that most objects we now classify as works of art began as sacred objects with auras, but that in the present age there is a "decay of the aura" due in part to their being available as photographs and in films. The availability of photographs, he argues, decreases distance, hence aura, because the masses can "get hold of an object at very close range by way of its likeness, its reproduction." The feeling of distance inspired by the object's aura, he suggests, is directly opposite to contemporary sensibilities:

> namely, the desire of contemporary masses to bring things "closer" spatially and humanly, which is just as ardent as their bent toward overcoming the uniqueness of every reality by accepting its reproduction. Every day the urge grows stronger to get hold of an object at very close range by way of its likeness, its reproduction. . . . To pry an object from its shell, to destroy its aura, is the mark of a perception whose "sense of the universal equality of things" has increased to such a degree that it extracts it even from a unique object by means of reproduction. (1969: 223)

Just as when Benjamin wrote, we masses can still now indeed possess symbolically any work of art or monument by possessing its replicas in the form of photographs, films, and miniatures, as well as in yet more forms, like videotapes and refrigerator magnets, thus decreasing the distance between ourselves and them. But now, far more than in the decades when Benjamin wrote, world tourism has increased exponentially. It is easier than ever before for the masses to go directly to former "cult objects" like Borobudur by visiting them, climbing on them, and touching them. We can literally "get hold of them at close range," by clambering all over the monument in any direction and order, as though it existed for our interest and pleasure, or by peering in and touching the enclosed Buddha figures (figure 81).

Figure 81. Tourists climbing on and touching Buddha figures in the dagobs of Borobodur.

MODERNIZING BOROBUDUR

Referring to the rationalization and perfection during the Renaissance of perspectival techniques in art, Panofsky (1955b) comments that "those who like to interpret historical facts symbolically may recognize in this the spirit of a specifically 'modern' conception of the world which permits the subject to assert itself against the object as something independent and equal; whereas classical antiquity did not as yet permit the explicit formulation of this contrast; and whereas the Middle Ages believed the subject as well as the object to be submerged in a higher unity" (99).

It would be easy, and in some ways, I think, correct, to interpret the modernization of Borobudur in similar terms, regarding the monument as moving from a premodern configuration of use to a modern one in which the subject asserts itself against the object as something independent and equal. If we wanted to argue that this was, indeed, the transformation that has occurred, we could point out that it was accomplished in part by processes and structures that allow or encourage a modern use and view of the space: one that constructs the space to privilege a single point of view (for example, from the grand promenade to the monument), encourages or allows the space to be used to achieve a view or a prospect (from the monument looking down), and allows symbolic possession of the monument by the ability to approach it "up close" and to own it in the form of postcards, coffee-table books, videotapes, and so forth. In short, those who like to interpret historical facts symbolically may recognize in the conversion of Borobudur from a Buddhist space into a tourist site a specifically modern conception of the subject, which constitutes the conscious subject as one who views and possesses. The Buddhist use of the same space, by contrast, was intended to dissolve the subject's boundaries and aid the dispersion of its attachments to material possessions and lower desires.

That story, however, is a little too automatic: it is more or less the visual version of the modernization narrative. In the modernization narrative, unidirectional change toward something called "modernity" is built into the structure of time itself, hence it is inevitable. The story can be told regretfully, in a way that praises the purity and glory of the past but sadly states that time marches on and that the religious and the local must be swept aside for the universal, secular, and global. In the visual version of the modernization story, which is

sometimes told by art historians and curators, progress in art occurs when Archaic Greek art transforms into Classical Greek art—and all the subsequent analogues based in that progressivist tale: that non-naturalistic forms are abandoned once naturalistic forms can be "achieved"; that stiff, angular forms precede organic curvilinear forms if one is responsible for sorting out sequence and does not know the actual chronology; that "schematic" or "conceptual" art will be abandoned for perspectival art once perspective is "discovered."[15] Applied to Borobudur, this plotting of time as modernization could be told as a before-and-after story in which the authentic pure Buddhist use of space has been modernized, rationalized, and secularized, thus becoming either "inauthentic" (if the teller of the tale dislikes "modernization") or, conversely, a tale in which formerly sacred and exclusive space has become democratic and accessible. The story of modernization, then, whether economic or visual, is too unidirectional, too universal, too Eurocentric, and, most of all, without human agency or state power.

"Awakening" as Building

And yet Borobudur's transformation *is* specifically and clearly an example of modernization and development, a major project under the guidance of General Suharto's government, which took power in the mid-1960s. The mainstays of Suharto's New Order were the capital-intensive exploitation of natural resources (mainly timber and oil) and cultural tourism. For reasons that can best be understood in the context of Indonesia's particular history, General Suharto wanted to make Central Java's art and culture into a major tourist attraction as well as to glorify them as part of the national heritage. The restoration of Borobudur became part of Suharto's first five-year plan, announced in 1969. The project's cost ran to around twenty-five million dollars, nearly three-fourths of which was paid by the Indonesian government.

The way to approach the modernization of Borobudur, I think, is not to regard a movement toward perspective as a natural goal of representation or to regard it as something that will occur automatically with the unfolding of progress, but to ask, rather, what changes have been made in structures, context, and practices concerning it, and therefore what meanings the new improved Borobudur is asked to bear. What rhetorical and symbolic functions does it serve?

Borobudur's symbolic conversion into a national monument and tourist site was accomplished largely through a change in its context—its enclosure, the building of the promenade, and so forth, all of which encourage or demand its being used, visually and experientially, in particular ways. It is now surrounded by other structures—- the vendors' stalls, the information building, the dance theater, the enormous promenade that leads to the monument—whose existence bespeaks the state and Suharto's New Order. Borobudur's conversion took place under the banner of *pembangunan,* a word usually translated as "development" but whose meaning is worth exploring.

The root of the word, *bangun,* is translatable more or less as "waking up," "getting up," or "becoming upright and conscious." ("Sudah bangun?" is a morning inquiry meaning "Are you up and about yet?") Indonesians who are the objects of *pembangunan* joke that the word's root is not *bangun* but *bangunan,* something erected or built, like bridges, roads, and government kiosks, because the main work of *pembangunan* seems to be erecting government buildings. The idea is plausible when one revisits, say, an ancient carved rock or bathing place in Bali that twenty years ago was accessible only by a trek on a minor footpath, but which now is clearly marked by cement steps, an official entrance, and an admission fee. Marking sites with *bangunan* increases their official visibility as tourist sites; it also asserts state notice and control of them.

The new grand entrances to traditional sites and the government kiosks and information booths that surround them signify the specifically national importance of those sites. Ephemera about major tourist attractions—art books, photographs, postcards, educational videos, and kitsch—spring up as scholars and entrepreneurs do their jobs. And people untutored in old methods of ascent do what comes naturally to the modern tourist and climb straight to the top, the place where the most scenic views can be obtained. All these together have the effect, quite unintended as such, of transforming the monument into a modern entity.

RECONCILING PROGRESSIVIST TIME
AND HIERARCHICAL SPACE

Suharto's political program was called the New Order, but it used old symbols: his political party's icon, significantly, was the banyan

tree, harking back to the days of encompassing kingship.[16] A constitutional monarchy understandably draws upon royal architecture and symbolism in promoting tourism and creating emblems of the nation-state. The Suharto regime's preoccupation with Central Javanese kingship requires more explanation.

Since the mid-1970s it has become increasingly apparent that the prestige and symbolism of the former kingly courts of Yogyakarta and Surakarta of Central Java are coming to stand as national symbols, while other areas of this enormously diverse country are being demoted to the status of ethnic minorities and ethnic groups. It is true that Suharto and his wife (who until her death in 1996 was a major force in Indonesian politics) happened to be from Central Java (he from Yogyakarta, she from Surakarta), but the reasons for the elevation of this region were more than personal. The political and economic reasons for the elevation of Central Java to what is beginning to look like symbolic hegemony are not difficult to discern. Java is the most populous of the islands, by far, and has the most commercial infrastructure, dating from the centuries when the Dutch were the colonial power there. The majority of the economic, political, and military power of the country is located in Java and controlled by Javanese.

The classification and production of knowledge and history not surprisingly tended to be pervasively and unselfconsciously Java-centric among people in the employ of the New Order. In 1989 an Indonesian bureaucrat in Bandung, himself originally from Sumatra but long resident in Java, explained to me with great conviction that Indonesia was a unified country long before the rule of the Dutch. Our country has historical unity, he explained, because all of Indonesia used to be ruled by Majapahit (a Javanese kingdom); he went on to point out that evidence of Javanese kingship has been found as far afield as Sulawesi. In discussing Java-centrism and the New Order with me the day after I visited the new, improved Borobudur, a Javanese intellectual told the story of how in the mid-1980s a Javanese minister of culture went on a pan-Indonesian tour to discover what (high) "culture" (*kebudayaan*) was like outside Java; the minister was quoted in the paper as reporting that the music in Kalimantan (Indonesian Borneo) is just "*ngak ngik ngok*," translatable more or less as "nothing besides plink plonk plink." An Indonesian intellectual in the employ of the government, after hearing and somewhat misun-

derstanding a lecture I gave on European modernism and primitive art, commented to me that Indonesia has classical art, primitive art, and modern art all at the same time: modern art is produced in Jakarta, classical art comes from Central Java, and primitive art comes from the Outer Islands.

Earlier I posed the distinction made by Benedict Anderson between two ways of imagining a political community—one imagines itself as a flat bounded territory and locates itself in time; the other imagines itself as stable, timeless, and hierarchically organized around a sacred center with a subservient periphery. Yet perhaps a progressivist view of history and a hierarchical configuration of space are not so incompatible. The Jakarta elite's understanding of *pembangunan*, certainly, appears to be more spatialized than temporalized. The movement of "development" under the guidance of Suharto's regime was less a movement along the line of time than it was the expansion of governmental central control (which drew its imperial symbols from Central Java) to dominate and encompass the periphery (the Outer Islands).

Afterword

Throughout this book I have emphasized the linear trajectory of time postulated in the idea of progress and have explored some of the types of Other it has produced. I began with the nineteenth-century notion of progress and moved to twentieth-century concepts of the modern; later in my story I claimed that in certain versions and contexts, narratives of nationalism, modernization, and development are incarnations of the idea of linear progress. Like the nineteenth-century version, these later narratives are linear in that they postulate a ceaseless forward movement of national unfolding and of the world economy. But now I want to ask a fundamental question about the idea of progress: Should it be construed and represented as a line, or should it be thought of as an expansion from a dominant center?

After all, linear time and hierarchical space were quite easily reconciled in nineteenth-century narratives of progress by the economically and territorially expanding and colonizing European nation-states. Darwin temporalized the Great Chain of Being, with the result that those taxa that had been higher in the hierarchy became later in time, and the earlier ones became the more rudimentary, inchoate, or primitive. This temporal account of natural history, one of the great master-narratives of the nineteenth century, could rather easily be reconverted into a spatial hierarchy, and was, with Social Darwinism. Europe, the colonizer, imagined itself as the peak of social evolution, imagined its own immediate past as lower than itself, and imagined the colonized beings in the far corners of the world as exemplars of earlier stages of human social, technological, and moral evolution. More recently (I suggested in chapter 8), Indonesia's Java-centric New Order Jakarta elite reconciled a progressivist view of history's forward motion with a hierarchical configuration of space by imagining "development" as an expansion of the Javanese center into the

Outer Island periphery. These examples of the fusion of linear time with hierarchical space in discourses of progress suggest that the fusion has been an unacknowledged (and therefore covert, but nonetheless basic) aspect of the idea of progress since its invention.

Therefore, rather than perpetuate even rhetorically the notion of time moving forward and leaving so-called Stone Age peoples behind, perhaps we should adopt the language of economists who speak of economic centers and peripheries in the global system, which at least has the virtue of implying a massive power difference in the two parts. That switch in metaphors allows us to construe current events less as the inevitable march of "progress" (with a vanguard of civilized modernity and a rear guard of people clinging to "tradition") and more as a dominant economic "center" (increasingly global and increasingly wealthy) that produces a growing underclass of people throughout the world who are incorporated generally at the periphery and bottom of this system. Using this second metaphor, I want to comment on the place of primitive art at this point in history.

By the end of the twentieth century, I have claimed, the supply of the kinds of artifacts that could qualify as "authentic primitive art" was dwindling ("they're not making it anymore"). The supply of ritual artifacts (that is, the kinds of artifacts most likely to have become authentic primitive art) was exhausted because the kinds of societies that produced authentic primitive art continue to be absorbed at an exponential rate into the global economic system. The peoples who formerly were the sources of authentic primitive art are now making artifacts for the market—artifacts still sold as "authentic," but on different grounds. Of course, since the beginning of the European economic expansion into the rest of the world, people on the economic peripheries have turned to the production of artifacts for the market for economic survival when their skills and products suited the markets of their times. But there is a difference under the regime of economic globalization. Authentic primitive art in the older, Rockefeller-Wing mode of high primitive art is over because the kinds of peoples who produced it have stopped being "tribal" and have become modern-day peasants or a new type of proletariat. These people do not conform to the classic definition of peasants— people who live on the peripheries of cities and whose agricultural

labor and products supply the cities' inhabitants—nor do they look like the proletarian class of industrialized cities. They live in rainforests and deserts and other such formerly out-of-the-way places on the peripheries of the main flows of capital, labor, information, and images within national and increasingly global systems of buying and selling, of using human and natural resources, and of marketing images and notions about products. Some lucky few of them make high ethnic art, sell it for good prices, and obtain a good portion of the proceeds. Others make objects classed as tourist art or folk art, usually for much less money, and often through a middleperson. Others, in sites such as Gallup, New Mexico, or Bali, Indonesia, have become jobbers of the primitive, producing either masses of "folk art" or expensive handmade items designed by people in touch with world taste and world markets. Primitivist spin-offs also abound. (To find the production site of the what I call Generic Tropical Jewelry—which is made of seashells and sold in Hawaii, the Caribbean, and by now probably in Bali as well—visit the island of Cebu in the Philippines.)

For most of the twentieth century, primitive art stood as the emblem of the Other—of the peripheral, the marginal, the unabsorbed, the undomesticated. Artifacts of newer sorts, although made for the market, continue to signify the primitive, the "real," the unsophisticated, or the naive. The conceptual space of the primitive Other is now visibly perpetuated in the form (among others) of marketable commodities at the very moment that the people who produce the commodities are threatened, whether directly displaced by mining, oil, timber, and hydroelectric dam projects, or indirectly but just as devastatingly by neo-liberal economic policies that cause people on the bottom not simply to "tighten their belts," as is sometimes euphemistically said, but to be deprived of clean water, an environment in which they can produce enough food for survival, and access to health care. Of course, fourth-world people and others are mobilizing against these forces, but the odds against them are certainly daunting.

One of my favorite visual comments about the discrepancy between the place of actual human indigenes and their location in a national imaginary is a drawing by the eminent Mexican political cartoonist known as Magú. A new character appeared in Magú's daily cartoon strip in the newspaper *La Jornada* in October 1996, during the Second Congress of Indigenous People in Mexico. It was Hernán

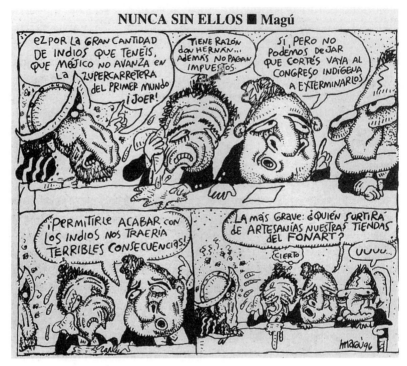

Figure 82. This cartoon by Magú appeared in Mexico's *La Jornada* on October 1996 during the first National Congress of Indigenous People in Mexico. In it, Cortés tries to get the government bureaucrats to allow him to exterminate the Indians.

Cortés, the man who brought down the Aztec empire in 1521. Magú's cartoon Cortés, speaking in a parody of sixteenth-century Spanish, returns to Mexico to tell the ruling party that he made a mistake in failing to kill off all the Indians several centuries ago, and he tries to convince the officials now in charge to let him do it during the Congress, while so many *indios* are conveniently gathered in one place.

In the cartoon reproduced here (figure 82), Cortés announces (I am translating loosely) to President Zedillo and two others: "It is because of the large number of Indians thou hast that Mexico advanceth not on the superhighway of the first world."

"Don Hernán has a good point there!" responds one official. "Besides, they don't pay taxes."

"Yes," says the other official, "but we cannot allow Cortés to go to the Congress of Indigenes to exterminate them. To allow him to do away with the Indians would bring terrible consequences! . . . the most serious: Who would supply the crafts for our government folk-art stores?"

Notes

INTRODUCTION: TWO CENTURIES OF PROGRESS

1. At its simplest and most general level, this idea is obviously indebted to the pervasive and salutary effect of Michel Foucault's work: one could speak of the "birth of primitive art" like the birth of the prison or the birth of the asylum, except that usually Foucault writes of ideas that become institutionalized, and institutions and practices that give material form to and reproduce ideas, more than he writes about physical objects that persist from one epistème to another, their meanings transformed in the course of the rupture.

More specifically about "art," I want to mention two thinkers. Arthur Danto (1981) has argued that commonplace objects actually *become* art when they are "discovered" to be "art." And yet he is not really serious on this point, because he believes both in the universal transcendent category "art" and also that some things were only recognized as art in particular historical circumstances: he therefore has it both ways. Philip Fisher's lucid article "The Future's Past" (1975), although in content it addresses only art and museums in the European tradition, was an early inspiration for the approach I adopt here.

2. The scholarly interest in collecting as a practice in colonial and protocolonial discourses has recently elevated the topic of curiosity cabinets to prominence. An extremely scholarly early work on this topic, full of useful articles for the specialist, is Oliver Impey and Arthur MacGregor's *The Origins of Museums: The Cabinet of Curiosities in Sixteenth- and Seventeenth-Century Europe* (1985). More casual readers will enjoy Lawrence Weschler's *Mr. Wilson's Cabinet of Wonder* (1995), which draws upon Impey and MacGregor's volume.

3. The classic work explaining the Great Chain of Being is Arthur Lovejoy's 1936 book of the same name; see also Margaret Hodgen's *Early Anthropology in the Sixteenth and Seventeenth Centuries* (1964).

4. For more detail on the invention of archaeology as a discipline, see Glyn Daniel's *A Hundred and Fifty Years of Archaeology* (1976) and Bruce Trigger's *A History of Archaeological Thought* (1989).

5. These facts hardly require a footnote, but it would be remiss to link them as I have without mentioning Eric Hobsbawm's classic works, especially *The Age of Empire, 1875–1914* (1987). See also Ernest Gellner's *Nations and Nationalism* (1983) for a politically very different socioeconomic analysis and interpretation from Hobsbawm's but one which nonetheless regards economic expansion as crucial for the development of European nation-states and the expectation of "progress."

6. The "civilizing mission" or the "white man's burden" is well known and does not require comment; but the pervasiveness of the nature/culture dichotomy in the minutiae of everyday life and its application to the civilizing mission even of matters like cookbooks and teaching American Indians to eat "civilized" foods is documented in Laura Shapiro's semiotically acute *Perfection Salad: Women and Cooking at the Turn of the Century* (1986).

7. An interesting account on the equation of national spirit and uniqueness with culture in Germany can be found in Norbert Elias's *The History of Manners* (1978); on elite interest in folk culture and folk objects at the end of the eighteenth century, see Peter Burke's *Popular Culture in Early Modern Europe* (1978). On the invention of European folk traditions, see Eric Hobsbawm and Terence Ranger's edited book *The Invention of Tradition* (1983), especially the pieces by Trevor-Roper, Morgan, and Hobsbawm. The literature on archaeology as a nationalist enterprise has been burgeoning lately; see, for instance, Bruce Trigger's article "Alternative Archaeologies: Nationalist, Colonialist, Imperialist" (1984).

8. An increasingly vast literature about world's fairs and their predecessors now crowds the library shelf. On its predecessors, see John Allwood's *The Great Exhibitions* (1977). On fairs in the United States, see Robert Rydell's *All the World's a Fair: Visions of Empire at American International Expositions, 1876–1916* (1984) and his *World of Fairs* (1993). An informative and interesting collection of articles on various aspects of the 1915 Exposition in San Francisco is gathered into Burton Benedict's *The Anthropology of World's Fairs* (1983). A revealing analysis, heavily influenced by Foucault, about the representation of Egypt in a world's fair can be found in Timothy Mitchell's "The World as Exhibition" (1989). On the related issue of the display of nature and its colonizing impulse, see Helen Horowitz's "Animal and Man in the New York Zoological Park" (1975); the man she mentions briefly was Ota Benga, whose history is recounted in Phillips Verner Bradford and Harvey Blume's *Ota Benga: The Pygmy in the Zoo* (1992).

9. One of the most famous examples of this kind of organization was the Pitt-Rivers museum in Oxford, in which artifacts were categorized by topic and arranged in a sequence; for example, a display of weapons might begin with the lowly ax, move to the cross-bow, and end with the gun (see Chapman 1985 and Jacknis 1985).

10. Although the recent expansion of the museum has added occasional other, more flexible space, the central spiral remains dominant.

11. See Albert O. Hirschman's great book on the subject, *The Passions and the Interests: Political Arguments for Capitalism before Its Triumph* (1977).

12. See Shapiro's *Perfection Salad* (1986).

CHAPTER 1. THREE WAYS TO TELL THE HISTORY OF (PRIMITIVE) ART

1. This passage is not actually a direct quote; but it is more a synopsis than a parody of the way many gallery owners, collectors, and art historians

(but not of primitive art) have described the process to me. Two accessible and careful, if brief, discovery narratives are "Primitive Art in Europe," the first chapter in Robert Goldwater's *Primitivism in Modern Art* (1966), and Douglas Fraser's "The Discovery of Primitive Art" (1957). Both are accounts of the historical circumstances and views that allowed these objects to be displayed and classified as art, and neither of them invites either an easy synopsis or a parody. They are discovery narratives nonetheless because both focus on the "discovery" of primitive art at the turn of the twentieth century, reviewing the nineteenth century as a lead-up to that point, and both cast the appreciation of this art as progress in taste.

2. It is worth examining all three editions of Helen Gardner's *Art Through the Ages*, published about a decade apart (1926, 1936, 1948) as well as the fifth edition (1970), a revision by Horst de la Croix and Richard Tansey, as a story of changing views about the primitive in art.

3. Alsop borrows the phrase from Gertrude Stein, who remarked that "People do not change from generation to generation. . . . Nothing changes from generation to generation except the things seen and the things seen make that generation, that is to say nothing changes in people from one generation to another except the way of seeing" (quoted in Alsop 1982: 4).

4. The most historically comprehensive and theoretically useful account of primitivism and modern art that I have encountered is Frances Connelly's *The Sleep of Reason: Primitivism in Modern European Art and Aesthetics, 1725–1907* (1995). It steps outside debates about style and content in art in order to reveal the structures of thought that produced the category "primitive," arguing that the category was produced by the Enlightenment as a kind of catch-all opposite to developed "reason" or, in art, to classicism. Thus twentieth-century modernists stepped into an extant tradition, filling the category of the primitive with new kinds of objects but not disrupting the structure.

For more specific accounts of modern art and non-European artifacts that also address some of the deep conceptual and aesthetic discursive structures that allow and promote primitivism, see Jill Lloyd's *German Expressionism: Primitivism and Modernity* (1991); Charles Harrison, Francis Frascina, and Gill Perry's *Primitivism, Cubism, Abstraction* (1993), especially Harrison's "Introduction: Primitivism in Art-Historical Debate" (3–9) and Perry's chapter "The Expressive and the Expressionist" (62–82); Barbara Braun's *Pre-Columbian Art in the Post-Columbian World* (1993); and Jackson Rushing's *Native American Art and the New York Avant-Garde* (1995). For smaller doses of this topic, see the articles by Braun and Rushing listed in the references, and James Clifford's "On Ethnographic Surrealism" (1988c).

As a note to a note, I should point out that the standard work for many years on the relations of the primitive and the modern in art was Robert Goldwater's *Primitivism in Modern Art*, first published in 1938. The second volume of the catalog for MoMA's 1984 exhibition "'Primitivism' in 20th Century Art," written by a number of prominent art historians, is devoted to primitivism in modern art, as is William Rubin's introduction (see Rubin

1984a). These pieces are extremely well informed and intelligent but on the whole conventional art-historical treatises, which is to say they tend to pay little attention to the deep conceptual structures or the social history and material circumstances of the production of art, and concentrate, rather, on formal qualities, content, artists' biographies, and influences.

5. Meyer Schapiro provides a very useful bibliography, as well as a socially modulated account of the Armory Show in "Introduction of Modern Art in America: The Armory Show" (1978; paper originally published in 1950).

6. For accounts of the founding and mission of MoMA, see A. Conger Goodyear's *The Museum of Modern Art: The First Ten Years* (1943) and Russell Lynes's *Good Old Modern* (1973).

7. Robert Bliss was a major collector of pre-Columbian artifacts, largely gold, which are now housed at his former residence, Dumbarton Oaks, in Washington, D.C. It does not seem that he appreciated the pieces, however, because they were "primitive art" but because they were made of gold and beautifully worked; in other words, Bliss, unlike Rockefeller, did not have a great interest in primitive art as such, and so far as I can see, did nothing institutionally to collect pre-Columbian artifacts under the umbrella rubric "Primitive Art." On Bliss's collecting, see Elizabeth Benson's "The Robert Woods Bliss Collection of Pre-Columbian Art: A Memoir" (1993).

8. In this paragraph I have condensed several decades of debate in the disciplines of anthropology and history about the place of history among "tribal" and other colonized peoples. The landmark works to consult on this topic, which have been followed by many others refining and disputing the issues raised in them, are Eric Wolf's *Europe and the People without History* (1982) and Johannes Fabian's *Time and the Other: How Anthropology Makes Its Object* (1983). On the construction of postcolonial histories and historiography, Gyan Prakash's "Writing Post-Orientalist Histories of the Third World: Perspectives from Indian Historiography" (1990) is exceptionally useful.

9. Lists of exhibitions can be found in the appendices in Goodyear (1943) and Lynes (1973). I collected the information concerning exhibits after 1973 in MoMA's library in New York and through correspondence.

CHAPTER 2. WHAT BECAME PRIMITIVE ART?

1. I cannot resist pointing out that this vague language comes straight out of the 1950s, when people spoke blithely of "culture contact" and "continuity and change," terms that disguise the history of colonialism before World War II and the effects of the expanding global market system after it, never mind the international art market itself.

2. I refer to Saussure's *Course in General Linguistics* (1959), Foucault's *Madness and Civilization* (1965), and Lévi-Strauss's *Totemism* (1963).

3. See Connelly (1995: 2), as well as Rubin (1984a), who also mentions the space occupied by the Japanese prints as "primitive." It is interesting to reread Joseph Alsop's 1982 account of the nineteenth century's "revolutions

in seeing" in this light; in this light and from this angle, the "revolutions" are an increasing absorption of the "primitive" and the irrational into the canon.

4. See Clifford Geertz's essays "The Cerebral Savage: On the Work of Claude Lévi-Strauss" (1973b) and "Slide Show: Evans-Pritchard's African Transparencies" (1988) for analysis of the rhetorical constructions of these other, anthropologically constructed primitives.

5. Jacques Maquet (1979, 1986) makes basically the same distinction, and acknowledges the same source, but he calls these categories "art by destination" and "art by metamorphosis." I am renaming the categories for two reasons. First, the term "metamorphosis" seems entirely too gentle for some of the transformations that have taken place. Second, I do it out of respect for both Malraux's and Maquet's ideas; the tenor of their writings about "metamorphoses" is entirely different from mine, and it is just as well to keep the terminology distinct.

6. The definitive social history of frames has not, to my knowledge, been written, but see Richard Brettell and Steven Starling's *The Art of the Edge* (1986) for a start.

7. The most useful account of the conceptual reorganization of the arts is probably still Paul Oskar Kristeller's "The Modern System of the Arts" (1965).

8. But, as Nelson Goodman (1976) wittily points out, optical naturalism attempts to depict the way something looks to a rational upright subject in certain conditions, *not* the way it looks to a drunk through a teardrop.

9. It is worth noting in passing that iconicity is partly in the eye of the beholder. Many societies have produced objects that have some iconic content—that is, signs that signify or refer to other things by resembling them, in local sensibilities. The resemblance may be highly conventionalized and schematic, recognizable as "resembling" something else only to people in that culture, or it may be secret knowledge, restricted to the initiated. Conventionalized and schematic though they be, the white spots painted on an Australian Aboriginal woman may be "readable" to her and her clan as signifying dappled light on water; the circles painted on Sepik River men's houses may signify "moons" and "women's bellies." These significations have an iconic content, but it would barely be recognized by those not clued in to the semiotic system; see Howard Morphy's *Ancestral Connections* (1991) on the Yolngu of Australia and Anthony Forge's "Style and Meaning in Sepik Art" (1973) on the Abelam of New Guinea. The problematic of iconicity is a deep topic that has had extensive commentary; see Goodman (1976).

10. This anecdote is told in Russell Lynes's *Good Old Modern: An Intimate Portrait of the Museum of Modern Art* (1973). He quotes the April 1936 MoMA bulletin, which explained, "Many objects . . . had been refused free entrance because it was impossible to prove that certain sculptures were not more than second replicas, or because the artist's signature could not be produced, or because no date of manufacture could be found, or because ancient bells, drums, spoons, necklaces, fans, stools and headrests were considered by the examiners to be objects of utility and not works of art. As a result the Mu-

seum was forced to give bond, the premium on which amounted to $700" (in Lynes 1973: 139).

11. Incidentally, I took Susan Vogel's recorded tour of the African part of the Rockefeller Wing after finishing the docent tour. It seems that there is a rainy season in the Western Sudan, and scads of little yellow butterflies appear right before it; as a consequence, according to the tape, butterflies are associated with rain, fertility, and crops. That appears to be the derivation of the docent's suggesting that the "butterfly mask" may be to "welcome Spring."

CHAPTER 3. THE UNIVERSALITY
OF ART AS A SELF-FULFILLING PROPHECY

1. The forms that "transcendence" can take is an interesting topic in itself. It is my impression that when we are speaking of art by appropriation, religious/ritual objects tend to be coded as transcendent (whether they are medieval Christian or gold work from an animist tribe). If, by contrast, we are talking about art by intention, objects made for the art market, the locus of transcendence tends to shift to the genius of the artist. I take up this topic in chapter 5.

2. Actually, Benjamin believes that the work of art never entirely loses its aura, even when it becomes a secular work of art. Yet at some point an overexposure to the public depletes, he believes, the cult value, hence the aura, of a work of art. Benjamin's essay is, in fact, about the deterioration of aura and especially the part played by photography and film in replicating and producing works of art, eventually transforming the nature of the work of art itself.

3. On the importance of regalia for a kingdom, see my *Meaning and Power in a Southeast Asian Realm* (S. Errington 1989), chap. 3; on textiles, see Ruth Barnes's "'Without Cloth We Cannot Marry': The Textiles of Lamaholot in Transition" (1994); and on *tau-tau*, a useful article is Eric Crystal's "The Rape of the Ancestors: Discovery, Display and Destruction of the Ancestral Statuary of Tana Toraja" (1994).

4. For a quick and excellent introduction to the topic of restricted exchange and, for that matter, some basic principles of economic anthropology, see Igor Kopytoff's "The Cultural Biography of Things: Commoditization as Process" (1986). The best-known anthropological study of restricted exchange is Bronislaw Malinowski's 1922 book on the exchange of *kula* valuables in the Trobriand Islands of Papua New Guinea.

5. On Australian art, see Nancy Munn's *Walbiri Iconography* (1973) and Howard Morphy's *Ancestral Connections* (1991). On *tubuan* masks in Papua New Guinea, see Frederick Errington's *Karavar* (1974).

CHAPTER 4. THE DEATH
OF AUTHENTIC PRIMITIVE ART

1. See Don Fowler and Catherine Fowler's "The Uses of Natural Man in Natural History" (1991).

2. On a wider context than the immediate difficulties of obtaining objects, see Jeanette Greenfield's *The Return of Cultural Treasures* (1989) and Phyllis Mauch Messenger's edited volume *The Ethics of Collecting Cultural Property* (1989).

3. "The need of a constantly expanding market for its products chases the bourgeoisie over the whole face of the globe," wrote Marx and Engels in the *Communist Manifesto*. Here I want to retain the image and spirit while changing the agent and topic. I was reminded of this sentence and its humor by Benedict Anderson's comments on it (1991: 139, n. 54).

4. Gamelan music did influence modernists in music, though a little later, partly through world's fairs; but that is not the artifact market. An informative film on this topic, tracing the influence of gamelan music via Colin McPhee to contemporary composers like John Cage, Terry Riley, Philip Glass, and Lou Harrison, can be seen in the excellent documentary film *Colin McPhee: The Lure of Asian Music*.

5. For a case study on this topic, see Kathryn Robinson's account of the nickel mining in northern South Sulawesi, *Stepchildren of Progress* (1989).

6. Tourism is a major topic and issue these days. Aside from interesting historical works on the grand tour, which are numerous, a useful if somewhat dated history of tourism is Louis Turner and John Ash, *The Golden Hordes* (1976). For a bitter critique, see Evelyne Hong's *See the Third World While It Lasts* (1985). On alternative tourism, see Valene Smith and William Eadington's edited volume *Tourism Alternatives* (1992). On the semiotics of receding authenticity (in the guise of a book review of Dean McCannell's *The Tourist*), see Jonathan Culler's "The Semiotics of Tourism" (1981). A history of the structures of meaning materialized in tourism can be found in Orvar Löfgren's *Making Holidays* (in press).

7. See Eric Crystal's "The Rape of the Ancestors" (1994) and Toby Volkman's "Visions and Revisions: Toraja Culture and the Tourist Gaze" (1990).

CHAPTER 5. AUTHENTICITY, PRIMITIVISM, AND ART REVISITED

1. Svetlana Alpers's *Rembrandt's Enterprise: The Studio and the Market* (1988) addresses the shift from individual patrons to the free art market in Europe. On the historiography of the concept of artistic genius, see Catherine Soussloff's *The Absolute Artist* (1997).

2. See E. L. Wade's "The Ethnic Art Market in the American Southwest: 1880–1980" (1985). On the larger contexts of collecting and museums at the turn of this century, see Curtis Hinsley's *Savages and Scientists: The Smithsonian Institution and the Development of American Anthropology, 1846–1919* (1981), Douglas Cole's *Captured Heritage: The Scramble for Northwest Coast Artifacts* (1985), and Diane Fane, Ira Jackniss, and Lise Breen's *Objects of Myth and Memory: American Indian Art at the Brooklyn Museum* (1991).

3. A tremendous amount has been written about Southwest fine arts and crafts, in very large part celebratory and market-oriented. A few books

and articles on the history of the fine arts movement there do stand out. J. J. Brody's *Indian Painters and White Patrons* (1971) is informative and historical. Most of Jackson Rushing's work, which is both well informed on art-historical issues and very cognizant of social and economic contexts, at least touches on the Southwest; see his *Native American Art and the New York Avant-Garde* (1995) and Bruce Bernstein and W. Jackson Rushing's *Modern by Tradition: American Indian Painting in the Studio* (1995). Also see the edited book by Margaret Archuleta and Rennard Strickland, *Shared Visions: Native American Painters and Sculptors in the Twentieth Century* (1991).

On a somewhat different note, see the collection edited by George Marcus and Fred Myers, *The Traffic in Culture: Refiguring Art and Anthropology* (1995), for some excellent pieces on the topic of their subtitle.

4. In some traditions, of course, categories of people do own particular designs, and in the current market they control them. See Howard Morphy's *Ancestral Connections: Art and an Aboriginal System of Knowledge* (1991).

5. See Bernstein and Rushing (1995) on Dorothy Dunn, and Hildred Geertz (1994) on the history of Balinese painting for the market.

6. On sand painting's history, see Nancy Parezo's *Navajo Sandpainting: From Religious Act to Commercial Art* (1983); its subtitle says it all. The Asia Society's 1988 exhibit of Aboriginal art also produced a scholarly and useful catalog, *Dreamings: The Art of Aboriginal Australia*, edited by Peter Sutton. Not to be neglected by those interested in the history of high ethnic art is its origin in tourist art; many interesting articles documenting what turned out to be its early stages can be found in Nelson Graburn's *Ethnic and Tourist Arts* (1976b).

CHAPTER 6. NATIONALIZING THE PRE-COLUMBIAN PAST IN MEXICO AND THE UNITED STATES

1. The most useful, complete, and available history of Mexican museums is Miguel Angel Fernandez's *Historia de los Museos de México* (1987). See also Enrique Florescano's "The Creation of the Museo Nacional de Antropología of Mexico and Its Scientific, Educational, and Political Purposes" (1993).

2. A new section, México Moderno, was not open when I visited this museum in 1989.

3. For an introduction see Michael Wallace's "Reflections on the History of Historic Preservation" (1986a).

4. It is true that Native American culture and artifacts have to some extent been appropriated as part of a folk American heritage. Rayna Green (1988), for instance, suggests that claiming symbolic "Indianness" by "playing Indian"—from Henry Lewis Morgan's secret society modeled on his and his friends' initial understanding of the Iroquois tribe, to children's games of cowboys and Indians—has been important to middle-class whites in the effort to invent a distinctly "American" culture. And Curtis M. Hinsley (1993) links the nineteenth-century appropriation of North American Indian arti-

facts as well as Mesoamerican objects by North American elites to their claims to territory in the construction of a national culture. Nonetheless, it is probably safe to say that no American national stories and accompanying exhibitions feature Native Americans in any way even remotely analogous to Mexico's featuring of the pre-Columbian past.

5. A good introduction to the topic of the appropriation of or invention of folk artifacts and culture as a means of creating a distinctly American identity is *Folk Roots, New Roots: Folklore in American Life* (1988), edited by Jane S. Becker and Barbara Franco. It offers an extensive bibliography and a variety of points of view.

6. Thanks to Dr. Clara Bargellini of the Instituto de Investigaciones Estéticas part of the Universidad Nacional Autónoma de México (UNAM) for this information.

CHAPTER 7. THE COSMIC THEME PARK
OF THE JAVANESE

1. The term "exemplary center" is Clifford Geertz's; see especially his *Negara: The Theatre State in Nineteenth-Century Bali* (1980).

2. Benedict Anderson's "Cartoons and Monuments: The Evolution of Political Communication under the New Order" (1990a) inspired reflection on the relations between monuments, ideas about history, kitsch, and Soeharto's New Order in several Indonesianists. One such is Timothy Lindsey's "Concrete Ideology: Taste, Tradition, and the Javanese Past in New Order Public Space" (1993). Both Anderson and Lindsey are clearly referring to the kind of architecture I call "hybrid fantasy," with its shorthand references, but they use somewhat different terms for it and trace its genealogy and associations differently.

3. The most comprehensive and readable summary and analysis of the symbolics of traditional houses is Roxana Waterson's *The Living House: An Anthropology of Architecture in South-East Asia* (1990); it draws on and cites the many classic articles on the topic, which is well studied in Southeast Asia.

4. The two models of the folk are discussed in Orvar Löfgren's "Materializing the Nation in Sweden and America" (1993) and in Tamas Hofer's "Construction of the 'Folk Cultural Heritage'" (1991). Although they do not call it by the same name, very useful pieces on this topic appear in Virginia Matheson Hooker's edited collection, *Culture and Society in New Order Indonesia* (1993).

5. The literature on this topic is vast; see Shelly Errington 1989 for many references.

CHAPTER 8. MAKING PROGRESS ON BOROBUDUR

1. A great deal of interesting material on this topic can be found in Manfredo Tafuri's *The Sphere and the Labyrinth* (1987) and *The Architecture of Western Gardens*, edited by Monique Mosser and Georges Teyssot (1991).

2. I borrow the phrase from Panofsky's great essay entitled *Perspective as Symbolic Form* (English translation 1991), which virtually originated the topic.

3. The English garden was made possible by the enclosures of public land that transformed the landscape into private property—so it is not too farfetched to say that it assumes a conscious, gazing possessor in motion. On enclosures and the visual, see John Barrell's *The Dark Side of the Landscape* (1980).

4. A stupa is a burial mound; the central form at Borobudur, as well as the monument itself, is usually referred to as a "stupa," although no relics have been found within it.

5. The central stupa had completely collapsed at the time Borobudur was brought to Sir Thomas Raffles's attention. Various archaeologists have speculated about its shape and size. The current one approximates Van Erp's reconstruction.

6. Since the panels on the upper square terraces are considerably less narrative, one might speculate that monks ascended to the highest terraces using any of the stairs; but that is pure speculation.

7. When the lowest open walkway was added, the panels were effectively covered over and hidden. There has been much speculation concerning why they were covered, but rather than there being a desire to cover up the panels it may have happened simply as an unanticipated side effect of putting in a broader walkway. Incidentally, there is much evidence, according to archaeologists, that the plans for Borobudur were modified and revised in the course of its construction.

8. This section describing the panels is based almost entirely on Miksic's attractive book on Borobudur, which describes the stories, their sources, the texts, and various inconsistencies in considerable detail.

9. This paragraph is a paraphrase of Claire Holt's observation (1967: 43 ff., esp. 47). Bernet Kempers gives a similar account of the pilgrim's "spiritual delight" and "spirit of deliverance" in *Ageless Borobudur* (1976: 42).

10. That meditators retraced downward the route they had taken going up is an informed guess made by the Buddhist scholar Raoul Birnbaum, whom I thank for suggesting it.

11. Borobudur's massiveness makes it an unlikely object for a collection that is physically assembled elsewhere, but pieces of it, like pieces of Angkor Wat, tend to disappear: there is an attrition rate of Buddha figures, and one often looks up and finds a Buddha's head gone, presumably resting now on a rich collector's coffee table.

12. See Miksic (1990: 34–35) for an account. His circumspect comment is as follows: "The archaeologists were often working just in front of the bulldozer, or sometimes regrettably just behind it, so that no stratigraphic data could be recorded, making it impossible to reconstruct the history of the site in any detail" (35).

13. There is a substantial literature on the lack of forthright directness in Javanese etiquette (and, to a lesser degree, in Balinese social practice) and on

its link to social status and to spiritual power in the minds of its practitioners. Clifford Geertz does not make the point about demons and architecture, but the most complete account of Javanese etiquette and an explanation of its indirection can be found in the relevant chapters of his *The Religion of Java* (1960). Other classic pieces on the topic include Benedict Anderson's *Mythology and the Tolerance of the Javanese* (1965) and "The Idea of Power in Javanese Culture" (1972). For very revealing cultural notes on linguistic etiquette in Javanese, see Ward Keeler's *Javanese, a Cultural Approach* (1984), and on power and language see his *Javanese Shadow Plays, Javanese Selves* (1987). A. L. Becker first pointed out to me in conversation the logic behind Balinese door structures.

14. Nonetheless, perspectival space is intrinsically individual and democratic, since anyone occupying the privileged point in space acquires the privileged point of view.

15. These terms are of course drawn from E. H. Gombrich's *Art and Illusion* (1960) and other writings. The story of the move to perspective told as unidirectional progress is much clearer, however, in Gombrich's *The Story of Art* (1950), written earlier than *Art and Illusion*.

16. The banyan tree, symbol of Golkar, symbolizes ancient kingship. A hill tribe in Kalimantan, which shall remain nameless, completely misunderstands the logic of the symbol, according to an anthropologist colleague who worked there. Banyan trees grow a trunk like an ordinary tree but then grow "roots" from the branches; these grow slowly down and eventually reach the ground and root there. Consequently the banyan kills everything underneath it. The people of this hill tribe find the banyan tree a very apt symbol for the government, which seeks to spread its umbrella while eliminating what is underneath it. But they are puzzled as to why a government would chose it as its symbol.

References

Abrams, M. H. 1985. "Art-as-Such: The Sociology of Modern Aesthetics." *Bulletin of the American Academy of Arts and Sciences* 38 (6): 8–33.

Agulhon, Maurice. 1981. *Marianne into Battle: Republican Imagery and Symbolism in France, 1789–1880.* Trans. Janet Lloyd. Cambridge: Cambridge University Press.

Allwood, John. 1977. *The Great Exhibitions.* London: Cassell and Collier Macmillan.

Alpers, Svetlana. 1988. *Rembrandt's Enterprise: The Studio and the Market.* Chicago: University of Chicago Press.

Alsop, Joseph. 1982. *The Rare Art Traditions: The History of Art Collecting and Its Linked Phenomena Wherever These Have Appeared.* New York: Harper and Row.

Ames, Michael M. 1986. *Museums, the Public and Anthropology: A Study in the Anthropology of Anthropology.* Vancouver: University of British Columbia Press.

———. 1992. *Cannibal Tours and Glass Boxes: The Anthropology of Museums.* Vancouver: University of British Columbia Press.

Anderson, Benedict. 1965. *Mythology and the Tolerance of the Javanese.* Monograph Series; Modern Indonesia Project. Ithaca, N.Y.: Cornell University Press.

———. 1972. "The Idea of Power in Javanese Culture." In *Culture and Politics in Indonesia,* ed. Clare Holt, Benedict Anderson, and James Siegel, 1–69. Ithaca, N.Y.: Cornell University Press.

———. 1987. "The State and Minorities in Indonesia." In *Southeast Asian Tribal Groups and Ethnic Minorities,* Report #22, 73–81. Cambridge, Mass.: Cultural Survival.

———. 1990a. "Cartoons and Monuments: The Evolution of Political Communication under the New Order." In *Language and Power: Exploring Political Cultures in Indonesia,* 152–93. Ithaca, N.Y.: Cornell University Press.

———. 1990b. "Old State, New Society: Indonesia's New Order in Comparative Historical Perspective." In *Language and Power: Exploring Political Cultures in Indonesia,* 94–120. Ithaca, N.Y.: Cornell University Press.

———. 1991. *Imagined Communities: Reflections on the Origin and Spread of Nationalism.* Rev. and extended ed. London: Verso.

Archuleta, Margaret, and Rennard Strickland, eds. 1991. *Shared Visions: Native American Painters and Sculptors in the Twentieth Century.* Phoenix: The Heard Museum.

Atl, Dr. 1922. *Las Artes Populares en Mexico.* Vol. 1. Facsimile edition published for Museo Nacional de Artes e Industrias Populares. Serie Artes y

Tradiciones Populares, no. 1. Mexico: Instituto Nacional Indigenista. 2nd edition, Mexico: Editorial "Cultura."

Barbier, Jean-Paul. 1994. "The Responsible and the Irresponsible: Observations on the Destruction and Preservation of Indonesian Art." In *Fragile Traditions: Indonesian Arts in Jeopardy,* ed. Paul Taylor, 59–70. Honolulu: University of Hawaii Press.

Barnes, Ruth. 1994. "'Without Cloth We Cannot Marry': The Textiles of Lamaholot in Transition." In *Fragile Traditions: Indonesian Arts in Jeopardy,* ed. Paul Taylor, 13–28. Honolulu: University of Hawaii Press.

Barrell, John. 1980. *The Dark Side of the Landscape: The Rural Poor in English Paintings, 1730–1840.* New York: Cambridge University Press.

Barron, Stephanie, ed. 1991a. *"Degenerate Art": The Fate of the Avant-Garde in Nazi Germany.* Los Angeles and New York: Los Angeles County Museum of Art and Harry N. Abrams.

———. 1991b. "1937: Modern Art and Politics in Prewar Germany." In *"Degenerate Art": The Fate of the Avant-Garde in Nazi Germany,* ed. Stephanie Barron. Los Angeles and New York: Los Angeles County Museum of Art and Harry N. Abrams.

Baudrillard, Jean. 1983. *Simulations.* Trans. Paul Foss, Paul Patton, and Philip Beitchman. New York: Semiotext(e).

Bazin, Germain. 1959. *A History of Art from Prehistoric Times to the Present.* Trans. Francis Scarfe. Boston: Houghton Mifflin.

———. 1967. *The Museum Age.* Trans. Jane van Nuis Cahill. New York: Universe Books.

Becker, Jane S., and Barbara Franco. 1988. *Folk Roots, New Roots: Folklore in American Life.* Lexington, Mass.: Museum of Our National Heritage.

Benedict, Burton. 1983. *The Anthropology of World's Fairs: San Francisco's Panama Pacific International Exposition of 1915.* Berkeley: Scholar Press.

———. 1991. "International Exhibitions and National Identity." *Anthropology Today.* Royal Anthropological Institute Newsletter. April.

Benjamin, Walter. 1969. "The Work of Art in the Age of Mechanical Reproduction." In *Illuminations,* trans. Harry Zohn; ed. and with introduction by Hannah Arendt, 217–51. New York: Schocken Books.

Benson, Elizabeth P. 1993. "The Robert Woods Bliss Collection of Pre-Columbian Art: A Memoir." In *Collecting the Pre-Columbian Past,* ed. Elizabeth Boone, 15–34. Washington, D.C.: Dumbarton Oaks.

Berger, John. 1977. *Ways of Seeing.* New York: Penguin Books.

Berlo, Janet. 1992. *The Early Years of Native American Art History: The Politics of Scholarship and Collecting.* Seattle: University of Washington Press.

Bernet Kempers, A. J. 1959. *Ancient Indonesian Art.* Cambridge, Mass.: Harvard University Press.

———. 1976. *Ageless Borobudur: Buddhist Mystery in Stone.* Servire, Netherlands: Wassenaar.

Bernstein, Bruce, and W. Jackson Rushing. 1995. *Modern by Tradition: American Indian Painting in the Studio.* Santa Fe: Museum of New Mexico Press.

Boas, Franz. [1927] 1955. *Primitive Art*. Oslo and Cambridge, Mass.: H. Aschehoug and Harvard University Press. Reprint, New York: Dover Publications.

Bodley, John. 1988. *Tribal Peoples and Development Issues: A Global Overview*. Mountain View, Calif.: Mayfield.

Bradford, Phillips Verner, and Harvey Blume. 1992. *Ota Benga: The Pygmy in the Zoo*. New York: St. Martin's Press.

Braun, Barbara. 1988. "Art from the Land of Savages or Surrealists in the New World." *Boston Review* 13 (3): 5–6, 8–9.

———. 1989. "Henry Moore and Pre-Columbian Art." *Res* 17/18: 159–97.

———. 1993. *Pre-Columbian Art and the Post-Columbian World: Ancient American Sources of Modern Art*. New York: Harry N. Abrams.

Brettell, Richard R., and Steven Starling. 1986. *The Art of the Edge: European Frames, 1300–1900*. Exhibition catalog. Chicago: Art Institute of Chicago.

Brody, J. J. 1971. *Indian Painters and White Patrons*. Albuquerque: University of New Mexico Press.

———. 1976. "The Creative Consumer: Survival, Revival, and Invention in Southwest Indian Arts." In *Ethnic and Tourist Art: Cultural Expressions from the Fourth World*, ed. Nelson H. H. Graburn, 70–85. Berkeley: University of California Press.

Brown, Donald E. 1971. "The Coronation of Sultan Muhammad Jamalul Alam, 1918." *Brunei Museum Journal* 2 (3): 74–80.

Burke, Peter. 1978. *Popular Culture in Early Modern Europe*. New York: Harper Torchbooks.

Bury, J. B. [1920] 1955. *The Idea of Progress: An Inquiry into Its Origin and Growth*. London: Macmillan. Reprint, New York: Dover Publications.

Cassirer, Ernest. 1955. *The Philosophy of Symbolic Forms*. Trans. Ralph Manheim. New Haven, Conn.: Yale University Press.

Chapman, William Ryan. 1985. "Arranging Ethnology: A. H. L. F. Pitt Rivers and the Typological Tradition." In *Objects and Others: Essays on Museums and Material Culture*, ed. George Stocking, Jr., 15–48. Madison: University of Wisconsin Press.

Clark, Kenneth. 1969. *Civilisation*. New York: Harper and Row.

Clifford, James. 1987. "Of Other Peoples: Beyond the 'Salvage Paradigm'." In *Discussions in Contemporary Culture Number One*, ed. Hal Foster, 121–30. Seattle: Bay Press.

———.1988a. "Histories of the Tribal and the Modern." In *The Predicament of Culture: Twentieth-Century Ethnography, Literature, and Art*, 189–214. Cambridge, Mass.: Harvard University Press.

———. 1988b. "On Collecting Art and Culture." In *The Predicament of Culture: Twentieth-Century Ethnography, Literature, and Art*, 215–51. Cambridge, Mass.: Harvard University Press.

———. 1988c. "On Ethnographic Surrealism." In *The Predicament of Culture: Twentieth-Century Ethnography, Literature, and Art*, 117–51. Cambridge, Mass.: Harvard University Press.

————. 1988d. *The Predicament of Culture: Twentieth-Century Ethnography, Literature, and Art*. Cambridge, Mass.: Harvard University Press.

Coe, Ralph T. 1986. *Lost and Found Traditions: Native American Art 1965–1985*. Ed. Irene Gordon; photographs by Bobby Hansson. Seattle and New York: University of Washington Press and American Federation of Arts.

Cohen, William. 1989. "Symbols of Power: Statues in Nineteenth-Century Provincial France." *Comparative Studies in Society and History* 31 (3): 491–513.

Cohn, Bernard. 1987. "The Census, Social Structure, and Objectification in South Asia." In *An Anthropologist among the Historians and Other Essays*, 224–54. New York: Oxford University Press.

Cole, Douglas. 1985. *Captured Heritage: The Scramble for Northwest Coast Artifacts*. Seattle: University of Washington Press.

Connelly, Frances S. 1995. *The Sleep of Reason: Primitivism in Modern European Art and Aesthetics, 1725–1907*. University Park: Pennsylvania State University Press.

Crystal, Eric. 1994. "The Rape of the Ancestors: Discovery, Display and Destruction of the Ancestral Statuary of Tana Toraja." In *Fragile Traditions: Indonesian Arts in Jeopardy*, ed. Paul Taylor, 29–41. Honolulu: University of Hawaii Press.

Culler, Jonathan. 1981. "The Semiotics of Tourism." *American Journal of Semiotics* 1 (1–2): 127–40.

Daniel, Glyn. 1976. *A Hundred and Fifty Years of Archaeology*. Rev. ed. Cambridge, Mass.: Harvard University Press.

Danto, Arthur C. 1981. *Transfigurations of the Commonplace: A Theory of Art*. Cambridge, Mass.: Harvard University Press.

————. 1988. "Artifact and Art." In *ART/Artifact: African Art in Anthropology Collections*, ed. Susan Vogel, 18–32. New York: Center for African Art and Preston Verlag.

Douglas, Frederic H., and René d'Harnoncourt. 1941. *Indian Art of the United States*. New York: Museum of Modern Art.

Dove, Michael R. 1990. *The Real and Imagined Role of Culture in Development*. Honolulu: University of Hawaii Press.

Duffek, Karen. 1983. "Authenticity and the Contemporary Northwest Coast Indian Art Market." *B.C. Studies* 57: 99–111.

Duncan, Carol, and Allan Wallach. 1980. "The Universal Survey Museum." *Art History* 3 (4): 448–69.

Eco, Umberto. 1986. "Travels in Hyperreality." In *Travels in Hyperreality*. Trans. William Weaver, 1–58. San Diego: Harcourt Brace Jovanovich.

Elias, Norbert. 1978. *The History of Manners: The Civilizing Process*. Vol. 1. Trans. Edmund Jephcott. New York: Pantheon Books.

Errington, Frederick. 1974. *Karavar: Masks and Men in Melanesian Ritual*. Ithaca, N.Y.: Cornell University Press.

Errington, Shelly. 1979. "The Cosmic House of the Buginese." *Asia* 1 (5): 8–14.

————. 1983. "The Place of Regalia in Luwu." In *Centers, Symbols, and Hierarchies: Essays on the Classical States of Southeast Asia*, ed. Lorraine Gesick,

194–241. New Haven, Conn.: Yale University Southeast Asia Mono-
graphs.

———. 1989. *Meaning and Power in a Southeast Asian Realm*. Princeton, N.J.:
Princeton University Press.

———. 1993. "Nationalist Stories and the Pre-Columbian Past: Notes on
Mexico and the United States." In *Collecting the Pre-Columbian Past*, ed.
Elizabeth Boone, 209–49. Washington, D.C.: Dumbarton Oaks.

Evans-Pritchard, Deirdre. 1990. "Tradition on Trial: How the American Le-
gal System Handles the Concept of Tradition." Ph.D. diss., University of
California, Los Angeles.

Ewen, Stuart. 1988. *All Consuming Images: The Politics of Style in Contemporary
Culture*. New York: Basic Books.

Fabian, Johannes. 1983. *Time and the Other: How Anthropology Makes Its Ob-
ject*. New York: Columbia University Press.

Fane, Diane, Ira Jackniss, and Lise M. Breen, eds. 1991. *Objects of Myth and
Memory: American Indian Art at the Brooklyn Museum*. Brooklyn and Seat-
tle: Brooklyn Museum in association with the University of Washington
Press.

Feld, Steven. 1982. *Sound and Sentiment: Birds, Weeping, Poetics and Song in
Kaluli Experience*. Philadelphia: University of Pennsylvania Press.

Fernandez, Miguel Angel. 1987. *Historia de los Museos de México*. México: Pro-
motora de Comercialización Directa.

Fisher, Philip. 1975. "The Future's Past." *New Literary History* 6 (3): 587–606.

———. 1991. *Making and Effacing Art: Modern American Art in a Culture of
Museums*. New York: Oxford University Press.

———. 1992. "Collections and Ruins." Paper presented at conference on the
Culture of Ruins, 24–26 January, University of California, Santa Cruz.

Florescano, Enrique. 1993. "The Creation of the Museo Nacional de
Antropología of Mexico and Its Scientific, Educational, and Political Pur-
poses." In *Collecting the Pre-Columbian Past*, ed. Elizabeth Boone, 81–103.
Washington, D.C.: Dumbarton Oaks.

Forge, Anthony. 1973. "Style and Meaning in Sepik Art." In *Primitive Art and
Society*, ed. Anthony Forge, 169–92. New York: Oxford University Press.

Foster, Hal. 1985. "The 'Primitive' Unconscious of Modern Art." *October* 34:
45–70.

Foucault, Michel. 1965. *Madness and Civilization: A History of Insanity in the
Age of Reason*. Trans. Richard Howard. New York: Pantheon Books.

Fowler, Don D., and Catherine S. Fowler. 1991. "The Uses of Natural Man in
Natural History." In *Columbian Consequences*, ed. David Hurst Thomas,
37–62. Washington, D.C.: Smithsonian Institute Press.

Fraser, Douglas. 1957. "The Discovery of Primitive Art." In *Arts Yearbook I:
The Turn of the Century*, ed. Hilton Kramer, 119–33. Garden City, N.Y.: Nat-
ural History Press.

Gamio, Manuel. 1986. *Arqueología e Indigenismo*. Introduced and selected by
Eduardo Matos Moctezuma. Mexico: Instituo Nacional Indigenista.

Gardner, Helen. 1926. *Art Through the Ages: An Introduction to Its History and Significance*. New York: Harcourt, Brace.

———. 1936. *Art Through the Ages: An Introduction to Its History and Significance*. Rev. ed. New York: Harcourt, Brace.

———. 1948. *Art Through the Ages: An Introduction to Its History and Significance*. 3rd ed. New York: Harcourt, Brace.

———. 1970. *Gardner's Art Through the Ages*. Rev. by Horst de la Croix and Richard G. Tansey. 5th ed. New York: Harcourt, Brace and World.

Geertz, Clifford. 1960. *The Religion of Java*. Chicago: University of Chicago Press.

———. 1968. *Islam Observed: Religion and Development in Morocco and Indonesia*. New Haven, Conn.: Yale University Press.

———. 1973a. "After the Revolution: The Fate of Nationalism in the New States." In *The Interpretation of Cultures*, 234–54. New York: Basic Books.

———. 1973b. "The Cerebral Savage: On the Work of Claude Lévi-Strauss." In *The Interpretation of Cultures*, 345–59. New York: Basic Books.

———. 1980. *Negara: The Theatre State in Nineteenth-Century Bali*. Princeton, N.J.: Princeton University Press.

———. 1988. "Slide Show: Evans-Pritchard's African Transparencies." In *Works and Lives: The Anthropologist as Author*, 49–72. Stanford, Calif.: Stanford University Press.

———. 1990. "'Popular Art' and the Javanese Tradition." *Indonesia* 50: 77–94.

Geertz, Hildred. 1994. *Images of Power: Balinese Paintings Made for Gregory Bateson and Margaret Mead*. Honolulu: University of Hawaii Press.

Geertz, Hildred, and Clifford Geertz. 1975. *Kinship in Bali*. Chicago: University of Chicago Press.

Gellner, Ernest. 1983. *Nations and Nationalism*. Oxford: Basil Blackwell.

Gibeson, Brian. 1989. "'Wild California': Evolution of an Exhibit Hall." *Pacific Discovery* 42 (1): 25–29.

Gillispie, Charles C. 1951. *Genesis and Geology: Scientific Thought, Natural Theology, and Social Opinion in Great Britain, 1790–1850*. Vol. 58, Harvard Historical Studies. Cambridge, Mass.: Harvard University Press.

Glacken, Clarence J. 1976. *Traces on the Rhodian Shore*. Berkeley: University of California Press.

Goffman, Erving. 1974. *Frame Analysis: An Essay on the Organization of Experience*. New York: Harper and Row.

Goldwater, Robert. 1966. *Primitivism in Modern Art*. Rev. ed. New York: Random House, Vintage Books.

Gombrich, Ernst H. 1950. *The Story of Art*. London: Phaidon Press.

———. 1960. "Reflections on the Greek Revolution." In *Art and Illusion: A Study in the Psychology of Pictorial Representation*, 116–45. Princeton, N.J.: Princeton University Press.

———. 1963. *Meditations on a Hobby Horse or the Roots of Artistic Form*. Chicago: University of Chicago Press.

———. 1966. *The Story of Art*. 11th ed. New York: Phaidon.

González, Andrés Lira. 1986. "Los Indígenas y el Nacionalismo Mexicano." In *El Nacionalismo y el Arte Mexicano* (Coloquio de Historia del Arte 9), 19–34. Mexico: Universidad Nacional Autónoma de México.

Goodman, Nelson. 1976. *The Languages of Art: An Approach to a Theory of Symbols.* Indianapolis: Hacket.

Goodyear, A. Conger. 1943. *The Museum of Modern Art: The First Ten Years.* New York: Museum of Modern Art.

Graburn, Nelson H. H. 1976a. "Introduction: The Arts of the Fourth World." In *Ethnic and Tourist Arts: Cultural Expressions from the Fourth World,* ed. Nelson H. H. Graburn, 1–32. Berkeley: University of California Press.

———, ed. 1976b. *Ethnic and Tourist Arts: Cultural Expressions from the Fourth World.* Berkeley: University of California Press.

Green, Rayna. 1988. "Poor Lo and Dusky Ramona: Scenes from an Album of Indian America." In *Folk Roots, New Roots: Folklore in American Life,* ed. Jane S. Becker and Barbara Franco, 77–101. Lexington, Mass.: Museum of Our National Heritage.

Greenfield, Jeanette. 1989. *The Return of Cultural Treasures.* New York: Cambridge University Press.

Gruzinski, Serge. 1988. "The Net Torn Apart: Ethnic Identities and Westernization in Colonial Mexico, Sixteenth–Nineteenth Century." In *Ethnicities and Nations: Processes of Interethnic Relations in Latin America, Southeast Asia, and the Pacific,* ed. Remo Guidieri, Francesco Pellizzi, and Stanley J. Tambiah, 39–56. Houston: Rothko Chapel.

Guidieri, Remo, Francesco Pellizzi, and Stanley J. Tambiah, ed. 1988. *Ethnicities and Nations: Processes of Interethnic Relations in Latin America, Southeast Asia, and the Pacific.* Houston: Rothko Chapel.

Handler, Richard. 1985. "On Having Culture: Nationalism and the Preservation of Quebec's Patrimonie." In *Objects and Others: Essays on Museums and Material Culture,* ed. George Stocking, Jr., 236–46. Madison: University of Wisconsin Press.

Haraway, Donna. 1989. "Teddy Bear Patriarchy: Taxidermy in the Garden of Eden, New York City, 1908–1936." In *Primate Visions: Gender, Race, and Nature in the World of Modern Science,* 26–58. New York: Routledge.

Harrison, Charles, Francis Frascina, and Gill Perry. 1993. *Primitivism, Cubism, Abstraction: The Early Twentieth Century.* New Haven, Conn.: Yale University Press in association with the Open University.

Haskell, Francis. 1976. *Rediscoveries in Art: Some Aspects of Taste, Fashion, and Collecting in England and France.* Ithaca, N.Y.: Cornell University Press.

Hill, David T. 1993. "'The Two Leading Institutions': Taman Ismail Marzuki and Horison." In *Culture and Society in New Order Indonesia,* ed. Virginia Matheson Hooker, 245–62. Kuala Lumpur and New York: Oxford University Press.

Hinsley, Curtis M. 1981. *Savages and Scientists: The Smithsonian Institution and the Development of American Anthropology, 1846–1919.* Washington, D.C.: Smithsonian Institution Press.

———. 1993. "In Search of the New World Classical." In *Collecting the Pre-Columbian Past*, ed. Elizabeth Boone, 105–21. Washington, D.C.: Dumbarton Oaks.

Hirschman, Albert O. 1977. *The Passions and the Interests: Political Arguments for Capitalism before Its Triumph*. Princeton, N.J.: Princeton University Press.

Hobsbawm, Eric J. 1975. *The Age of Capital, 1848–1875*. London: Weidenfeld and Nicolson.

———. 1987. *The Age of Empire, 1875–1914*. London: Weidenfeld and Nicolson.

———. 1990. *Nations and Nationalism since 1780: Programme, Myth, Reality*. Cambridge: Cambridge University Press.

Hobsbawm, Eric, and Terence Ranger, eds. 1983. *The Invention of Tradition*. New York: Cambridge University Press.

Hodgen, Margaret. 1964. *Early Anthropology in the Sixteenth and Seventeenth Centuries*. Philadelphia: University of Pennsylvania Press.

Hofer, Tamas. 1991. "Construction of the 'Folk Cultural Heritage.'" *Ethnologia Europaca* 21 (2): 145–70.

Holm, Bill. 1965. *Northwest Coast Indian Art: An Analysis of Form*. Seattle: University of Washington Press.

Holt, Claire. 1967. *Art in Indonesia: Continuities and Change*. Ithaca, N.Y.: Cornell University Press.

Hong, Evelyn. 1985. *See the Third World While It Lasts: The Social and Environmental Impact of Tourism with Special Reference to Malaysia*. Penang, Malaysia: Consumer's Association of Penang.

Honour, Hugh, and John Fleming. 1982. *The Visual Arts: A History*. Englewood Cliffs, N.J.: Prentice-Hall.

———. 1986. *The Visual Arts: A History*. 2nd ed. Englewood Cliffs, N.J.: Prentice-Hall.

———. 1991. *The Visual Arts: A History*. 3rd ed. Englewood Cliffs, N.J.: Prentice-Hall.

Hooker, Virginia Matheson, ed. 1993. *Culture and Society in New Order Indonesia*. Kuala Lumpur: Oxford University Press.

Hooker, Virginia Matheson, and Howard Dick. 1993. "Introduction." In *Culture and Society in New Order Indonesia*, ed. Virginia Matheson Hooker, 1–23. Kuala Lumpur: Oxford University Press.

Horne, Donald. 1984. *The Great Museum: The Re-presentation of History*. London and Leichhardt, New South Wales: The Works and Pluto Press Australia.

Horowitz, Helen. 1975. "Animal and Man in the New York Zoological Park." *New York History* 56 (4): 426–55.

Hoskins, Janet. 1987. "The Headhunter as Hero: Local Traditions and Their Reinterpretation in National History." *American Ethnologist* 14 (4): 605–22.

Hughes, Robert. 1990. "The Art of the Quilt." In *Amish: The Art of the Quilt*, 13–36. Plate commentary by Julie Silber. New York: Knopf.

————. 1992. "Art, Morals and Politics." *New York Review Books* 39 (8): 21–27.

Hunter, Sam. 1984. "Introduction." In *The Museum of Modern Art*, 8–41. New York: Museum of Modern Art and Harry N. Abrams.

Impey, Oliver, and Arthur MacGregor, eds. 1985. *The Origins of Museums: The Cabinet of Curiosities in Sixteenth- and Seventeenth-Century Europe*. Oxford and New York: Clarendon Press and Oxford University Press.

Jacknis, Ira. 1985. "Franz Boas and Exhibits: On the Limitations of the Museum Method of Anthropology." In *Objects and Others: Essays on Museums and Material Culture*, ed. George Stocking, 75–112. Madison: University of Wisconsin Press.

Janson, H. W., and Samuel Cauman. 1981. *A Basic History of Art*. Revised by Anthony F. Janson. 2nd ed. Englewood Cliffs, N.J., and New York: Prentice-Hall and Harry N. Abrams.

Janson, H. W., and Anthony F. Janson. 1987. *A Basic History of Art*. 3rd ed. Englewood Cliffs, N.J., and New York: Prentice-Hall and Harry N. Abrams.

Janson, H. W., and Dora Jane Janson. 1962. *History of Art: A Survey of the Major Visual Arts from the Dawn of History to the Present Day*. New York: Harry N. Abrams.

Johnson, Barbara C. 1986–87. "Four Dan Sculptors: Continuity and Change." *Triptych* (Dec.–Jan.): 10–11. San Francisco: Museum Society.

Jones, Suzi. 1983. "Art by Fiat, and Other Dilemmas of Cross-Cultural Collecting." In *Folk Art and Art Worlds*, ed. John M. Vlach and Simon J. Bronner, 243–69. Ann Arbor, Mich.: UMI Research Press.

Kaeppler, Adrienne. 1979. "Tracing the History of Hawaiian Cook Voyage Artifacts in the Museum of Mankind." In *Captain Cook and the South Pacific*, 167–97. British Museum Yearbook 3.

Karp, Ivan, and Steven D. Lavine, eds. 1991. *Exhibiting Cultures: The Poetics and Politics of Museum Display*. Washington, D.C.: Smithsonian Institution Press.

Keeler, Ward. 1984. *Javanese, a Cultural Approach*. Southeast Asia Series, no. 69. Athens: Ohio University Center for International Studies.

————. 1987. *Javanese Shadow Plays, Javanese Selves*. Princeton, N.J.: Princeton University Press.

Kenji, Tsuchiya, and James Siegel. 1990. "Invincible Kitsch or As Tourists in the Age of Des Alwi." *Indonesia* 50: 61–76.

King, J. C. H. 1985. "North American Ethnography in the Collection of Sir Hans Sloane." In *The Origins of Museums: The Cabinet of Curiosities in Sixteenth- and Seventeenth-Century Europe*, ed. Oliver Impey and Arthur MacGregor, 232–36. Oxford and New York: Clarendon Press and Oxford University Press.

Kopytoff, Igor. 1986. "The Cultural Biography of Things: Commoditization as Process." In *The Social Life of Things*, ed. Ajun Appadurai, 64–91. Cambridge: Cambridge University Press.

Krauss, Rosalind. 1980. *Grids: Format and Image in Twentieth Century Art*. 2nd ed. New York: Pace Gallery Publications.

Kristeller, Paul Oskar. 1965. "The Modern System of the Arts." In *Renaissance Thought II*, 165–227. New York: Harper and Row, Harper Torchbooks.

Lévi-Strauss, Claude. 1961. *A World on the Wane*. Trans. John Russell. New York: Criterion Books.

———. 1962. *The Savage Mind (La Pensée sauvage)*. London: Weidenfeld and Nicolson.

———. 1963. *Totemism*. Trans. Rodney Needham. Boston: Beacon Press.

———. 1982. *The Way of the Masks*. Trans. Sylvia Modelski. Seattle: University of Washington Press.

Lindsey, Timothy C. 1993. "Concrete Ideology: Taste, Tradition, and the Javanese Past in New Order Public Space." In *Culture and Society in New Order Indonesia*, ed. Virginia Matheson Hooker, 166–82. Kuala Lumpur and New York: Oxford University Press.

Lloyd, Jill. 1991. *German Expressionism: Primitivism and Modernity*. New Haven, Conn.: Yale University Press.

Löfgren, Orvar. 1993. "Materializing the Nation in Sweden and America." *Ethnos* (3–4): 161–96.

———. In press. *Making Holidays*. Berkeley: University of California Press.

Lovejoy, Arthur O. 1936. *The Great Chain of Being: A Study of the History of an Idea*. Cambridge, Mass.: Harvard University Press.

Lovejoy, Arthur O., and George Boas. 1935. *Primitivism and Related Ideas in Antiquity*. Baltimore: Johns Hopkins University Press.

Lynes, Russell. 1973. *Good Old Modern: An Intimate Portrait of the Museum of Modern Art*. New York: Atheneum.

Maass, John. 1972. "Who Invented Dewey's Classification?" *Wilson Library Bulletin* (December): 335–41.

MacCannell, Dean. 1976. *The Tourist: A New Theory of the Leisure Class*. New York: Schocken Books.

Malinowski, Bronislaw. 1922. *Argonauts of the West Pacific*. New York: Dutton.

Malraux, André. 1949. *Museum Without Walls*. Trans. Stuart Gilbert. Bollingen Series, no. 24. New York: Pantheon Books.

———. [1953] 1978. *The Voices of Silence*. Trans. Stuart Gilbert. Bollingen Series, no. 24A. Garden City, N.Y.: Doubleday. Reprint, Princeton, N.J.: Princeton University Press.

Maquet, Jacques. 1979. *Introduction to Aesthetic Anthropology*. 2nd rev. ed. Malibu, Calif.: Undena Publications.

———. 1986. *The Aesthetic Experience: An Anthropologist Looks at the Visual Arts*. New Haven, Conn.: Yale University Press.

Marcus, George E., and Fred R. Myers, eds. 1995. *The Traffic in Culture: Refiguring Art and Anthropology*. Berkeley: University of California Press.

Marcus, George E., and Michael M. J. Fisher. 1986. *Anthropology as Cultural Critique: An Experimental Moment in the Human Sciences*. Chicago: Chicago University Press.

Marin, Louis. 1977. "Disneyland: A Degenerate Utopia." *Glyph* 1: 50–66.

McCannell, Dean. 1976. *The Tourist: A New Theory of the Leisure Class.* New York: Schocken Books.

McCracken, Grant. 1988. *Culture and Consumption.* Bloomington: University of Indiana Press.

McEvilley, Thomas. 1984. "Doctor Lawyer Indian Chief: Primitivism in 20th Century Art at the Museum of Modern Art." *Artforum* 23 (3): 54–61.

McGovern, Charles F. 1990. "Real People and the True Folk." Exhibition review. *American Quarterly* 42 (34): 478–97.

Messenger, Phyllis Mauch, ed. 1989. *The Ethics of Collecting Cultural Property: Whose Culture? Whose Property?* Albuquerque: University of New Mexico Press.

Meyer, Karl E. 1973. *The Plundered Past.* New York: Atheneum.

———. 1979. *The Art Museum: Power, Money, Ethics.* A Twentieth Century Fund Report. New York: William Morrow.

Miksic, John. 1990. *Borobudur: Golden Tales of the Buddhas.* Photographs by Marcello Tranchini. Boston: Shambala Press.

Minor, Vernon Hyde. 1994. *Art History's History.* Englewood Cliffs, N.J.: Prentice-Hall.

Mitchell, Timothy. 1988. *Colonising Egypt.* Cambridge: Cambridge University Press.

———. 1989. "The World as Exhibition." *Comparative Studies in Society and History* 31 (2): 217–37.

Moertono, Soemarsaid. 1968. *State and Statecraft in Old Java: A Study of the Later Mataram Period, 16th to 19th Century.* Modern Indonesia Project Monograph Series. Ithaca, N.Y.: Cornell University Southeast Asia Program.

Morphy, Howard. 1991. *Ancestral Connections: Art and an Aboriginal System of Knowledge.* Chicago: University of Chicago Press.

Morton, W. Brown. 1983. "Indonesia Rescues Ancient Borobudur." *National Geographic* (January): 126–42.

Mosser, Monique, and Georges Teyssot, eds. 1991. *The Architecture of Western Gardens: A Design History from the Renaissance to the Present Day.* Cambridge, Mass.: MIT Press.

Mullaney, Steven. 1983. "Strange Things, Gross Terms, Curious Customs: The Rehearsal of Cultures in the Late Renaissance." *Representations* 3: 40–67.

Mullin, Molly H. 1995. "The Patronage of Difference: Making Indian Art Art, Not Ethnology." In *The Traffic in Culture: Refiguring Art and Anthropology,* ed. George E. Marcus and Fred R. Myers, 166–98. Berkeley: University of California Press.

Munn, Nancy. 1973. *Walbiri Iconography: Graphic Representation and Cultural Symbolism in a Central Australian Society.* Ithaca, N.Y.: Cornell University Press.

Murray, Peter. 1963. *The Architecture of the Italian Renaissance.* London: B. T. Batsford.

Myers, Fred R. 1995. "Representing Culture: The Production of Discourse(s) for Aboriginal Acrylic Paintings." In *The Traffic in Culture: Refiguring Art and Anthropology,* ed. George E. Marcus and Fred R. Myers, 55–95. Berkeley: University of California Press.

Nash, June. 1993. *Crafts in the World Market: The Impact of Global Exchange on Middle American Artisans.* Albany: State University of New York Press.

Newton, Douglas. 1978. *Masterpieces of Primitive Art.* Introduction by André Malraux. New York: Knopf.

Nochlin, Linda. 1971. *Realism.* Harmondsworth: Penguin.

Olmi, Giuseppi. 1985. "Science-Honor-Metaphor: Italian Cabinets of the Sixteenth and Seventeenth Centuries." In *The Origins of Museums: The Cabinet of Curiosities in Sixteenth- and Seventeenth-Century Europe,* ed. Oliver Impey and Arthur MacGregor, 5–17. Oxford and New York: Clarendon Press and Oxford University Press.

O'Neill, Hugh. 1993. "Islamic Architecture under the New Order." In *Culture and Society in New Order Indonesia,* ed. Virginia Matheson Hooker, 151–65. Kuala Lumpur: Oxford University Press.

Panofsky, Erwin. 1955a. "Iconography and Iconology: An Introduction to the Study of Renaissance Art." In *Meaning in the Visual Arts,* 26–54. New York: Doubleday.

———. 1955b. "The History of the Theory of Human Proportion as a Reflection of the History of Styles." In *Meaning in the Visual Arts,* 55–107. New York: Doubleday.

———. 1991. *Perspective as Symbolic Form.* Trans. Christopher S. Wood. 1st ed. New York: Zone Books.

Parezo, Nancy. 1983. *Navajo Sandpainting: From Religious Act to Commercial Art.* Tucson: University of Arizona Press.

Paz, Octavio. 1972. "Critique of the Pyramid." In *The Other Mexico: Critique of the Pyramid,* 69–112. Trans. Lysander Kemp. New York: Grove Press.

Pemberton, John. 1989. *The Appearance of Order: A Politics of Culture in Colonial and Postcolonial Java.* Ann Arbor, Mich.: UMI Dissertation Services.

———. 1994a. *On the Subject of "Java."* Ithaca, N.Y.: Cornell University Press.

———. 1994b. "Recollections from 'Beautiful Indonesia': Somewhere Beyond the Postmodern." *Public Culture* 6 (2): 241–62.

Phillips, Ruth B. 1993. "How Museums Marginalise: Naming Domains of Inclusion and Exclusion." *Cambridge Review* 114: 6–10.

———1995. "Why Not Tourist Art?: Significant Silences in Native American Museum Representations." In *After Colonialism: Imperial Histories and Postcolonial Displacements,* ed. Gyan Prakash, 98–125. Princeton, N.J.: Princeton University Press.

Pietz, William (n.d.) "Allegories of Order: From the Natural History Museum to the Television Game Show" (unpublished).

Pijoan, Joseph. 1933. *History of Art.* London: B. T. Batsford.

Pletsch, Carl. 1981. "The Three Worlds, or the Division of Social Scientific Labor, circa 1950–1975." *Comparative Studies in Society and History* 23 (4): 565–90.

Prakash, Gyan. 1990. "Writing Post-Orientalist Histories of the Third World: Perspectives from Indian Historiography." *Comparative Studies in Society and History* 32 (2): 383–408.

Pratt, Mary Louise. 1992. *Imperial Eyes: Travel Writing and Transculturation.* New York: Routledge.

Price, Sally. 1989. *Primitive Art in Civilized Places.* Chicago: Chicago University Press.

Prijotomo, J. 1984. *Ideas and Forms of Javanese Architecture.* Yogyakarta: Gadjah Mada University Press.

Raffles, Thomas Stamford, Sir. [1817] 1965. *The History of Java.* London: Black, Parbury and Allen [etc.]. Reprint, Kuala Lumpur: Oxford University Press.

Ramirez Vazquez, Pedro. 1968. *The National Museum of Anthropology, Mexico.* New York: Harry N. Abrams.

Robinson, Kathryn. 1989. *Stepchildren of Progress.* Albany: State University of New York Press.

———. 1993. "The Platform House: Expression of a Regional Identity in the Modern Indonesian Nation." In *Culture and Society in New Order Indonesia,* ed. Virginia Matheson Hooker, 228–42. Kuala Lumpur: Oxford University Press.

Rodgers, Susan, and Rita Smith Kipp, eds. 1987. *Indonesian Religions in Transition.* Tucson: University of Arizona Press.

Rothschild, Joseph. 1981. *Ethnopolitics: A Conceptual Framework.* New York: Columbia University Press.

Rubin, William. 1984a. "Modernist Primitivism: An Introduction." In *"Primitivism" in 20th Century Art,* ed. William Rubin, 1–71. New York and Boston: Museum of Modern Art and Little, Brown.

———. ed. 1984b. *"Primitivism" in 20th Century Art.* New York and Boston: Museum of Modern Art and Little, Brown.

Rubín de la Borbolla, Daniel F. 1986. "Valoración de las Artes Populares in México 1900 a 1940." In *El Nacionalismo y el Arte Mexicano* (Coloquio de Historia del Arte 9), 353–68. Mexico: Universidad Nacional Autónoma de México.

Rushing, Jackson W. 1992. "Marketing the Affinity of the Primitive and the Modern: René d'Harnoncourt and 'Indian Art of the United States.'" In *The Early Years of Native American Art History,* ed. Janet C. Berlo, 191–236. Seattle: University of Washington Press.

———. 1995. *Native American Art and the New York Avant-Garde: A History of Cultural Primitivism.* Austin: University of Texas Press.

Rydell, Robert W. 1984. *All the World's a Fair: Visions of Empire at American International Expositions, 1876–1916.* Chicago: University of Chicago Press.

———. 1993. *World of Fairs: The Century-of-Progress Expositions.* Chicago: University of Chicago Press.

Saarinen, Aline. 1958. *The Proud Possessors: The Lives, Times and Tastes of Some Adventurous American Art Collectors.* New York: Random House.

Said, Edward W. 1978. *Orientalism*. New York: Pantheon Books.

Saussure, Ferdinand de. 1959. *Course in General Linguistics*. Trans. Wade Baskin. New York: McGraw-Hill.

———. 1986. *Course in General Linguistics*. Ed. Charles Bally and Albert Sechehaye with collaboration of Albert Riedlinger; trans. and annotated by Roy Harris. LaSalle, Ill.: Open Court.

Schapiro, Meyer. 1978. "Introduction of Modern Art in America: The Armory Show." In *Modern Art: 19th and 20th Centuries: Selected Papers*, 135–78. New York: George Braziller.

Schorske, Carl E. 1979. *Fin-de-siecle Vienna: Politics and Culture*. New York: Knopf.

Scobie, Alexander. 1990. *Hitler's State Architecture: The Impact of Classical Antiquity*. University Park: Published for the College Art Association of America by the Pennsylvania State University Press.

Seligman, Thomas K., and Ellen C. H. Werner. 1991. "Saidi Oumba and Andi Ouloulou: Tuareg Artists of the Sahara." In *Viewpoints: New Perspectives on the Collection*. San Francisco: M. H. de Young Memorial Museum.

Shapiro, Laura. 1986. *Perfection Salad: Women and Cooking at the Turn of the Century*. New York: Farrar, Straus, and Giroux.

Shiraishi, Saya. 1990. "Pengantar, or Introduction to New Order Indonesia." *Indonesia* 50: 121–57.

Shoji, Naohisa. 1991. "The Privatisation of Borobudur." *Inside Indonesia* (28): 13–15.

Smith, Valene L., ed. 1989. *Hosts and Guests: The Anthropology of Tourism*. 2nd ed. Philadelphia: University of Pennsylvania Press.

Smith, Valene L., and William R. Eadington, eds. 1992. *Tourism Alternatives: Potentials and Problems in the Development of Tourism*. Philadelphia: University of Pennsylvania Press.

Solis-Cohen, Lita, and Sally Solis-Cohen. 1993. "Going Native: Indian Artifacts Are Becoming Hot Collectibles." *San Francisco Chronicle*, February 3.

Soussloff, Catherine. 1997. *The Absolute Artist: The Historiography of a Concept*. Minneapolis: University of Minnesota Press.

Stanton, Max. 1989. "The Polynesian Cultural Center: A Multi-Ethnic Model of Seven Pacific Cultures." In *Hosts and Guests: The Anthropology of Tourism*, ed. Valene L. Smith, 247–65. Philadelphia: University of Pennsylvania Press.

Steiner, Christopher B. 1995. "The Art of the Trade: On the Creation of Value and Authenticity in the African Art Market." In *The Traffic in Culture: Refiguring Art and Anthropology*, ed. George E. Marcus and Fred R. Myers, 151–65. Berkeley: University of California Press.

Stocking, George, Jr., ed. 1985. *Objects and Others: Essays on Museums and Material Culture*. History of Anthropology, vol. 3. Madison: University of Wisconsin Press.

———. 1987. *Victorian Anthropology*. New York: Free Press.

Summers, David. 1982. "The 'Visual Arts' and the Problem of Art Historical Description." *Art Journal* (Winter): 301–10.

———. 1987. *The Judgment of Sense: Renaissance Naturalism and the Rise of Aesthetics.* New York: Cambridge University Press.

Sutton, Peter. 1988. *Dreamings: The Art of Aboriginal Australia.* New York: George Braziller in association with Asia Society Galleries.

Sweeney, James Johnson, ed. 1935. *African Negro Art.* New York: Museum of Modern Art.

Tafuri, Manfredo. 1987. *The Sphere and the Labyrinth: Avant-Gardes and Architecture from Piranesi to the 1970's.* Trans. Pellegrino D' Acierno and Robert Connolly. Cambridge, Mass.: MIT Press.

Taylor, Leighton. 1989. "A Brief History of Dioramas." *Pacific Discovery* 42 (1): 30–35.

Taylor, Paul, ed. 1994a. *Fragile Traditions: Indonesian Art in Jeopardy.* Honolulu: University of Hawaii Press.

———. 1994b. "The Nusantara Concept of Culture: Local Traditions and National Identity as Expressed in Indonesia's Museums." In *Fragile Traditions: Indonesian Art in Jeopardy,* ed. Paul Taylor, 71–90. Honolulu: University of Hawaii Press.

Thompson, Michael. 1979. *Rubbish Theory: The Creation and Destruction of Value.* Oxford: Oxford University Press.

Torgovnick, Marianna. 1990. *Gone Primitive: Savage Intellects, Modern Lives.* Chicago: University of Chicago Press.

Trigger, Bruce G. 1984. "Alternative Archaeologies: Nationalist, Colonialist, Imperialist." *Man* 19: 355–70.

———. 1989. *A History of Archaeological Thought.* Cambridge: Cambridge University Press.

Turner, Louis, and John Ash. 1976. *The Golden Hordes: International Tourism and the Pleasure Periphery.* New York: St. Martin's Press.

Varnedoe, Kirk. 1985. "Letter." *Artforum* (February): 45–46.

Venturi, Robert, Denise Scott Brown, and Steven Izenour. 1972. *Learning from Las Vegas.* Cambridge, Mass.: MIT Press.

Vogel, Susan, and Francine N'Diaye. 1985. *African Masterpieces from the Musee de l'Homme.* New York: Center for African Art and Harry N. Abrams.

Volkman, Toby. 1984. "Great Performances: Toraja Cultural Identity in the 1970's." *American Ethnologist* 11: 152–69.

———. 1990. "Visions and Revisions: Toraja Culture and the Tourist Gaze." *American Ethnologist* 17 (1): 91–110.

Wade, E. L. 1985. "The Ethnic Art Market in the American Southwest: 1880–1980." In *Objects and Others: Essays on Museums and Material Culture,* ed. George Stocking, Jr., 167–97. History of Anthropology, vol. 3. Madison: University of Wisconsin Press.

Wallace, Michael. 1986a. "Reflections on the History of Historic Preservation." In *Presenting the Past: Essays on History and the Public,* ed. Susan

Porter Benson, Stephen Brier, and Roy Rosenzweig, 165–99. Philadelphia: Temple University Press.

————. 1986b. "Visiting the Past: History Museums in the United States." In *Presenting the Past: Essays on History and the Public*, ed. Susan Porter Benson, Stephen Brier, and Roy Rosenzweig, 137–61. Philadelphia: Temple University Press.

Waterson, Roxana. 1990. *The Living House: An Anthropology of Architecture in South-East Asia*. Singapore: Oxford University Press.

Watkin, David, and Tilman Mellinghoff. 1987. *German Architecture and the Classical Ideal*. Cambridge, Mass.: MIT Press.

Weisberg, Louis. 1989. "Taking Another Look at Phony Indian Art." *Indian Market 1989:* 49–51. Santa Fe: Southwestern Association on Indian Affairs.

————. 1990. "Update: Fake Indian Art." *Indian Market 1990:* 24–25. Santa Fe: Southwestern Association on Indian Affairs.

Weschler, Lawrence. 1995. *Mr. Wilson's Cabinet of Wonder*. New York: Pantheon Books.

White, Hayden. 1987. *The Content of the Form: Narrative Discourse and Historical Representation*. Baltimore: Johns Hopkins University Press.

Widodo, Amrih. 1995. "The States of the State: Arts of the People and Rites of Homogenization." Special Issue: Performances. *RIMA* (Review of Indonesian and Malaysian Affairs) 29: 1–35.

Williams, Nancy. 1976. "Australian Aboriginal Art at Yirrkala: The Introduction and Development of Marketing." In *Ethnic and Tourist Arts*, ed. Nelson Graburn, 266–85. Berkeley: University of California Press.

Williams, Raymond. 1973. *The Country and the City*. New York: Oxford University Press.

Wolf, Eric. 1982. *Europe and the People without History*. Cartographic illustrations by Noel L. Diaz. Berkeley: University of California Press.

FILM AND VIDEO

Baare, Gabai, Ilisa Barbash, Christopher Steiner, and Lucien Taylor. *In and Out of Africa*. Los Angeles: Center for Visual Anthropology, University of Southern California, 1992.

Colin McPhee: The Lure of Asian Music. New York: M. Blackwood Productions, 1985.

Index

Page numbers in italics refer to illustrations.

Illustration Credits

Compositor:	Impressions Book and Journal Services, Inc.
Text:	10/13 Palatino
Display:	Palatino
Printer and binder:	Edwards Brothers, Inc.